EISENSTEIN'S
Ivan the Terrible

A NEOFORMALIST ANALYSIS

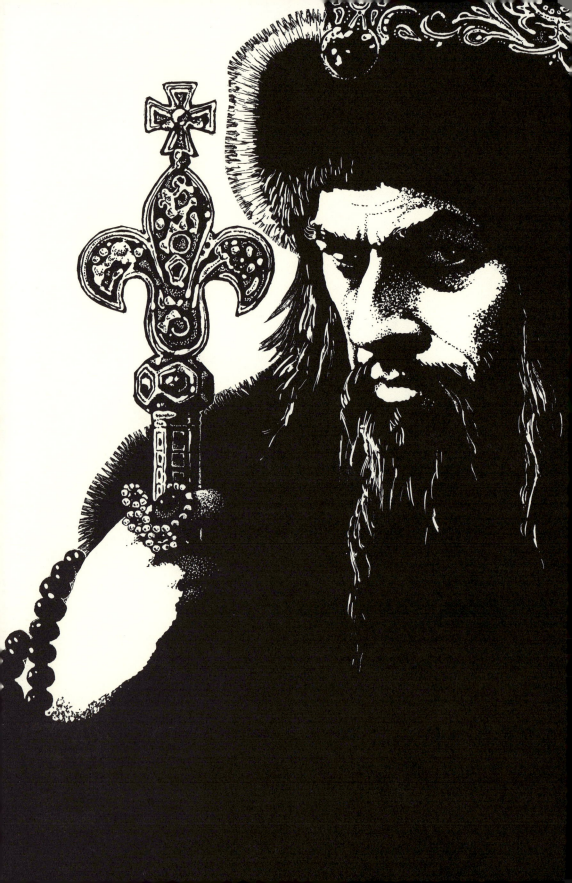

EISENSTEIN'S
Ivan the Terrible

A NEOFORMALIST ANALYSIS

by Kristin Thompson

Princeton University Press

Publication of this book has been aided by a grant from the
Paul Mellon Fund of Princeton University Press

This book has been composed in Linotron Sabon

Clothbound editions of Princeton University Press books
are printed on acid-free paper, and binding materials are
chosen for strength and durability

Printed in the United States of America by Princeton
University Press, Princeton, New Jersey

Library of Congress Cataloging in Publication Data

Thompson, Kristin, 1950-
 Ivan the Terrible: a neoformalist analysis.

 Bibliography: p.
 Includes index.
 1. Ivan Groznyĭ (Motion picture) I. Title.
PN1997.I773T5 791.43′72 81-5154
ISBN 0-691-06472-5 AACR2
ISBN 0-691-10120-5 (pbk.)

For David

ORVILLE THE SCROOCH OWL: What in this book?

HOWLAND OWL: Words, mostly.

ORVILLE: Well, it harder to review books with words in, but here goes. First thing to reviewing is to tear out every second page. That simplify the task.

—*Pogo*

Contents

Preface ix

Introduction 3

Chapter One: A Neoformalist Method of Film Criticism 8

Chapter Two: Narrative Analysis 61

Chapter Three: Spatial Relations 112

Chapter Four: The Floating Motif 158

Chapter Five: Expressionistic Mise-en-scene 173

Chapter Six: Simple Sound Relations 203

Chapter Seven: Vertical Montage 224

Chapter Eight: Disjunctions and Discontinuities 261

Chapter Nine: Excess 287

Appendix 303

Select Bibliography 307

Index 317

Illustrations *following Index*

Preface

Any attempt to discuss a film necessitates the use of notational or descriptive systems. I have relied to a large extent on a corrected version of the numbered shot description published by Simon and Schuster (see Bibliography), since this is widely available. This description includes a number of shots that do not actually exist in the film, but I have not redone the numbering, as this would necessitate my including another complete shot list. The description also fails to note several shots that *are* in the film; I have labeled each of these shots with the number of the preceding shot followed by a lower-case "a."

The narrative analysis of *Ivan*, Part III depends upon the published script, rather than upon a finished film, as with the first two parts. Although the status of Part III is different, I am assuming that the narrative structures are sufficiently accessible from the script for the purposes of this analysis. Page numbers in parentheses after quotations from Part III are from the Montagu-Marshall translation; see Bibliography.

Most prints of *Ivan the Terrible*, Part I that I have examined in the United States lack several small segments of scenes; these prints are the 16mm and 35mm distribution prints, as well as the print at the Anthology Film Archives. The Museum of Modern Art has a complete 35mm print, and at least some European prints are also complete. All the missing scenes are included in the Simon and Schuster shot list: 1) the end of the coronation speech in Part I, with the initial reactions of the European ambassadors (90-92); 2) a segment near the beginning of the scene by Anastasia's coffin, when Malyuta reads off the list of Boyar treacheries (705-716); 3) a shot near the end of the same scene, with Ivan exulting above the coffin (759); and 4) the opening of the Herald scene (767-769). Prints of Part II are not missing any footage, although the color scenes are much faded in 16mm prints.

A number of persons and organizations contributed in various ways to the writing of this book. My thanks to Dudley Andrew, who years ago fostered my interest in this film. Ms. Mary Peatman aided me by making her dissertation on *Ivan* available for my research. She also helped me to obtain a copy of the oratorio piano

score upon which much of the sixth and seventh chapters of this work depend. Without her generous help, this study could not have taken its current shape. I am particularly grateful as well to Vance and Betty Kepley, who were willing for two years to drop their own activities in order to translate passages of Russian dialogue and texts. The care and precision of their translations have enabled me to make a number of important points about the film. (Translations from French sources are my own.)

A study of a single film necessitates weeks of work with prints, in this case on loan from film companies. Audio-Brandon was kind enough to supply me with 16mm prints for this purpose. In addition, Kino International was extremely generous in allowing me to use their 35mm prints; this aided greatly in an analysis of the color sequences, as well as in obtaining the frame enlargements.

This book began as my dissertation; my committee members, Keith Cohen, Jeanne Allen, Joe Anderson, and my chairperson, Russell Merritt, lent invaluable assistance throughout the processes of research, writing, and rewriting. The fifth member of the committee, David Bordwell, has most influenced the development of my critical method and my ability to analyze film. It was he who originally pointed out a copy of Lemon and Reis in a bookstore and recommended that I read it; the first chapter of this dissertation began as a paper for his seminar on critical methodology. He has made many valuable suggestions and encouraged me greatly along the way.

My thanks to all these people and to the Wisconsin Center for Film and Theater Research, whose research facilities made working on this film a pleasure; the frames from *Sergeant York* are reproduced with the permission of the Center and its head, Tino Balio. Jacques Ledoux and the staff of the Royal Film Archive of Belgium made it possible for me to study those segments missing in most American prints of Part I. Badia Rahman devised the means for taking the frame enlargements, and Mary Agnes Beach printed the stills. My thanks finally to Joanna Hitchcock and Cathy Thatcher of Princeton University Press for their patience and contributions during the revision process.

Two sections of this study have appeared previously: an excerpt from Chapter Three as "Non-classical Space in *Ivan the Terrible*: A Sample Analysis," in *Explorations in National Cinemas: The 1977 Film Studies Annual* (Redgrave, 1977), pp. 57-64, and one from Chapter Nine as "The Concept of Cinematic Excess," in *Cine-Tracts*, no. 2 (Summer, 1977), pp. 54-63.

EISENSTEIN'S
Ivan the Terrible

A NEOFORMALIST ANALYSIS

Introduction

WHY *Ivan the Terrible?*

Arguably, a book-length study of any single film could teach us
something about the cinema. We might learn about the expectations
with which we approach films, the ways in which film texts guide
our perceptions, or the relations of films to their historical contexts.
But for critics setting out upon such a project, certain other con-
siderations enter the situation. First, for such a lengthy study, read-
ers will be at a disadvantage unless they are reasonably familiar
with the film. *Ivan the Terrible* is a readily accessible film, having
become a film society and classroom regular. I would invite the
readers of this study to see the film before reading the book and
ideally again after reading it. Second, critics who must concentrate
on the film for months need to be able to live with it without losing
interest; certainly for this critic, *Ivan* has retained its fascinating
qualities over several years of study. And finally, unless the study
uses the film in question purely to deduce theoretical concepts, it
should be complex enough to sustain a lengthy analysis of interest
to its readers.

And *Ivan* is a complex film. I do not mean by this that it contains
a hidden thematic system that I propose to explicate. Indeed, the
film's thematic material is fairly simple, due in part to the historical
conditions of its production. Eisenstein made *Ivan* during World
War II, when it served largely as patriotic propaganda. Its central
concern with the maintenance of Russian unity against encroaching
Europeans made it an obvious parallel for the contemporary war-
time situation. But if this thematic material were all there was to
Ivan, we would hardly watch it today, except as an historical doc-
ument. Rather, the complexity I attribute to the film involves pri-
marily its formal density, both narrative and stylistic. Although the
plot remains comprehensible to the viewer, I will be arguing that
events proceed in a convoluted, extremely indirect path from the
opening to the closing scenes. And anyone who has seen the film
has necessarily been struck by its profusion of visual and sonic
elements: there are so many stylistic structures that even several
viewings will not allow us to sort them all out. In my analysis I

have attempted not simply to catalogue these structures but to show how they function in relation to each other within the formal whole.

Perhaps as important as complexity in making *Ivan* appropriate to close scrutiny is its strangeness. Whereas every film is different from others to some degree, *Ivan*'s striking qualities arise in part because it differs so greatly from other films. *Ivan*'s actors stare oddly, pause a great deal, and make abrupt gestures. The settings thrust themselves upon our attention almost as much as the main action itself (sometimes more) because of their unusual shapes and decorative surfaces. Space in general seems warped, both within and between shots. The giant shadow that Ivan casts in the throne room in what is perhaps the film's most famous composition typifies the overblown, distorted quality of the whole. This strangeness is for me both the beginning and the end point of a critical study: it lures us to *Ivan* to start with, and analysis, however much it tells us about the film, should preserve this unique characteristic.

My purpose here will be to analyze *Ivan*'s strangeness, not to reduce, explain, categorize, or tame it. To do this, I ask the question, What are the film's significant formal and stylistic relationships? In answering this question, I shall be employing a formalist method. Within the field of film studies, this method follows the general tradition of such theorist-critics as Eisenstein and Noël Burch, whose writings I shall occasionally draw upon in the course of my analysis. But since I do derive many of my assumptions from outside the field of film, and specifically from the literary theory and criticism of the Russian Formalists, I shall call this method neoformalism.

Before going on to describe neoformalism, however, I would like to fill in some background for those who may be unfamiliar with Eisenstein's theory and its relation to *Ivan*. This will be followed by a brief discussion in Chapter One of Russian Formalism and how it relates to some other major twentieth-century critical theories.

Ivan the Terrible and Eisenstein's Theory

Andrew Sarris has called *Ivan* "a virtual repudiation of the fundamental montage theory."[1] His statement typifies, I suspect, the

[1] Andrew Sarris, *Interviews with Film Directors* (New York: Avon Books, 1969), p. 164.

opinion of many viewers who are introduced to Eisenstein's work through *Potemkin* or *October*. *Ivan*'s extreme differences from Eisenstein's silent films certainly suggest a profound change in his thinking. Yet Eisenstein had not repudiated his entire early theory; rather he had made major changes in the assumptions upon which he based his theory of montage. In order to suggest why montage provides a valuable tool for analyzing even so late a film as *Ivan*, I will briefly outline the two phases of Eisenstein's theoretical beliefs. For a more detailed treatment of the changes in Eisenstein's theory that occurred around 1930, see David Bordwell's "Eisenstein's Epistemological Shift."[2]

Several fundamental aspects of montage theory remained constant over Eisenstein's career. First, montage always involved the juxtaposition of disparate elements. Second, these juxtaposed elements were the techniques of the film medium, and they were all considered to be equal in their potential as montage devices: sound, color, depth, editing rhythm, or any other technique could come forward at a given moment in a film to become the most important expressive element. Eisenstein first discusses this concept very early in his theoretical writings, but it becomes most prominent after his discovery of Kabuki theater in 1928. In his two 1928 essays on the subject, "The Unexpected" and "The Cinematographic Principle and the Ideogram,"[3] he formulates the equality and interchangeability of film techniques as the *monistic ensemble*.

In the pre-1930 period, Eisenstein wrote that montage should be used to stimulate the audience to the desired response; his model was Pavlovian physiology. For Eisenstein, the spectator's response to the film consisted of a chain of increasingly complex levels: perception, emotion, and cognition. To carry the viewer to the perceptual level took minimal stimulation, but with additional bombardment by filmic material, the viewer would move to the emotional and finally the cognitive levels. Because Eisenstein's theory was based upon a dialectical materialist model, he stressed tension among elements, with the resolution being provided by the spectators' response. Montage elements were devices in collision.

Although Eisenstein's early theory was remarkably unified, it did

[2] David Bordwell, "Eisenstein's Epistemological Shift," *Screen* 15, no. 4 (Winter 1974/1975): 32-46.

[3] Sergei Eisenstein, "The Unexpected" and "The Cinematographic Principle and the Ideogram," in *Film Form,* trans. and ed. Jay Leyda (New York: Harcourt, Brace, and World, 1949), pp. 18-44.

have one fundamental ambiguity that acted as a sort of hinge to bring him into a new formula. The Kabuki's monistic ensemble, with its equality of devices, could be seen as encouraging abrupt juxtapositions; this indeed frequently occurs in Kabuki. Eisenstein's most famous example describes a scene from *Chushingura*:

> Yuranosuke leaves the surrendered castle. And moves from the depth of the stage towards the extreme foreground. Suddenly the background screen with its gate painted in natural dimensions (close-up) is folded away. In its place is seen a second screen, with a tiny gate painted on it (long shot). This means that he has moved even further away. Yuranosuke continues on. Across the background is drawn a brown-green-black curtain, indicating: the castle is now hidden from his sight. More steps. Yuranosuke now moves out on to the 'flowery way.' This further removal is emphasized by . . . the *samisen*, that is—by sound![4]

But the monistic ensemble also suggests that disparate elements can be combined in striking ways to reinforce each other—to create emphasis, for example, or to heighten emotion. This kind of combination happens in Kabuki as well. Eisenstein describes another scene from the same play, where sound reinforces gesture: "that combination of the moving hand of Ichikawa Ennosuke as he commits hara-kiri—*with* the sobbing sound offstage, *graphically* corresponding with the movement of the knife."[5] From about 1930, such functions of montage become increasingly important for Eisenstein.

The later theory, evident in such works as *The Film Sense* and *Non-Indifferent Nature*, is more relevant to *Ivan*; here Eisenstein holds that the spectator responds to the world through a mental activity called *inner speech*. This inner speech is prelogical and accumulates through the repetition and combination of sensations from the outer world. Eisenstein now maintained that the filmmaker should seek to make films that work upon the spectator in the same way; that is, by orchestrating montage elements with repetitions and variations in a dense weave, the film could touch off this prelogical, sensuous thought in the spectator. If correctly—that is, intensely—done, the result for the spectator would be *ecstasy*, an irresistible carrying of the self completely over into the sensuous

[4] Eisenstein, "The Unexpected," p. 22.
[5] *Ibid.*, p. 23.

effect of the film. This is a far cry from the intellectual response that Eisenstein held to be the highest plane of cinematic art during the silent period. As we shall see in examining the play of motifs and sound in *Ivan*, Eisenstein believed that repetition and variation could build upon associations in the inner speech of the spectator. These would grow in intensity with each return until the culmination point, when the excitement would be so great that the spectator would reach the point of ecstasy.

Although this second theory is far more traditional and romantic than the early Marxist one, these views are in a sense more difficult to understand. To some extent I suspect this may be because *Potemkin* is narratively and stylistically more straightforward than *Ivan*. To many viewers *Ivan* seems ponderous and mannered; its acting style and predominant interiors help promote this impression. Here the objects that had functioned as intellectual images of decadence in *October* and *Old and New* provide the pretext for lingering and sensuous contemplation. *Ivan*'s editing rhythm is noticeably slower than those of the silent Eisenstein films. These and other differences suggest that if viewers expect collision and tension, they may indeed find *Ivan* to be a nonmontage film. Part of my concern in analyzing *Ivan* will be to discover how the juxtaposition of sound and image creates the complex and intense structure Eisenstein termed *vertical montage*.

Eisenstein's own explications of scenes from *Ivan* using his montage theory are probably the best analyses done thus far.[6] But Eisenstein was not primarily a critic; he dealt only with individual scenes because they provided examples for his theoretical statements. Thus, while I have not tried to duplicate or supersede his writings, I have attempted to analyze *Ivan* more systematically and as a whole. At times, Eisenstein's theory will be relevant to the point being made, and I shall refer to it again on occasion. My main method, however, will be neoformalism.[7]

[6] These writings, particularly *Non-Indifferent Nature*, are available in French and will appear in English from The MIT Press.

[7] The neoformalist method is not unique to this study. A number of people working at the University of Wisconsin at Madison have contributed and continue to contribute to it. David Bordwell's *The Films of Carl-Theodor Dreyer* (Berkeley and Los Angeles: University of California Press, 1981) uses a similar approach.

 A Neoformalist Method of Film Criticism

THE TRADITION OF NEOFORMALISM

The Russian Formalist Movement

As I will be defining it for my purposes here, neoformalism derives largely from Russian Formalism. The necessity for a new name arises from several circumstances. The Russian Formalist movement as such is over; one can hardly call oneself a "Russian Formalist" today. Also, since Russian Formalism was a method of literary study, some changes must be made before it can be applied to other arts. At times, the critic must fill in gaps in the original method. Hence film study demands a "new" formalism.

Our century has produced a number of major aesthetic theories, some of which have furnished models for the analysis of films. Two such major, and quite different, theories are New Criticism and structuralism. By relating the less familiar Russian Formalism to these two, I shall try to situate it sufficiently to show how it may be adapted for film study.

Russian Formalism was historically the earliest of the three, beginning in 1914 with the publication of "The Resurrection of the Word" by Viktor Shklovski and tapering off by about 1930, when official displeasure with the "formalist" and non-Marxist bent of the method forced the members of the movement to change their ideas. As with so much that was exciting in the Soviet art world of the 1920s, Russian Formalism was virtually outlawed by the doctrine of Socialist Realism, declared officially in 1934. In addition to Shklovski, the major members of the Moscow (1915) and Petersburg (1916) groups that comprised the movement were Boris Eikhenbaum, Juri Tynjanov, Boris Tomashevski, Osip Brik (an editor of *Lef* and *Novyi Lef*), and Roman Jakobson. The group had close ties to film: Shklovski was a friend of Eisenstein and a film reviewer; Shklovski, Brik, and Tynjanov wrote scenarios for major films of the period, including *Bed and Sofa, Wings of a Serf,* and *The House on Trubnoi Square* (Shklovski); *Storm Over Asia* (Brik); *The Cloak, SVD,* and *Lieutenant Kizhe* (Tynjanov).

The Russian Formalist movement has exerted considerable influence on subsequent literary study. Roman Jakobson left Russia and became a key figure in the Prague Linguistic Circle, an important link between Formalism and the more recent structuralism. In addition, the first major anthologies of Russian Formalist essays in translation were finally published in English and French in 1965.[1] Subsequently, concepts from the earlier movement have been filtering into some structuralist writing; Roland Barthes's "An Introduction to the Structural Analysis of Narrative" and *S/Z* owe something to Formalism. In the United States, less influence is apparent so far. Some studies have attempted to apply concepts from the morphological studies of Russian folk tales by Vladimir Propp, a marginal Formalist.[2] The more general Formalist theory, however, lends itself readily to adaptation into forms appropriate to other media.

Major Modern Critical Theories

Russian Formalism has often been compared to New Criticism, since the two approaches overlapped historically and were both reactions against romantic critical practices of the nineteenth and early twentieth centuries. New Criticism is better known in this country, since its proponents all wrote in English, and the texts have thus been available here since the movement began.[3]

Structuralism is also better known than Russian Formalism. In spite of the influences I have mentioned, structuralism overlaps only slightly with Formalism; the former constitutes a different methodology. Since my main purpose here is to place Russian Formalism before going on to derive my own method from it, I can hardly attempt to give complete overviews of either New Criticism or structuralism. At most, I hope to suggest enough about them to

[1] Lee T. Lemon and Marion J. Reis, trans. and eds., *Russian Formalist Criticism: Four Essays* (Lincoln: University of Nebraska Press, 1965) and Tzvetan Todorov, trans. and ed., *Théorie de la littérature* (Paris: Seuil, 1965).

[2] "Proppian analyses" that try to apply Propp's findings directly to film narratives are doomed to failure. Propp stated that his work was an attempt to define Russian folk tales as a specific literary form. By applying Propp's categories to baseball, genre films, games, and any other object at hand, critics contradict his assumptions. Either Propp was wrong about the specific nature of his own method (and this would seem to throw doubt upon the general validity of the method), or Propp was correct, and any attempt to apply it to material other than Russian folk tales is inappropriate.

[3] The method of New Criticism is often labeled "contextualism."

indicate that Russian Formalism stands somewhere between the two other theories and that it overlaps slightly with each. For more complete and highly readable summaries of each movement, I would recommend Murray Krieger's book on New Criticism, *The New Apologists for Poetry*, and Jonathan Culler's *Structuralist Poetics*.[4]

For purposes of comparison, I will break the three theories down into their assumptions about the art object, the reader (since these are largely literary theories), and the historical context.

THE ART OBJECT. The New Critics analyze the artwork as a contextual object—as a self-contained system whose internal relations are the only relevant ones for the reader. Literature is seen as a separate and unique form of human activity. Its uniqueness arises from a difference between *poetic* and *scientific language*. Since the latter is designed to yield empirical, testable truth about the world, poetic language must yield something else. For the New Critics, literature employs language that conveys a deeper truth in the form of intuited, emotional insights that only the poet can give the reader. Hence poetry is valuable not as a special means of communicating factual information; rather, it provides a medium in which the poet can work out, for him or herself as well as for the reader, intuited ideas that could come into being nowhere but in poetic language. The poet begins with a vague, unformed germ of an idea and can develop it only by working it in language; hence the poem does not convey an idea but helps to create it.

As an alternative to earlier, romantic approaches to poetry, New Criticism marked a shift in assumptions. Previously most theories had involved a distinct split between the form and content of a poem. On the one hand, the poem was believed to convey potentially true and important ideas from the poet's mind to the reader; form here acts as a container, important only in aiding the transfer of ideas. On the other hand, some critics believed that artistic form is more important than any ideas it might convey; they held that art's purpose is to bring pleasure through beauty. This position has generally been known as art for art's sake. The New Critics improved upon both of these positions by according language an active role in the creative process of poetry. Form and content become more firmly linked when ideas are not only conveyed, but even

[4] Murray Krieger, *The New Apologists for Poetry* (Bloomington: Indiana University Press, 1963); Jonathan Culler, *Structuralist Poetics* (Ithaca: Cornell University Press, 1975).

created, by the artist's work in language. W. H. Auden's famous question, "How can I know what I mean till I see what I say?" signaled a strong effort to eliminate the form-content split. This effort succeeded only to a degree.

In fact, form and content moved together and meshed, yet remained distinct elements because New Criticism continued to rely upon a communications model. Whereas the element to be communicated changed—now it was an essential reality arising from the poet's intuition—the model itself implies that the reader's main relation to the artwork is still an interpretive one: we read poetry in order to be given a meaning. The artwork supposedly affords us an experiential grasp of this meaning, but the aesthetic activity still conveys something from one mind to another. This view of artistic creation remains somewhat mystical; the poet is one who understands more of the world and has command of a medium for conveying that deeper understanding. As Krieger puts it, the New Critics were "battling romanticism with the tools furnished them by romanticism."[5] They had failed to make a complete break.

Russian Formalism overlaps with New Criticism to some extent here, since its proponents made a distinction between poetic and practical language. But they went further to create the break with a romantic view of the artist as the conveyor of truth. The Formalists eliminated the communications model almost entirely. For them, the poet was not trying to communicate meaning, whether empirical or intuited; instead, he or she uses language in a distinctive way to create a new perceptual experience for the reader. Thus readers do not gain information or insight in the usual sense: for the duration of the aesthetic activity, they perceive in a way unique to art. This unfamiliar perception may, if the artwork is successful, linger on and affect a reader's perception of nonaesthetic events. As we shall see later in this chapter, the Formalists viewed aesthetic perception as difficult, unaccustomed perception; the reader's regular perceptions, dulled by habit, could be renewed by the strangeness encountered in artworks. With this view of the aesthetic object, the Formalists eliminated the need for the form-content split, since the work's purpose is not to convey content to the reader.

The Formalists did not conceive of the art object as a closed, self-sufficient context, and here again they differed from the New Critics. They saw the artwork as a system; indeed, the word "form" itself

[5] Krieger, *New Apologists*, p. 43.

refers in this approach to the sum total of internal relationships in the work. But they denied complete originality and uniqueness to each work. For the Formalists, every work depends on its relations to other systems: nonpoetic language, other artworks, aspects of the everyday world. These external systems were referred to as *backgrounds*. In contrast, although the New Critics made some concessions by acknowledging the existence of fixed forms—those conventions of everyday usage and poetic practice that the poet must distort in the act of creation—they did not see these fixed forms as a concern for the critic. For them, outstanding poetry was defined by its unique qualities, not by its similarities to other things. So they did not systematize and study these fixed forms, since they wanted each poem to remain resolutely self-contained. The Formalists organized the norms as well as the deviations into objects of study for the critic. As we shall see shortly, the background allows the Formalist to deal with history where the New Critic cannot.

Structuralism shares virtually nothing with New Criticism, but it does overlap a bit with Formalism. Indeed, throughout this discussion, Formalism seems to fall between the two other theories, sharing a few assumptions with each but also differing considerably from both. Structuralism shares Formalism's rejection of the romantic view that the artist conveys higher truths or special insights of any kind. For the structuralists, language suggests many false or ambiguous meanings. The critic's focus shifts, then, from the romantic concentration on the artist to an emphasis on the work's control over the reader's interpretation of it. This still involves a communications model of sorts; meaning does return as the focal point for the critic, even though the meanings conveyed by an artwork may no longer be unambiguous, true, or consciously intended. Jonathan Culler has characterized structuralism as "a poetics which strives to define the conditions of meaning."[6]

The New Critics, with their emphasis on the poem as the growth of the idea in the material of language, emphasized the organic quality of the work; this metaphor suggests their view of the self-contained system. By contrast, the Russian Formalists use a quite different type of metaphor. They didn't see the poet as a communicator of ideas that grow into artworks but as a skilled artisan in a special field. By being familiar with both the poetic material—

[6] Culler, *Structuralist Poetics*, p. viii.

language and poetic devices—and the conventions of the art, the poet can combine these in a new way. Only by doing so can he or she create something perceptually stimulating for the reader. Hence the metaphors employed by the Formalists suggest not growing things but crafts, buildings, and sometimes machines; the Formalists refer to weaving, braiding, sewing, staircases, and so on. For them, the artwork is a constructed system. Finally, the structuralists view the artwork as a system of signs that control the reader through conventions of meaning. Structuralist metaphors are perhaps more varied and hence harder to generalize about; but prominent in structuralist analyses are references to traps, deceit, violence, rupturing, camouflage, and so on. These varied metaphorical vocabularies will perhaps help summarize the considerable differences among the three critical systems.

There are several varieties of structuralism, but all derive from linguistics to some degree (as indeed does Russian Formalism). One system that sticks quite closely to the original linguistics model is what we might conveniently term Jakobsonian structuralism (for its leading proponent, Roman Jakobson). This approach is not typical of the structuralist practices that have recently become widespread in film studies. Such structuralism has a distant relationship to New Criticism in that it treats the poem as a system of internal structural relationships. The critic's job is to analyze and catalogue the poem's structures down to the most minute possible level; these structures include symmetry, repetition, and various traditional poetic figures like metonymy. Jakobson and Claude Lévi-Strauss's essay "Charles Baudelaire's 'Les Chats' "[7] provides a typical example of Jakobsonian structuralism. Objectors to Jakobson's theory suggest that it includes no criteria to determine whether a discovered structure is significant or not in the work's overall context and that the methods applied by Jakobson can be shown to find the same structures at work in nonpoetic language.[8]

Perhaps the more familiar approach is late structuralism, popular in France, especially during the late 1960s and early 1970s. This structuralist approach emphasized the difference—again borrowed from linguistics—between *langue*, a system of conventionalized

[7] Roman Jakobson and Claude Lévi-Strauss, "Charles Baudelaire's 'Les Chats'," trans. F. M. de George, in *The Structuralists From Marx to Lévi-Strauss*, ed. Richard T. de George and Fernande M. de George (New York: Doubleday and Company, Inc., 1972), pp. 124-146.

[8] Culler, *Structuralist Poetics*, Chapter 3, pp. 55-74.

signs that a society shares, and *parole*, individual utterances drawing upon that system. Late structuralism does not seek to distinguish between aesthetic and nonaesthetic objects (a distinction that forms one of the basic premises of Formalism). Rather, it treats artworks as sign systems like any others—advertisements, games, speech acts, and so on. For the critic still interested in "defining the conditions of meaning," individual works (*parole*) are less interesting in their own right than they are for what they reveal about the larger system (*langue*) that supports them. The critic studies a poem to be able to generalize about the conventions of poetry in society and about how a poem as a specific method of organizing signs conveys meaning to the reader.

Here again the Russian Formalists overlap with the late structuralists to some extent. The Formalist critic similarly takes an interest in the conventions underlying the individual work, organized, as I have mentioned, into backgrounds. But for the Formalist, these backgrounds are not only sign systems; they are systems of artistic devices, familiar from other works, upon which the poet draws, using them in perceptually fresh ways. Meaning is only one of the devices that participates in the overall formal relations of a work; the Formalist critic also wants to cast light upon backgrounds through examining individual works. In studying *Ivan the Terrible*, I have tried to draw some conclusions not only about this one film but about how films affect us in general. Ideally for the Formalist, as for the structuralist, each critical analysis should have some theoretical implications as well.

THE READER. One of the principal problems that arises from the New Critics' strictly contextual view of the artwork is the question of how readers comprehend what they read. If the artwork forms a system unto itself, cut off from both reality and other artworks, would readers be able to deal with it? Logically speaking, this new artwork should be like an unknown foreign language or nonsense, yet this is clearly not the case. And if the theorist allows that poetry does actually derive from reality and from poetic convention, how can the poem be an organic development of an idea that comes into being only in the context of the individual work? By not destroying the form-content split thoroughly, by continuing to depend on the conveyance of ideas, the New Critics created a lingering problem in coping with the reader.

The New Critics insisted that poetic meaning cannot be para-

phrased. Instead, the reader experiences the intuited truth of the poem only in the process of reading the poem itself. The idea is there, but the poem is so closed, so self-contained a system that interpretation will destroy the meaning. From the critic, the reader can receive only guidance through the intricate structures of the work itself; the critic does not interpret for the reader. And again, because the artwork is self-sufficient, New Criticism seems to imply that the reader need not bring anything to the work to be able to understand it (no knowledge of other artworks, no special understanding of world events, etc.). This leads one to ask how some people can be more skillful at reading poetry than others—why some are even good enough at it to be critics. In trying to deal with the reader, the critic runs into problems with New Criticism not initially apparent in its rather attractive view of the poem as contextual system.

Russian Formalism provides answers to some of these questions. While considering the artwork to be a system, Formalist critics make it an open system. The backgrounds of other artworks, practical language, and everyday reality affect the poem; they also guide the reader's perception of it. The reader approaches the poem with a knowledge of other works, with an ingrained understanding of how language functions in nonpoetic contexts, and with some knowledge of reality. These allow the reader to recognize the familiar aspects of the work, which draws upon certain norms as its beginning point. The reader also can detect the deviations from these norms that constitute the main interest of the individual work—its originality and complexity. The Formalist critic does not treat the reader as a real person but as a set of perceptual cues within the work, implicit in its relations to the background. Such a critic compares the work with the implicit backgrounds it draws upon and then constructs a reasonable set of responses based upon those relations. Some readers can be more skillful than others, then, for they may be more familiar with the conventions of language, with the norms of other artworks, and with events in the world. As we shall see later in this chapter, the critic's activity strives in part to teach the reader something about these backgrounds in order that the reader's experience of the work may be enhanced. For the Formalist critic, the reader becomes in effect a construct suggested by the work itself.

Structuralism also sees the reader as a construct of the text itself. The structuralist's distinction between *langue* and *parole* creates a

critical tool that resembles the Formalists' backgrounds; both methods use these tools to show how the reader is implied within the work and its context. The difference between the two results from the structuralists' concentration upon meaning, in contrast with the Formalists' interest in perception.

For the later structuralists, the guidelines for interpretation lie primarily outside the artwork, in society and in the complex conventions of reading as an institution. This is the case because the work is seen as one particular instance (*parole*) of the larger system (*langue*); the latter furnishes the understanding that allows the reader to deal with the individual work. The work becomes not a container of fixed, intended meanings but a site for the generation of multiple meanings. Knowledge gained from the work has little importance; the object of study becomes the poem as the producer of its own endless meanings.

THE HISTORICAL CONTEXT. Russian Formalism quickly gained a reputation for being ahistorical. In the context of postrevolutionary Russia, its orientation was decidedly not towards the Marxist historiography that would have pleased many Communists. The "formalist" charges against the movement by Trotsky and others have lingered on.[9] Even today, the image of Russian Formalism is of a closed contextualist system akin to New Criticism, with no mechanism for admitting history. Yet I would argue that this image is highly misleading; of the three critical methods under consideration here, Russian Formalism incorporates history most basically at all levels in dealing with the artwork.

New Criticism, with its emphasis on the individual work as a unique and self-contained whole, implicitly eliminates history as a relevant context for study. The art object is seen as a reworking of fixed norms, but these norms do not become proper objects of interest for the critic as explanatory tools. And, since the poem provides the reader with all the elements needed for understanding, the reader's historical context is also irrelevant. Here we can see that the New Critics' basic problems arise from the elimination of

[9] For examples of contemporary Marxist attacks on the Russian Formalists, see P. N. Medvedev and M. M. Bakhtin, *The Formal Method in Literary Scholarship*, trans. Albert J. Wehrle (Baltimore: The Johns Hopkins University Press, 1978), and Gérard Conio, trans. and ed., *Le Formalisme et le futurisme russes devant le Marxisme* (Lausanne: Editions l'Age d'Homme, 1975).

history from the critical sphere. That is, the New Critics' inability to account for the reader's understanding of a work that is totally self-contained results from removing the reader from the world; their inability to deal with the poem's referentiality similarly results from removing *it* from the world.

Here lies the main importance of the background for the Russian Formalist. By organizing the norms against which each artwork is perceived, the Formalist critic can account for the reader's ability to understand the work. Moreover, the work does not exist as an eternal captured experience or intuition; instead, the critic can account for changes in the work's effect in different periods of history. The critic can also deal with the work's referentiality without thrusting poetry right back into a simple mimetic mode; the backgrounds thus become part of the material that the artist strives, in Formalist terms, to *deform* in perceptually stimulating ways.

But what of the structuralists, many of whom stress the importance of dealing with history in a critical approach? The structuralists divide the study of language into two types: the *synchronic*, in which a complete system is studied as it exists at a given moment in history, and the *diachronic*, in which the system is studied as it develops across time. In general, the synchronic systems of language or other signs tend to determine how the reader will understand a work; they are the experienced, internalized systems that govern response. Diachronic systems are more abstract and hence relate less directly to the reader's interpretation of individual works. As a result, most structuralist studies tend to emphasize the synchronic. For example, in his study, *Système de la mode*,[10] Barthes examined one year of fashion magazines to determine what constitutes the sign system of high fashion. His purpose was not to see how concepts of fashion change but what cues us to understand something as "fashionable." The diachronic, on the other hand, deals with the change of conventions and institutions over time and thus will encompass the historical. But diachronic study, separated from the synchronic, cannot generate readings of individual texts. This approach divides history and criticism into distinct systems in which synchronic interpretation is cut off from the historical context of the work.

Because of its use of backgrounds, Russian Formalist criticism may be seen as striving to deal with the work at the intersection

[10] Roland Barthes, *Système de la mode* (Paris: Seuil, 1967).

of its synchronic system and the larger diachronic systems. For example, many Formalist studies emphasize the individual work in the context of its genre and more specifically in the context of its place in the historical development of that genre. Structuralism discourages the mixing of synchronic and diachronic study. Diachronic study supposedly confuses the study of synchronic systems; the latter is to be frozen in time to be studied. This seems reasonable, but one might also argue that systems are in constant flux and that their significance derives largely from their *difference* from earlier systems.

Their concentration upon the synchronic system leads the structuralists to emphasize the similarity between the individual work and the overall system of signs upon which it draws. The work is symptomatic of this system, and it provides a tool for getting at the system. For the Formalist, difference remains at least as important as similarity. The artist draws upon an existing sign system in order to change its elements, and as a result the system itself evolves a bit with each new work. Hence the Formalist task is inevitably historical. The work is at once symptomatic of the larger backgrounds and also important in itself as a historical development of those backgrounds. Also, readers relate to the work by perceiving it in terms of norms assimilated from the backgrounds; their activity is not to find an eternal "content." To analyze both the work and the reader's response, the Formalist critic must remain grounded in history.

Film Criticism

Any critic operates with some kind of method, whether openly acknowledging it or not. The method may be only a set of unconsciously applied assumptions, but no one approaches a film without some basic stance. Many critical studies of film use assumptions derived from older traditions than those discussed here. A common approach comes from romantic critical theory. The critic assumes that the filmmaker (usually the director) is essentially a philosopher with great insights to convey; the process of criticism consists of interpreting the film to extract these insights.

But critics attempting to give the film medium its due by treating it as more than a container for preformed ideas may choose another approach. They have a choice of methods derived largely from one of the three general types of criticism discussed here: contextualism, formalism, or structuralism. In practice, structuralism is currently

in wide use in the study of film in France, England, and elsewhere abroad. Within limited circles, it has been adopted in the United States and forms one of the major current approaches.

More traditional film study continues to exist alongside the structuralist approach, especially in this country. Leaving aside romantically derived interpretive procedures, much critical methodology has been based on general New Critical approaches. That is, the critic defines a context for analysis and interpretation. This context does not necessarily limit itself to a single work. Auteur study is a sort of combination of romanticism (the privileging of the authorial insight and intention) with the notion of a closed system as a field for interpretation. In this case, the director's *oeuvre* provides the closed context; it figures in the analysis essentially as one large artwork, with the critic trying to find internal unities (organicism) across the whole. For the strict auteurist, the only context is the closed system of like objects.

New Criticism itself placed great emphasis on style; it was not simply an interpretive tool for extracting meaning. With literature this was possible because a set of terms and concepts had been developed over centuries to characterize literary style (especially in poetry). But the direct application to films of systems derived from New Criticism has not proved so successful in most cases. This is because film critics did not have the necessary theoretical knowledge of the film medium; they could only apply New Critical concepts to films by treating them as works of literature. Hence the main products of their "readings" would be interpretations, with a simple grasp of stylistic elements serving primarily to determine the meaning of any given technique. The early criticism of Robin Wood, particularly his book on Hitchcock, is perhaps the most successful attempt to ground thematic readings in close stylistic analysis.[11] Yet in less skillful hands, the problems of the method become more apparent. The form-content split begins to stand out when the analyst extracts thematic meanings from their carriers, the individual cinematic devices of the film. Since this approach consists mainly of paraphrasing cinematic meanings into words, reductivism inevitably results. Often the contextualist film critic (and by now we are far from the sophistication of true New Criticism) resorts to "literaricizing" films by basing interpretations on metaphorical descriptions of filmic techniques. To take a simple but frequently

[11] Robin Wood, *Hitchcock's Films* (New York: Paperback Library, 1970).

repeated mistake, a low angle comes to be taken as an inevitable signal for "power" because the critic does not have the theoretical tools to cope with techniques as part of a specifically filmic system.

Certain formalist critics—and here I am not talking about Russian Formalism—have attempted to create a theory of the film medium that could remedy this problem. The most successful results have been the works of Sergei Eisenstein and the *Theory of Film Practice* of Noël Burch.[12] Both of these provide valuable suggestions for a formalist method; yet neither is complete. Again, both tend to eliminate history and hence do not provide the necessary context of the specific norms against which the work is perceived. And neither provides an adequate procedure for analyzing complete narratives; only such a procedure can provide the analyst with a basis for discussing the functions of individual techniques and structures in context. For this reason, in preparing for a formalist analysis of *Ivan the Terrible*, I decided to derive my method from what I consider a more successful overall system, Russian Formalism. The resulting method, neoformalism, can provide a significant alternative to either contextual or structuralist methods as they have so far been applied to film.

Neoformalism does not propose the elimination of auteur, genre, or any other kind of film study. Rather, it would change the traditional emphasis of such approaches by breaking the closed limits of contextualist study. The concept of the background demands that every study place at least two contexts side by side thus achieving a true contextualism, since "context" implies the placement of an object against a larger system that renders its traits intelligible through relations of similarity and difference.

Recently structuralism has provided another alternative to contextualist study as it has been applied to films. A critic employing structuralist methods will attempt to ground interpretation concretely in the text but will not be concerned to ferret out meanings as actual attributes of the filmic text. Rather, the critic studies how a film goes about determining its own reading. Both phases of structuralism have contributed to the field. Raymond Bellour's early, prepsychoanalytic essays resemble those of Jakobson in literature, since Bellour is concerned with precise description of the structural properties of the text. His method avoids the problem

[12] Noël Burch, *Theory of Film Practice*, trans. Helen R. Lane (New York: Praeger, 1973).

of significance by simply assuming that any similarity or opposition pattern that can be shown to be present is relevant to a reading. His essay on Hitchcock's *The Birds*, " 'Les Oiseaux': Analyse d'une séquence," deals with the scene of Melanie's boat journey back and forth across the bay to the Brenners' house; his stated purpose is "to organize from a limited segment the greatest possible number of elements which constitute the cinematographic 'text'."[13] Bellour points up similarities between elements within the scene (which he terms "rhymes") at some length. His overall interpretation does not particularly depend upon the preceding lengthy analysis, nor does it place the sequence in the context of the entire film. This approach shares the problems I briefly outlined in relation to Jakobson's methodology.

There have been numerous analyses of individual films or sequences that apply a late structuralist approach. Often the critic will utilize categories formulated by Christian Metz, the central figure in this type of film studies. Others attempt to modify Metz's findings or to go on and investigate similar questions; Kari Hanet's "The Narrative Text of *Shock Corridor*" provides a good example. Hanet also takes a single sequence, the waterfall scene, as her focus of attention, but instead of analyzing its structures in detail, she takes the scene to be an extreme moment within the film as a whole. It is a rupture that affords the critic a way into the narrative's strategies for creating meaning. Nick Browne, in his "The Spectator-in-the-Text: The Rhetoric of *Stagecoach*," also employs structuralist methods, and he, too, chooses a single sequence as his subject. Here the choice results from Browne's desire to find a sequence absolutely typical of classical narrative films in order to draw conclusions about such films' strategies for creating the spectator's relation to the action. Both essays concentrate upon narrative, and more specifically, upon narration, the process by which a narrative is presented by the text. Both deal with narrative as a type of discourse. Hanet's purpose is, she says, to examine the waterfall sequence's "function and place within the narrative discourse."[14] For Browne, the formal features of his chosen sequence provide the film with "a characteristic answer to the rhetorical problem of telling a story,

[13] Raymond Bellour, " 'Les Oiseaux': Analyse d'une séquence," *Cahiers du cinéma*, no. 216 (October 1969), p. 24.
[14] Kari Hanet, "The Narrative Text of *Shock Corridor*," *Screen* 15, no. 4 (Winter 1974/1975): 18.

of showing an action to an audience."[15] For structuralist critics, then, the work as an aesthetic object is unimportant; they study the process by which a film creates a reading of its meaning. Style demands attention because it provides a portion of the work's system of signs.

This is not to say that style simply sugarcoats the thematic material of the film to make it palatable to the spectator. The structuralist would say that the spectator receives pleasure from artworks not only in the interest provided by style but also in the interpretive act itself. To the reader, reading and understanding are desirable ends in themselves. The critic provides a systematic method for examining these processes and how the work controls them.

What are the implications of a return to a communications model that does not maintain that the artwork conveys truth about the world? Films generate meanings and readings that are taken to be of interest to spectators, yet these same films perform no other particular function; hence they become rather devious objects, controlling us in ways we may not understand. The critic serves to demonstrate how the film works upon us—not to destroy the reading or the pleasure (except in some cases) but to objectify it.

The neoformalist system I will be proposing jettisons a communications model. Yet, through its claims about perception, this system insists that films do perform a function in nonaesthetic areas of life as well. Structuralist film studies do overlap with neoformalism considerably, since both attempt to study the medium thoroughly; often structuralist analyses could be translated with minor changes into neoformalist terms, and vice versa. But the emphasis that structuralism places upon meaning, in opposition to neoformalism's concentration upon perception, determines that beyond a certain point their paths diverge.[16] I shall concentrate upon systematically laying out the neoformalist system; its appropriateness to the central purpose of this study will become more apparent in the remainder of this chapter.

[15] Nick Browne, "The Spectator-in-the-Text: The Rhetoric of *Stagecoach*," *Film Quarterly* 29, no. 2 (Winter 1975-1976): 26.

[16] For a comparison of the two types of structuralist methodology applied to *Ivan*, see Jacques Aumont's *Montage Eisenstein* (Paris: Editions Albatros, 1979), pp. 119-149, which contains an "early structuralist" style comparison of two scenes from the film, and Andrew Britton's "Sexuality and Power, Pt. 2," *Framework* 7/8 (Spring 1978): 5-11, which uses an approach derived from later structuralism. (For comments on these two works, see the Bibliography Addenda.)

ASSUMPTIONS OF A NEOFORMALIST METHOD OF FILM CRITICISM

The Nature of Film Criticism: Limiting the Field

The most basic tenet of Russian Formalist criticism is that the aesthetic object differs from other objects in the world. In most pursuits, we employ our perception as economically as possible in order to gain the necessary knowledge about the things we encounter; that perception is *practical*, a means to an end. But according to the Formalists, art is separate from this practical existence; here perception becomes an end in itself, for reasons that will become apparent as we look at other Formalist assumptions. Boris Eikhenbaum summarizes how Formalism "advanced the principle of the palpableness of form as the specific criterion of perception in art."[17] Because artistic objects form a unique class, they must be treated with a unique approach.

As a result, the Formalists begin by limiting the field of study of the literary critic. At the time they were working, the idea of using literary principles as the basis for an approach to literature was relatively new; biographical, sociological, and philosophical methods dominated the analysis of literary works. But such methods reduced literature to a secondary position, making it simply evidence to be used in constructing nonliterary arguments. As Eikhenbaum wrote: "Literature, like any other specific order of things, is not generated from facts belonging to other orders and therefore *cannot be reduced* to such facts."[18] The Formalists posited that these irreducible elements of literature form a quality they called *literariness*, or that which is specific to literature. This literariness, they said, is the proper realm of study for the theorist, the critic, and the historian. This is not to say that these scholars could never bring in material from other fields; Formalism is not a strict contextualist system. But in using such nonliterary materials, scholars must realize that all elements function by the laws of literariness when they enter a work of literature. As Viktor Shklovski put it,

[17] Boris Eikhenbaum, "The Theory of the 'Formal Method'," trans. I. R. Titunik, in *Readings in Russian Poetics*, ed. Ladislav Matejka and Krystyna Pomorska (Cambridge, Mass.: The MIT Press, 1971), p. 12.

[18] Boris Eikhenbaum, "Literary Environment," trans. I. R. Titunik, in *Readings in Russian Poetics*, ed. Ladislav Matejka and Krystyna Pomorska (Cambridge, Mass.: The MIT Press, 1971), p. 61.

"For the artist, the external world is not the content of a picture, but material for the picture."[19] In going outside the artwork, the scholar must examine external facts in the light of the function they perform when transformed in the context of the work. With literariness established as a separate field of inquiry, the literary critic's problem became the development of an approach that was able to deal with the specific principles of literature.

The logical extension of this is that cinema also constitutes a unique field. The assumption here will be that it is possible to develop an approach to film that uses specifically cinematic traits to develop principles of analysis; the object of the film theorist, critic, and historian is *cinematicness*, or that which is specific to cinema.

Films as Artworks: Cinematicness

Once a unique field is marked off, the theorist/critic must specify the nature of the objects within that field. The Formalists needed to differentiate literary usage not only from other arts but from other uses of language, the basic material of literature. Since they assumed that art differs from other types of objects by its non-practical nature, the Formalists located this difference largely in the distinction between practical and nonpractical usages of language. *Nonpractical* language is created when language is used for its own sake, poetically. Boris Tomashevski defined the difference in this way:

> Prose was opposed to poetry as a practical and utilitarian language facing other languages having their own laws, the principal trait of which is no longer to present an utterance as a simple *means* or the play of an automatic mechanism, but as an element having acquired an original aesthetic value and having become a linguistic end in itself.[20]

This distinction provides a principle for exploring the specific devices by which poetic language calls attention to itself and creates a unique aesthetic perception.

The Formalists consider literary works to be those texts that make

[19] Viktor Shklovski, "Form and Material in Art," trans. Charles A. Moser and Patricia Blake, in *Dissonant Voices in Soviet Literature*, ed. Patricia Blake and Max Hayward (New York: Harper & Row, 1962), p. 22.

[20] Boris Tomashevski, "La nouvelle école d'histoire littéraire en Russie," *Revue des études slaves* 8 (Paris, 1928): 230-231.

use of language in an aesthetic, nonpractical way. Literariness is not inherent in the individual words themselves, of course, but in the usage within the context of actual works. The Formalists insisted that their theory had to be an empirical one, founded on data about how language is used in artworks. The final determination of the aesthetic or nonaesthetic status of an individual work must rest on the function of the language. For example, a text might exist that is of itself quite mundane and practical; an artist might then incorporate that same text into a novel for, say, satiric purposes. In this new context, the original text may suddenly appear quite strange and hence comic; its language has not changed at all, yet it serves an aesthetic function in an artwork.

At times, aesthetic usages of language appear in nonaesthetic texts. A political speech or religious sermon that has a definite rhetorical purpose will often employ striking images and elaborate language. In cases such as these, the Formalist will determine function by the dominant structure of the entire work (for a discussion of the concept of the dominant, see p. 34). The main structure of a political speech or sermon will presumably be argumentative, with the poetic language playing a subsidiary role; its aesthetic qualities are used in the service of a rhetorical function.

Here we already discover a major difference between literature and cinema that prevents a direct application of Formalist assumptions to the analysis of films. Clearly the distinction in this case is not between the everyday use of motion pictures and their artistic use; films, unlike words, are not used as part of ordinary discourse. Although some films are used for practical purposes, this does not mean that they are not films (in the sense that a conversation is not a work of literature). Yet we can make a distinction between practical and aesthetic usage of film by examining the traits of the medium itself.

Film is not a language in any strict sense of the word, for the material elements of cinema have no set denotations as words do. Yet we may take the material elements of cinema to be those components that are equivalent to words in literature; that is, they may be combined to serve practical or nonpractical functions. There are five basic types of elements that form the material basis of film. In the following list, I have outlined some of the potential aspects of these types of elements (technical and functional categories have been grouped to some extent):

Mise-en-scene. Light; decor; costumes; placement and movement
of figures. Graphics: composition, color, movement.

Sound. Music; effects; voice: fidelity, pitch, volume, mixage
(multiple tracks), timbre. Synchronous/nonsynchronous, die-
getic/nondiegetic, simultaneous/nonsimultaneous, onscreen/
offscreen.

Camera/Frame. Movement; distance; angle; height; lens; expo-
sure; stock; speed.

Editing. Temporal; spatial; graphic; continuity/discontinuity.

Optical effects. Transitions; mixages; color; distortion.

Since these techniques are used in some combination in all films,
they are not sufficient to define cinematicness. Their aesthetic qual-
ity ultimately depends on their being combined to create a difficulty
of perception. To take a concrete example, several films might use,
say, libraries as a central part of their subject matter, yet not all
would necessarily be aesthetic works. The familiar informational
films of the "Your Friend the Library" type would be likely to use
mise-en-scene: cinema lights added to illuminate dark stacks for
filming, books arranged deliberately on a table to make their covers
visible, scenes staged with librarians typing catalogue cards. Simi-
larly the other techniques—voice-over narration, framing, editing—
would work strictly to convey information as efficiently as possible.

In contrast, there might be a nonfiction film on libraries that
introduces nonpractical elements. Alain Resnais's *Toute la mémoire
du monde* is such a film. It does convey considerable information
about France's Bibliothèque Nationale, but Resnais goes beyond
this initial premise by seeking to overturn our usual ways of looking
at a familiar institution. He begins by suggesting the dominant
metaphors of the library as a prison for knowledge and as a giant
brain. Here the cinematic techniques are not neutral. Framing and
wide-angle lenses suggest that the attendants in the stacks are like
prison guards and the aisles like the barred walkways of a prison.
Resnais chooses to illustrate the cataloguing process by following
a single book that has a woman's photograph on the cover. This
manipulation of mise-en-scene allows him to frame the book being
tagged with a number and placed within several cagelike cabinets,
all carrying forward the prison metaphor. With its brooding, con-
templative commentary, Resnais's film seems more an essay than
a factual account.

Finally, one can easily imagine a fiction film using a library for

purposes that have nothing to do with teaching an audience about libraries. A murder might occur in one, with the criminal a fiendish librarian. In sorting through the cryptic clues to be found in the books or card catalogue, the detective figure might have to convey much information about libraries to the reader. Yet such information would be of interest only as far as it served to unravel the fictional puzzle. Here framing and lighting might seek to suggest a mysterious atmosphere; sound could startle the viewer or create an anticipation of danger. The aesthetic use of the medium overturns our everyday attitudes about an everyday locale like a library. Parts of actual films like *Shadow of a Doubt* and *The Spy Who Came in From the Cold* do indeed use libraries in this aesthetic way.

Our responses to these three separate types of films would clearly be quite different. An understanding of the differences between practical and aesthetic films depends upon a concept of perception. Yet, although specifically aesthetic perception is central to their method, the Formalists barely mention a definition for the term; their view of perception was never worked out in detail. Shklovski gave perhaps the best brief statement: " 'artistic' perception is perception in which form is sensed"[21]; here he means sensed *as such*, with the perceiver having no practical reason for noticing form.

A few implicit assumptions on perception are present in the Formalists' work. For them, perception is an active process. They assume a perceiver and an object perceived; form involves the relationship between the two, rather than simply the system of the work. This view of perception is in a philosophical rather than a strictly psychological tradition. Indeed, the influence of Husserl and phenomenology is noticeable in the Formalists' method. In his study of Russian Formalism, Victor Erlich points out that Husserl's work was having some impact in Moscow; students of linguistics knew the *Logische Untersuchungen* through readings and lectures by Russian followers of Husserl.[22] Some of these students were among the founders of the Moscow Linguistics Circle, one of the two Formalist groups. As we shall see shortly, the Formalists shared Husserl's concern with renewing habitualized perceptions. But Husserl's aim was to strip away layers of conceptualization and com-

[21] Viktor Shklovski, "The Resurrection of the Word," trans. Jane Knox, *20th Century Studies* 7/8 (December 1972): 42.

[22] Victor Erlich, *Russian Formalism: History—Doctrine*, 3d ed. (The Hague: Mouton, 1969), pp. 61-62.

plexities to return to a renewed perception of the thing itself. The Formalists took the opposite route; they did not believe in this stripping-away process but in the creation of greater difficulties of perception. They did not see art as a way of re-creating the initial perception or experience—which would be an impossible task. For the Formalists, art creates an *entirely new* perception, comparable neither to an initial nor a habitualized sense of the object. They saw art not as a simple tool that allows us to *return* to a nonaesthetic, initial experience of an object. Instead, aesthetic perceptions relate to our experiences in the world, but they are of a type specific to aesthetic objects.

Although film images are often directly produced by the objects photographed, the aestheticization process is inherent from the beginning in the very act of framing, which isolates the images in a new context. In practical films, framing is therefore something to overcome; once the object has been removed from its original context, such films must compensate by using other devices to insure that the spectator is aware of the object's practical purpose (most often this involves a voice-over narration to guide the spectator's perception). In effect, a practical film substitutes its techniques for the spectator's presence, and the frame creates the definition of that presence. The frame embodies the distinction between aesthetic and nonaesthetic. The practical film's work of display *ends* at the boundary of the frame; the aesthetic film *begins* with the act of framing, the removal from context, and creates its aesthetic structures upon this base. Each type of filmic technique has its potential for altering the photographed space and time in some way. The practical film must overcome this as a problem; it uses techniques in as unobtrusive a way as possible, in a way that has become so conventionalized as to be reasonably unnoticeable. The aesthetic film uses techniques to build away from the profilmic event—the original event filmed by the camera—to achieve the perceptual play that is its purpose. (Note how André Bazin's aesthetic of realism emphasizes the disadvantages of filmic technique for the use of the frame as window.) The possible combinations of these techniques in aesthetic ways creates montage; Eisenstein's writings help to demonstrate some of the kinds of combinations the critic is concerned with.

First let us look at contexts that create a practical usage of the film medium. We generally call films that employ such contexts "informational films." Such films structure their material in an economical, practical fashion somewhat comparable to everyday

language. If the techniques of the informational film are used as a substitute for the presence of the viewer, they convey visual information that depends on the viewer being placed in the position of a person actually looking on at the scene photographed. (It is quite possible that a documentary film on surgery might even teach the medical students more than they could gain if actually present at an operation, due to problems of class size, sterile environment, and so forth.) In the case of our hypothetical library example, one conventional organization would be a tour of the facilities, with the check-out process coming toward the end rather than the beginning of the film. The model here is an actual visit by a person going to a real library.

Informational films utilize techniques, but they deemphasize style to the point where it may be imperceptible. I am here assuming style to be a way of structuring techniques systematically. While informational films may use techniques that go beyond simple transmission of data, they do so sporadically or accidentally. The usage doesn't form a major structure; it remains subordinate to the central purpose of communication, just as the aesthetic language in a sermon remains subordinate to rhetorical function. This is not to suggest that they are poor films—for their purposes, style would be detrimental.

As I have suggested, some documentaries do use filmic technique to create a structure that somewhat impedes the presentation of information; to this extent they move into the realm of aesthetic films. In fact, *Toute la mémoire du monde* or *Olympia* impair their own informational character: there are certainly clearer ways to show us the Bibliothèque Nationale or the 1936 Munich Olympics. But the devices Resnais and Riefenstahl introduce change our perception of the events and the objects their films depict; the informational aspects of the films are pushed to the background, and other considerations take over. Undoubtedly these films (and indeed many fiction films) convey information, but their main purpose in doing so is to set up a perceptual play partly on the basis of that information. This suggests why we tend to differentiate between "informational" films, which are seldom viewed by film students, and "documentaries," which come to be as admired and studied as other modes. The fact that these different types of films exist suggests that we may provisionally make a distinction between practical and nonpractical usage of film.

In making this distinction, we should keep in mind that, to a

large degree, we perceive films as aesthetic or practical through their context. Informational films almost invariably are screened as part of classes or lectures. The teacher prepares us to receive the films as sources of facts; this would be the case with our example, "Your Friend the Library." In contrast, aesthetic films appear in theaters, museums, college film series, and during certain time slots on television. In earlier years, commercial theaters played an informational role by giving over a certain portion of the program to a short newsreel or travelogue. Now the service of television has usurped this role of the film theater. Today informational and aesthetic films hold distinct and recognizable places in our social lives. Documentary films, however, fall between these two social uses. A French class planning a tour abroad might use *Toute la mémoire du monde* as a way of learning about the Bibliothèque Nationale, while a film class might look at its use of Resnais's style. The social uses to which the film is put in each context still determine whether the viewer will see it in a practical or an aesthetic way.

Of course, one could deliberately ignore the cues within the work and in its context, choosing to perceive an informational film aesthetically. Indeed, one can perceive anything in the world with an "aesthetic attitude." This ability indeed supports the Formalists' view of aesthetic perception. They would say that by learning how to perceive in a certain way in relation to artworks, we change our general perception as well. Oscar Wilde's famous comment that life imitates art has implications here. Occasionally events do seem to imitate artworks, but more often our perceptions, altered by our exposure to artworks, lead us to be interested in objects and events specifically because they remind us of other artworks we have experienced. Moreover, certain comparisons of real objects to artworks recur frequently enough to suggest that we understand some perceptual experiences largely through aesthetic habituation. Beautiful things are often "pretty as a picture"; bird calls become songs; ongoing series of events are grasped as closed narratives. The imposition of aesthetic perception does not make any object aesthetic, however, for aesthetic usage is a matter of structural function demonstrable in the object and its context. So a further assumption of neoformalism will be that the theorist/critic may differentiate between aesthetic and nonaesthetic usages of filmic techniques; only the former constitutes cinematicness, and only films that employ such usage will be the object of neoformalist criticism.[23]

[23] I have not based my remarks on cinematicness on the Formalists' own writings

In spite of much effort on their parts, the Formalists did not create a system for looking at the cinema that logically grew out of their already-established literary theory. Both Eikhenbaum and Tynjanov attempted to locate cinematicness by trying to find the equivalent for poetic language; their conclusion was that cinema is poetic, while still photography is practical![24] Clearly this is a mistake, since still photography has developed both its practical and poetic functions; the photographs of Man Ray or Hans Richter can hardly be denied the status of art.

Similarly, much of the Formalists' writing on cinema was concerned with the possible parallel between cinema and language. Tynjanov was concerned with the "semantic" aspects of film,[25] while Eikhenbaum discussed film as "inner speech" and tried to find the "basic unit of film speech."[26] Yet the theoretical justification for considering cinema as analogous to language remains unclear; a strong suspicion exists that the Formalists were trying to get a grasp on an artform less familiar to them than literature. (The fact that several Formalists were important script writers for Soviet films would not argue against this; none ever took the step into directing films.) The current study makes no assumptions that film is a kind of language. On the whole, then, the Formalists' writings on cinema are of little use in this analysis.

The Function of the Artwork

If the artwork is not practical, what is its function? The Formalist critics denied that art exists to convey the "vision" of the artist ("great themes") or to reflect society in any direct fashion. Critics who do assume that art exists to convey such world views usually fall into a split between form and content, assuming implicitly that the form is in some way the vessel by which the message/content/theme is carried from artist to audience. But such an assumption

on film, even though several of them did consider the problems of the new art. The interested reader is referred to two useful summary essays, "La théorie du cinéma chez les formalistes russes" by Christine Revuz (Ça, no. 3 [January 1974], pp. 48-71), and "Introduction à Poetika Kino" by Jean Narboni (Cahiers du cinéma, no. 220/221 [May-June 1970], pp. 52-57). I shall limit my discussion to an explanation of my avoidance of Formalist concepts directly applied to the cinema.

[24] See Juri Tynjanov, "Des fondements du cinéma," trans. Sylviane Mossé and Andrée Robel, Cahiers du cinéma, no. 220/221 (May-June 1970), p. 64, and Boris Eikhenbaum, "Problems of Film Stylistics," trans. Thomas Aman, Screen 15, no. 3 (Autumn 1974): 8.

[25] Tynjanov, "Des fondements du cinéma," pp. 64-67.

[26] Eikhenbaum, "Problems of Film Stylistics," pp. 4, 23.

immediately violates the Formalists' view of literary specificity by placing the main emphasis of the artwork outside literature itself. In this view, the idea "behind" the work is simply translated into literary terms and can be translated back into a message by the critic.

The Formalists managed to avoid this split by keeping the literary system separate from the world without denying that the literary system *functions* within that world. They did this through their assumptions about perception. The basic function of the artwork is to renew perception through a process called *defamiliarization.* Viktor Shklovski describes the process whereby our everyday perception becomes habitual and dulled:

> If we start to examine the general laws of perception, we see that as perception becomes habitual, it becomes automatic. . . . Such habituation explains the principles by which, in ordinary speech, we leave phrases unfinished and words half expressed. . . . The object, perceived in the manner of prose perception, fades and does not leave even a first impression; ultimately even the essence of what it was is forgotten.

Shklovski goes on in a key passage to describe the process by which art helps to change perception:

> Habitualization devours work, clothes, furniture, one's wife, and the fear of war. . . . And art exists that one may recover the sensation of life; it exists to make one feel things, to make the stone *stony.* The purpose of art is to impart the sensation of things as they are perceived, and not as they are known. The technique of art is to make objects "unfamiliar," to make forms difficult, to increase the difficulty and length of perception because the process of perception is an aesthetic end in itself and must be prolonged. *Art is a way of experiencing the artfulness of an object; the object is not important.*[27]

The last phrase indicates the Formalist belief that thematic material is not an end in itself but is rather an element of the form of an artwork. The simple inclusion of a weighty philosophical question within a work confers no merit; that idea must contribute to a perceptual play that is itself the central purpose of the work.

[27] Viktor Shklovski, "Art as Technique," in *Russian Formalist Criticism: Four Essays*, trans. and ed. Lee T. Lemon and Marion J. Reis (Lincoln: University of Nebraska Press, 1965), pp. 11-12.

The Formalist belief that theme, or meaning, is not the end product of the critic's analysis does not indicate that the Formalists are guilty of a form-content split themselves. Although the term "formalist" was first applied to the group in a derogatory way by outsiders, their position is far from being a sterile, art-for-art's-sake approach, as I suggested earlier in this chapter. Rather, they viewed artworks as collections of devices interacting to create a formal system; themes, meaning, and characters, as well as stylistic elements, make up these devices. As Shklovski put it, "It is true that in a work of literature we also have the expression of ideas, but it is not a question of ideas clothed in artistic form, but rather artistic form created from ideas as its material."[28] Although the end product is not a meaning or theme, these do contribute their share in creating the whole film. The concept of "content" has no place in Formalist criticism.

The idea that meanings have a structural function in the artwork implies that cognition is not ruled out by the Formalist emphasis on perception. Although they spend little time on the role of cognition, they seem to have thought that a play with cognition is part of the general perceptual play of the work. Shklovski differentiated between the cognition associated with aesthetic and nonaesthetic activities: "Practical thinking moves towards generalisation, towards the creation of the broadest, all-encompassing formulae."[29] But undoubtedly the prolongation of perception forms the basis for aesthetic cognition, as well as being an end in itself; hence it receives most of the Formalists' attention.

Again, this view of the function of the artwork as a renewal of perception through defamiliarization can be applied to film, since it is basic to all artforms.

The Internal Structure of the Work

Because the Formalists viewed the function of an artwork as a play with perception, they saw its internal structure as a set of formal devices that tend to prolong and complicate the audience's engagement with the work. Yet they did not believe that all the structures the critic could locate in the artwork were equally important;

[28] Shklovski, "Form and Material in Art," pp. 27-28.
[29] Viktor Shklovski, "On the Connection Between Decides of *Syuzhet* Construction and General Stylistic Devices," trans. Jane Knox, in *20th Century Studies* 7/8 (December 1972): 54.

instead, they formulated guidelines by which one could determine the saliency of the structures. These general principles are equally applicable to film.

Perhaps the most fundamental assumption about form that the Formalists made is that each work has one *dominant* structuring principle. This dominant is a formal organizational principle around which other structures in the work cluster. Juri Tynjanov summed it up clearly: "Every literary system is formed not by the peaceful interaction of all the factors, but by the supremacy, the foregrounding, of one factor (or group) that functionally subjugates and colors the rest."[30] In the case of very standardized artworks such as B westerns in Hollywood, the dominant may be a set of conventions common to many films; in a work with any degree of originality, a dominant structure peculiar to that work will be constructed. Thus Burch has analyzed Hanoun's *Une Simple histoire* through its most pervasive device, a play with nonsimultaneous sound-image relations.[31] Similarly, I have analyzed *Les Vacances de Monsieur Hulot* in terms of a dominant consisting of overlapping formal elements.[32]

Because aesthetic perception is prolonged perception, the Formalists also have a view of various structures that create delays in the artwork. These structures are summed up under the general term *staircase construction*. Since artworks are nonpractical, they could logically be of any length or size in terms of subject matter; in order to keep them from ending prematurely, they must be delayed, and the devices used to do this tend to turn the action away from a straight path. Retardation, roughened form, and repetition are some of the devices that serve to deflect and tangle the structure of the work.

The Formalists assumed that everything included in the artwork has some *function*. The work need not be practical or economical, however, so elements may be included that are not necessary to the basic progression, or that may even work against it. The Formalists called the justification for the presence of a given device its *motivation*. The motivation for a device falls within one of three general

[30] Quoted in Igor Chernov, "A Contextual Glossary of Formalist Terminology," trans. Ann Shukman and L. M. O'Toole, in *Russian Poetics in Translation* 4 (1977): 20.

[31] Burch, *Theory of Film Practice*, pp. 80-88.

[32] Kristin Thompson, "Parameters of the Open Film: *Les Vacances de Monsieur Hulot*," *Wide Angle* 2, no. 1 (Winter 1977): 22-30.

categories: realistic, compositional, or artistic.[33] A device is realistically motivated if its inclusion implicitly appeals to a knowledge of the workings of the real world; we shall investigate this further in looking at the Formalists' assumptions about the work's relation to reality. Compositional motivation is a justification of the inclusion of a device because it is necessary to the progress of the work's narrative structure. An example from Shklovski illustrates this point:

> To the question of Tolstoi: "Why does Lear not recognise Kent and Kent—Edgar" one may answer: because this is necessary for the creation of the drama, and the unreality disturbed Shakespeare no more than the question "Why cannot a Knight move straight?" disturbs a chess player.[34]

Compositional motivation also helps to assure unity among the elements of a work. If a gun is to be fired at the end of a play, someone introduces it earlier to prepare the way for its use. The early emphasis on Quinlan's cane in *Touch of Evil* is another simple example; it prepares the way for—motivates—the later scene in which the cane becomes incriminating evidence. Finally, a device that is included for its own sake is artistically motivated. The graphic matches of Ozu's films are an example.

At times the work will include a device that in addition to being artistically motivated actively calls attention to its own lack of other motivation. This is called a *baring of the device*. The concept is an important one because this is a structural strategy that defamiliarizes the form of the work itself; it may prevent the viewer from slipping into too comfortable a perceptual attitude.

The Formalists were themselves so vague on the definition of this idea that they usually defined it by example. In his *Tristram Shandy* essay, Shklovski contradicts himself on the type of motivation needed to bare the device. Compare these two statements:

> Sterne was an extreme revolutionary; it was characteristic of him to "lay bare" his technique. The artistic form is presented simply as such, without any kind of motivation.

> Sterne, however, simply lays bare the technique.

[33] Boris Tomashevski, "Thematics," in *Russian Formalist Criticism: Four Essays*, trans. Lee T. Lemon and Marion J. Reis (Lincoln: University of Nebraska Press, 1965), pp. 78-85.
[34] Shklovski, "On the Connection Between Devices," p. 65.

As I have said already, Sterne thought such [aesthetic] moti-
vation an end in itself.[35]

Such a contradiction on this point is typical of the Formalists (al-
though it is one of the few concepts on which they were truly
contradictory). Did a baring of the device mean no motivation at
all, or only artistic motivation, or even a special kind of artistic
motivation? Because the Formalist system offers no clear-cut defi-
nition, the concept must be redefined.

First, the Formalists' definition of motivation is logically ex-
haustive; they called anything that was not realistic or composi-
tional motivation "artistic" motivation. By using this very general,
"miscellaneous" category, they made it clear that everything in a
work has *some* motivation, even if it is included only to call atten-
tion to itself. Thus we must conclude that a bared device is *not* an
unmotivated device.

Second, we must go on to conclude that not every device which
is artistically motivated is bared. In the cinema, elements in the
background of a shot may be artistically motivated, but they are
often not central enough to call definite attention to themselves.
For example, several shots in Ozu's *Equinox Flower* show a hallway
with a red teapot in the foreground and a small white vase on a
shelf by a picture in the room beyond. The red of the teapot is part
of a motif of red that is important in the film. But it is not clear
that the whiteness of the vase has any particular function; the vase
could have been yellow, light blue, or any other subtle color. Here
is a case of artistic motivation, yet we would hardly say a device
is bared.

A baring of the device, then, is a specific type of artistic motivation
that foregrounds the artistic structure the device belongs to—an
element appears that is realistically and compositionally unneces-
sary, and that element becomes, at least momentarily, the most
important one present. In addition, the moment of foregrounding
calls attention to related elements that form a structure in other
parts of the film. Several examples may help to clarify this claim.
I have argued elsewhere[36] that Alfred Hitchcock's *Stage Fright* con-

[35] Viktor Shklovski, "Sterne's *Tristram Shandy*: Stylistic Commentary," in *Russian Formalist Criticism: Four Essays*, trans. Lee T. Lemon and Marion J. Reis (Lincoln: University of Nebraska Press, 1965), pp. 27, 30.

[36] Kristin Thompson, "The Duplicitous Text: An Analysis of *Stage Fright*," *Film Reader* 2 (Winter 1977): 52-64.

tains a baring of a key device in its credits sequence: the raising of the theatrical safety curtain to reveal the landscape of the actual city of London sets up a systematic juxtaposition of theatricality with "real life" that will inform much of the narrative. A more spectacular example occurs in Otto Preminger's *Laura*, which depends on a complete ambiguity over whether the second half of the narrative is the detective's dream or not. Dream imagery is prominent throughout the film but is bared at one point when the detective questions a suspect; the latter claims to have been asleep at the time of Laura's death. The actual murderer then says disparagingly, "Next he'll produce photographic evidence of his dreams."

David Bordwell has pointed out that even such a classically constructed film as *His Girl Friday* bares its central device, the extremely fast pace of the dialogue. During Hildie's visit to Walter's office near the beginning of the film, Walter tries to argue her into staying with the paper. As he talks, Hildie simultaneously launches into a fake "auctioneer's" patter to parody Walter's rapid speech.[37] These examples suggest that a baring of the device often calls attention to the most original aspects of the work; it may be that a wholly conventional work (a B western, for example) has no need for baring the device, since audiences are already aware of the devices from other, previous works. (When a genre or convention becomes *too* familiar, a new approach that depends almost wholly on baring the device comes into play—parody.) We shall see that *Ivan* has moments which bare certain of its devices.

A further structural principle of the Formalists applies to narrative film only: the *story-plot distinction*. Tynjanov summed up this distinction, saying that plot

> is the general dynamics of the thing, which is put together from the *interaction* between the movement of the story-line and the movement, the rise and fall, of the stylistic masses. The story-line can only be guessed at, but is not a given. The spectator can only guess at it from the unfolding plot—and this riddle will be an even greater motive force for the plot than that story-line which unfolds before the spectator's eyes.[38]

The story, then, is a construct in the viewer's mind; in watching the film, the spectator mentally arranges the presented events into

[37] Conversation with the author.

[38] Juri Tynjanov, "Plot and Story-Line in the Cinema," trans. Ann Shukman, *Russian Poetics in Translation* 5 (1978): 20.

chronological order, as they "really" happened; the principle for this arrangement is an appeal to the logic of causality. The plot, on the other hand, is the presentation, in material terms, of the events in the film itself; that is, the plot is the formal manifestation of the events. Much of the perceptual play of a film may result from the way the plot presents the story (as in *Citizen Kane* or Straub-Huillet's *Nicht Versöhnt*).

At first glance, the study of cinematicness may not appear to include narrative because narratives are generally viewed as transmedia. Yet the Formalist story-plot distinction suggests that this is not entirely the case. A narrative consists of a story—the portion that is transmedia—and a plot. The plot involves the cinematic devices of the story's unfolding. In discussing cinema, Eikhenbaum states that "the laws of film-montage and the nature of photography are so specific that the slightest subordination is sharply felt. Even though the story line may be borrowed, plot takes unique shape in film, inasmuch as the elements themselves are original."[39] Shklovski was similarly firm on the idea that adaptations from one artform to another could never create equivalent structures. In writing on cinema, Shklovski expressed his views on the unique properties of each art in characteristic fashion: "Certainly one can give a trombone to someone and say to him, 'Play me the cathedral of Kazan,' but that would be either a joke or a proof of ignorance."[40] Thus cinematicness definitely encompasses narrative as it manifests itself in film.

The Formalists considered character an important device in the structuring of a narrative. They did not see characters as real people; rather, they conceived of them as clusters of characteristics. Tomashevski summarizes this idea:

> The character is a guiding theme which makes it possible to untangle a conglomeration of motifs and permits them to be classified and arranged. . . . A character is recognized by his *characteristics*. By characteristics we mean a system of motifs intimately related to a given person. . . . The simplest characteristic of a person is his name.[41]

Tomashevski does not define the term "characteristic" in a way

[39] Boris Eikhenbaum, "Literature and Cinema," trans. Thomas L. Aman, *20th Century Studies* 7/8 (December 1972): 124.
[40] Quoted in Revuz, "La théorie du cinéma chez les formalistes russes," p. 61.
[41] Tomashevski, "Thematics," p. 88.

specific to literature or art. Thus it is fortunate that Roland Barthes has further developed the Formalist view and provided a specific term for "characteristic," the *seme* or single trait. For Barthes, the character is no more than a "combination of semes concentrated in a legal Name."[42] Similarly, the Formalists speak of the "transfer of motifs"[43] among characters, while Barthes claims that several characters may share semes. This idea of character provides us with a formal definition.

In the cinema, however, character is more than a collection of semes concentrated around a name, as the character is physically represented in most cases. The semes that make up a character in a film may be embodied in many channels. As we shall see in dealing with *Ivan*, character semes may appear in settings, in lighting, in musical themes. Thus in film, the character is a cluster of semes centered around a body rather than a name.

The term *protagonist* will also need to be defined. This is the character that is most central to the overall structuring of the work. Thus we would label Hildie the protagonist of *His Girl Friday*, since her return precipitates the action and her decision to remain with the paper and Walter brings it to a close. Without a clear-cut definition of the term, there could be many arguments concerning the protagonist of *The Man Who Shot Liberty Valance*. Yet for the current system, Ransom Stoddard is the center of the film's key structures, such as the western/eastern and desert/garden contrasts; and his arrival (both in the frame and flashback sections) starts the plot in motion. Thus the highest degree of structural importance marks the protagonist. As with semes, characters may also share this function.

The series of events presented in a work is not random; in particular, the beginning and ending occupy a privileged status. Shklovski investigates the question, "What is necessary in order that we perceive the short story as completed?"[44] He posited that the beginning and ending in some way form "a circular construction, or, better, a buckle."[45] The form this circularity takes may vary: there may be a return to the initial state, a reversal of it, a parallel state,

[42] Roland Barthes, *S/Z*, trans. Richard Miller (New York: Hill and Wang, 1974), p. 68.

[43] Tomashevski, "Thematics," p. 88.

[44] Viktor Shklovski, "La construction de la nouvelle et du roman," in *Théorie de la littérature*, trans. and ed. Tzvetan Todorov (Paris: Seuil, 1965), p. 171.

[45] Ibid.

and so on. This idea is in keeping with the Formalists' view of narratives as closed structures turning in upon themselves in some way; the dominant would determine how.

As I have mentioned, the Formalists' concept of narrative structure was somewhat incomplete. In spite of their ideas on staircase construction and beginning/ending patterns, they seem never to have formulated the principles that actually propel a narrative forward. In other words, they understood that *roughening of form* occurs and they saw how roughening functions (to lengthen perception), but they did not explain its specific purpose within the work. As we have seen, Barthes carries forward a number of Formalist ideas, and he goes further in helping to eliminate this gap in their theory. His basic development was the division of the forward motion of the narrative into two intertwined forces, the *proairetic* and the *hermeneutic codes*. He explains these complex elements at length in his analytical essay, *S/Z*. Briefly, the proairetic code is the flow of logical connections from action to action; a single unified series of actions forms a proairetic chain or line. But simultaneously, the narrative poses an enigma, which is usually cleared up by the end.[46] The hermeneutic code elicits from the audience a series of expectations and speculations that constitute part of the process of reading (or viewing). These two forces, proairetic plus hermeneutic, logic plus enigma, combine to form the driving force of the narrative.

The lines of action set in motion as the narrative opens work toward an answer to the enigma. When the truth is revealed, the narrative comes to an end; that it, it achieves *closure*. According to Barthes, in the classic text, "expectation becomes the basic condition for truth: truth, these narratives tell us, is what is *at the end* of expectation. . . . It implies a return to order, for expectation is a disorder."[47] This final truth is known as "closure" because it is a closing off of expectations and lines of action that have remained incomplete—"open"—through the body of the narrative. Barthes distinguishes the modern text specifically in terms of its lack of closure. As we shall see, *Ivan* has a relatively closed narrative structure.

[46] Again, the germ of this idea is already present in the Formalists' writings. The quote from Tynjanov on story-plot relations deals with the story as a "riddle" that the spectator solves as the plot unfolds. See Tynjanov, "Plot and Story-Line in the Cinema," p. 20.

[47] Barthes, *S/Z*, p. 76.

Barthes follows the Formalists in putting a great emphasis on delay. Since an artwork is a nonpractical construct, the choice of how long to delay the revelation of the truth is purely arbitrary. The narrative may be stretched indefinitely. Both the Formalists and Barthes realized this and made a distinction between those events in a narrative that are necessary to the basic cause-effect chain of the story and those events that are added as delaying factors. This distinction leads to the staircase image, with its suggestion of action moving toward the revelation of truth and toward closure at some points and moving in another direction at others.

Narrative films do not function in exactly the same way that literary works do. While a novel presents one event after another, a film may present several simultaneous actions at any given moment. As a result, the potential for roughening form is double: action may be stretched "horizontally" over the film's temporal flow, but it may also be multiplied "vertically." This means that the filmmaker may create an interplay of multiple actions within the same frame. A film like Jacques Tati's *Play Time* provides an example. In the restaurant sequence, layers upon layers of action occur simultaneously, to the point where the spectator is unable to notice every joke on a single viewing. Noël Burch has pointed out that individual shots have varying degrees of *legibility*[48]; by this term he means the relative amount of visual material presented in a given length of screen time. The more complex the pattern of a shot, the longer it must remain on the screen for the audience to be able to register the presence of any one element. Thus a complex shot that is held for a long time may actually be less legible than a simple shot that appears only briefly. Again, *Play Time* provides many instances of this relative illegibility. Legibility has important implications for a neoformalist method of film analysis. By adding different elements to the basic events of the story, film can create a variety of strategies for defamiliarization. These include not only the patterns of temporal delay but also a play with the legibility of the individual images to create a difficulty of perception for the viewer. Sound can also create this vertical complexity.

But if the narrative structure operates in the manner I have just described—as an interaction of proairetic and hermeneutic lines working through a series of delays toward an answer/resolution—

[48] Burch, *Theory of Film Practice*, p. 34.

what initially sets the narrative in motion and what limits its possibilities?

Stephen Heath has offered a valuable suggestion concerning the force that is necessary to set the narrative in motion and sustain it; he calls it simply *violence*. If the beginning of a work is usually stasis (if only for a moment), then something must interrupt that stasis with enough force to set many elements in motion against each other. This basic principle is the traditional notion of *conflict*. Tomashevski summarizes the development of the narrative in a fairly conventional way:

> Each situation is characterized by a *conflict* of interest, by discord and struggle among the characters. . . . This conduct of the struggle . . . is called the *intrigue*. . . . The development of the intrigue . . . leads either to the elimination of the conflicts or to the creation of new conflicts. Usually at the end of the story all the conflicts are reconciled and the interests harmonized. . . . That is why the condition at the end of the work is so static. This static condition is called the *ending*.[49]

Obviously these ideas did not originate with the Formalists. But Heath goes beyond this older idea by demonstrating that the conflict is not only one among characters and narrative forces, that it is indeed a violence generated by the work itself. Speaking of the initial state of the work as "S," Heath says:

> A beginning, therefore, is always a *violence*, the violation or interruption of the homogeneity of S (the homogeneity—S itself—being recognized *from* the violence). . . . The narrative transformation is the resolution of the violence, its containment—its *replacing*—in a new homogeneity.[50]

This narrative conflict is often a literal violence, as Heath points out in this same passage in relation to the explosion that ends the first shot of *Touch of Evil*.[51] Heath's argument is that a narrative generates its own violence because it needs that violent energy in order to begin. Once it is set in motion, the narrative must continue to move in the direction of its violence at least sporadically; other-

[49] Tomashevski, "Thematics," p. 71. Italics in original.

[50] Stephen Heath, "Film and System: Terms of Analysis, I" *Screen* 16, no. 1 (Spring 1975): 49. Italics in original.

[51] Genre films provide similar examples of this principle, as with the openings of *Scarface* and *Johnny Guitar*.

wise it would grind to a premature halt in a new state of ho-
mogeneity, self-destructing through this process. But if violence is
necessary, it also continually threatens to push the narrative struc-
tures toward destruction by throwing them into chaos. Thus the
narrative must continually strive to maintain a balance in its forces;
it must remain in a heterogeneous state until the proper moment
for the ending. To keep this balance, Heath says, the narrative
"contains" its own violence, "as one contains an enemy, holding
in place but defensively."[52] With this in mind, we can now see that
Barthes's proairetic and hermeneutic structures are in part the
means the narrative takes to keep itself on track. These structures
provide the narrative with a logic that directs the temporal, spatial,
and causal flow.

Because a film narrative is so precariously balanced, there are
moments when the critic can detect brief falterings that signal a loss
of control. These sections of a text Heath calls *figures of distress*.[53]
But do films ever lose their balance between violence and stasis to
the point where they are unable to continue? Occasionally. I do not
mean that the film literally stops short at that point. The central
narrative, however, does come to an end or is deflected in such a
way that it completely changes.

Mel Brooks's *Blazing Saddles* is an example of a film that over-
balances its narrative with violence. By throwing more and more
disparate elements into its story, which is set in the old West, the
film becomes incapable of achieving closure; rather than beginning
to connect up its narrative line towards the end, it continues to
introduce further incongruities and new possibilities. Suddenly, the
old West narrative disappears and is replaced by a sequence set in
the studio where *Blazing Saddles* is supposedly being made. This
sequence, too, becomes increasingly frenzied until the entire film
ends in chaos.

If Brooks's film goes haywire at the end, Alexandro Jodorowsky's
The Holy Mountain could be said to fizzle out. The narrative traces
the picaresque, extremely disjointed adventures of a group of pil-
grims traveling to a holy mountaintop. Their goal is to hear the
revelation of a mystical secret. While the adventures are somewhat
interesting in themselves, they serve largely as delays to the achieve-
ment of the goal. Once the pilgrims reach the mountaintop, their

[52] Heath, "Film and System: Terms of Analysis," p. 4. Italics in original.
[53] Ibid., p. 50.

leader (played by Jodorowsky himself) says that the promised rev-
elation cannot take place. The camera pulls back to include the
camera crew within the frame, and the cast waves at us as the film
ends. The narrative has failed to maintain the energy of its central
hermeneutic until the end and simply stops short of closure.

At first glance, these two films might seem strange bedfellows.
Each in its own way, however, is striving to produce a series of
"outrageous" effects that are only slightly motivated by the weak
narrative. In each case, the resultant lack of control results in the
self-destruction of the narrative. Interestingly, the two films also
choose similar devices to extricate themselves from difficulty: the
inclusion of the filmmaking process. In neither case is the intro-
duction of the filmmaking scene motivated by anything that pre-
cedes it. The final filmmaking frame device serves to introduce a
sense (false though it be) of unity. The narrative cannot continue,
but the film must end. Therefore the filmmakers point out the film
as film; they substitute simple ending for closure, in an attempt to
deflect the audience's attention from the narrative flaws. In each
case, the ending forms a blatant figure of distress.

In more subtle films, the figures of distress need not always involve
flaws in the narrative, as they do in the preceding two examples.
The figure of distress is useful for the critic because it can signal
the points at which the narrative comes closest to losing its unifying
power over the proairetic chains, and, in turn, these moments may
serve as indications of the extreme limits of the text's ability to
motivate its devices. Although *Ivan* never loses control of its nar-
rative to the degree that *Blazing Saddles* and *The Holy Mountain*
do, nevertheless, it does contain a few figures of distress which
signal that the narrative has momentarily come close to allowing
its violence to dominate.

Heath's concept of narrative violence argues against the tradi-
tional view of art as completely unified and economical. Since art
is not communication, it has no need of these qualities. Yet precisely
because it *is* impractical, art must generate its own reason for being,
its own interest. The Formalists did not go as far as Heath, but they
did see the need for disorder in art. In his "Art as Technique,"
Shklovski spoke of rhythm in art: "The rhythm of prose is an
important automatizing element; the rhythm of poetry is not. There
is 'order' in art, yet not a single column of a Greek temple stands
exactly in its proper place; poetic rhythm is similarly disordered

rhythm."[54] A few years earlier, in the first major Formalist essay, Shklovski had gone further by declaring that "the history of art shows us that (at least very often) the language of poetry is not a comprehensible language, but a semi-comprehensible one."[55] In examining film, we shall similarly expect to encounter difficulties; a work's opaque structures are not flaws but necessary defamiliarizing qualities. After all, if we could explain a work, it would diminish in its power to engage our perception; as we shall see, the goal of the Formalist critic is *not* explanation.

Similarly, an artwork's main concern is not to communicate but to keep its forces organized without dissipating its energy. Each work has both its own unique mode of disturbing the initial stasis through violence and its own process for formal structuring beyond that point. The narrative is at its most open at the beginning, for at that moment virtually anything can happen. Usually only the title has narrowed the viewer's expectations. We shall see that in *Ivan*, spoken words and titles begin to define relationships swiftly. The film's violence occurs in the first scene, throwing the hermeneutic and proairetic chains in motion, and the possibilities narrow rapidly. According to this model, the narrative could be compared to a cone-shaped figure lying on its side. The wide, open end is the narrative beginning; gradually certain lines of action are shown to be impossible (*Ivan* will not be the story of how Ivan came to power, since he takes the crown in the first scene; Efrosinia will not support him because she has a son who is a claimant to the throne, and so on). The possibilities narrow more and more until only one thing can happen: the ending comes; the cone's apex is reached. In contrast, in an "open" narrative, the possibilities never narrow off to a single inevitability; the cone remains open. So we shall consider the beginning a privileged point in the narrative structure because of the richness of the codes; here we may find the establishment of the nature of many of the lines of action and relationships that will continue to play an important part throughout the film.

Another Russian Formalist, Vladimir Propp, suggests a means of further specifying the flow of action. He divides the structure of a narrative into *moves*.[56] A move consists of a line of action (a proairetic chain) that requires its own separate resolution within the nar-

[54] Shklovski, "Art as Technique," p. 24.
[55] Shklovski, "The Resurrection of the Word," p. 46.
[56] Vladimir Propp, *Morphology of the Folktale*, trans. Laurence Scott, ed. Louis A. Wagner, 2d ed. (Austin: University of Texas Press, 1968), p. 156.

rative. One move may either follow or interrupt another; an episodic narrative strings moves together. For example, *Ivan* has four basic moves: Ivan's struggle to unify Russia (interrupted often, terminated only at the end—the "buckle" move), Ivan's conflict with the Boyars (the most prominent move, terminated late in Part III), Ivan's changing relationship with the people (cropping up at intervals throughout the film, resolved about midway through Part III), and the war with Kazan (occurring only in two sequences, resolved in Part I). The concept of moves helps in determining the functions of various devices in the work's narrative; it also provides a starting point for the study of the relationship of plot to story.

In approaching a neoformalist analysis of films, we may apply these ideas on narrative directly, with the provisional statements I have added. Basically, we may consider a film a temporal flow of devices, each justified in its inclusion by a specific motivation; these are collectively shaped by a dominant structure. A proairetic chain creates a narrative, with a hermeneutic helping to provide its forward impetus; the delays in the unraveling of the enigma deflect the proairetic into a staircase construction. Among the most important agents in the proairetic code are the characters, which are made up of semes associated with a specific name and/or body. The narrative as embodied in the film is the plot; the events rearranged into a chronological, causal sequence in the viewer's mind constitute the story. Finally, in order to impede perception and call attention to the form, certain elements may be included specifically to bare the device.

The Work in the World: Perception and Norms

As we have seen, one of the Formalists' most basic assumptions is that art is perceived in a special way unique unto itself. The ability to perceive a work's aesthetic qualities is not automatically present in a person; it must be learned. Tomashevski speaks of an "artificial reading" of a poem to scan its meter: "Only the first stage of poetic perception needs this reading out loud. To the reader gifted with a developed poetic ear, this reading becomes an automatic act, subconscious and involuntary, just as the ability to write is for a literate person."[57] This concept of an ability to learn reading skills follows logically from the Formalists' attempt to anchor the study

[57] Boris Tomashevski, "Sur le vers," in *Théorie de la littérature*, trans. and ed. Tzvetan Todorov (Paris: Seuil, 1965), p. 156.

of literature in language itself; an objective approach precludes the notion of taste, with its implication that some readers are naturally better than others.

The same idea applies to cinema, where the ability to notice the effects of cutting, camera movement, and the many other stylistic features of a film is one that the viewer must learn.[58] The argument also works against an assumption that crops up in various attitudes towards film criticism: the belief that the critic's task is to determine how a viewer would most likely perceive a film. But is the perceptual experience of a less skilled viewer the most valuable subject for the attention of the highly trained critic? If viewing skills can be learned, then presumably criticism can help in the process by pointing out elements and hence making them more noticeable to the viewer. I shall have more to say concerning the specific function of criticism after looking at the place of the arts in relation to other objects in the world.

Because the Formalists viewed literature's function as defamiliarization, they needed a concept of the *familiar*, that which is thrown into new relief by the work. They assumed that artworks are always perceived in some kind of context that provides them with a norm against which the individual work's difference stands out. They called this norm the *background*; one work could be perceived differently if placed against different backgrounds. In fact, the Formalists' view of literary history and change was largely based on the idea that older works may be perceived in new ways as new backgrounds evolve. These backgrounds are varied, but they all fall within three basic categories: the norms of general aesthetic usage (other artworks), the norms of everyday language, and the norms in some way determined by "life" or "reality."[59] The first two are fairly clear. A work may be seen as different because it uses the aesthetic conventions of its day in new ways or because it overturns them. (Literary history is thus seen as a constant series of reactions

[58] The fact that so many intelligent, educated people from other fields almost invariably approach cinema as though it were literature or moving painting seems to support this idea. Literary scholars will tend to apply their learned reading abilities to the viewing of a film.

[59] Victor Erlich formulates these three areas in *Russian Formalism: History— Doctrine* (see p. 252). There he takes the third background to be "actuality" itself, the real world of everyday life. Although I am using Erlich's helpful breakdown of the backgrounds into three areas, I will be developing a different view of this third background.

against earlier norms rather than as a set of older artists "influencing" younger ones.)[60] Similarly, aesthetic language is perceived against a background of the way language is used in ordinary discourse. These two backgrounds may be used to some extent in analyzing films. The critic may choose to compare a film to other films or artworks in order to reveal its unique qualities. Thus a comparison of a John Ford western with other members of the genre would reveal aspects of the Ford work that would not be apparent outside such a context; placing the same western against other Hollywood films of its period would bring out other salient aspects of its functioning. Similarly, the films of the Soviet filmmakers of the twenties may be compared to the other arts of the period in order to bring out such aspects as their Constructivist elements. This procedure is not a replacement for formal analysis but an aid to it. In addition, the critic does not necessarily attempt to reconstruct the conditions in which the film was originally viewed (although this is one approach). Yet the choice of background is not random; the critic justifies it by showing how the background chosen relates to the work through its dominant.

As we have seen, film has no equivalent to "everyday language." There exists, however, the possibility of practical filmic usage that deemphasizes style. The aesthetic usage of film, in which form comes forward, implies this opposite possibility. By failing to fulfill a practical, communicative function, the aesthetic techniques of film call attention to themselves. This does not mean that critics must continually compare aesthetic films to informational films in order to analyze them, but they should recognize that such an implicit background exists.

A major problem comes in defining the work's relation to everyday reality. The Formalists provide little help on this matter, as they were primarily concerned with fighting the simple views of art as a reflection of life that permeated the criticism of their day—views that have definitely not disappeared even now. On one point the Formalists were adamant, however: reality is completely transformed when it is incorporated into a work of art as subject matter. Tynjanov stated the Formalist view:

[60] See, for example, Juri Tynjanov, "On Literary Evolution," trans. C. A. Luplow, in *Readings in Russian Poetics*, ed. Ladislav Matejka and Krystyna Pomorska (Cambridge, Mass.: The MIT Press, 1971). Tynjanov states, "A work is correlated with a particular literary system depending on its deviation, its 'difference' as compared with the literary system with which it is confronted" (p. 73).

I am not objecting to the "connection of literature and life." I simply doubt that the question has been properly posed. Can we say "life and art" when art is also "life"? The unique nature and inner logic of art as compared to everyday existence, science, etc.—that is another matter. . . . Whenever everyday life enters literature, it becomes itself literature, and should be evaluated as a literary fact.[61]

So the Formalists did not deny the connection between art and life (except perhaps in their earliest years of polemical reaction against existing schools of criticism); their idea of life as a background for the work, although it wasn't explicitly formulated, was a more complex one than art as a simple reflector of reality.

How then can we define the role that reality plays as a background to the artwork? The problem is obviously a thorny one; this discussion can only put forward a tentative set of assumptions. First among these is the belief that a film is not viewed against reality as a whole; the film itself structures those aspects of reality which are to be seen as its background. Thus each film has its own particular background derived from reality. Such a background exists neither in the work itself nor in reality; it is implicit in the structures of the work and must therefore be a product of the perception of the film, a mental construct produced by the viewer.

We shall provisionally call the background that the spectator produces the *background construct*; that is, the structured aspects of the world that the work implies. This is *not* a "content" of the work, since it has absolutely no status apart from its structural functioning in the work: separated from the work, such aspects would merge back into the undifferentiated swirl of reality. Tynjanov speaks of how artworks create meaning: "Language is not only the vehicle of concepts; it is also the device of their construction. This is why, for example, one is ordinarily much more clear in explaining the ideas of others than in explaining one's own idea."[62] The background construct, then, consists of the "unique nature and inner logic" that distinguishes the representational aspects of an artwork from the represented elements as they may be

[61] Juri Tynjanov, "Rhythm as the Constructive Factor of Verse," trans. M. E. Suino, in *Readings in Russian Poetics*, ed. Ladislav Matejka and Krystyna Pomorska (Cambridge, Mass.: The MIT Press, 1971), p. 133, n. 1.

[62] Juri Tynjanov, "Fragments d'*Archaistes et Novateurs*," trans. and ed. Lily Denis, *Change*, no. 2 (n.d.), p. 76.

presumed to exist in reality. This is the structural level at which the work plays off the laws of nature and society. Thus a western may represent "the old West" not as it actually existed but as the work itself creates it. Other films, such as science fiction or horror films, may create a set of natural laws for themselves that are not those of the real world yet that depend on our awareness of their difference from reality.

The background construct is the level at which ideological analysis may enter the critical process. Critics should not simply compare the ideas in the work with the world directly but should study their status as formal elements; only when this status is known will they be able to understand the implication of these ideas in relation to reality. For example, critics with a literalist approach might take Lina Wertmuller's *Swept Away* to be a film chiefly about the political conflict between a Marxist servant and an upper-class woman. Yet a neoformalist view reveals that the Marxist subject matter of the film is largely subsumed into the romantic love story by the end of the film. At that point, the audience is emotionally involved in the hermeneutic line of whether the heroine will renounce her upper-class position and rejoin her lover on the island; this romantic situation virtually obscures the fact that the island life they had lived was not a classless utopia but a society in which class positions were simply reversed—the servant holding the dominant position because of physical and sexual power. By the end of the film, we are invited to be disappointed that the woman fails to accept what would clearly be as intolerable a position for herself ideologically as the servant's had been at the beginning of the film. Thus the Marxist ideas, while undoubtedly present, have been subverted into performing a subsidiary function and must be critiqued with this in mind.

The background construct allows the filmmaker great freedom in playing off viewer expectation and understanding. On a simple level, our awareness of the existence of an *assumed* profilmic event allows us to be aware that when the frame shows only a part of a character's body, that person is not physically truncated but still extends in some sense "beyond the frame." This may seem self-evident, but one of the persistent myths of early film history is that producers would not permit close-ups because they assumed the audience would not understand the action if "the whole person" wasn't shown. Clearly we do understand, through a mental process that posits certain aspects of the work's relation to reality, even

though we realize that that relation is itself a structure. This mental process brings into being many formal possibilities, such as that of offscreen space.

Aside from its form, one thing that distinguishes the background construct from reality is its plurality of meaning. As Barthes has shown in *S/Z*, artworks have multiple connotations.[63] In life, ambiguity in communication is undesirable, nonpractical; art transforms life into literary, or cinematic, facts by using it in ambiguous, nonpractical ways.

One of the relations between the background construct and the work is that the former functions to provide the realistic motivations of the work's devices. Aspects of history, science, psychology, logic, "common sense," and all the other forms of knowledge that may be used as background to the work can justify the presence of a given element. Thus in *Ivan*, Eisenstein makes huge changes in the historical "facts" about Ivan IV, yet includes accurate but relatively insignificant bits of historical data that are presumably common knowledge to Russians. These minor facts provide a sense that the events occurring have some sort of historical validity; they are realistic motivation.[64]

The story-plot distinction relates closely to this idea of the background construct. Since the viewer's mental construct, the story, is formulated in terms of knowledge of cause-effect principles operative in everyday life, we can assume that the story is one portion of the background construct.

In summary, we can see that the Formalists' view of the artwork's relation to reality is essentially an antimimetic theory that still manages to avoid claiming that the work does not relate to reality. In mimetic theory, the artist begins his work in some realm of unclear status ("inspiration," "genius") and works towards reality until a copy is completed. For the Formalists, the artist starts very simply in the midst of reality—a reality that includes clearly defined traditions and conventions of art. (Recall Tynjanov's "Can we say 'life and art' when art is also 'life'?") The artist then takes the conventions and the reality as materials for the creation of the work; the basic movement is exactly the opposite of imitation of reality—it goes away from reality.

[63] Barthes, *S/Z*, Sections 2 to 5.
[64] Barthes talks about these aspects of the work as the "cultural code" in *S/Z*.

The Function of the Critic

The Formalists had a simple, well-defined set of assumptions about the role of the critic. Since the conventions of reading (or viewing in the case of the cinema) can be learned, the critic can aid this process by revealing the structures of an artwork and the relations among these structures.

According to the Formalists, devices of defamiliarization gradually grow *automatized*; as they reappear in artworks over and over, they no longer seem fresh. The spectator is so used to them that they come to resemble everyday language—they are no longer perceptible in themselves. As a factor of this process, the backgrounds may have changed over time so that certain aspects of the work are no longer thrown into relief.[65] Thus, according to Shklovski, "the aim of the formalist method, or at least one of its aims, is not to explain the work, but to call attention to it, to restore that 'orientation towards form' which is characteristic of a work of art."[66] Since there are people who have not yet learned to watch films skillfully, the aim of criticism may also be understood to be a making of the forms of art perceptible to those for whom they are "too defamiliarized." The critic may deal with a difficult film by showing how the complex structures within it function, thereby enabling a less experienced viewer to comprehend what was hitherto an undifferentiated tangle. In this way, the critic may help to bring the more radical work into the perceptual field of the viewer, not by simplifying the work, but by providing the perceptual tools to deal with its very difficulties. Thus Shklovski took *Tristram Shandy*, a work generally ignored in Russia at the time, and demonstrated the modernity of its structures; the novel came to be held in high esteem following his study.[67] Conversely, the critic may take the automatized work and place it in an unfamiliar light. This may involve an historical definition of its original backgrounds, which over the years have been forgotten and may now appear unfamiliar once again, or it may involve finding a new background that will reveal new aspects of the work which had gone unnoticed until that point. The Formalists have written much on the changing views

[65] For example, to many viewers, *Stagecoach* may seem a conventional western today, yet it was the film that introduced many of those very conventions.

[66] Viktor Shklovski, "Pushkin and Sterne: *Eugene Onegin*," trans. James M. Holquist, in *20th Century Russian Literary Criticism*, ed. Victor Erlich (New Haven: Yale University Press, 1975), p. 68.

[67] See Shklovski, "Sterne's *Tristram Shandy*."

literary works encounter as time passes.[68] They do not see this process as a detriment to the work but rather as a fact of literary history.

Because the Formalists placed a great emphasis on perception, the question arises concerning the real nature of the object of study. Do critics attempt to analyze the naive viewer's experience of a work? Clearly not, since they wish not to define that experience but to broaden it by aiding in the perception of the work's defamiliarizing structures. In order to do this, critics analyze the *conditions of perception*, renewing perception in the process. These conditions are not all present within the work; those that lie outside are organized into coherent backgrounds. However, analysis inevitably leads back into the work, for its concrete structures always control the conditions of our perception.

APPROACHING *Ivan the Terrible*

These indications of the assumptions of the neoformalist critic should provide a sufficient basis to allow us to turn to the analysis of a specific film. I have stressed the responsibility of the neoformalist critic to tailor the general assumptions of the Russian Formalist method to the demands of the individual filmic system. Here, then, are some indications of the shape this particular study will take.

One basic activity of the critic is the definition of a background that he or she can refer to as a touchstone for comparison; this context helps to put certain aspects of the work into relief. In dealing with *Ivan*, one of my main purposes will be to demonstrate the importance of discontinuities in its editing. I will also be looking at the narrative's apparent lack of concentration on the central goal or question that the beginning sets up. For both of these purposes, the most useful background would be a set of films that emphasize continuity of style and economical, "tight" narrative progression. In fact, this approach has been common historically in Hollywood films and the many commercial cinemas that have imitated the American model; I shall call this category of films the *classical narrative cinema*.[69]

[68] See, for example, Shklovski's "Pushkin and Sterne: *Eugene Onegin*."

[69] I should emphasize here that the phrase *classical narrative cinema* or *classical Hollywood cinema* is a critical construct. Historically no one film may conform

The classical narrative cinema's most prominent feature is its suppression of artistic motivation in favor of a clear, direct narrative structure. That is, the stylistic aspects of a film will function to present the story events but will simultaneously strive to efface themselves so that narrative virtually always governs the work's dominant. Various critics have attempted to characterize this approach to cinema: Bazin called it "invisible,"[70] and Burch described it as the "zero-point of cinematic style."[71] But the idea that narrative generally effaces style is not necessarily valid. For example, the style of classical films is unnoticeable only because it is familiar to us from many other films. As Jan Mukařovský has pointed out, "There are periods in the history of art in which adherence to norms obviously predominates over violation of them."[72] The classical cinema represents just such a period, when a norm dominates, minimizing the deviations in the works that the period produces. In spite of numerous small changes over the years, the classical cinema has retained a basic standardization of approach.

Stylistically, the classical cinema has constructed a framework that is generally known as the *continuity system*; this system involves the familiar "rules" for linking shots and achieving a smooth narrative flow: the axis of action, screen direction, eyeline matches, and so on. Similarly, the camera placement creates the optimum framing of the narrative action, both in terms of distance and angle; camera movement either follows action or ends by revealing a narratively significant element. As David Bordwell has pointed out, a classical framing typically places the subject in the upper central portion of the screen; if the subject is not centered, the elements will generally be in balance.[73] The result is a deemphasis of the frame as such; the illusion of depth and "real" space within the

exactly to this model. Rather, the system I shall define sums up the typical traits of a large group of films; any one instance is likely to contain deviations from the pattern.

[70] André Bazin, "The Evolution of the Language of Cinema," in *What is Cinema?* trans. and ed. Hugh Gray, 2 vols. (Berkeley and Los Angeles, University of California Press, 1967), 1:24.

[71] Burch, *Theory of Film Practice*, p. 11.

[72] Jan Mukařovský, *Aesthetic Function, Norm and Value as Social Facts*, trans. Mark E. Suino (Ann Arbor: Michigan Slavic Contributions, 1970), p. 35.

[73] David Bordwell, "Imploded Space: Film Style in *The Passion of Jeanne d'Arc*," in *Film Studies Annual* (West Lafayette, Indiana: Purdue Research Foundation, 1976), p. 99.

frame becomes more prominent than the graphic qualities of the composition on the flat screen.[74]

Few rules, explicit or implicit, govern the arrangement of mise-en-scene. Typically, classical narrative films do not include elements that are insignificant to the narrative; characters all contribute their actions to the cause-effect chain, while objects contribute by characterizing their owners. Because such films do not wish to call attention to their devices, many elements of mise-en-scene are realistically motivated. If a certain object is necessary, a character may be given semes which indicate that he or she is the type of person that would have such an object. Similarly, the narrative sets up causes that seem to "naturally" call for the characters to react in certain ways. Their actions become "realistic" because certain effects are necessarily derived from certain causes; what the narrative conceals is that its causes are in themselves arbitrary constructs.

Sound functions similarly to support narrative without calling attention to itself as a technique. Mary Ann Doane has described how Hollywood sound effaces its own materiality, becoming an "invisible" technique parallel to continuity editing. The classical film's goal is to create synchronization of sound and image—a totality that masks the split between the two. Doane provides various rules, similar to those used by editors of the image, for the creation of an unobtrusive sound track.[75]

To eliminate the audible click caused by a sound splice, according to Doane, sound editors use *blooping*, a technique for covering the splice and making it silent. Abrupt juxtapositions of different sounds are avoided; fades or dissolves on the track provide smooth transitions. Hollywood films avoid repetitious sounds, which are considered irritating to the listener. A Hollywood film would seldom allow absolute silence; a continuous flow of sound is the rule, with low environmental resonance added when no other sounds are present. A cut on the sound track seldom occurs at the same time as an image cut; sound that continues over a cut helps make the change less noticeable. Similarly, dialogue is given primary consideration, with its volume level determining the levels of other sounds. The intelligibility of the dialogue always takes precedence over canons

[74] The films of Busby Berkeley that involve his famous geometrical dance numbers are perhaps the greatest departure from the norm within the Hollywood industry.

[75] Mary Ann Doane, "Ideology and the Practices of Sound Editing and Mixing" (paper delivered at the conference, "The Cinematic Apparatus: Technology as Historical and Ideological Form," Milwaukee, 22-24 February 1978), pp. 6-7.

of realism: volume will rise and fall according to the audience's need to hear rather than in relation to the situation of the scene.

In addition to Doane's comments, we can describe several other characteristics of Hollywood's use of sound. Classical narrative films usually make the sources of diegetic sounds, particularly dialogue, clear.[76] (In contrast would be a film like Godard's *Tout va bien*, in which the speaker is not always ascertainable because characters block each other or keep their backs to the camera.) The camera either remains on the source of the sound or frames a significant reaction to it. If displaced diegetic sound is used, the time relationship between sound and image is reasonably clear. Diegetic and nondiegetic sounds are relatively easy to distinguish, and a play with the diegetic-nondiegetic categories is rare. (One instance occurs in Welles's prologue to *The Magnificent Ambersons*, where one character seems to answer the remarks of the nondiegetic narrator.) Sound effects remain faithful to their sources; the distortion of fidelity present in such films as *Le Million* (René Clair) and *Les Vacances de Monsieur Hulot* (Jacques Tati) is not characteristic of classical narrative cinema.

The classical cinema also emphasizes smooth transitions between different spaces and times. Devices like fades and dissolves are used almost exclusively to create a flow between scenes; even slight ellipses within scenes are typically "covered" by a dissolve. For larger temporal, spatial, or causal gaps, Hollywood has devised the *montage sequence* (an ironic name for a device so completely opposed to Eisenstein's notion of conflict through abrupt juxtapositions). The simplest, most clichéd versions of such montages make clear their function of smoothing over roughnesses in the plot: changing calendar leaves signify a lapse of considerable time, spinning train wheels signify a shift over some distance, and newspaper headlines present important narrative information. Other montages are more complex and original, but most still serve these basic functions.

Another device for creating a smooth narrative flow is known in Hollywood as the *dialogue hook*.[77] With this device, the last line

[76] *Diegetic* sounds are those that originate from the space of the narrative. In contrast, *nondiegetic* sounds come from outside the story space; the most common examples would be voice-over narration and atmospheric music. Displaced diegetic sound indicates a temporal disparity between a diegetic sound and the image that accompanies it. For further clarification of these categories, see David Bordwell and Kristin Thompson, *Film Art: An Introduction* (Reading, Mass.: Addison-Wesley, 1979), Chapter 7.

[77] See the discussion in Lewis Herman, *A Practical Manual for Screen Playwriting*

of dialogue in one scene sets up the action that will occur in the next scene. If a character speaks of going "to Joe's bar," the dissolve that follows will most likely reveal a sign, "Joe's," on a bar that the same characters are entering. The break between sequences has been minimized.

This brief summary is enough to show that the characteristics of this approach to cinema form a coherent system with an overall goal: the clear presentation of narrative.[78] A change in any of these traits would have to imply a general shift in purpose—a shift in the kind of dominant possible. A similar mode can be seen to exist in the nineteenth-century novel. According to Tomashevski, the 1800s was a period

> distinguished by its attempt to conceal the device; all of its motivation systems are designed to make the literary devices seem imperceptible; to make them seem as natural as possible—that is, to develop the literary material so that its development is unperceived.[79]

Clearly the classical narrative system utilizes many devices that have become automatic by repeated, pervasive usage. Such devices remain relatively imperceptible, and the traditional film exploits this fact in the service of narrative.

The classical narrative cinema provides a useful background against which many alternative systems can be viewed. Its automatized nature, a product of uniformity, sets off attempts to find new, defamiliarizing devices. As we shall see, *Ivan* departs from this model in many ways, although not to such a radical degree as many more recent films.

As a methodological convenience, I shall be using a couple of films, *Sergeant York* (Howard Hawks, 1940, Warner Brothers) and *Mary of Scotland* (John Ford, 1936, RKO), as a specific background for *Ivan*. These films form a point of comparison because they are similar to *Ivan* in several respects. Both fall into the genre of historical biography and were made in the same general period. *Sergeant York* in particular resembles *Ivan* in that it deals with a past national hero who is held up as a model and used for patriotic

for Theater and Television Films (New York: New American Library, 1952), pp. 205-210.

[78] For a more complete study of the classical narrative system, see David Bordwell, Janet Staiger, and Kristin Thompson, *The Classical Hollywood Cinema*, forthcoming.

[79] Tomashevski, "Thematics," p. 94.

propaganda relating to World War II. Both of the American films were among the "quality" productions of their day; similarly *Ivan* was an "A" production for the Soviet film industry. These two works will serve to demonstrate a specific, standardized filmic practice.

But can this background tell us about our current perceptions of *Ivan*? I would argue that this background remains with us today, as the classical Hollywood system has changed little over the intervening years. *Ivan*'s discontinuities and stairstep construction are strange in a way that has changed little in relation to this system. *Mary of Scotland* and *Sergeant York* still seem closer to our current conventions than does *Ivan*. These two American films can provide us with a sense of *Ivan*'s uniqueness both in its original period and today.

This is not, of course, the only way to study the film. The use of other backgrounds would allow other elements to come forward; the critic would then have the tools to examine the function of these elements by noting their departure from the norm. One possibility would be an attempt to discover the meanings the film would hold for a contemporary Russian audience as a result of the film's derivation of structures from the historical situation of the time. Such a study would enrich the film by revealing additional formal play undiscernible without such a background. The critic would then deal with Stalinist Russia in the thirties and forties, examining how Ivan IV was viewed during that period, what connection the figure of Ivan might have had to Stalin, how the film would have related to patriotic military propaganda during the war, and so on.[80] Another group of films that would probably serve as an appropriate historical background are those made during the Socialist Realist movement of the thirties and forties. Whereas contemporary non-Russian audiences might be inclined to ignore *Ivan*'s place in contemporary genres, viewing it rather as a relatively isolated phenomenon, the critic could reveal new aspects of the film by comparing it to the popular historical epics depicting the lives of famous pre-revolutionary personages. These and other Socialist Realist films might give other indications of contemporary norms against which *Ivan* stands out in certain respects.

So why choose a general category like the classical narrative

[80] For a more detailed analysis of this type of study, see Kristin Thompson, "*Ivan the Terrible* and Stalinist Russia: A Re-examination," *Cinema Journal* 17, no. 1 (Fall 1977): 30-43.

cinema? Why not take a specifically Soviet set of films in order to try and reconstruct *Ivan*'s original background for Russian viewers of 1944? Mainly because I feel that the broader background will reveal more about the film. *Ivan*'s original audiences took it to be a very fine example of patriotic Socialist Realism. Part I received a flock of Lenin Prizes for its makers, yet Part II was so unacceptable that it was banned. Their experience with contemporary Russian films enabled Soviet viewers to come to terms with the strange aspects of the work to a large degree; to them Part I evidently seemed little different from earlier Tsar films like *Peter the First* (Petrov, 1937/1938). However, the extreme departures of Part II from the familiar genres and styles led officials to an abrupt about-face.

As Tynjanov points out, a work placed against a different background does not remain unchanged:

> A work torn out of the context of a particular literary system and transferred to another takes on a different coloring, acquires different features, becomes part of another genre, loses its own genre—in other words, its function shifts. This brings about a shift of functions within the work as well so that what had earlier been a subordinate factor now becomes the dominant.[81]

It seems to me that *Ivan*'s history subsequent to its first Soviet screenings plays an important role for viewers of today, especially in the West. *Ivan* has moved from being a prestigious Socialist Realist film to being a world classic, if an eccentric one. I suspect that for most post-1944 audiences, Hollywood or Hollywood-style films form the dominant viewing habit. I am not particularly interested in trying to tame *Ivan* back into Socialist Realism and docility. I want instead to highlight those factors that continue to fascinate us in the film.

The neoformalist methodology I have set forth here gives the critic the tools to answer a certain range of questions. With its emphasis on defamiliarization, the system clearly seeks the complex and original tendencies of a film. In analyzing the devices of *Ivan*, therefore, I shall be concentrating on its departures from the system outlined here as a background, the classical narrative cinema.[82] I

[81] Quoted in Chernov, "A Contextual Glossary of Formalist Terminology," p. 41.

[82] This is not to claim that the films of the background are clichéd or valueless. The more interesting films of the classical Hollywood cinema—of which there are many—reveal unique, original aspects when compared with the more standardized, run-of-the-mill pictures.

shall not attempt to describe the film exhaustively, for some ele-
ments of *Ivan* are common to many films. Thus I shall not go into
such distinctions as the fact that the film uses studio settings rather
than location shooting in most of its scenes, nor shall I synopsize
the cause-effect chain of *Ivan*'s narrative at length; I assume the
reader is reasonably familiar with the film. Rather my concern will
be the fact that *Ivan* employs certain defamiliarizing devices to
deflect its narrative in an unconventional way and that it contains
a number of unusual stylistic patterns.

Narrative Analysis

SEGMENTATION

For the purposes of narrative analysis, I shall treat the three parts of *Ivan* as one continuous structure; the breaks between parts do not necessarily represent the most significant structural pauses or turning points in the narrative. Yet, due to the restrictions of standard feature-length films, Eisenstein structured the parts so as to give each a certain autonomous form, with each achieving some degree of closure at the end. Thus Parts I and II each conclude with the completion of a major line of action, even though they leave the main narrative goal open. Part I ends with the accomplishment of Ivan's goal of having the populace recall him, yet in Part II we discover that the resolve to return to Moscow is in a sense simply a dialogue hook, for it is not until the second sequence that we see Ivan actually traveling to Moscow. Although little story time has elapsed between the end of Part I and the second sequence of Part II, in terms of screen time, Eisenstein has separated the two scenes not only by the break between parts but also by the scene in the Livonian court. Similarly, at the end of Part II, Ivan declares his resolve to turn his attention to the external threats to Russia. Again the second scene of Part III shows Ivan beginning this process by setting out to prevent Novgorod from allying itself with Livonia against him. But once more Eisenstein separates the two scenes by beginning Part III with a scene in Livonia, with Kurbsky plotting against Ivan. Thus the three parts, although relatively continuous in action and time, contain structuring elements that emphasize the three-part narrative. This division is also marked by the device of the brief, tableaulike scenes at the end of each part, in which Ivan stands before an admiring crowd and reiterates his resolutions concerning the unity and permanence of the Russian state.

For the purposes of this chapter's analysis, the projected third part of the trilogy will be treated on an almost equal level with the two finished parts, while its status in later chapters will necessarily be minimal and tentative. Here I will attempt to deal with the

overall narrative structure of the trilogy, something that is not clear from simply viewing the two completed films.

In order to be able to speak about the film, I shall break it down into sequences. Such a division is relatively easy with *Ivan*, as its story-plot relation is a fairly straightforward one. In setting out the scenes of the film, I have numbered and labeled them with respect to the major action. The first part of the trilogy breaks down into nine clear sections; within each, time is usually continuous, a single basic locale is maintained (involving at most several contiguous rooms), and fades are used at beginning and end. The sequences are: 1) Ivan's coronation, 2) the wedding banquet, 3) the battle at Kazan, 4) Ivan's illness, 5) the Boyars' plot, 6) Anastasia's poisoning, 7) Ivan's mourning, 8) the heralds' announcements, and 9) Ivan's exile and recall.

The second film is subtitled "The Boyars' Plot." It can be broken down into eight clear-cut parts: 10) the ceremony at the Livonian court, 11) Ivan's return to Moscow, 12) the executions of the Kolychevs, 13) the Boyars' mourning, 14) the Fiery Furnace play, 15) the Boyars' second plot, 16) the feast and Vladimir's death, and 17) Ivan's speech.

Part III, tentatively subtitled "Ivan's Struggles," is more difficult to divide. The script has a number of scenes that presumably would have been eliminated in shooting. (These primarily involve two minor characters, cannoneers named Foma and Yeroma, and some jesters in foreign courts; Eisenstein had already eliminated these from the other parts of the film.) There is also one section that consists of a string of short scenes set in widely different locales. It begins with a scene in which Kurbsky, now in Livonia, receives a letter that Ivan has sent to deceive him; this is followed by a short scene in England in which Queen Elizabeth I decides to betray Livonia and help Ivan. Finally there is a brief scene of Ivan's men killing guards posted at the Livonian border. Clearly the first two of these scenes are designed to work together in spite of the different locales, for the script notates a musical bridge between them, with a page in Elizabeth's court picking up a song about "Queen Bess" begun by a jester in Livonia. The scene at the border is too short to form a separate part of the film and contains no major line of action, so I have grouped these three short scenes together as one sequence of the film under the general description, "intrigues in foreign countries." Similarly, I have grouped other scenes in Part III in the most logical manner I could devise for purposes of analysis,

but any such grouping must remain tentative. As I have divided the script, there are eight major sections: 18) Kurbsky's plots in Livonia, 19) the treachery of Novgorod, 20) Ivan's march on Novgorod, 21) Ivan's confession, 22) intrigues in foreign countries, 23) the Oprichniki feast, 24) battles in Livonia, and 25) the arrival at the sea.

THE DOMINANT

The dominant in *Ivan*'s structure cannot be determined by simply looking within the narrative, since it is a principle that informs all formal levels of the work. Because the dominant to a certain degree represents those aspects of the film that set it apart from other films, it is best to begin by stating the principal devices of *Ivan* that seem unusual. Noël Burch has remarked upon the scenes in the film where spatial relations within the shots shift noticeably from shot to shot; he compares this to a painting by Gris.[1] The device is not characteristic of every scene but occurs frequently enough to form a definite formal device; this technique, which I have called "cubistic editing," will be discussed in Chapter Eight. Such editing is paradoxical: a spatial shift of mise-en-scene objects at a cut implies a temporal gap between shots, since movement through space takes time, yet no ellipsis is indicated at these cuts.

Another characteristic device in *Ivan* involves its abrupt transitions between scenes. Although many transitions link the end of one sequence with the next by means of a dialogue hook, the sequences are clearly demarcated by fades. At some points, lengthy gaps of time occur with little or no indication of intervening events. Ivan sets out for Alexandrov into exile and is called back immediately in the next sequence; only his despairing attitude and grayer hair indicate the duration of exile. The film eschews many of the possible conventions for providing a smooth transition (the most standard one being, ironically, the Hollywood montage sequence). Thus, along with a spatial shift between shots in some scenes, Eisenstein sometimes employs a narrative shift from one scene to another.

Within scenes there is a lack of concentration upon the central hermeneutic line set up at the beginning of the film. In his coronation speech, Ivan declares that he intends to unify Russia by pushing its

[1] Noël Burch, *Theory of Film Practice*, trans. Helen R. Lane (New York: Praeger, 1973), p. 39.

borders to the Baltic Sea. Once this goal is set, one logical pattern
of development would be to trace the methods Ivan uses to win
back the Russian lands; the central move would be the reaching of
the goal, with subsidiary moves consisting of major obstacles (each
battle or intrigue). Yet of the three parts of the trilogy, only Part
III deals with the initial move to any great degree. The larger part
of the work's structure consists of three other moves involving a
series of obstacles, not all of which relate directly to the central
move. These other moves are: 1) Ivan's conflict with the Boyars,
2) Ivan's changing relationship with the people, and 3) Ivan's war
against Kazan. The Boyar move occupies the greatest part of the
action; introduced along with the central move of the goal, it con-
tinues almost up to the end of the film. Its resolution comes only
when the last Boyar, Kurbsky, is defeated. The people's move
weaves in and out of the film, resolving itself about midway through
Part III with the death of the Basmanovs. The Kazan move occurs
in two sequences of Part I. These three moves retard not only the
accomplishment of the goal but even the initial movement towards
it. In addition to the abrupt transitions, then, there is another nar-
rative digression between moves that diverts the narrative from the
central hermeneutic.

 Ivan contains a great wealth of stylistic devices that relate to each
other to create numerous patterns of narrative associations and
connotations. Much of the mise-en-scene is expressionistic, here
defined as the mutual distortion of several devices within the frame
so that they create similar narrative functions on multiple stylistic
channels (see Chapter Four). Sound-image relations are also re-
markably complex; a number of key moments in *Ivan* involve a
weaving of speech and music to convey narrative information. Often
onscreen movement and sound become very closely coordinated,
so that once again several stylistic channels seem fused together in
a single functioning web of devices.

 This brief discussion does not exhaust the list of devices that
characterize *Ivan*, but it does give us enough of an indication of
the types of structures employed to identify the dominant. A simple
opposition is apparent. On the one hand, there are structures on
both the narrative and stylistic levels that depend on the combi-
nation of a number of devices that all function in a similar fashion.
On the other, there are devices that seem to work against clear
narrative functioning; they do not aid in an understanding of char-
acter semes, causal relations between events, or spatio-temporal
placement of the action.

 The multiplication of devices that perform the same function

creates *redundancy* on the stylistic level. Each new device that is added tends to repeat what another device has accomplished; *Ivan* in fact contains a great number of redundant devices, as we shall see in Chapters Five and Seven. This redundant style is matched by *overdetermination* on the level of narrative structure. We shall see how the film begins with a situation in which Ivan's power and the desirability of the goal of Russian unity are already unquestionable. The end of the film is therefore inevitable, determined. I call this *over*determination because the motivation of the film's initial state is so strong that it allows the narrative nowhere to proceed; Ivan seemingly can do nothing but conquer Livonia immediately.

Overdetermination and redundancy are static structures. Therefore if the film is to move forward, it must create a counterstructure for each static structure. On the narrative level the film needs to introduce a disruption into the initial situation that will allow forward progression without actually destroying the given conditions upon which the whole is based. *Ivan* does this by abruptly abandoning the initial proairetic and hermeneutic lines and substituting obstacles to Ivan's achievement of the goal that do not seem to relate directly to that goal. Thus, while the central question of the goal's accomplishment remains intact and overdetermined, the film's narrative as a whole includes long digressions. The issues and values embodied in the central hermeneutic and proairetic are *displaced* onto a series of other obstacles and goals.

A similar structure is at work on the stylistic level. Certain narrative elements are reiterated by multiple stylistic devices. So the style is in some ways extremely redundant, reinforcing the overdetermination of the narrative. The stylistic devices also work together to such a degree that they often create an effect of fusion. Again, the danger of this pattern is its potential for static structures. Once redundancy becomes a guiding principle, there is nothing to determine how many reiterations of a single function are sufficient: the cinematic techniques can multiply and fuse indefinitely unless a counterforce creates a different kind of structure. In *Ivan*, the stylistic devices that work against tight narrative unity tend to break up the spectator's concentration on the redundant repetitions; they introduce a perceptual difficulty that lends dynamism to the great number of narratively unified stylistic devices in the film. These counternarrative devices will here be called *disjunctions* and *excess*; I will deal with them in the last two chapters.

The preceding discussion defines *Ivan*'s dominant. But in order to assess the significance of this dominant we must first see how it relates to the dominants of other films or groups of films.

Like *Ivan*, the classical Hollywood film is redundant, in that it provides multiple clarifications and reiterations of the relationships between all causes and effects. After the initial cause (which must be assumed if the proairetic is to be finite), each subsequent cause has a clear effect. Similarly, each effect has a clear cause. The classical film achieves closure at the end; failure to do so would leave dangling causes and hence move away from redundancy.

As alternatives to the classical cinema, there have arisen a variety of strategies that result in different structural approaches. To a relatively large degree, these strategies tend to avoid redundancy. Such nonredundant alternative approaches may be of different types, including:

1) *Ambiguous*. The film provides a series of causes and effects but links them clearly enough to enable us to determine the specific relationships among them. Alternatively, the film provides a clear series up to or following a certain point, without supplying the initial cause or closing effect. This happens most often at the end of a text, producing a lack of complete closure (*Diary of a Tenement Gentleman, Quatre Cents Coups*). It may also happen throughout a film (*Day of Wrath, L'Année dernière à Marienbad*).

2) *Sparse*. Here the film may provide too few cues for the formation of a clear chain of cause and effect. Such a film may achieve closure (as with Bresson's films) but leave individual gaps. Alternatively, the film may provide a clear causal chain but one that consists of too few cues to support the action. Here noncausal actions, extremely lengthy actions, or intervals of no action may expand the narrative (Ozu's transitions and cutaways, portions of *The Chronicle of Anna Magdalena Bach*).

3) *Overloaded*. Redundancy also disappears when the film provides a great deal of information without allowing the spectator sufficient time to assimilate it. Godard's late films, for example, present a barrage of events and facts without sufficient emphasis to differentiate the important narrative events from the minor events.

Needless to say, individual films may combine these approaches. *Nicht Versöhnt*, for example, both overloads its audience with events and refuses to create unambiguous relationships among these events.

All of these strategies provide alternatives to redundant narrative

structuring, but there is at least one other possibility for departing from the classical Hollywood model. *Ivan* is a rare instance of this type of departure. Instead of downplaying or eliminating redundancy, *Ivan* increases it in many cases. Narrative cause and effect are completely clear, and repeated motivations make the proairetic code strong and unified. But in opposition to this intensely redundant narrative structuring, *Ivan* contains other structures of disjunction and rupture. These latter structures tend to break apart the redundancy, diverting attention from it, working against it, confusing it. *Ivan* simultaneously bears resemblance to the classical Hollywood model (no one with any viewing experience at all could possibly fail to comprehend its story events and character motivations) and also to the more overtly avant-garde modernist texts of later decades (as exemplified by its discontinuities and extreme stylization of sound and image). Historically perhaps this approach arose from Eisenstein's situation; he was forced to produce a film sufficiently within the Socialist Realist mold to be acceptable to the authorities, yet his theoretical inclinations were mostly in the opposite direction. But be that as it may, *Ivan*'s dominant is set apart from those of other films by its initial creation of an extremely redundant structure, which is in turn partially broken apart by the film's disjunctions.

An analysis of *Ivan*'s narrative will necessarily deal with meaning and abstract ideas that many critics might wish to interpret thematically. That is, they would make an interpretive reading the primary activity of the critic. Such an approach is not the goal of neoformalist criticism, and I will treat this material in a different fashion. For our purposes here, meaning and abstract ideas are important for their narrative functions. "Power" is a major concept in *Ivan*, but it is hardly the central theme. (*Ivan*'s theme in this sense is straightforward patriotic propaganda.) Instead, it is a main seme for Ivan, motivating many of his actions; it also motivates his symbolic position as the embodiment of the goal.

INTRODUCTION OF THE CENTRAL MOVE AND HERMENEUTIC

I have indicated that comparatively little of the film's proairetic chain directly involves the central move of regaining unity for Russia. Yet we are never allowed wholly to forget this move because its characteristics are displaced onto the character of Ivan himself. The assumption of this study is that the protagonist of a narrative

is that character who to the greatest degree forms the basis for the primary structures of the work. Ivan is an extremely strong protagonist. The film works out its narrative overdetermination through him.

Ivan's first words reveal his most fundamental seme, his desire for unity: "Today, for the first time, the Archduke of Moscow wears the crown of the Tsar of all the Russias." This seme of unity is not directly one of personality; rather, it places Ivan symbolically in the scheme of the film. Ivan desires unity for Russia, but, more importantly, he embodies that unity. He outlines in his coronation speech the central move of the film, the unification of Russia. The accomplishment of this goal immediately becomes linked with the physical sign of the boundary, the sea. Ivan's speech is a privileged moment in the filmic text; his words dictate the shape the film must then take (as a classical text), for no matter how many events intervene, the end of the film must be the accomplishment or failure of the goal of unity.

As *Ivan* begins, all we know is its general subject. The opening narrows down the possibilities quickly. A coronation is taking place; it could be Ivan's father's, but it turns out to be Ivan's own. Ivan could be the cruel, mad figure of popular myth, but he turns out to be a dignified, regal figure. Already we have a much more specific idea of the nature of the narrative we are about to see. Thus far, though, the narrative exists only on the level of a general hermeneutic; once we have seen Ivan, the mysteries of the film's opening are cleared up. But even before his arrival, the remarks of the ambassadors prepare the way for the violence that erupts to set the narrative's main forces in motion. These characters provide us with the information that Efrosinia and her followers oppose Ivan's domination. The conflicting parties are known by the time Ivan introduces the narrative violence with his speech, declaring that he will unify the Russian state. At this moment of the statement of the goal, the film is still relatively open; all that is clear is the shape the ending must take. The hermeneutic—Will Ivan reach the sea/goal?—dictates that the moment of closure—the answer to the enigma—must come at the Baltic.

Since the beginning and ending are inextricably bound, the critic's task must in large part be an examination of the means used to progress indirectly along the path between those two points. What principles govern the film's shift from one move to another? In order to begin our analysis, we must first banish any notion that

the choice of actions or the use of the many retarding mechanisms was in some sense natural, or realistically motivated, simply because the subject matter of the film is derived from historical material. On the simplest level, the inclusion of any one event is arbitrary in terms of historical authenticity, since the vast majority of events in Ivan IV's life have had to be omitted. Also, Eisenstein has chosen to include events unrelated to the basic goal of reaching the sea, while eliminating events that actually would relate to it. (I say "would" since Ivan's reaching of the sea is Eisenstein's fiction; Ivan actually never reached the sea, ultimately losing some Russian land to Livonia rather than gaining any ground in the struggle.) So the motivation for including certain events rather than others must be primarily compositional.

There is little point in detailing the intricate combination of historical accuracy and invention the narrative entails. Suffice it to say that there is no scene in the film that does not contain substantial differences from the historical Ivan IV's life. Eisenstein does scatter a number of authentic details throughout his film; many of these are brief references that often occur outside the action of the main plot line. For example, in Part III, Ivan speaks of having had Philip strangled in a monastery, and Eustace reveals that the treacherous letter Novgorod proposes to send to Livonia is hidden behind an icon in a certain church. In Part I, the arrival of the English ships in the White Sea is announced. But while all of these incidents correspond to the various historical accounts of Ivan IV, they remain embedded in what constitutes a highly fictionalized version of historically based material.

Spectators recognize these details as historical references because of their knowledge of the material upon which the film bases its background construct. If the narrative briefly introduces an object or event without providing either an adequate motivation for its presence or an explanation of its significance, we may suspect that a reference is being made; even if we are ignorant of the significance of the object or event, we do pick up the cue that this is something in need of investigation. We will then either discover its place in the work's background construct (if it is based on actual fact) or learn that it is not a realistically motivated device.

These historical details have a special kind of realistic motivation that lies outside the work, in the spectator's background knowledge of such facts. Within the context of the film, such events as the falling of the bells during the riot on Ivan's wedding day remain

unexplained. Yet these same events provide the film with a sort of catalyst; in effect, they themselves have an automatically realistic motivation due to their historical status. They in turn provide an appearance of realistic motivation for other events in the work that are in actuality almost wholly compositionally motivated.

Eikhenbaum has a special term that he uses in relation to a similar kind of motivation that applies to certain types of literary works which make use of devices without needing to motivate them. He calls this "transparent motivation."[2] According to Eikhenbaum's original analysis, these works are implied to be those belonging to genres; they use the conventions of their genres without needing to provide justification, since these conventions are already so familiar that they are automatically acceptable in the proper context. Eisenstein is working in the genre of historical films; specifically, depictions of the life of Ivan IV were common in Russia, both before and after the Revolution. Accordingly, Eisenstein may include these bits of commonly known historical information without supplying their background. By not providing a cause-effect explanation for these certain events, he is able by extension to imply a realistic justification for other events that may be historically untrue.

Barthes's remarks on the use of historical personages in a work of fiction relate to this point:

> If the historical character were to assume its *real* importance, the discourse would be forced to yield it a role which would, paradoxically, make it less real. . . . Yet if they are merely mixed in with their fictional neighbors, mentioned as having been present at some social gathering, their modesty, like a lock between two levels of water, equalizes novel and history . . . they give the novel the glow of reality, not of glory: they are superlative effects of the real.[3]

All of *Ivan*'s characters are to some degree based on real historical figures, so Barthes's quote does not apply directly. But if "historical events" is substituted for "historical characters," the principle is similar. By mixing offhand details of truth with large constructs of

[2] Boris Eikhenbaum, "O. Henry and the Theory of the Short Story," trans. I. R. Titunik, in *Readings in Russian Poetics*, ed. Ladislav Matejka and Krystyna Pomorska (Cambridge, Mass.: The MIT Press, 1971), p. 241.

[3] Roland Barthes, *S/Z*, trans. Richard Miller (New York: Hill and Wang, 1974), pp. 101-102.

fiction, Eisenstein is able to shift the whole thrust of his film away from a simple depiction of epic historical events while still maintaining an illusion of authenticity.

This discussion may give some indication of how Eisenstein uses history as a device in structuring his film. As I have mentioned, however, the gloss of realism lent to the film by its inclusion of historical facts does little to explain the particular combination of episodes in the narrative.

Having now established that historical authenticity cannot be the primary motivating device of *Ivan*'s narrative structure, we can return to the question of how the film moves from the setting-up of the goal of unifying Russia to its achievement. Clearly, in order to get Ivan to the shore of the Baltic, it is not logically necessary to send him to Kazan or to have a Fiery Furnace play. Many of the events in the film are not realistically motivated: they are not necessary to the cause-effect chain of the struggle against Livonia. They are, however, compositionally motivated. They relate to the principles structuring the work, and these principles once again are governed by the protagonist.

The opening scene, the coronation, defines the possibilities the film offers—and those it rejects—in relation to the overall move towards the unification of Russia. Many aspects of this scene serve to mark the fact that Ivan's ascent to power is the first instance of a Muscovite prince taking power over all of Russia; the ambassadors and Boyars alike comment on this fact. The crown itself is linked both with power and with the unity of Russia. As Ivan takes the crown, he also takes these qualities upon himself. He immediately goes on to formulate the conflict of the narrative, its violence: Russia's unity has been destroyed by its loss of land in the past; his goal will be to restore that lost unity. Significantly, this is not a goal that has existed already and that Ivan takes up. Rather, he creates the goal himself.

Ivan is introduced as a complete character, lacking in nothing needed to achieve his goal. Important character semes assigned to him in the coronation sequence are power, determination, love of Russia, and wisdom in statesmanship. Therefore in order for the hermeneutic (and the film) to continue, the retarding devices must be such that they throw his capacity into question. To *begin* with the question, Is Ivan capable of unifying Russia? is not possible; the task is not presented as one that the protagonist could "grow into."

This is in contrast to many classical narratives (in literature as well as film) that concern the protagonists' growth to capability. In *Sergeant York*, for example, York goes through two drastic changes: his religious conversion and his later meditation on the mountaintop, where he decides to accept a combat post. As a result, he becomes a hero and accomplishes his goal of marriage. In *Mary of Scotland*, Mary is doomed to be defeated politically by Elizabeth I. But because she develops a love for Bothwell, she is able to rise above Elizabeth and to defeat her morally at the end.

But Ivan's taking of the crown at the beginning is symbolic of his desire to unify Russia, and he never deviates from his goal. For the goal to exist at all, the character who formulates it, Ivan, must not be unworthy of it at the point of formulation, the coronation sequence. This premise seems tautological, and indeed it is, for this is the sine qua non of the narrative. We only learn much later that the initial cause of the entire proairetic chain was the Boyars' relinquishment of Russian land. The film's beginning, however, provides no justification for Ivan's desire for unity; we must simply accept it so that the narrative may proceed. Hence we must also accept that he is worthy of embodying such a goal.

Here we have the reason for the displacement of the central proairetic—the unification of Russia—onto the character of Ivan. The hermeneutic concerning the reaching of the sea is transmuted into the hermeneutic of Ivan's character: Will he be able to overcome the many obstacles placed in his way?

This transmutation of the hermeneutic creates greater potential for narrative complexity. The goal of Russian unity is immutable; it cannot be questioned, only defeated. But a hermeneutic based on Ivan is more flexible; we may begin to doubt him without ever wholly believing he has become unworthy of the goal. The narrative manages to keep Ivan the complete, perfect embodiment of the goal and simultaneously to cast doubts upon him by splitting his character into two halves, the public and private. Ivan's public character remains complete and untainted: he always maintains his wisdom, his military power, his upper hand in international intrigues. But a new set of semes relating to his private concerns and psychological motivations eventually enters the narrative, beginning with Ivan's first moment of doubt as he mourns by Anastasia's coffin. This development of Ivan's private self comes relatively late in the film; the first few sequences concentrate on confirming Ivan's ability to

cope with political threats of various kinds. In contrast to these difficulties, the psychological weaknesses—Ivan's loneliness, his apparently developing madness—emerge as even greater threats to Ivan and the goal, since they come from within the protagonist himself. Hence the narrative's displacement of the central hermeneutic onto Ivan allows it to maintain a far riskier (and more interesting) balance by concentrating on these two aspects of Ivan's character. The goal itself remains abstract, whole, and untainted; it comes into danger only through our doubts about Ivan.

If the delaying obstacles of the film consisted of a series of reversals in Ivan's battles with Livonia, his ability to conquer the ancient enemies of Russia would be called into question and this must not happen. This presents a paradox: Ivan's ability to achieve his goal is established and cannot be subverted, yet we must in some way doubt his capacity in order for the film to be able to continue. The dilemma is solved by the second major displacement of the film's narrative. Just as the hermeneutic concerning the ultimate accomplishment of the goal is transferred to Ivan's character, so the obstacles that Ivan must encounter along the way become not those of battle with Livonia but those of opposition from other forces—finally including the other, weaker side of Ivan's character.

This structure of obstacles is possible because the film does not motivate its characters' actions primarily in terms of conventional psychological traits. Rather it presents characters in somewhat the manner of an ancient epic. As a figure of heroic stature, Ivan must undergo a series of ordeals or trials to prove his worthiness.[4] These obstacles form the delaying pattern of *Ivan*, with three basic moves deflecting the action away from the central move. As we have seen, these three moves involve the Kazan war, the people, and the Boyars.[5]

[4] Within the individual sequences that contain these ordeals, the motivation may be psychological. Ivan's conflicts are often psychological rather than physical, involving the loss of friendship, love, or confidence.

[5] *Ivan*'s delay of forward movement on the central move contrasts sharply with an earlier Soviet "Tsar" film. Petrov's *Peter the First* (1937/1938) resembles *Ivan* superficially, but it does not employ any symbolic network of delays. As a result, its plot is extremely episodic, leading to a vastly different overall narrative structure.

Petrov's film (also in two parts) begins with Peter already at war with Livonia; he is defeated in battle in the first sequence. We might expect that Peter would continue to fight the Livonians and eventually signal his victory by building St.

Because these obstacles cannot take the form of political weaknesses or failings on Ivan's part, they generally derive from other characters who act against him. Thus most of the film up until the last portion of Part III creates variations on a pattern of opposed loyalty and treachery. Every character is placed within this structure in some way. Because Ivan himself embodies the goal, he also defines the pole of loyalty. (If he decides to abandon the goal, it is not simply defeated but rather disappears completely; his moments of doubt constitute some of the greatest dangers to the progress of the narrative.) His opposite is Efrosinia, the embodiment of treachery. If Ivan and Efrosinia form the extreme limits of the pattern, virtually every other character in the narrative traces some path of change between the two poles. Characters who begin by supporting Ivan betray him at some point, while the loyal followers he gains are converts from opposing groups. In spite of her relatively small part in the action, Anastasia is the only exception to this pattern; her importance in the narrative is great because of this difference. (Even Vladimir ultimately rebels against the treacherous role Efrosinia has thrust upon him and tries to become Ivan's friend.)

As I have indicated, the pattern of oscillation between loyalty and treachery replaces the central proairetic chain of the conflict with Livonia. No longer engaged in a war, Ivan must struggle with the doubts and loneliness that treacherous acts thrust upon him. Only when he has finally overcome these psychological setbacks is he capable of pursuing the Livonian war. But even his psychological setbacks result from Boyar treachery. Ivan's loneliness and madness result from Boyar plots to help Livonia and from their murder of Anastasia. The narrative implies that without his continual perse-

Petersburg on the edge of the Baltic. Yet he reverses his fortunes quite early in the film, wins the war, and builds St. Petersburg partway through Part I. The only move the film has initiated has now ended, and the film continues to introduce lines of action: a love triangle among Peter, his best friend, and the friend's wife; a revolt among a group of convicts working in a factory; battles against various European alliances that keep popping up without prior introduction. Throughout this, Peter remains the same capable, down-to-earth fellow as in the beginning. Indeed, he is so two-dimensional that in Part II, the film's narrative must be rejuvenated by its villain, Peter's son Alexei (played by Cherkasov). Alexei vacillates for some time, allows the Boyars to propose him as the new Tsar, then finally regrets his plotting and is executed by Peter. (Alexei and his pushy wife are forerunners of the functions to be filled by Vladimir and Efrosinia in *Ivan* and there are other superficial similarities that allow little doubt that Eisenstein borrowed certain conventions and incidents from Petrov's film.)

cution by the Boyars, Ivan's private semes would not cause any weaknesses on his part. Once he does set out to do battle with Livonia in Part III, his victory is swift and its outcome certain. This fact confirms that the question of Ivan's ability to conquer Livonia and unify Russia was never really an issue.

By these displacements, the film defines the boundaries that will "contain" the violence it has set in motion. If Ivan fails the tests in any way, the narrative must go out of control; its entire existence is posited on his worthiness. But similarly, it cannot continue without risks, such as the possibility that Ivan will give up, go mad, be murdered, be defeated in battle, or become morally inferior to his enemies. The narrative's development is a series of movements towards and away from these possibilities. Occasionally, when the action draws too near to a confirmation of the presence of such actions and qualities in Ivan, it retreats after displaying a figure of distress.

THE DELAYING MOVES

The staircase construction of *Ivan* consists of those obstacles that delay Ivan in his movement toward his goal (or subsidiary intervening goals). These delays have specific functions in the overall pattern of proving Ivan's worthiness for his task.

The Kazan War

The simplest move in the film is that of the war with Kazan. Although it is the last move to be initiated, it takes up the least time and resolves itself first. The Kazan conflict is also the only major action of the film that does not stem from dedication or opposition to the goal of regaining Russia's ancient lands. Instead, the episode simply involves a fight, thrust upon Ivan by outside forces; the complexity of the Kazan sequence stems from the interweaving of actions from the other moves of the Boyar conflicts and from dealings with the people.

Leaving aside these latter actions which are part of other moves, the war with Kazan functions primarily to confirm Ivan's ability as a military leader. Once again we find a displacement in the narrative structure resulting from the initial overdetermination. The question of whether Ivan can win against Livonia is a forbidden one according to the film's own terms, since Ivan's creation of and identification with the goal is the basis of the entire narrative. The

question of whether he can win against Kazan replaces it by providing an implicit answer to the forbidden question. If Ivan can conquer Kazan, we are confirmed in our necessary belief that he can conquer Livonia. Thus the whole issue of military power can be disposed of by the middle of Part I. Further military matters (the acquisition of supplies from England, the defeats and treacheries of Boyar commanders) may take place outside the action of the plot; these are merely reported in various scenes. Only toward the end of the trilogy does Ivan return to battle.

Even in the Kazan sequence Ivan never contributes physically to the fighting. His position above the battle once the attack begins reinforces the fact that he embodies the goal, which cannot be questioned. Instead Ivan wins the battle through a combination of his own ingenuity and his command of the loyalty of his troops.

The sequence contains three major incidents within the general preparations for battle. In the first, the troops dig tunnels and plant kegs of gunpowder to mine the city; Ivan himself has planned this strategy. A simple opposition is set up: Ivan believes in the mines, while Kurbsky, who is eventually to lead the Livonian troops against Ivan, does not. The last great battle in Part III will pit Ivan against his own devices at Weissenstein Castle. There the Livonians blow up their own fortress with gunpowder in a desperate attempt to catch Ivan in the wreckage as well. Even with his own strategy turned against him, Ivan proves to be superior. The Livonian troops despair and abandon the struggle, but once again Ivan's followers remain loyal and make a great effort in his behalf.

The following scene of Kurbsky tying up prisoners from the city to be killed by the arrows of their own troops is the only action involving the Boyar move, but it occupies an important place in the sequence. Most directly, this opposes Ivan and Kurbsky in their qualities as military leaders, respectively compassionate and cruel. The incident also provides further evidence of Kurbsky's growing dissatisfaction, which will eventually motivate his desertion. In addition, Kurbsky's temper flare-up gives Ivan his first indication of the active Boyar treachery that will come to form such a large part of the action of the film. Ivan's remark, "Some arrows arrive at just the right moment," introduces his seme of suspicion. That suspicion will continue to grow until Ivan at last reigns without friendship, punishing treachery ruthlessly.

Ivan's remark about the arrow leads directly into the next section of the sequence, this time involving the move of the people: Ivan

encounters Alexey Basmanov, who warns him against the Boyars. The people's alliance with Ivan against the Boyars had been set up in the wedding banquet sequence. Ivan had begun by winning the people over with a speech, but Kazan provides the first project Ivan has attempted to carry through with their aid. Basmanov now comes forward, representing the ranks of the common troops, confirming their loyalty. The introduction of Basmanov and his son Fyodor sets up the causes that will later motivate the founding of the Oprichniki; it assigns to them semes of admiration and loyalty that will gain importance in the scene by Anastasia's bier. In the course of the film, Ivan moves steadily away from a dependence on Boyar leaders, coming eventually to base his entire strength on followers raised from the ranks of the people.

The battle itself is brief. As with the film as a whole, the question does not involve any real doubt concerning Ivan's ability as a conqueror. Because the move functions primarily to confirm that ability, it can be short; the Kazan issue virtually never comes up again. It also functions to provide an arena for actions that relate to the other, larger moves of the film.

Political Maneuvers with the Boyars and the People

The two moves involving the conflicts with the Boyars and the shifting loyalties of Ivan's followers weave together throughout the course of the trilogy. This intertwining results from the fact that the unification of Russia demands the elimination of the Boyars, whose feudal status is the ultimate cause of the country's division, and the replacement of the old system with a new base of support, the common people. Historically, the popularity of Tsar Ivan IV in Stalinist Russia was based on the official view that he had systematically attempted to overthrow the old class structure of nobility and replace it with the Oprichnina, a system of government by appointed officials. Eisenstein has taken this basic view and used it to create a structure of oppositions in his film. Yet the common people are not set up as totally admirable and the Boyars wholly villainous. Indeed, functions of betrayal are assigned to characters within both groups; thus Basmanov, who himself suggests the formation of the Oprichniki guards, betrays Ivan in Part III. Ultimately the opposition of the two groups is subsidiary, functioning in the larger pattern of the testing of Ivan and the change of his character during the approach to the achievement of the goal.

The title names the historical personage that is the film's subject,

but in addition, the film concerns the process of Ivan's becoming "terrible" (*grozny*—that is, possessing the ability to inspire fear, reverence, and awe). Ivan takes the nickname himself in the Fiery Furnace play sequence; the moment occurs approximately in the center of the trilogy, halfway through the second part. It marks the turning point in the primary delaying move of the film, the conflict with the Boyars.

Although Ivan remains the embodiment of loyalty to the goal from the beginning of the film to its end, the treacheries of the Boyars and his own followers confront him continually. In order for the idealistic Ivan to succeed, his character semes must undergo a shift in the course of the narrative. The film's structures allow for two forms that this change may take. First, Ivan may become disillusioned with his task, in which case the goal disappears; second, he may become suspicious of all who surround him, rejecting the possibility of friendship. Since we have seen that switching of loyalty is rampant among the characters, Ivan's psychological dependence on anyone would tend to throw the goal into danger. The first reaction would be tantamount to renouncing the righteousness of the goal of unifying Russia. Therefore the narrative dictates Ivan's ultimate choice of the second reaction. In becoming "terrible," Ivan must repudiate his private happiness (his ability to have friends he can trust). Instead, he functions almost wholly in his emblematic public role as the embodiment of loyalty to the Russian cause. Significantly, the image of Ivan as a monk, set up in the earlier scene by Anastasia's bier, comes to the foreground in this central scene. Up to this point, Ivan has allowed his enemies to strike at him through his personal life; now he renounces that personal life, consecrating himself to a monklike existence (at times even playing ironically at being a monk) in order to devote himself wholly to the goal. His only fulfillment can be the attaining of that goal; happiness will no longer come through friends or family.

Boyar treachery is the first causal device to be introduced in the film. Even before the action begins, a chorus sings over the credits:

Black clouds are gathering
Crimson blood bathes the dawn
Cunning treason from the Boyars—
To royal power offering battle.[6]

[6] Sergei Eisenstein, *Ivan the Terrible: A Screenplay*, trans. Herbert Marshall and Ivor Montagu (New York: Simon and Schuster, 1962), pp. 23-25. This song does not appear in the American release prints, but it is in complete prints.

This stanza is repeated several times. After the credits are over, the singing continues over a series of titles:[7]

> The film is about the man/who, in the XVIth Century first united our country,/about the Prince of Muscovy,/who out of separate, discordant, and autonomous principalities created a unified, mighty state,/about the Captain, who spread the military glory of our motherland to east and west,/about the Ruler who, to achieve these great tasks, first took upon himself/the crown of Tsar of all Russ.[8]

This last title serves as a hook into the first shots of the crown itself. The phrase sets up the crown as an emblem of the power by which Ivan will achieve unity for Russia. The coronation is the first movement towards the goal, the first "landing" of the staircase construction: the forces that will create the delays of the narrative are introduced here. The chorus spoke of glory "east and west": the skeptical ambassadors represent the western enemies that Ivan will eventually confront. Their conversation also introduces the Boyars, particularly Efrosinia and Vladimir. By the end of the scene, both the Livonian ambassador and Efrosinia have made threats against Ivan, preparing the way for the whole pattern of delays to come. The first (implicit) defection occurs in this scene: Pimen rebels at paying church revenues to support Ivan's battles, and he joins Efrosinia in plotting.

If Ivan is the embodiment of unity for Russia, Vladimir is a perfect image of the alternative, disunity. By presenting Vladimir as simpleminded, Eisenstein creates the greatest possible gap between Ivan's ideals and the schemes of the other forces of the drama.[9] Ivan's semes of strength and intelligence are appropriate to his position as an image of unity. Vladimir, on the other hand, is not adequate even as an embodiment of the simple feudal system of disunified land ownership that his "followers" desire; as an emblematic character, he implies only chaos. In terms of the proairetic sequence, the Boyars plan to use him as a puppet ruler. In the symbolic schema of values within the narrative, however, he marks the Boyars' goal as completely unacceptable.

[7] Again, these titles are not in the American release prints. The American title declaring that the film is about "a man, not a legend" is not in the original film.

[8] Eisenstein, *Ivan the Terrible: A Screenplay*, p. 288.

[9] This includes King Sigismund. In accepting Boyar help in the first sequence of Part II, he agrees that a weak leader on the throne of Moscow would be in Livonia's interest.

The coronation scene explains the basis of the Boyars' strength, which depends on a lack of strong central political control. But the link between the Boyars and the ancient loss of Russian land appears only in the flashback in Part II. The flashback scene shows how the Boyars exploited Ivan as a boy ruler by forcing him to sign away land to their profit. This reveals that the Boyars in fact originally caused the disunity Ivan seeks to overcome, and they continue to depend on it. Because of this, Ivan must completely defeat the Boyars before he can achieve his goal.

The strategies of the Boyars up to the center point of the trilogy are indirect: they seek primarily to eliminate Ivan by driving him to resign his power or by inducing others to destroy him. Their first plan sets the riot in motion on Ivan's wedding day, thus initiating the narrative move of Ivan's dealings with the people. Ivan easily wins the support of the crowd. The people are represented by Malyuta, who mirrors Pimen by becoming the first character to switch his allegiance *to* Ivan. Although he begins with an assassination attempt, he comes to be Ivan's most enduringly loyal follower (after Anastasia). As the populace takes Ivan's side, the Boyars attempt the new strategy of seeking to employ the threat of war from Kazan to topple Ivan's power. Although the Boyars have not arranged the arrival of the Kazan ambassador, Efrosinia seizes upon it as a weapon she can exploit. But the support of the people provides Ivan with the strength he needs to accept Kazan's challenge.

The Boyars continue to use indirect means to drive Ivan off the throne. When he falls ill, they seek to guarantee that Vladimir will succeed him. Upon recovering, Ivan sets in motion his battles against Livonia by appointing military commanders; his raising of Basmanov to a post of power brings the people's move into play once more. The treachery of the Boyars causes Ivan to rely increasingly upon the support of the common people in the remaining action. Eventually, however, certain of Ivan's new supporters will begin to take over the functions of the Boyars by becoming traitors as well.

I have mentioned that treachery is one of the key motifs of the narrative. In order to maintain the tension created by the Boyars' machinations, the narrative must attach to Ivan a seme of trust. If he were to suspect the Boyars from the start, there would be no reason for him not to get rid of them immediately and then go about the business of battling Livonia. Later we shall see how Ivan's seme of trust mitigates many of the actions he must undertake in later parts of the narrative.

From the start, Ivan has been aware that the Boyars oppose his plans for unifying Russia, yet he remains oblivious to the plots they hatch in each scene. He gives no indication that he connects Efrosinia and Pimen with the riot on his wedding day; similarly he fails to notice Kurbsky's designs on Anastasia. The incident of the arrow at Kazan makes Ivan slightly suspicious, but he seems to forget this later when he assigns Kurbsky to lead the troops against Livonia. The real revelation comes during his illness, when the Boyars refuse to support the heir, Dimitri. Ivan's knowledge of Boyar treachery leads him to make a few arrests and to send Pimen to a less prestigious post as metropolitan of Novgorod. But the scene preceding Anastasia's death establishes that he still places too high a degree of trust in Efrosinia.

Efrosinia is clearly acting as a nurse to Anastasia in her illness; Ivan seems not at all surprised to see her in the bedroom as he enters. He even pauses to put an arm around her shoulder. It is a strange moment for the audience, for we have seen Efrosinia only as Ivan's enemy; the two characters have not been seen in any attitude of intimacy up to this point. But as we will learn in Part II, Ivan still does not associate his aunt with any serious wrongdoing and even has some affection for her. In this scene, the significance of the embrace can be read only through the glances. Ivan's wordless look at Efrosinia suggests an inquiry concerning Anastasia's condition. Efrosinia's mute response and lowered eyes in turn suggest that the patient is not doing well; Ivan reacts to this with a disturbed expression. Efrosinia thus sets up the motivation for Ivan's later failure to suspect poison in Anastasia's death by leading him to believe that her condition is worse than it really is. His lack of suspicion in Part II might lead us to infer her deception retrospectively in this segment.

Anastasia's death is one of the key retardation devices in the narrative. Precisely because he does not suspect the Boyars, Ivan begins to interpret the death as a divine judgment against himself: for the first time he wonders if his cause is just. At the beginning of the scene of his mourning for Anastasia, he asks, "Have I done wrong? . . . Is it God's punishment? . . . Am I right in my heavy struggle?" This is the greatest threat to the goal of unifying Russia that occurs in Part I, and it is at this point that the Boyars come closest to defeating Ivan. Although they do manage several other times to drive Ivan to the brink of despair, the Boyars will eventually

be forced to turn to the impossible task of destroying Ivan physically.

In the mourning sequence, Malyuta summarizes the forces that are gathered against Ivan to defeat his purpose: various Boyar leaders are deserting or suffering defeat, and Kurbsky has gone over to Livonia. Pimen and Efrosinia try to exploit this moment of despair to drive Ivan to abandon his goal. Although they fail in this endeavor, Ivan does temporarily give up his purpose by going into exile in Alexandrov. Once again Ivan's progress towards war with Livonia is checked; he almost seems to take a step backwards by going away to wait for the acclaim of his subjects. Yet the narrative function of the scene is important in the ultimate victory over the Boyars because in forming the Oprichniki guard, Ivan takes the first steps towards changing the very mode of government. The long-range implication of the change is the partial abolition of the feudal system upon which the Boyars depend.

Development and Elimination of Ivan's Private Motivations

The end of Part I sets up the implication that Ivan is now prepared to begin actually fighting in earnest. As Ivan is recalled from Alexandrov, Nepeya's message detailing the arrival of English ships bringing military supplies gives the first indication of concrete progress towards defeating Livonia. The film ends as Ivan prepares to depart for Moscow, apparently with the support of the Boyars, who have come to call him back; they stand in the supplicating crowd below Ivan's window.

Part II continues the suggestion that Ivan is now prepared for the war. The opening sequence is the first to be set in Livonia. We have already heard of Kurbsky's defection to the enemy. The dialogue here sets up much of the action of Parts II and III: the Boyars have gone beyond simply trying to force Ivan off the throne and are plotting to aid Livonia against Russia. As the leader of this particular treachery, Kurbsky will be the only Boyar who survives to participate in the final battles between Livonia and Russia. He tells the court that the Boyars have taken advantage of Ivan's absence to set plots in motion against him, thus motivating the ruthless purge that Ivan will soon begin. The sequence ends with the implication that Ivan's return to Moscow puts him at a considerable advantage over the Livonians, who scatter in confusion at the announcement of the messenger.

Ivan's triumphant return to his own court seems to mark a point

at which he has complete control over the Boyars. By instituting the Oprichnina, a government-owned system of lands administered by appointed officials, Ivan strips the nobility of much of their feudal power. Yet the reaction of the assembled Boyars is one of meek submission; they bow without a protest. Once again Ivan has reached a point where he is in control and might logically begin his Livonian campaign. To prevent this, the film introduces a new delaying pattern, one that brings Ivan and the Boyars into a much more personal, direct struggle for power. With Kurbsky in Livonia and Efrosinia temporarily silenced, Philip once more appears upon the scene as an opponent; he strides in to protest Ivan's formation of the Oprichnina. The assembled onlookers, both Boyar and Oprichnik, depart. The resulting simple confrontation between Ivan and Philip sets up the forces that will now rule the conflict: Philip's struggle on behalf of the Boyars versus Ivan's desire for personal friendship.

The seme of loneliness that the narrative now assigns to Ivan creates a fresh potential for the failure of the goal. Once again there is no question of Ivan's failing through lack of power, as his Oprichniki give him the ability to defeat his opponents. The potential failure must originate with Ivan himself yet must not be of a nature that throws into question his worthiness as the symbolic embodiment of the goal. As a result, the seme that threatens to impede Ivan's ability to carry on is a positive one: loneliness, the desire for friendship. But such a seme *is* a threat to the goal because it still posits a split between Ivan the private person and Ivan the public emblem of unity. The simple act of accepting a personal relationship with a character who is not loyal to the cause threatens the cause itself. Only later will Ivan dedicate himself wholly to the goal, submerging personal feeling in the desire to reach the sea. As we shall see, this gradual shift in Ivan's emblematic status—the gradual unification of personal and symbolic semes—is embodied to a large degree in the style of the film, particularly the mise-en-scene.

The split between Ivan's public and private roles depends on the first major use of the device of psychological motivation. Up to this point, we have never seen Ivan falter as a result of any posited psychological inadequacy to the task. In Part I, he had fought battles and encountered treachery, and his inertia after Anastasia's death had resulted from momentary doubt about the validity of the goal. But upon his return in Part II, he declares himself to be in complete physical and political control and ready to carry through his task.

His only block is his own loneliness. Here psychological motivation functions in the film as a threat. In this, *Ivan* differs from most classical films, where psychological motivation is a staple device. In *Mary of Scotland*, for example, Mary's duties as queen are a stumbling block to her personal happiness; she too faces loneliness, separated from her lover, Bothwell. Consider the following exchange between the two:

> MARY: What's my throne? I'd put a torch to it for any one of the days I've had with you. They've been so few.
> BOTHWELL: Aye, but wonderful days, Mary. Twenty wonderful days. Better than a lifetime.
> MARY: Take me with you.
> BOTHWELL: No, no, you're queen of Scotland. That's your destiny.

The primary interest of the film lies in Mary's happiness. At her death, she uses this same argument—that a few days of love are better than a lifetime alone as queen—to declare her triumph over the lonely Elizabeth I.

Ivan eventually must expunge the effects of psychological motivation from its protagonist. Again, the model for the film's structures is closer to the epic: Ivan has much in common with Achilles, for example. In the siege of Troy, the Greeks are clearly predestined to win because *without* Achilles they are evenly matched with the Trojans. Achilles is the emblem of their superiority; there is no doubt from the beginning that he is the perfect warrior. As with Ivan, we simply do not question this initial ability. But Achilles withholds himself from the battle because of his unfortunate predilection towards psychological motivation in one thing only—his quarrel with Agamemnon over the slave woman. Here, and in *Ivan*, psychological motivation is not the basis of the character but only a temporary weakness—a weakness necessary in the delaying of the narrative's progression. (If Achilles went into battle with the others on the first day, where would the plot be?) We can see that the Stalinist censors zeroed in quite correctly on the difference between the two completed films when they gave the protagonist's psychological weakness as the justification for their ban on Part II.

The flashback that occurs in this scene is important to the shift towards psychological motivation. Virtually any departure from chronological order in the creation of a proairetic chain creates a significant structural moment; in *Ivan*, this departure is particularly

important because it is the only flashback in the film. The anecdotes Ivan tells from his childhood play a large part in motivating his new seme of loneliness. If the flashback were not present and Ivan were suddenly to fall on his knees begging for Philip's friendship, the viewer would be jarred; by inserting a causal pattern (the poisoning of Ivan's mother, his lack of control over the earlier Boyar treachery) into the scene, the despair and wavering of Ivan in the first half of Part II become more acceptable. In addition, the flashback provides a way in which the scene may linger over the insertion of the loneliness seme into the narrative structure, marking its significance in the future conflict.[10] Similarly, the scenes that show Ivan as a defenseless child provide a parallel image to the new weakness of character that has appeared in the grown man; we are allowed to sympathize with this weakness because we know its origins.

And this sympathy is necessary because in the next scene another new seme is introduced to balance the positive one of loneliness. Here Ivan begins for the first time to exhibit a madness that will crop up again in a few other scenes in this section of the film and again in Part III.

Like the loneliness seme, the madness seme is associated with Ivan's inability to proceed with the ruthless measures he must use to eliminate Boyar treachery. He retains his trust in his relatives and the other Boyars as long as he can, reluctant to admit that treachery has spread so pervasively among those near to him. Thus Malyuta must urge him to go ahead and execute the traitorous Kolychev family members before Ivan finally agrees to it. But the conflict between loyalty to the cause and desire for reconciliation leads to a short period of madness and self-doubt. After Malyuta takes the actual task of execution onto himself and departs, Ivan again questions the righteousness of the goal: "By what right do you set yourself as a judge, Tsar Ivan? By what right do you wield the sword of justice?" Once more the Boyars have driven Ivan to the point of despair, but they do so at greater and greater expense to themselves; Ivan's final attack of conscience will come over the

[10] Loneliness is not the only seme involved in the flashback. The second portion of the story Ivan tells helps set up the private/public split. The young Ivan declares firmly at the end that he will reign alone, "without the Boyars." In the ensuing action in the "present," Ivan goes back on this declaration by giving in to Philip.

virtual extermination of the Boyar group in the slaughter at Novgorod in Part III.

In the throneroom scene and the following conversation with Fyodor in Anastasia's bedroom, followers from the common people urge Ivan to deal with the Boyars. Fyodor hints at Efrosinia's guilt in the poisoning of Anastasia. But even at this point, Ivan refuses to believe in Efrosinia's treachery, although the narrative emphasizes his growing suspicion. Trust is another positive seme of Ivan's character because it helps create his symbolic worthiness for the task of unifying Russia. Yet it is also a detriment, since it means Ivan is often one step behind his enemies. He is unaware of Kurbsky's designs on Anastasia and the throne; he fails to realize Efrosinia's treachery and so accepts the poisoned cup from her at Anastasia's sickbed; he allows Philip political concessions in return for friendship without realizing that Philip will attempt to halt his efforts on behalf of Russia. Ivan must *come to suspect*, to realize the treachery that surrounds him. The film must transform the positive seme of trust into a seme of suspicion without attaching negative connotations to that suspicion. This is achieved by adding moderating agents to create the suspicion: Ivan doesn't *become* suspicious—he is *made* to be suspicious. His followers, Malyuta and Fyodor in some scenes, Basmanov in others, point out treacheries to him. Thus the movement of Ivan towards becoming "terrible" is motivated as an inevitability thrust upon him. Even in the midst of his suspicion and cruelty in the latter part of the narrative, Ivan is able to retain an innocence conferred by his reluctance.

This innocence is deemphasized, however, in the scene of the Boyars' executions, where Malyuta summarily reads the condemnation of the three men from a scroll and beheads them. The motivation for this action was provided earlier: during the scene at the Livonian court, Kurbsky mentioned that the Kolychevs had been sending messages to Livonia. To a certain extent, Eisenstein is also relying upon his audience's awareness of the historical background: one of the conditions Ivan demanded and received when he agreed to return to Moscow was the right to punish whomever he felt had contributed to making his exile necessary. Thus in executing the Kolychevs, Ivan is going back on his word to allow Philip to intercede for accused individuals but is otherwise carrying through his previous (assumed) agreement with the Boyars. Such reliance upon historical facts provides a minimal motivation for the executions. But by greatly deemphasizing this motivation, by limiting

it to an implicit historical background construct and a brief mention in an earlier scene, the film throws the stress onto the cruelty of the executions. The end of the scene also emphasizes the conflicting semes of Ivan's character at this point. Horrified at the sight of the bodies of the dead Boyars, Ivan begins to cross himself, then finishes the gesture by pointing at them and saying, "Too few"; the apparent regret contrasts with the implied madness.

The introduction of this hint of madness into Ivan's character comes at almost the same point where the Boyars begin to appear in a somewhat more sympathetic light. The execution scene stresses the humanity of the condemned men and the horror of their deaths.[11] For the first time the Boyars appear as victims. The next scene in the Boyars' chapel continues and intensifies this portrayal. Philip grieves over the bodies of his relatives. His position is not the same as that of the other Boyars, as he has not been a party to their earlier schemings and treacheries. By departing to a monastery early in the film, he had chosen to remove himself from a situation in which he might be faced with the necessity of betraying Ivan. His arrangement with Ivan to intercede for those whom Ivan accuses bespeaks a desire to help the Boyars without using treacherous means. Now the betrayal seems to have reversed itself, with Ivan going back on his word. Pimen and Efrosinia seem also to be genuinely grieved; the latter is in tears as she demands justice against the Tsar. The decision Philip makes to try to crush Ivan "with the weight of the Church" is no longer a plot connived at by traitors but a retaliation for a wrong.

Why this sudden shift in function for the Boyars and Ivan? These scenes lead into the Fiery Furnace play, the sequence in which Ivan declares that he will become "terrible." This turning point in the plot development needs considerable motivation. Since Ivan embodies the goal of unifying Russia, the possibility that he might become a treacherous, unjust character creates a great threat to that goal. However, the seeming injustice of Ivan's execution of the three Boyars is an illusion; the Boyars really are guilty of the murder of Anastasia and the betrayal of Russia. We have come to doubt Ivan only because he doubts himself. The introduction of madness into his character results from his fear that he is wrong, a fear that in turn invites us to question him.

In the dynamics of the narrative, this new shift introduces a

[11] We shall see how in our examination of the stylistic structure of the scene.

section of the film that comes dangerously close to allowing the underlying violence to overcome the restraining forces. The basic opposition of the Boyars to the unity of Russia makes them impossible as positive figures. Previously Ivan had supplied the stable, positive basis of the narrative. Now a new balance is set up between conflicting semes in Ivan's character: his previous determination becomes opposed to his new wavering, his trust opposed to suspicion, and his justice opposed to cruelty. Any one of these traits, if carried to an extreme, could destroy the earlier goal that has formed the core of the narrative progression. Much of the rest of the trilogy keeps these forces at an uneasy balance, and, as we shall see in examining Part III, at one point, comes very close to violating its own structures.

The sequence of the Fiery Furnace play turns the tables once more in Ivan's favor. As the Boyars confidently proceed with their presentation, Ivan enters the cathedral. Joking with Malyuta, he is once again declaring his trust in Efrosinia, reasserting this positive seme of his character; this foregrounds all the more strongly his discovery in this scene that Efrosinia did in fact kill Anastasia. Her guilt cancels his. Self-doubt is left behind, and Ivan dedicates himself wholly to the goal once more, even while realizing at last that it will involve the elimination of the Boyars. Other characters have made Ivan suspicious, and the Boyars themselves confirm that suspicion. The fact that his own aunt betrayed him makes Ivan realize that he must give up all hope of reconciliation, of friendship. His private and public ambitions have become one.

Direct Confrontation with the Boyars

Once Ivan has renounced all possibility of alliance with the forces hostile to his cause, the indirect struggles that have thus far occupied the film's proairetic chains become impossible. One force, for or against the goal, must triumph by destroying the other. Efrosinia formulates this choice in the next scene, in her chambers: "There is a solution. Just one, the last—kill the Tsar. Either kill the Tsar or lay our own heads on the block." This scene begins the basic movement of the second half of the trilogy, a series of direct confrontations that constitute the long process of resolving the hermeneutic and proairetic lines set up in the first half.

Efrosinia's line leads to a reaction from Vladimir that in effect reintroduces him into the action; at this point the semes associated with his character change. Previous to this scene Vladimir has ap-

peared only as a foolish and laughable figure. In Part I, he barely speaks; his only words echo the toast to the bridal couple at the wedding banquet, where he shouts with his mouth full. Outside Ivan's sickroom, he mindlessly catches flies and seems not to comprehend the implications of the procession of priests that solemnly passes him. Generally his only actions come as the result of Efrosinia's manipulation: she pushes him forward as Ivan seems about to die and leads him out as the "Tsar" after Ivan's apparent death. All Vladimir's early scenes combine to convey an impression of a completely childish character with no will of his own.

Vladimir is systematically eliminated from the early scenes of Part II, although his silliness and passivity are recapitulated briefly in the credits sequence (the flycatching shot from Part I and two close shots of him looking on at Ivan's coronation). Then he disappears until the Fiery Furnace play, being significantly absent from those scenes in which the rest of the Boyars, including Efrosinia, are placed in a relatively sympathetic light. His first appearance in the action of Part II comes in the scene of the Fiery Furnace play, where his only action is his gleeful response when a child in the audience mistakes Ivan for the "terrible, pagan Tsar" mentioned in the play. Ivan quickly squelches this gesture with a look. Yet even though Vladimir remains ineffectual in this scene, his reaction does indicate for the first time that he has some understanding of what is happening in the conflict between the Boyars and Ivan, thus preparing the way for his larger part in subsequent action.

In the shot of Vladimir that follows Efrosinia's line about the necessity of killing Ivan, he speaks his first line in the film that does not simply mimic what someone else has said, "But who will do it?" as if expecting to have the task conferred upon himself. After Pimen and Pyotr have gone out, Vladimir questions his mother about why she is "sacrificing" him. Here it becomes apparent that he knows the consequences of the Boyars' plans for himself. He has some of the insight of the traditional "wise fool" figure, realizing that the course his mother has embarked on will end in his destruction, something that has not occurred to Efrosinia herself.

As had happened with the Boyars earlier in Part II, Vladimir suddenly appears in a sympathetic light. Because he must play the role of a true victim in his death, he was necessarily excluded from the scenes in which the other Boyars were only apparently victimized by Ivan. In those scenes, the Boyars were only victims as a result of treacherous actions they themselves had instigated. Vladimir, on

the other hand, is not the worker of his own downfall on this moral plane, however much he may cause it through his foolish actions at the feast.

The scene provides a brief repetition of the pattern of the first half of Part II, but in reverse. The earlier scenes had examined Ivan's character motivations; ultimately the Fiery Furnace scene confirmed Ivan as the savior of Russia. Now the scene of the plotting among the Boyars provides a set of motivations for *their* actions. Like Ivan, Efrosinia has her private reasons for her side of the fight: part of her general self-interest in eliminating Ivan is her intense desire to see Vladimir on the throne. The fact that Vladimir does not want to be Tsar eliminates any possible justification for Efrosinia's actions, since she cannot be said to be acting from a wish to achieve another character's desires.

Up to this point, Vladimir has been aware that Efrosinia wanted to make him Tsar, but the idea that this will be accomplished through a killing spurs him to resistance. The lullaby Efrosinia sings provides the moment of discovery for him, as the Fiery Furnace play had for Ivan. As she begins the song, it seems to be a straightforward little narrative about an animal, a typical child's song; the beaver is the only figure in the first verse. Only the second verse reveals that the subject of the poem is really a beaver hunt.

Jean-Pierre Oudart has pointed out that the song's significance involves an ambiguity.[12] Is the beaver Ivan or Vladimir? Drawn into the story, Vladimir sympathizes with the beaver. Yet Efrosinia's glee at her little allegory clearly indicates that she associates the killing of the beaver with the killing she has planned for Ivan. The beaver's black fur meant to adorn "Tsar" Vladimir is already worn by Ivan—both the crown itself and his huge black cloak are of fur. Vladimir becomes horrified when he realizes the implication of the song: Efrosinia is still determined to kill Ivan and make Vladimir take his place.

Oudart connects the ambiguity of the song with the later "hunt" enacted in the cathedral. There the uncertainty about the significance of the beaver is worked out in earnest. Having set out to kill Ivan, Efrosinia's "hunter" kills Vladimir instead. As the song is sung, Vladimir cries out as he discovers the beaver's fur will be used "to array Tsar Vladimir." His fears about becoming Tsar are

[12] Jean-Pierre Oudart, "Sur *Ivan le Terrible*," *Cahiers du cinéma*, no. 218 (March 1970), p. 16.

confirmed by the association of the office with killing. In the cathedral, Ivan makes Efrosinia's song come true. The fur-trimmed crown does sit on Vladimir's head: he has been forced to his death because he "is" the Tsar. The irony of the lullaby is underlined by Efrosinia, who sings it again while seated on the floor by Vladimir's body. As the guards take the body away, she continues to hold the crown itself.

The central event of the latter half of the scene of the Boyar plotting in Efrosinia's quarters is Vladimir's discovery of and revulsion from his mother's ruthless schemes. In this way, he goes through an experience paralleling Ivan's realization in the previous sequence that Efrosinia had killed Anastasia. Both have moved from an initial position of trust to one of confirmed suspicion. Ivan recoils from his aunt and decides to become "terrible," initiating a new direction for the entire second half of the trilogy. Vladimir has a similar moment, rushing away from Efrosinia's attempted reassurances and burying his head in his hands. At this point, Malyuta enters to call him away to a feast with Ivan; the empty winecup Malyuta brings confirms not only Ivan's knowledge of Efrosinia's guilt but also his determination to act upon this knowledge.

The parallel between Ivan and Vladimir in their discoveries concerning Efrosinia's actions provides compositional motivation for the new relationship set up in the sequence of the feast leading into the scene of Vladimir's death. These two characters have previously had little to do with each other; now they unite for a brief time as victims of Efrosinia's schemes. Clearly, a simple compositional function of the sudden parallel between Ivan and Vladimir is to motivate the latter's revelation of Efrosinia's assassination plot. The Vladimir of earlier scenes would not have done this, but his new semes allow him to get drunk, mistake Ivan's blandishments for true friendship, and express his lack of desire to go along with his mother's plans for him. But beyond this, the parallel serves to cement the many associations that combine in the final substitution of Vladimir for Ivan in the procession to the cathedral.

The most basic requirement of this sequence is that Ivan must not be killed. In addition, the *way* in which he is not killed must work to the detriment of Ivan's would-be assassin (so that the narrative will progress). Vladimir is, as it were, the sacrificial lamb caught in the meshes of these necessities. Once he has discovered his mother's intent, he wishes to prevent Ivan's murder. But since either Ivan or the Boyars must ultimately be destroyed, Vladimir's

desire to intervene makes him come forward from his passive role and step inevitably into Ivan's place as victim.

Because Vladimir has a basic innocence, Ivan cannot be the one to bring about his death. If Ivan were to kill Vladimir he would violate his own position in the film by tainting himself with treachery, placing himself in the same sphere with his enemies. But there is no need for Ivan to kill. He simply turns the Boyars' own methods back upon themselves—he strikes indirectly, as they had through the earlier scenes of the trilogy. Efrosinia had tricked Ivan into giving Anastasia the poisoned cup "with his own hands"; now Ivan uses the Boyars' own agent, Pyotr, to kill Vladimir.

The specific form the retribution against the Boyars takes results from Vladimir's revelation of the assassination plot, but its status as a just action results principally from Efrosinia's earlier poisoning of Anastasia. The punishment must fit the crime. Ivan cannot merely kill Efrosinia; she must suffer a great emotional loss, as he had. Vladimir's death will be that loss, and the manner of that death is made fully appropriate to its purpose. In order to accomplish this, the feast scene sets up a number of parallels between Vladimir and Anastasia.

Many of the parallels between the Part II feast and the wedding banquet involve similarities of mise-en-scène, and we shall deal with them in a discussion of stylistic structures; suffice it to say at this point that there are a number of elements repeated from scene to scene. In the feast, Ivan drinks amidst a large group with his companion, now Vladimir rather than Anastasia. Ivan proceeds to give Vladimir too much to drink, inducing him to reveal the Boyars' plot; this leads to his death. The parallel to Anastasia's murder is apparent; although in a different fashion, both deaths are brought about by a drink, in each case given to the victim by Ivan, yet each death is actually brought about by Efrosinia. By manipulating the circumstances so as to cause Vladimir's death at the hands of his own mother, the text permits Ivan to avoid guilt while still meting out punishment to Efrosinia.

The feast, with its parallels to the wedding banquet, ends with an abrupt transition to the mock coronation. Here the narrative switches tactics to emphasize Vladimir's strong parallels to Ivan; thus the dressing of Vladimir in Ivan's clothes does more than simply prepare the way for the deception of Pyotr. At this important moment before Vladimir's death the film brings forward more strongly than ever his ludicrous inadequacy for the role of Tsar.

Vladimir's continued existence as a potential claimant to the throne is another threat to the goal of Russian unity. The scene's comparison of him with Ivan points up another reason why he must be disposed of. The basic similarity arises from the relative political positions the two occupy. We learned from the flashback that Ivan had reigned as a child monarch, first under the guidance of his mother, Helena Glinskaya, then under the direction of the Boyars after they had poisoned her. The Boyars had exploited Ivan's youthful weakness to enrich themselves by selling off Russian land, creating the situation he now struggles to overcome. Now they have sought to carry out a similar plot. They poison Anastasia just as they had poisoned Ivan's mother. By removing his only support, they had hoped to reduce him once more to a position where they could control his reign. When this proves impossible, they decide to eliminate the strong Tsar and replace him with a figure that will be a puppet ruler as the young Ivan had been.

The mock coronation contains some echoes of the first scene of the film. Perhaps more directly, it relates to the scene of the young Ivan on his throne in the flashback. The pseudorespect that the Boyars show Ivan in that scene parallels that of the Oprichniki and Ivan as they bow low to Vladimir. The latter's drunken state and ingenuous pleasure at his apparent rise to power mark his childishness and inappropriateness for the throne, even as the young Ivan's small size had been the sign of *his* inadequacy. Yet in another way their situations are the reverse. Ivan the child had quickly rebelled against his tormentors, having the most important among them arrested; even as a boy he had displayed his ability to reign. Vladimir, on the other hand, is a man; yet that very fact makes his lack of capacity to be Tsar all the more ludicrous as he sits on Ivan's throne.

The associations with Ivan and Anastasia that cluster around Vladimir in the feast and processional scenes are central to the climax of Part II, the point at which the conflict between Ivan and the Boyars comes to a head. Vladimir is the first to die, but his followers will soon meet the same fate. Appropriately, this scene, which gathers together so many threads of earlier action, is prolonged by an intricate combination of songs, dances, and squabbles between Ivan and his supporters, followed by the long procession through the cathedral. Lines of action are repeatedly interrupted and drawn out. Ivan's conversation with Vladimir, which finally leads to the latter's revelation of the Boyar plot, takes place in

sections; Fyodor's song interrupts them twice, and the talk is also delayed by the arrival of the swan platters. After each such interruption, Ivan and Vladimir resume their discussion as if no time had elapsed, replying to statements or questions that preceded the interruption. A further retarding device is the mock coronation itself, which inserts the extended "homage" of the Oprichniki into the flow of action. Finally, the procession into the cathedral proceeds at a slow pace, with inserted shots of all the onlookers prolonging the suspense. After the murder, there is a further pause in which Efrosinia mourns, brokenly singing the lullaby again. Here the action has come to a virtual standstill; even Ivan's gesture regarding Efrosinia's fate remains unresolved until we find out in Part III what has happened to her. Ivan's pardoning of Pyotr sets up the latter's change of sides between Parts II and III, but otherwise the last moments in the cathedral are a hiatus after the resolution of the Boyars' attempted treachery.

A brief incident in the feast scene reintroduces the move concerning Ivan's dealings with the people. The Oprichniki have not played a prominent role in the action of Part II. Although they follow Ivan about, they serve primarily as a support to him in his dealings with the Boyars (as when Fyodor reveals that Anastasia had been poisoned). Now Basmanov has a brief squabble with Ivan, protesting that the Tsar is favoring Vladimir over his own loyal supporters. Ivan replies that Vladimir is his relative, while the Oprichniki are simply his servants: "The ties of blood are sacred." Malyuta taunts Basmanov about "catching the Boyars' sickness"— wanting to be rich and powerful. The function of this exchange is primarily to motivate Basmanov's actions in Part III, where the function of betrayal shifts and splits, with the Boyars attempting to join Livonia. The Basmanov family then replaces Efrosinia and Vladimir as plotters against Ivan. The quarrel also introduces a new split between Fyodor and Alexei; their father-son situation will come to parallel the earlier mother-son situation between Efrosinia and Vladimir, with each parent pushing the reluctant son to betray Ivan.

Ivan's speech in the last few shots of Part II prepares the way for the new concentration on the problem of Russia's outside enemies. He will eventually discover that internal troubles are far from over, but now they will come from the people. With the failure of their assassination plot, the Boyars will cease all direct or indirect attacks on Ivan as an individual. The remaining Boyar followers will con-

centrate upon supporting the Livonian cause. Because of this, the Boyar and Livonian moves begin to merge. The action of Part III involves a gradual elimination of Ivan's enemies. The film becomes far more savage here, with multiple killings occurring or reported in every major scene.

Intensification of Treachery and Madness

The Boyars' conflict with Ivan has been the main source of the narrative's violence. As they are eliminated, the narrative reverts to the original conflict of winning the way to the sea. But since the hermeneutic of Ivan's ability to win is not a question that can be posed as such, the narrative must struggle harder than before to avoid winding down prematurely. As a result, the plot begins to push Ivan's character further, taking more risks of allowing him to destroy his symbolic status in relation to his goal. This play with Ivan's character leads to the greater extremes of Part III. As we shall see, some scenes must struggle considerably to keep the film from spinning out of control, and one scene of the story is even eliminated from the plot.[13]

One characteristic of *Ivan* seems to be that it becomes progressively more peculiar. Part II is somehow stranger than Part I, and the script of the last part is more peculiar still. And I suspect this is not simply due to the fact that it only reached the script stage. Again and again Part III overturns our expectations about the relation of the proairetic chains to the central hermeneutic concerning the unification of Russia. Between the elimination of the Boyars in the first third of the work and the battles with Livonia in the last third occur the odd scenes in which Ivan's followers, the Basmanovs, betray him. Eisenstein also introduces a character in the first scene, the German Henryk Staden, whose function also presents unexpected twists. Sent by Kurbsky to infiltrate the Oprichniki as a spy, he in fact never provides the enemy with any information about Russian strategy, remaining simply an opportunistic follower of Ivan. The film also directly presents the dealings with England instead of having characters report on them: for example Part III includes a scene of Queen Elizabeth conferring with the Livonian and Russian ambassadors. Finally, for the most part, the strategies and actual battles virtually always show Ivan with the upper hand

[13] For those readers unfamiliar with the script of Part III, I have included a summary of its action in the appendix.

right from the start. Except at the end of the film, when he is in danger of being caught in the explosion that destroys Weissenstein Castle, there is no question that Ivan is easily winning the war.

We have seen how the question of restoring Russian unity was displaced onto the character of Ivan. Yet by the end of Part II, Ivan has passed through his series of tests. He has declared himself "the Terrible," indicating his entire identification with and dedication to the goal. He has likewise proved indestructible by indirect and direct means. In Part III, Ivan's enemies acknowledge this fact by shifting their tactics. Now, instead of attacking the Russian state (its unity) through Ivan, they begin to attack Ivan through Russia itself. With the acknowledgment of Ivan's superiority comes envy, an important motivating device in Part III. The principal figures of betrayal, Kurbsky and the Basmanovs, all gain new semes or further develop old ones; they wish to supplant Ivan not because they disapprove of his actions but because they wish to be like him. As a result, there is a concentration on the inferiority of Ivan's enemies; their despair, miscalculations, and foredoomed strategems occupy much of the action in this last section of the trilogy. This concentration is paradoxical in an "epic" battle narrative, where we might expect the film to create suspense—a hermeneutic—by emphasizing the protagonist's desperate situation. In *Sergeant York*, for example, York and his men are surrounded and vastly outnumbered behind the German lines. York's victory and later fame result from his unexpected slaughter and capture of a large group of German soldiers. But in *Ivan*, the Russian side is never in an inferior position.

Because of the increased emphasis on the struggle over Russia itself rather than on the conflict with Ivan personally, Part III returns to a concentration on geography as it was first introduced in the coronation speech with the setting up of the sea as emblematic of the goal. The restricted action of Part II, which takes place mainly in the Kremlin, expands in Part III, where a wide variety of locales is introduced. Short scenes in Livonia, England, and Russia follow each other: Ivan's marches and battles concentrate on swift movement from one spot to another. This return to a renewed interest in geographical locale leads inevitably to the moment that must bring closure, the arrival at the sea.

The opening scene of Part III begins the pattern of a struggle between hatred of and admiration for Ivan. Kurbsky speaks, alternating between two trains of thought. He begins by acknowledging Ivan's wisdom: "Truly, truly dost thou act, Ivan! Without blood

thou couldst not accomplish thy task." Yet in dictating a letter to Ivan he rages, "Savage beast, now even the very graves shall call to Heaven for vengeance." Kurbsky then returns to his previous meditations: "On the throne I, too, would have acted so" (pp. 208-209).[14]

Although he is one of the Boyars, Kurbsky has been set apart from them during the earlier parts of the narrative. Initially he had seemed to support Ivan. His reaction to the coronation speech was apparently favorable: he was seen listening attentively and smiling. The later moment of his temptation by the Livonian ambassador outside the wedding banquet introduced the motif of envy, and the wedding banquet itself makes it clear that Kurbsky desires everything Ivan possessses, including Anastasia. Even in the scene where the Boyars plot to kill Anastasia, they refer to Kurbsky as "the Tsar's best friend," since he had kissed the cross for Dimitri. Yet during this same scene, Kurbsky is on his way to Livonia. Through this series of shifts and betrayals, Kurbsky comes to be a sort of sounding board whose weaknesses emphasize Ivan's strengths. He is not Ivan's opposite, as is Efrosinia, who seeks not to replace Ivan but to eliminate him. Kurbsky, on the other hand, attempts to imitate Ivan, and it is the very process of his failure that reinforces Ivan's emblematic status. If Ivan is superhuman, Kurbsky provides the human scale against which he is measured. I have mentioned that Kurbsky's role in the Kazan sequence is to be shortsighted in the matter of the gunpowder and cruel in the matter of the prisoners. In each of these qualities he takes a position opposite to that of Ivan. Again in that scene, Kurbsky expresses his envy of Ivan but continues to fight for him, planting the standard on the tower of Kazan; later Ivan's followers from the common people, Malyuta and Pyotr, will raise the standard over the Livonian castle. Unlike Kurbsky, they have realized that their loyalty is to Ivan as an emblem of the cause rather than simply as a figure of personal political power.

The fact that Kurbsky longs precisely for that personal power comes forward in the scene of Ivan's illness. There, given the choice between supporting the Boyar cause by kissing the cross for Vladimir or giving his pledge to Ivan's heir, he rejects both by trying to seize power on his own. When this attempt fails, he realizes that

[14] All quotations from Part III are from the Eisenstein screenplay and will be cited parenthetically in the text.

sooner or later someone will reveal his treachery to Ivan. Just as the failure of the Boyars' assassination plot ends their possibilities for dealing with Ivan directly, so Kurbsky can have no second chance at seizing the throne. His departure for the Livonian war soon results in the news of his defection. Thus he becomes the chief device for linking the parallel motifs of foreign and domestic treachery: through the repeated scenes of Kurbsky in the Livonian court, the film prepares the way for the shift in Part III to the battles between the two countries. The Livonian sequence that begins Part II reestablishes the struggles between Kurbsky and Ivan as involving *the same kind* of power. Ivan had taken the crown in Part I; now Kurbsky receives a chain of office in a ritual that contains echoes of the earlier sequence. After the Livonian court scene, the bitter struggle of the Boyars against Ivan banishes Kurbsky from the rest of Part II; Philip substitutes for him as an opposing figure, one who is more selfless in a dedication to the Boyar cause.

But Kurbsky's function in the Livonian struggle goes beyond simply the forming of a link between proairetic chains; he provides an extremely economical way to characterize the nature of that struggle. Without Kurbsky, Ivan would simply wage his war against a country that resists having him reclaim certain territories. By presenting the corruption of Kurbsky by the Livonians, the narrative creates another displacement: Kurbsky's treachery broadens out from him and becomes associated with the Livonian forces in general. We do not in fact see much of the Livonian side of the war except as it relates to Kurbsky. Without detailing exactly what his position is, the film shows him organizing strategies and dispatching the messages upon which the Livonian cause will depend. The traps the two sides set for each other are sent in the form of messages, not between Ivan and Sigismund, but between Ivan and Kurbsky.

In keeping with the film's greater emphasis on geographical oppositions, Part III now sets up Pskov and Novgorod as parallels to the cities Ivan wishes to win back. A Boyar messenger enters to tell Kurbsky that these two cities are ready to defect to Livonia and join the war against Ivan. In Part I, Ivan spoke of Riga, Revel, and Narva, the port cities on the Baltic; their names became metonymic for the regaining of all the lost Russian territories. Now the Livonians seek to gain the allegiance of two of Russia's great cities in order to destroy Ivan's hope of ever reaching the sea.

The Boyar move, sometimes in combination with the central move of the struggle with Livonia, has occupied most of the action

since the opening of Part II. Now the narrative reintroduces the move of Ivan's relations with the people. I have mentioned that virtually every character changes allegiances during the course of the plot. In the second sequence of Part III, Pyotr, the assassin from Part II, follows Malyuta's pattern, becoming the loyal servant of the man he had intended to kill. As Pyotr gives information about the three who had forced him into the deed, Ivan once more grieves over the fact that his friends, Kurbsky and Philip, have betrayed him.

One of the distinctive features of Part III is a change in Ivan's character functions. Up to this point, he had continued to gain new semes or develop old ones. Here, however, Ivan's character has been altered to the point where it coincides exactly with his emblematic function in relation to the unification of Russia.[15] Now semes that had earlier become attached to his character recur, often in exaggerated form. He exhibits his old qualities of remorse, grief at treachery, and "mad" cruelty. Upon hearing of Kurbsky's part in the assassination plot, Ivan asks: "Andrei . . . Andrei . . . What did not suffice thee? . . . Or didst thou covet my Royal cap?" (p. 216), recalling his similar line by Anastasia's coffin when he first received the news of Kurbsky's defection. The script's description of his grief also recalls earlier scenes: "He has let his head fall crash onto the table. . . . Struck to the very heart by the treachery of his friends, his head supported on the table, Ivan sits" (p. 217). This repetition revives the positive seme of trust assigned to Ivan in the first half of the film. The later scenes of Part II had somewhat eroded these semes; Ivan himself had been forced to betray the naive Vladimir. Now the film must remind us that Ivan is being forced to see the treacheries of others against his will and to punish them. Upon entering the cathedral in the Fiery Furnace sequence, Ivan had remarked of Efrosinia: "God grant it was not she who was guilty," and this has been his general attitude toward all his betrayers.

A combination of this generous faith with cruel punishment carries through a comparison that occurs repeatedly in the course of the film: the heavenly Tsar and the earthly Tsar. Like God, Ivan functions as an absolute judge; once the betrayer's guilt is certain, he acts ruthlessly. Since there is no one above Ivan to decree *his* guilt, the acts he commits carry their own form of punishment—

[15] This occurs not through any growth process but through a stripping away of the private semes of his character.

remorse. For Ivan, remorse is not a sign of real guilt; rather it has a purging effect. Each scene in which Ivan questions the righteousness of his course leads to a renewal of his determination. This pattern will intensify in Part III.

The narrative also sets up a series of actions that will establish Ivan as above judgment. In this second sequence, the character of Eustace is introduced; he had appeared in the scene of the conversation between Ivan and Philip in Part II but had remained a shadowy figure. He continues to remain a mystery in this scene by revealing apparently contradictory semes. Upon first hearing the news that Pskov and Novgorod have planned to defect, he shouts, "A *lie!*" (p. 217), but when Ivan looks suspicious, he quickly proposes the cruel plan of marching against the city. Later scenes will reveal that Eustace is in fact one of the Boyar family of Kolychevs. Although he acts as Ivan's confessor and is apparently in a position to judge Ivan's actions, in actuality he uses the post to betray Ivan.

Once again Ivan adopts a plan that is suggested by another, thus avoiding in part the guilt of having conceived the slaughter of the townspeople himself. His decision leads into one of the strangest sequences of the plot, in which he leads his troops on a secret march toward Novgorod; in order to prevent any possibility of a message getting through to warn the city, he has every living thing in the path of the army killed. The indiscriminate slaughter of birds, animals, and people creates the first image of wanton cruelty in the trilogy. The second half of the scene takes place in Pimen's rooms at Novgorod, where he and the nobility await the signal from their spy in Moscow. Instead of the spy, Ivan arrives and arrests Pimen.

Ivan's cruelty in these scenes presents a pecular problem for the narrative. By almost any historical interpretation, the march against Novgorod was the low point of Ivan IV's career; in a pro-Ivan portrayal like Eisenstein's, his choice to include it at all seems somewhat mysterious (particularly since elsewhere in the film he has taken considerable liberties with the historical accounts). Yet an examination of the sequence's function in the trilogy's overall narrative dynamics helps explain its presence. The three parts contain a succession of threats. In Part I, enemies from outside the country challenge Ivan in the Kazan scenes. After his victory in battle, threats begin to come from those directly around him and become far more personal; the struggle against loneliness and physical violence occupies most of Part II. Ivan has largely disposed of these problems by the beginning of Part III. The major threat delaying the final

battle scenes must not fall short of the preceding obstacles dramatically; it also must not be simply a repetition of the earlier kinds of threats. In fact, the threat in Part III follows the progression of threats from external to internal; now the final danger—madness—comes solely from Ivan's psychological motivation. In effect, there is no force left in the narrative strong enough to challenge Ivan but Ivan himself.

Ivan's drift towards madness raises the narrative to a high dramatic pitch, but it does so at the risk of making him into a morally unacceptable character. To a certain degree this risk is lessened by the whole web of motivations that has already been woven around Ivan. The extremely redundant assignment of semes to Ivan has made him such an imposing and likable character that it has become almost impossible by this point to undermine him. The film has created a moral world in which the cards are stacked in Ivan's favor. In addition, the presentation of the events at Novgorod strives to keep a balance between Ivan's cruel actions and the narrative motivations for these actions. In some cases, however, that balance becomes precarious.

The scene in Pimen's rooms at Novgorod has several functions. The simplest is its confirmation of Pyotr's information about the treachery of the cities: Ivan's ruthless punishment needs to be seen as totally necessary to the achievement of Russian unity. In addition, Pimen's ally in Moscow, Eustace, has sent a message of warning to Novgorod. His suggestion that Ivan march against the cities was simply a ruse to lure the Muscovite army into a trap; by forewarning Novgorod, Eustace thought to insure that Ivan would find a prepared army waiting for him. But Ivan kills the messenger in the general slaughter of animals and guards the army wreaks on its way. Thus the film strives to justify his tactic to some degree by enabling him to prevent word from reaching Pimen.

But these reasons seem insufficient to motivate the bulk of the march scene in which cattle, dogs, and birds are indiscriminately shot down. Ivan seems to slip towards paranoia at this point. Yet an examination of the story-plot relations in the sequence following this one suggests a more important, compositional function for the march sequence. The film's plot shows the lead-in to the slaughter at Novgorod (the march and arrest of Pimen) and it also shows the result of the massacre (Ivan's remorse in the cathedral and the list of the dead). But a key event, the killing itself, is ellided. The motivation for this is clear enough: to show Ivan in a frenzy of cruelty,

actually executing the townspeople, would be unacceptable given his character status. By presenting the fact of the massacre in the sequence of Ivan's anguish in the cathedral, the plot foregrounds his remorse at the deed rather than the deed itself. Yet the film cannot avoid the fact of the cruelty altogether because the proairetic chain demands that Ivan continue to eliminate treachery ruthlessly. The narrative must convey the totally destructive force unleashed by Ivan's fury without showing the scene at Novgorod.

In the opening section on methodology, I discussed Stephen Heath's view of how a film must struggle to "contain" its elements, how it must alternate between the chaos of the destructive forces it has set up and the unity produced by its internal relationships. The massacre at Novgorod is this narrative's forbidden scene, the scene which, if shown, would pull the film apart too violently. The march to Novgorod brings the narrative as close as it ever comes to overbalancing itself. This sequence together with the cathedral sequence that follows are the narrative's most elaborate figures of distress; they struggle to bring the forces of the narrative violence back to an acceptable level.

In order to avoid the massacre scene, the film once again follows its frequent strategy by displacing the element of destructive fury: instead of showing Novgorod, Part III presents the destruction of all living things on the way to Novgorod. These deaths are comparatively acceptable. Mostly animals and birds fall victim to Ivan's archers, and the only humans killed are Novgorod's guards and the traitorous messenger from Eustace. This strategy of displacement of violence follows the pattern of other scenes. Ivan stands above the Kazan battle, contributing his clever plan of the mines under the city but not his physical participation. In Part II, Malyuta takes Ivan's task of execution upon himself, as Ivan simply looks off at the unseen—and unseeable—bodies of the Boyars. Here Ivan rides behind his troops, urging them on to destruction. The scenes of widespread killing are reserved for the later sequence of the battles against Livonia, where such actions cannot be construed as cruelty or unjustified violence.

But the film must recuperate the disturbance created by the violence of the Novgorod massacre beyond simply displacing it. The scene of Ivan's remorse in the cathedral presents an intricate weave of motivating devices. Once again Ivan doubts the righteousness of his own actions in his quest for a unified Russia. One line of action involves his monologue addressed to "the Heavenly Tsar" in the

fresco of the Last Judgment, whom he asks for a reply to the excuses he gives for his actions. At the same time, a monk reads out the names of those Ivan has had killed. In addition to the slaughter at Novgorod, we learn that a number of major characters have perished, indicating that once again the plot has ellided violent episodes of the story: Efrosinia has been drowned and Pimen killed in the massacre. Later in the sequence Ivan reveals that he has had Philip Kolychev strangled in the monastery to which he had returned.

In previous scenes, Ivan's punishments were justified by the characters' betrayals. Now, however, although Ivan's reason for the killings is still the treacheries the Boyars had committed, the Boyars are no longer present to remind us of this fact. The loss of these characters in such a sudden fashion creates a considerable rupture, and to counteract this, the narrative introduces another strong rupture that deflects the emphasis of the scene. Interspersed with the lines of action of the monk's reading and Ivan's grief is a conversation in which Alexey Basmanov reveals that he has been stealing from the treasury. Basmanov's agent in his embezzlements has been his "lieutenant," Demyan, who was formerly a servant of Efrosinia Staritsky. The German spy, Staden, also joins Basmanov in his thievery. As Ivan grieves, these three discuss the spoils of Novgorod to Fyodor's horror. This strange alliance helps indicate the function of the sudden turnabout in Basmanov's character. As I have indicated, the film needs at this point to remind us of Boyar treachery in order to motivate Ivan's massacre at Novgorod as a righteous action, but because the Boyars themselves have been eliminated from the narrative, a further displacement must occur: the function of treachery that the Boyars had performed now shifts to the group led by Basmanov. The fact that he employs Efrosinia's former servant helps to signal this. As we shall see, there are other specific parallels between the actions of the two clusters of characters.

With Basmanov's crime revealed, the narrative places Ivan's remorse in context. Yes, Ivan has been cruel, but how could he act otherwise when surrounded by such treachery on every side? Ivan justifies his actions in this sequence: "Not from malice. Not from wrath. Not from savagery. For treason. For betrayal of the cause of the whole people" (p. 227). At each stage along the way, the narrative provides corroboration of the need for such tactics.

I have mentioned that the character Eustace exists in the narrative primarily to establish the fact that Ivan is above judgment. This structure of meaning is completed when Ivan, in agony, starts mak-

ing his confession to Eustace; the latter is unable to conceal his agitation when Ivan mentions that he has had Philip Kolychev killed. Ivan forces Eustace to admit his identity as the youngest of the Kolychev clan and to reveal the conspiracy with Kurbsky. Now the last character that has apparently been in a position to judge Ivan, his confessor, is revealed as a traitor. If judgment has become impossible, so has guilt itself; Ivan snaps out of his remorse and prepares to send a message, signed with Eustace's name, to Kurbsky. From this point on in the film, Ivan will have no doubts about his course.

With this scene, the last major lines of action in the film have been introduced; from this point on, the narrative will concentrate on resolving those that remain open. The next scene commences this process. It serves primarily to establish that Kurbsky believes the letter to be from Eustace and plans his campaign on this basis. This follows the pattern I mentioned earlier of showing Ivan's enemies at a disadvantage. In effect, the narrative declines to build up suspense by concealing the situation of the Livonians. Here and in subsequent scenes, Ivan is a leap ahead of his enemies. As I have noted before, this is necessary because of the basic premise that Ivan's ability to accomplish his goal is unquestionable.

The Livonian scene leads directly into another scene set in Queen Elizabeth's court in England; a song about cunning "Ginger Bess" provides the bridge between locales. The dealings between Moscow and England have been deemphasized by the retardation processes of the narrative up to this point. In Part I, we witnessed both the departure of the ambassador Nepeya and his successful return in the last scene with the news that English ships bearing armaments had at last arrived in Russia. There has been no intervening scene or mention of Ivan dispatching Nepeya to negotiate for troops as well, yet that is the question at hand. Once again the scene confirms the inferiority of Ivan's enemies; we know before the battles even begin that Elizabeth has chosen to support Russia rather than Livonia because she realizes the advantages for England of that arrangement. According to the English queen: "As always—that German is ready to pay with the skin of an unkilled bear. And this time the bear's—a Russian one!" (p. 242). The metaphor recalls Kurbsky's reference to Ivan as a "bear surrounded in his den" (II, 71)[16]

[16] Roman numerals followed by Arabic numerals refer to shot numbers from the Simon and Schuster script (here, Part II, shot 71). This system will be used throughout the text.

in the first sequence of Part II. Elizabeth and Kurbsky use the same image, but Elizabeth rightly sees the bear as the Russian state, of which Ivan is simply the emblem. The scene also carries through the game imagery that Ivan had begun in Part I when he sent Elizabeth a message in the form of a chessboard. Now she tricks the Livonian ambassador by giving him an ambiguous, riddling reply; as he sues for English support, she tells him, "English men-at-arms shall be there, in Russia" (p. 241). We are informed of Elizabeth's real meaning—that the English will be fighting on Russia's side—by her laughter after the Livonian ambassador's departure and by the fact that Nepeya is next in line for an audience with the queen. Only after the Livonian ambassador leaves the court does he realize the true implications of her statement. By the time he returns to Livonia, his message will be too late to prevent the Livonian army from setting out. Thus the scene demonstrates the strategies that trick the Livonians in the international game of military strength they play.

The next brief scene shows bands of Oprichniki seizing the traitorous Russian outposts on the Livonian border. The Russian army advances to the border itself. Now all stands on the brink of war.

The beginning of the war proper is delayed once more, however, by the intervention of the feast sequence of Part III, which occurs between the preparations for war and the actual setting out. It is the last scene in the film where matters other than the war play more than a tangential role. The banquet sequence contains strong echoes of two earlier scenes. As in the earlier feast in Part II, the Oprichniki sing and dance in wild abandon as Ivan sits watching and plotting. Fyodor again leads the song, this time a blasphemous chant for the dead. In this particular element, the Part III feast also parodies the sequence of Ivan's remorse in the cathedral, where a monk had similarly read a list of the executed; here the participants knowingly make fun of the religious ceremony. Ivan and his followers all amuse themselves by pretending to be monks, while Fyodor stands at a lectern chanting "in a high falsetto," pretending to read from a "psalter in front of himself upside down" (p. 245). The script calls this "Ivan's favorite jest."

In this parody, Ivan ridicules his earlier remorse. The reading of the list of the dead, combined with the treachery of the Basmanovs, repeats the juxtaposition within the earlier cathedral sequence; there Basmanov's plotting with Staden to defraud the treasury had proceeded during the reading of the real list of the dead. We have seen how that sequence justified Ivan's ruthless actions by demonstrating

that treachery existed all around him—in the Boyars and Oprichniki alike. Now this sequence reemphasizes that fact: in order to win the Livonian war, Ivan must not allow his remorse to interfere with those actions necessary to victory. By this point in the narrative, the struggle with the Boyars has completely merged with the Livonian war. Earlier Pskov and Novgorod had been attempting to secede to Livonia; in the scene immediately before the feast, Ivan's men had advanced to the border. Ivan's hesitation and doubts are impossible if he is to carry on, and he must entirely put them aside in this sequence. Revealing that he is aware of their betrayal, Ivan firmly orders the Basmanovs killed, shedding a single tear over Fyodor's death but no longer hesitating or questioning the justice of his actions.

This tear reconfirms Ivan's entire character development over the course of the film. While the initial sequence had posited Ivan as perfect, there soon appeared a split between his public and private aspects. The public side remained the invulnerable Tsar, capable always of dealing with Russia's enemies; the private side had led to major threats to the goal. With his declaration in the Fiery Furnace sequence that he would become the "Terrible," he in effect vowed to fuse these two aspects of his character. But his madness and remorse in the earlier scenes of Part III raised a question concerning whether Ivan had been able to overcome those portions of his character that had been threats to the goal. Now the deaths of the Basmanovs display Ivan's success in suppressing both his longing for friendship and his remorse at the necessity of ruthlessly eliminating traitors. He does not become utterly heartless (the single tear signaling hidden regrets), but he now acts exactly as he must. From this point on, Ivan returns to being the perfect public leader he had been in the coronation sequence. Even the death of his only remaining friend, Malyuta, will cause not loneliness but the triumphant race to the sea. There the private goal (allowing Malyuta to see the Baltic before he dies) and the public goal (expanding Russia's boundary to the Baltic) coincide exactly; no conflict remains.

The connection between the Boyars and the Basmanovs becomes even clearer in this sequence. As Alexey and Fyodor go outside the hall for the execution, the father tells his son the reason for his betrayal of Ivan: Basmanov envies Ivan greatly and desires that his own descendants should grow as rich and powerful as the Tsar's. "Who knows whose seed is more fit to live? And which tree in the course of ages shall outgrow another?" (p. 253). Basmanov's words

to his son echo a metaphor of the feast scene of Part II. In the earlier scene, he had compared the Oprichniki to a new forest growing up around Ivan to replace the Boyars, to which Ivan had replied angrily, "I don't hack down oaks to make room for wretched aspens" (II, 523-535). Basmanov reveals that his motives parallel those of Kurbsky; both wish to replace Ivan in some way, not because they despise his goals, but because they envy his greatness.

Basmanov has undergone a complete reversal since his first appearance in the film. There he had warned Ivan against Boyar treachery and had directed his son's admiring gaze up towards Ivan on the hilltop above them. Now the Basmanovs have replaced the Boyars in terms of general character function, and their admiration has turned to envy. Alexey Basmanov sees himself as one father struggling against another for the good of his descendants. Yet his attempted subversion only succeeds in wiping out his own line when Ivan discerns that Fyodor has shared his father's betrayal. Basmanov himself had suggested the Oprichniki as an institution in which sons would renounce their fathers in order to serve Ivan. As we have seen, the film carries this idea through in literal imagery of religious vows; the Oprichniki often appear as monks devoted to the cause, with Ivan as their abbot. The band of followers makes its first appearance in that same sequence at the end of Part I where the approaching chorus sings to Ivan as "the Father of us all." Basmanov has failed to realize that Ivan's position as the emblem of Russia supersedes all personal kinship.

The feast sequence ties up most of the loose ends of the people's move. With the Basmanovs dead, Ivan goes into the Livonian war with all the internal enemies of Russia eliminated. Although Malyuta moves to arrest Staden, the news of the Livonian advance arrives to interrupt this action; Staden later shows up in the war. With this single enigma of Staden remaining open, the narrative moves into the long, final sequence of the war with Livonia.

THE RETURN TO THE CENTRAL MOVE: CLOSURE

Once again the four short scenes of the battle sequence place the emphasis on the confusion and despair of the enemies: there is never a question that Kurbsky and the Livonians will lose. And again, Ivan's part in the battle is not that of the strong, fighting leader: we see little of the confrontation as he advances; instead, he and his army appear suddenly in the locale where each scene is set.

Ivan's character-function throughout the sequence is that of conqueror rather than of leader or invader.

As this sequence begins, Kurbsky, in his richly-outfitted tent, discovers that England, which he had assumed to be on Livonia's side, is in fact supporting Ivan. The script makes it quite clear that Kurbsky has lost the game of international intrigue: "Scattered on a low table, military maps. And near them, as though with the rational game of strategy were mingled crazy games of hazard, are strewn gaming cards and gambling dice: more fit indeed for such a crazy venture as this campaign against Moscow" (p. 261). Immediately after the revelation of England's trick, Kurbsky hears the guns of Russia approaching and discovers that his ploy of winning over the border cities has failed. He flees, and the next few scenes form a sort of chase in which Ivan's sweep across Livonia also becomes a search for Kurbsky. The contrast between the two opponents is strongest here, as Kurbsky ignominiously runs at Ivan's approach. In this first scene, he leaves his tent after it has been set afire by Ivan's cannon. Malyuta's horse tramples the maps and playing cards: "And it is plain from both the one and the other that the game is lost" (p. 264). Pyotr even smashes the gilded armor Kurbsky has left behind in his haste. The latter's cowardice contrasts strongly with Ivan's heroic appearance at the very end of this scene, riding forward after his victorious army.

The short scene at the castle of Wolmar repeats this pattern briefly. Again Kurbsky is startled by the approach of the Russian army. This time he is even more a figure of ridicule as he jumps from his bed and "flees half-clad" (p. 265). The scene continues with the protest of the Livonian peasants against Staden, who has been burning and pillaging their farms.

Here at last Staden's narrative function becomes clear. I have mentioned that he at first appears to be an anomaly in the plot. Dispatched to spy for Livonia, he never sends any information to Kurbsky. His primary actions consist of allying with Basmanov to rob Ivan's treasury, killing Fyodor, and looting Livonian farms. He remains a peculiar combination, neither wholly Livonian nor wholly Russian in his loyalties. This scene of his capture creates another reversal: Staden, a Livonian by birth, has pillaged Livonian land, while Ivan, a Russian, protects this very land from him. Staden's actions in this scene foreground a concept that had been distorted by the war: the Livonian soil the army now occupies is by rights Russian land (in the narrative's terms). Staden functions to help

bridge the paradox of land that is at once Russian and Livonian. As a Livonian, Staden betrays Ivan; but he also betrays Livonia. Ivan's intervention on behalf of the Livonian peasants seals the return of the "primordial land" (p. 266), as Ivan calls it, to its rightful ruler. And just as the Russian peasants and workers had hailed Ivan after their riot against him in Part I, now the Livonians accept him joyfully as their leader. Staden's death at the hands of the peasants once again allows the punishment of Ivan's enemies without his participation. With this scene's confirmation of Ivan's position as the leader of the Livonian people, the war resumes.

The next sequence affirms the implication that Russia has a "natural" right to Livonia beyond the possession gained by victory in battle. It opens as had the previous one: inside Weissenstein Castle, the Livonians hear Ivan's guns advancing. Their leaders complain of Ivan's ability to win over the people, who have been hailing him as their Tsar. In panic, Kurbsky breaks down and urges the Livonians to flee: "The earth holds none stronger than the Russian warrior!" (p. 269). When they refuse, Kurbsky departs by a back entrance, once again forsaking his honor to save himself. The actions that follow set up a simple juxtaposition between the decadence of the Livonian nobility and the bravery of the Russian troops. As Ivan's army batters at the gates of the castle, the Livonians within the castle abandon all hope of victory and begin to drink and dance in a frenzy.

Interwoven with the dancing and the attack is a scene in which the head of the castle, Oldenbock, goes with the German emissary down into a chapel in the depths of the castle. There he attempts to defeat Ivan by blowing up the castle. The parallel to Ivan's earlier tactics is clear: Ivan had previously conquered Kazan by setting off mines under the city. Now Oldenbock does the same but to his own stronghold. Like the Boyars in Part II, the Livonians make one last desperate attempt to kill Ivan, but as in the previous case, they fail, managing only to bring about their own destruction. The final explosion topples the castle, but Ivan escapes the devastation.

Ivan in fact does try to enter the castle during the battle, but Malyuta restrains him: "Your job is to build the state. Not to crawl amidst gunpowder!" (p. 274). Malyuta then enters the castle to plant Ivan's standard on the highest bastion. As he has been Ivan's agent in everything else, including Ivan's guilt in Part II, now Malyuta becomes the final sacrifice Ivan makes before reaching the sea. Up to this point, the script mentions no loss on the part of Ivan's

troops. Yet the fighting of the war in order to regain the lost Russian
lands implies a struggle in which Ivan must suffer some loss in order
to win. His own death is out of the question, but Malyuta accepts
the risk. Malyuta's death is also necessary because there must be
no sense at the end of the film that several people have won the
victory: Ivan must stand alone on the beach, just as he alone has
represented the goal of unity. The one servant who remains to him
by this point is Pyotr, a relatively minor figure; the narrative care-
fully avoids suggesting at any point that Pyotr is a replacement for
the more important figures, Fyodor or Malyuta. Malyuta's death
caps the long series of sacrifices Ivan has made through the loss of
loyal followers. As he has punished treachery, he has also lost
friendship and support; by the time he walks down onto the beach,
both have become irrelevant. Now all of Livonia has been merged
into Russia, and with its leaders gone, the people accept Ivan as
their Tsar. The exchange of loyal support for victory is made clear
during the race to the sea. Malyuta lies dying and expires at the
moment he sees the Baltic. After he cries, "I see it!" and dies, the
script reads, "And the billows have roared out in answer to Mal-
yuta" (p. 280). With the passing of the last of Ivan's key supporters
comes the final displacement of the film: the loyalty of the sup-
porters of Ivan/Russia passes onto the sea itself. The homage pre-
viously paid by servants and friends shifts to the waves:

> And the sea does him homage.
> And the waves bow slowly to his feet.
> And they lick the feet
> of the Autocrat of all Russ. (p. 280)

As the narrative draws to a close, the shouts of the troops and the
music of the trumpets merge with the roar of the waves to proclaim
Ivan the embodiment of his now-accomplished goal.

CONCLUSIONS: THE ROUGH EDGES OF NARRATIVE

This analysis attempts to account for the major narrative structures
of *Ivan*. I have examined the functions of those collections of motifs
we termed characters; I have separated the four moves of the film's
proairetic and shown how they are interwoven; I have traced the
film's major delays and final closure of its enigmas. Most impor-
tantly, I have demonstrated how the trilogy manages to overcome
the inertia of its initial overdetermination by creating a series of

digressions that rupture the main hermeneutic line; in addition, a series of displacements allows one device to substitute in function for another, permitting a narrative progression by sidestepping the overdetermination of the opening.

But this does not mean that the analysis has dealt with all the narrative factors. As I have tried to indicate, many elements in the plot of the three parts are not strictly necessary to the presentation of the basic story. Because a film retards what it presents, many actions function in part to deform the narrative. Thus, although these elements relate to the cause-effect chain, they are also present as a kind of excess. Such elements may delay the narrative flow through repetition (redundancy), expansion (the insertion of repetitions or causally unnecessary events), deflections, or deformation.

Most of these excessive elements are adequately motivated so that they do not seem to stand out from the texture of the narrative. To attempt to assign every such element a strong narrative significance would be to overload the film with meaning; such an analysis would indeed privilege meaning at the expense of perception. The Russian Formalists claim that meanings are one type of structuring process that plays upon perception. There is no necessity, therefore, to reduce the work to a network of meanings. But neither should we examine the narrative structures as if all stylistic patterns function neatly within them, for this is clearly not the case. If the critic makes the form of the work appear *too* neat, it will lose its power as an unfamiliar, fascinating object. An artwork's power lies in its ability to escape our easy understanding. The critic should not mystify the work's complexity, but rather preserve it by pointing it out. For this reason, we will be returning briefly to the narrative structures of *Ivan* later in this study to look at some of the more problematic aspects—their disjunctions.

In this chapter, I have not always been able to speak of narrative structures without having to glance forward to the analyses in later chapters, a fact that emphasizes that the structures we have been examining in this chapter never work in isolation. A narrative film like *Ivan* is a constant orchestration of devices. Having determined the large-scale patterns of *Ivan*, I can now go on to look at the specific embodiment of the narrative in stylistic terms.

3 Spatial Relations

ANALYZING *Ivan*'s VISUAL STYLE

The dominant we have seen at work on the level of the narrative of *Ivan* also governs its other levels of structure. On the one hand, there are a number of technical devices that work together in support of the narrative to the point of extreme redundancy. *Ivan* goes further than most films in its reiteration of relatively static semes and symbolic lines; these relate largely to Ivan and the goal of Russian unity. Costumes, sound, lighting, and acting may all work simultaneously to embody virtually the same narrative elements. But just as the overdetermination in the narrative level is counterbalanced by a set of slippages into other proairetic moves, so certain of the film's stylistic structures work in opposition to this redundancy. These "counternarrative" devices[1] will be examined in Chapter Eight; they include patterns of editing discontinuity, lack of transitions, and other disruptive devices.

In examining the general principles of spatial organization in the various sequences of *Ivan*, I shall not be going through the film scene by scene. This approach may serve the critic well for answering certain questions. For instance, Barthes uses it to great effect in *S/Z* to analyze the codes (conventions and structures) of reading the classical literary text. But for the purposes of this analysis, it is my belief that a scene-by-scene progression through the film would not in itself generate any useful results; it would only be a convenient method for grouping findings. Therefore, I shall employ another approach, grouping scenes from the film that have similar structural dominants; an individual section of a film may have a local dominant that organizes that section and perhaps others as well. *Ivan*, for example, has one scene that organizes its mise-en-scene, framing, and editing around symmetry, while several other scenes deal with Ivan's assertion of power by placing him in the

[1] Roland Barthes, "The Third Meaning," trans. Richard Howard, *Artforum* 11, no. 5 (January 1973): 49.

center of a crowd. By juxtaposing scenes with the same dominant, I hope to make clear certain parallels and contrasts of narrative function that might otherwise be less apparent. In each case, we shall see that the scene's local dominant supports the general dominant of the entire film; that is, each scene's organization supports the narrative redundantly, transferring proairetic, hermeneutic, and semic material into the various film techniques. These groupings are by no means the only ones that could be made for this film.

DOMINANT STRUCTURAL PRINCIPLES WITHIN SEQUENCES

The headings I have chosen are not always parallel (most are based on the organization of scenographic space, but one—the examination of the ray motif—depends on a graphic pattern), a fact that arises in part from Eisenstein's dependence on different strategies in creating the dominant principles of each scene. For a neoformalist method, such nonparallel strategies should not be a problem. In speaking of poetry, Shklovski stated that no one technique was more important than others:

> Poetic imagery is a means of creating the strongest possible impression. As a method it is, depending upon its purpose, neither more nor less effective than ordinary or negative parallelism, comparison, repetition, balanced structure, hyperbole, the commonly accepted rhetorical figures, and all those methods which emphasize the emotional effect of an expression. . . . Poetic imagery is but one of the devices of poetic language.[2]

Thus any one device may become dominant in a given scene, with other devices subordinated to it. But at other times, the dominant may change. *Ivan*'s basic difference from the Hollywood cinema lies in the fact that the latter has privileged certain techniques (primarily narrative), creating a narrow range of filmmaking possibilities. Only occasionally does a Hollywood film vary its spatial techniques between scenes; some Busby Berkeley musicals, for example, insert musical numbers that structure their space around graphic patterns rather than narrative action. Eisenstein's theoretical writings suggest his conviction that all film techniques hold equal potential for the creation of montage structures.

[2] Viktor Shklovski, "Art as Technique," in *Russian Formalist Criticism: Four Essays*, trans. and ed. Lee T. Lemon and Marion J. Reis (Lincoln: University of Nebraska Press, 1965), p. 9.

By *organization* of a scene, therefore, I do not refer exclusively to either the scenographic or screen space of various shots but to the principles that govern the whole. Relevant questions for this analysis refer to the placement of characters in relation to each other and the camera, to compositional (framing) strategies, to eyeline directions, and to other methods of relating the space of one shot to that of another.

The Assertion of Power: Ivan as Center

One of the most common cues that helps convey a sense of space from shot to shot is the eyeline match, in which the glance of a character towards offscreen space is followed by a shot of the seen space. *Ivan* uses this device in a particularly complex way, making the glance at once a central spatial device, a visual motif, and a semic element. In this pattern, Ivan (or occasionally another character) asserts his power by placing himself at the center of a space in which others gather around and watch him; he becomes the spectacle to which all attention is drawn. The cutting then emphasizes the eyeline match, with Ivan's gaze dominating those of other characters. Thus eye contact and direction of gaze frequently become indications of character relationship and dominance. This pattern of spectacle begins in the coronation sequence, where Eisenstein uses a variation on the classical pattern of the eyeline match, and specifically the shot/reverse shot.[3]

In order to demonstrate this, I would first like to draw upon the background of the classical Hollywood cinema by presenting a brief analysis of a scene from *Sergeant York*. A comparison of this with a scene from *Ivan* will help to illustrate how Eisenstein uses some aspects of the norm of continuity editing but in a way that departs from classical usage.

Continuity editing is a *system*; it presents the filmmaker with a limited set of principles for organizing the space within a scene. Howard Hawks is one of the most proficient of Hollywood directors in obeying the rules of continuity unobtrusively, while keeping his action flexible. This is apparent in the opening scene of *Sergeant York*, which forms a handy parallel to the coronation sequence. Hawks's scene also consists of a gathering in a church, with the hero's first appearance in the film occurring partway through the

[3] Again, "power" and the other abstract ideas I will be discussing here are not "themes" in the conventional sense of a summary of a film's meaning. They are semic and symbolic narrative devices.

sequence. Hawks's space is absolutely faithful to and typical of Hollywood continuity editing patterns.

The initial fade-in reveals a long shot of a country church, with a large tree in the left foreground (Fig. 1). This shot establishes not only the church but also its proximity to the tree into which York will soon shoot his initials. A dissolve smooths the transition to another establishing long shot of the interior of the church (Fig. 2).[4] There follows a series of medium shots of small groups within the congregation (including York's family), all looking off left as they sing a hymn (Fig. 3); interspersed are reverse medium shots of the preacher, looking off right and leading the hymn (Fig. 4). He gestures them to sit, and they begin to do so. A match on this action places several members of the congregation in soft focus in the foreground while the preacher is in sharp focus standing in the background (Fig. 5). This shot reestablishes the spatial relationships between preacher and onlookers, in terms of both direction and distance. The preacher begins to speak. This is the longest held shot to this point, dwelling on the clear spatial relations before cutting to an extended shot/reverse shot pattern. The shot/reverse shot carries over the comic action of the arrival of a latecomer with squeaky shoes who interrupts the sermon. This series of thirteen shots steadily alternates shots of the preacher and the latecomer (Figs. 6 and 7); at no point are there two consecutive shots of either.

Once the preacher is able to resume his story, he is seen in medium shot for some time, again creating a stable space in preparation for the interruption to come. As he speaks, a gunshot is heard from offscreen, followed by several others. The preacher pauses and looks off right. A cut takes us outdoors once more, to exactly the same long-shot framing of the church as in the first shot of the film. Three men on horses ride into this space (Fig. 8). After a second long shot of these riders (maintaining constant screen direction), there is a cut back to the interior of the church. The next few shots are similar interior and exterior set-ups. Then a pan right with two of the horsemen stops suddenly as they pass behind the third—York (Fig. 9). Now we see him clearly for the first time; he fires his gun at the tree, and, in a separate close shot, we see the bullet holes beginning to form a pattern (Fig. 10). Back inside the church, the preacher calls the meeting off (with further intercutting to the action out-

[4] Dissolves frequently serve in Hollywood films to bridge a slight change of space or time within a scene. In contrast, *Ivan* does not have a single dissolve for this or any other function.

doors). Another dissolve outside returns to the same initial long-shot view of the church as the congregation approaches the tree (Fig. 11). Two cut-ins to the group pick out the preacher and York's mother as they discuss the fact that York has been one of the culprits (Fig. 12); a medium close-up of the tree reveals the holes in an AY pattern (Fig. 13). Thus the space of the scene strongly marks York by a large number of shots as he first appears on the scene—intercutting interior and exterior shots at some length. He is also prominent by means of the pan, which marks him as the most important of the three men, and by the shooting of the initials.

This analysis demonstrates how the classical Hollywood cinema consistently takes care to establish an absolutely clear space through long shots (placement of proximate elements within a single shot at intervals through the scene), matched screen movement, and consistent eyeline directions from shot to shot. It also smoothes the progress of the scene by using dissolves over small transitions and by repeatedly returning to the same framing.

Whatever the virtues of this mode of spatial presentation in *Sergeant York*, the pattern remains firmly within conventional usage. The continuity approach exists apart from *Sergeant York*; I could have chosen another film of this tradition to illustrate the same point. Moreover, all the scenes of the film obey the same continuity rules; there is not a single cut that breaks continuity. (Two scenes do begin on close, nonestablishing shots, but this is in each case motivated, and an establishing shot quickly follows.)

Eisenstein, on the other hand, does not use the same editing pattern in every scene; one dominant structuring principle may appear in two or three scenes. The similarities between the dominants may function to create parallels. In a film like *Sergeant York* that uses shot/reverse shot in virtually every conversation situation, the repetition carries little significance. But *Ivan* differentiates its spatial patterns enough from scene to scene that a shot/reverse-shot structure in one scene might be *specifically* related to a similar structure in another scene.

The difference between Eisenstein's system of spatial structuring and that of Hollywood becomes clear in the coronation sequence. Dudley Andrew has pointed out[5] that the first part of this sequence creates a spatial lack that needs to be filled and that *is* filled by the entrance of Ivan. Unlike the scene from *Sergeant York*, the con-

[5] Lecture in the course "Novel and Film" at the University of Iowa, Autumn 1972.

struction of the coronation scene's space does not begin with an establishing shot; instead, the first shot is a close-up of the crown. This abstract emblem of the coronation and of Russian unity already implies an absence—that of the person who is to wear it. Pimen's entry in shot 4 is unclear in its spatial relation to the crown; he looks off right and front to give a blessing. Shots 6 and 7 (there is no shot 5 as noted in the screenplay) are long shots of the congregation (Fig. 14). But again, unlike the shots of the preacher in the *Sergeant York* scene, the speaker does not appear in the background; the people look and bow towards the left. In spite of his systematic avoidance of some aspects of the continuity system, Eisenstein is relatively careful about obeying the axis of action; only a small number of cuts in both parts of the film violate screen direction. Hence the shots of Pimen and the onlooking ambassadors (9-15) preserve the pattern of reverse shots as he looks off right and they look off left. But at no point are we able to get any sense of the distances between areas of the cathedral. We never see Pimen and the ambassadors (and later the Boyars) in the same shot; the space between them remains uncertain—and this is the space reserved for Ivan.

The spatial instability of the sequence becomes more apparent in the next series of shots, as one ambassador explains the situation to another (beginning with shot 16); they are looking off right now (Fig. 15). With shot 17, there commences an extraordinary play with eyelines. In the three shots of the main Boyar group (17-19), the eyes of all are continually moving about the room in a variety of directions. Initially, the situation at the cut to shot 17 is as follows: Efrosinia and Vladimir gaze off right, as does Turunty-Pronski, on Vladimir's left; the two Boyars on Efrosinia's right are looking off left (Fig. 16). The latter two begin to glance right, while Turunty-Pronski and Vladimir turn further right; Efrosinia now moves her eyes left, and is the only one looking off left at the cut (Fig. 17). In shot 18, Efrosinia is now looking off right, Vladimir, left; the direction of their gaze has been changed (mismatched) (Fig. 18). A Boyar at the left is looking off left. By this point, the eyelines provide little spatial anchoring in relation to other elements of the scene; we don't know what these people are looking at. During this shot, Efrosinia shifts her eyes left, while the others' eyelines remain the same. Shot 19 has Vladimir still looking off left (Turunty-Pronski, visible behind, also looks left, Fig. 19); Vladimir moves his

head and eyes right (as does Turunty-Pronski), just before the shot ends.

This emphasis on details of eyelines of three short shots may seem unnecessary, but the systematic shift and mismatch of the direction of the characters' gazes indicates the careful undermining of stable spatial cues that the first part of the sequence provides. The cut to shot 20 confuses as well. Is this what Vladimir is looking at, or does the cut follow the attention of the ambassador whose voice is still being heard off? It leads to a pair of close shots of Ivan's male supporters, all looking off right. Shots 22 and 23 show a group of women of Anastasia's retinue; they look in different directions—some off left, some right—while the old woman shifts her eyes left to right in shot 22.

This series of shots is typical of *Ivan*'s tendency to give several shots in a row of the same person or small group, often from relatively similar set-ups (in a cut from a frontal medium close-up to a frontal close-up, for example—a violation of Hollywood's "thirty-degree rule").[6] We have seen that *Sergeant York* always follows a shot of a person looking with a shot of the seen space or with a shot of another person looking off in the same direction, rather than with another shot of the first person. The resulting strict alternation of spaces functions to remind the spectator constantly of spatial relations. Eisenstein's clusters of shots of the same person tend to diminish the effects of spatial cues by spreading them out; instead of an eyeline match at every cut, there is only one at every third or fourth cut. In combination with the sequence's avoidance of overall establishing shots, this pattern makes for a tenuous set of spatial relations.

We first see Anastasia in shot 23 with her eyes lowered or closed; she is the only figure so far whose gaze is not directed offscreen. This differentiation prepares the way for the transition to Ivan's presence. After a cut to a close-up (25), Anastasia opens her eyes and looks up and off right (Fig. 20). The cutting to this point has created an implicit circle, if we may trust the direction of the gazes. That is, the ambassadors glance (screen) left at Pimen and right at

[6] The thirty-degree rule suggests that at any cut the camera position must shift significantly in angle of vision on the subject photographed—thirty degrees or more. A smaller shift supposedly gives the impression of a jump or unnecessary cut. Classical films eliminate such cuts as disturbing; Eisenstein systematizes them into a structure.

the Boyar group, who then look right again at Anastasia and Ivan's other followers. These in turn look right, presumably towards Pimen, completing the circle. But during this chain of glancing, we do not see the center of this circular space, nor do the characters appear to look towards it. This anchorless space, over which the characters' gazes flutter but do not rest, implies an emptiness or instability. This is the void into which Ivan will step, thereby stabilizing the space of the entire sequence.

The cut from Anastasia's upward gaze to the high-angle long shot of the cathedral is the culmination of all the confusion of eyelines and distances in this scene. She looks *up*, and we see a shot taken from high above the ground that subsequently introduces a crane down (Fig. 21). A shot from her point of view would have to be from a low or straight-on angle; thus the high-angle framing undermines our sense of Anastasia's location in relation to the space of this new action. Comparing this cut with the eyeline matches in *Sergeant York*, we can see that classical practice tends toward angles that do not contradict the directions of the eyelines. The shots of the congregation, whether long or medium framings, are approximately straight-on. The reverse shots of the preacher, however, are from slightly low angles; these do not represent any specific character's point of view, but they tend to reinforce the preacher's position as higher than that of the congregation. A classical editing pattern would tend to avoid the kind of contradictory spatial cue present in the high-angle long shot that follows Anastasia's upward glance.

At this point, we finally see the dais, which occupies the space in the center of this pattern of glances. Pimen now moves forward with his ceremonial procession until he faces the empty space in front of the dais—the space around which the entire scene is now explicitly laid out. The boys with poles form a little aisle in the foreground, into which Ivan walks. His two supporters immediately turn to face him at each side, bowing and retiring to form a part of the group configuration; all the people are now arranged in a horseshoe-shaped group facing Ivan (Fig. 22). Finally we have the establishing shot that creates a relatively clear set of spatial relations. Virtually all the shots in the remainder of the sequence are cut to a glance-object relationship, with Ivan as the spatial center.

The crane down brings into view the shafts of light slanting down from high windows in the background of the set. Ivan steps into the frame just as these beams become clearly visible. Soon the

crown, orb, and scepter are brought forward as well. In short, the semes of the mise-en-scene begin to cluster rapidly around Ivan.

Ivan's utter domination of the space of the sequence, and his position as the object of all glances, introduces an important device of the entire film: spectacle. Many of Ivan's semic associations are embodied in his position as a visual object, attracting the gazes of all around him. Later we shall see how the Boyars attempt to oppose Ivan precisely by setting up a substitute spectacle.

The series of shots in the actual coronation pivots around Ivan while avoiding a direct look at his face. The shots of Pimen lifting the crown and scepter (27, 35) are taken from a position right of Ivan; the shots of him raising the orb (37) are taken from Ivan's left. Once again the mise-en-scene collects semes around Ivan. In shot 32, Ivan lowers the crown onto his head; it fits perfectly, its fur trim coming to rest on his row of curls (Fig. 23). The head is shaped to fit the crown, which Ivan handles confidently, without moving his head or seeming to glance at it as he takes it. The framing from behind emphasizes these qualities.

The motif of Ivan as a figure of spectacle intensifies in the next section of the sequence. The archdeacon's song leads up to the moment in shot 44 when Ivan turns around. Shot 45 is an absolutely still long shot of the scene (Fig. 24). Both these shots reaffirm his position as a spatial anchor, placing him in the foreground and the others behind, all staring toward him.

Shot 48 shows Ivan in long shot, towering over the onlookers (Fig. 25). This repeats the set-up of shot 7, the early long shot of the crowd (Fig. 14). Previously, Ivan had not yet entered; now the repetition with Ivan reiterates the fact that he has formed the pivot of the sequence by entering the previously unoccupied central space. The coin pouring further reinforces this pattern, as the reaction shots in this segment are part of a pattern of clearly directional eyelines. This pattern had begun during the crowning, as Efrosinia and Vladimir gazed intently off left and Anastasia looked right. Now we know what all the characters are looking at. During the coin pouring, the three women, including Anastasia, all look off right in admiration; Kurbsky and Kolychev also look in directions consistent with their positions in relation to Ivan (Figs. 26 and 27). These onlookers no longer shift their eyelines within shots (except at one point when Efrosinia glances around to see the effect of Ivan's speech on the other Boyars).

During the entire scene leading up to the speech, Ivan is set apart

by the fact that he does not return these glances. At first we are unable to see his face. When he turns, he keeps his gaze fixed ahead: while all look to him, he looks to none. During the shower of coins, he keeps his eyes open but continues to gaze straight ahead (Fig. 28). The speech opens in the same way, but at this point, Ivan begins to glance off to left and right (Fig. 29). The reaction shots still maintain consistent directions, with the main group of Boyars and the ambassadors looking left, Anastasia and Pimen looking right.

These exchanges of glances set up the basic character conflicts of the narrative. This is the point at which the narrative violence occurs—the moment that destroys the opening equilibrium and initiates the proairetic chain. The violence is not literal: it consists of Ivan's declaration that he will unify Russia. In the next shot of Efrosinia (80), she flings up her staff angrily, looking off left (Fig. 30). The gesture marks the entry of imbalance and violence into the text.

During the course of the speech, the shots of Ivan move in gradually closer to his face. As he shifts from a challenging tone to an emotional discussion of the "dismemberment" of the Russian land, he looks upward with a new type of gaze—a visionary stare, as if at something only he can see. This abstracted gaze will return repeatedly throughout the films. As he speaks of the rivers, he looks up and left, as if tracing an imaginary geography. Following this shot of Ivan looking up with tear-filled eyes (Fig. 31), there is a cut to Anastasia, looking on, also with tears in her eyes (Fig. 32). These shots (86-87) place their faces in the frame so as to create a close graphic match; the next cut (87-88) has an even closer match. The arrangement of graphic patterns supports the close link between Anastasia and Ivan in their mutual commitment to the goal.

The end of the sequence returns to a series of shots of onlookers. Again their glances are directed off at Ivan (at least apparently). However, this group talks among themselves, making vague threats. Now the space becomes more confusing than ever. Efrosinia suddenly seems to be talking to Pimen, yet she was previously at the other end of the cathedral from him (96-97). Nor is it clear what Ivan is glancing at in the close-up of him with the scepter's shadow (95); if he is reacting to the Livonian ambassador's line, "He must not become strong" (heard in voice-over), then he should be looking right, not left. This dissolution of the tight spatial pattern prepares

the way for the promise of opposition and conflict iterated at the sequence's end.

The analyses of the opening sequences of *Sergeant York* and *Ivan* suggest fundamentally different approaches to the creation of spatial patterns. Such differences are apparent as well in Eisenstein's theoretical works. In *Lessons With Eisenstein*, Eisenstein distinguishes between the strategies for arranging mise-en-scene and the breaking of that mise-en-scene into shots in his two chapters on a hypothetical filmed scene from the life of Dessalines.[7] In the section on mise-en-scene, he lays out the scene in a circular pattern; the action involves soldiers surrounding Dessalines in an attempt to capture him. (Although the narrative is different, the similarity of the encircling pattern to the spatial layout of *Ivan*'s first sequence is apparent.) Eisenstein then works out a series of individual shots of different segments of this mise-en-scene. Given the circular spatial arrangement, Eisenstein also creates a circular cutting pattern, frequently shifting his camera 90 degrees and 180 degrees around the action.[8]

In contrast, *Sergeant York*'s sequence uses the linear layout of mise-en-scene so typical of classical Hollywood films of the 1930s. The most basic instance of this is an arrangement of two characters facing each other, forming the two ends of the axis of action (as with the series of shot/reverse shots when the man with squeaky shoes interrupts the sermon). When more than two characters are involved, two figures will typically form the axis, while the others are visible beyond and between these two. This linear approach to setting up mise-en-scene, combined with the "rule" that the camera must not cross the axis of action at the cut, creates a semicircular area for camera positioning. The camera may change from shot to shot only on one side of the line.

The contrast between these two abstract systems of laying out space in the mise-en-scene and in the cutting is clear enough. But interestingly, Eisenstein does not use a circular cutting pattern in *Ivan*'s coronation sequence. Instead, as we have seen, the sequence obeys the "rules" of classical cutting insofar as it does not appear to include cuts that cross the axis (although some cuts are ambiguous in this regard due to the lack of establishing shots). Eisenstein is employing circular mise-en-scene as in his Dessalines example

[7] Vladimir Nizhny, *Lessons With Eisenstein*, trans. and ed. Ivor Montagu and Jay Leyda (New York: Hill and Wang, 1962), pp. 19-92.

[8] Ibid., see especially pp. 67, 72-73.

but then shoots and edits his footage with a semicircular rather than circular pattern. The resulting incongruities are the basis for the spatial instability that structures the opening scene before Ivan's entrance.

The device of Ivan as a visual center of a scene reappears repeatedly but not always as the dominant spatial principle; sometimes it remains subordinate to other structures, as an overtone. In much of the wedding banquet sequence, for example, his union with Anastasia leads to a pattern in which they both serve as the spatial center.[9]

The last sequence of Part I, the recall by the people, has a relatively simple spatial patterning in which Ivan once again becomes the center of a spectacle situation. He is placed repeatedly in the foreground of shots, with other characters behind (the Oprichniki indoors, the crowd outdoors). The action is minimal, with characters bringing objects and messages to Ivan. The sequence ends with Ivan's visionary stare into the distance as he decides to return to Moscow. The structure of this sequence needs little analysis in comparison to the more complex scenes in the film.

As we saw in Chapter Two, the sequence of the Fiery Furnace play is the turning point in Ivan's overall progress, the moment when he renounces his split between private and public considerations and declares himself to be the "Terrible." The sequence is split equally, each half possessing certain parallels with the coronation sequence. The same bells open the sequence, and the setting is virtually the same, with the play staged on a dais similar to the earlier one. But while Ivan had previously set himself as a spectacle in the center of the crowd, the Boyars now set up a substitute spectacle that replaces Ivan spatially. Now a similar crowd gathers around this space, but they stare at the players. Ivan's absence in the first half of the sequence creates the possibility of his being portrayed as a tyrant in the Boyars' play.

A child in the audience serves as a motivating device for the explanation of the play's significance, first to ourselves and later to Ivan. In the first four shots of the sequence (315-318, Figs. 33 through 36), the set for the little play goes from dominant to overtone as we move in toward the group of Boyars. The child's naive delight at the play and its ignorance of the drama's allegorical significance emphasizes the play's function as spectacle; the child's

[9] I shall examine separately the scenes that depend spatially on the couple.

mistaking of Ivan for part of the drama underlines the parallel between the play and Ivan as objects of competing visual attention. As Efrosinia explains the story to the child, we see two shots of the set (II, 320-320a, Figs. 37 and 38), framed somewhat as the shots of Ivan's crown were framed in the coronation sequence (I, 34, Fig. 39, and shot 39). Similarly, the shots of the crowd in the cathedral are similar (or identical) to several shots in the coronation sequence; again, the orientation is towards an event off left. At the entrance of the players, the bells begin again, as they had when Ivan entered in the earlier sequence. There is a literal repetition from the coronation sequence of the two shots of onlooking women (334-335, Figs. 40 and 41), emphasizing their function as spectators in each sequence; in the previous sequence, these shots had come during the coin pouring. Finally, the last shot of the first part of the sequence shows the three boys standing above the congregation (344, Fig. 42), accentuated both by lighting and positioning; this is a direct parallel to shot 48 of Part I, where Ivan had towered over the congregation in long shot (Fig. 25). It is at this moment, when the youths have exactly replaced Ivan spatially and compositionally, that Ivan's great booming laugh is heard off screen.

The little segment that begins the second half of the sequence takes place in an outer area of the cathedral that we have not seen before. Its function is to introduce and reiterate several threads of proairetic and symbolic material important to the upcoming confrontation in the cathedral proper. First of all, the scene sets up some visual parallels between Ivan and Philip. As with Philip's first entrance in Part II (122, Fig. 43), Ivan comes through an archway into a generally white set. He is now dressed in a black cassock, as are his followers. The framing of shot 349 (Fig. 44) through an archway as Ivan ascends a short flight of steps recalls shot 122, which has a similar framing and action as Philip comes forward calling his challenge to Ivan in the earlier throneroom scene. Both shots contain right to left movement. Aside from this parallel, the scene contains a discussion of Efrosinia's suspected crime. This reintroduces the issue and thus motivates Ivan's later discovery that she is guilty. The conversation also reiterates Ivan's seme of trust in Efrosinia; this seme has been seriously eroded in the last few scenes and needs reinforcement here in order to place Ivan at a moral advantage over Efrosinia before his final declaration.

Ivan's entry into the cathedral restructures the space of the scene: as the crowd steps aside to let him pass, they create a new spatial

gap into which he walks. Ivan reasserts his position as the center of the scene but is immediately challenged by Philip's entrance from the other end of the cathedral. A high-angle long shot (358) sets up the space of the confrontation as the two men stride in from opposite sides and stand near each other (Fig. 45). The Boyars are in a long, thin, horseshoe-shaped crowd extending to the rear and centered around the play; this is the space that Philip and Ivan enter, standing before the set. But as Ivan moves, his Oprichniki follow and set up a new horseshoe-shaped group extending to the foreground. These groups form an interlocked, opposed space of control and spectacle.

At this point (359), the boys consult among themselves and begin to sing again; reasserting the Boyar spectacle, they attempt to return attention to themselves. In the next series of shots, neither Ivan nor Fyodor looks at the boys, but they listen to their song about the "lawless, pagan Tsar." Shot 362 is a medium close-up of Vladimir and Efrosinia looking off right (Fig. 46); but the spectacle is no longer simply the play set up by the Boyars. In spite of the boys' having recommenced their song, the drama now lies inevitably with Ivan, as the pair watch to see how he will react to the song. Even in attempting to replace and weaken Ivan, the Boyars set him once again in the place of spectacle.

In Ivan's confrontation with Philip and the other Boyars, the direction of gazes again plays a major role. Ivan asks Philip's blessing with downcast eyes; the latter, however, refuses to look at Ivan (Fig. 47) as he had in their first confrontation, earlier in Part II. Their initial exchange ends in a stalemate (Fig. 48). In shot 375, both men withdraw from the foreground of the shot, as the camera racks focus and tracks forward toward the boys in their furnace. Ivan turns as he withdraws to stare up at them (Fig. 49). This constitutes a second reassertion of the Boyar spectacle as the boys once again begin their song. In the two close shots (376, Fig. 50, and shot 377) that follow, the boys stare off and stop singing one by one. The visionary gaze they have assumed is brought back to earth, and spectacle becomes spectator as they stare off at Ivan. As Philip's voice is heard off screen berating Ivan, a series of shots shows the onlookers: Pimen, Vladimir and Efrosinia, and finally Philip.

By shot 383, Philip is pleading and looks desperate. He leans forward, now looking directly at Ivan, off left (Fig. 51). In the next shot (384), Ivan is in medium close-up, now facing away from Philip

(Fig. 52): their earlier positions in the scene of Philip's return are reversed, with Ivan listening with turned back. Shot 386 brings a direct confrontation as Ivan thrusts his face directly up to Philip's, shouting, "Silence!" A cut-in to a close-up shows their intense stares into each other's eyes, until Philip is unable to hold Ivan's gaze and lowers his eyes (Fig. 53). As he does so, the voice of the child is heard off screen, asking if Ivan is the "lawless, pagan Tsar" of the play. This marks a transition as Ivan turns his attention to the group of onlooking Boyars.

The next segment is the culmination of the motif of the stare, as Ivan's stare stops Vladimir's laughter (Figs. 54 through 56) and causes Efrosinia to avert her eyes in guilt (Figs. 57 and 58). At first, it might seem odd that Ivan picks this particular moment to become convinced of Efrosinia's guilt, but the pattern of glances, spectacle, and power that weave together through the film have made Ivan's stare a highly charged gesture; this structure provides a symbolic motivation for his ability to divine Efrosinia's guilt by staring at her. After thrusting Fyodor and one of the boys out of the frame (395), Ivan pauses, continuing to look off left (Fig. 59). He then makes his momentous declaration, beginning over reaction shots of Efrosinia (Fig. 60) and Vladimir (Fig. 61) gazing wide-eyed off at Ivan. Finally, the close-up of Ivan that closes the sequence (398) shows him raking his eyes across the offscreen spectators (Fig. 62), then glancing out at the audience and raising his eyebrows significantly (Fig. 63).

The sequence had begun with the Boyar spectacle designed to supplant Ivan and now ends with Ivan once more at the center of the crowd of spectators. He controls them with his gaze and finally acknowledges his role as an object of spectacle for the lens—that is, the spectator. This complicitous exchange of glances with the audience not only bares the whole device of Ivan as a figure of spectacle but also signals a swing back toward a comparative stability in the narrative. After the long digression into Ivan's personal situation that has occupied the film's first half, the proairetic series now focuses once again on the direct struggle against the foes of Russian unity. Previously, cause and effect had been split. Efrosinia and the other Boyars' guilt in killing Anastasia *should* have been the justification for Ivan's actions. We know, however, that he is unaware of that guilt, and because of this, his actions seem somewhat irrational. But when Ivan divines Efrosinia's guilt, cause and effect are linked: her murder of Anastasia retrospectively justifies

Ivan's persecutions of the Boyars. Although Ivan was right all along—a basic condition of the narrative's existence—he also *seemed* to be wrong for awhile—another basic condition, this time for the narrative's continuation. Having joined one cause and effect, the narrative will proceed to set up a new cause of which Ivan is unaware: the assassination plot formulated in the next sequence.

No other sequences use the pattern of Ivan as the center of an onlooking crowd so extensively as do the coronation, the Fiery Furnace play, and the recall from Alexandrov. Some small scenes within sequences employ this device, however, before shifting to another dominant for the remainder of the sequence.

One such subsequence occurs in Ivan's return to Moscow in the second sequence of Part II; he again gains dominance by moving to the center of the scene's space and forcing others to stare at him. The initial four shots of the galloping Oprichniki give little sense of locale or specific action; rather they set up an atmosphere of Ivan sweeping energetically back to Moscow to conquer the Boyars. A straight cut leads to Ivan's entry into the throne room. The space of the scene again involves a large open area into which Ivan moves, but this time the space is bordered by two lines of onlookers, the Boyars on one side and the Oprichniki on the other. The action of the scene involves Ivan's assertion of control over the Boyars by the formation of the Oprichnina, a system of land ownership that considerably diminished Boyar power. The film never shows any of the seizure or governing of this land (although Part III makes reference to the fact that much of the captured Boyar loot went into Ivan's treasury); instead the takeover is evident primarily through the presence of the Oprichniki in this and subsequent scenes. As Ivan enters the hall, he is now flanked by Malyuta and Fyodor (Fig. 64), both in black Oprichniki garb. Fyodor's new relationship to Ivan is briefly characterized in a pair of medium close-up shots (106-107). First Ivan, then Fyodor looks at the room, shifting their gazes from left to right (Figs. 65 and 66). In the remainder of this first part of the scene, most shots show Ivan moving slowly between the two lines of spectators toward the throne, speaking as he goes (Fig. 67); there is an occasional reaction shot. As Ivan moves up the stairs from the lower level of the room to the upper, the Oprichniki rush forward to gather in a group below him (117); as they do so, they blot out our view of the Boyars behind.

The end of this part of the scene comes with Philip's entrance. As often happens, the shift is marked by a camera movement: in

shot 122, the camera tracks back as Philip climbs the steps and shouts his challenge at Ivan (beginning of shot, Fig. 43, end of shot, Fig. 68). Philip appears as the new champion of the Boyars, and his entrance breaks up the spatial pattern in which the Boyars simply stand and listen to Ivan's mocking speech. The departure of the Boyars and Oprichniki leaves Philip alone to confront Ivan.

The sequence of Ivan's return is fairly simple in its relation of spatial patterning to its narrative situation. Much of its interest stems not simply from what happens within the scene but also from its juxtaposition with the flashback that Ivan soon narrates to Philip. The flashback shows us the earliest events of Ivan's story; the third of its three scenes includes Ivan's first assertion of his power, which occurs after he has returned to his own room after having been used by the Boyars to conclude a trade agreement that further depletes Russia's power. The sequence begins with a medium close-up of Ivan (175) in which he stares abstractedly (Fig. 69); this seems to suggest the beginning of his "visionary" gazes, as he prepares to propose his plan for Russia's future. In contrast to the previous scene in the throne room, we now see the private side of the Boyars' treatment of Ivan: they now make no pretense of including him in the space of the conversation, ignoring him as they bicker. His voice is first heard from offscreen during a shot of the two main Boyars (178). A cut reveals Ivan sitting beside his crown, which is quite prominent in the shot (Fig. 70). The crown seems to sit directly on the lower frameline, recalling its similar position in close-ups during the coronation sequence (I, 34, Fig. 39, and shot I, 39). This attempt by Ivan to assert himself leads to a shot/reverse-shot pattern in which the Boyars briefly face Ivan and ridicule his ideas about regaining the Baltic cities (180-184). Ivan crosses over to them to accuse them of wasting Russia's strength for their own gain; this movement leads Byelsky to turn away from him as the group laughs at Ivan. His apparent helplessness in the situation is emphasized by shot 186, which places him in the center background of the space, with two large Boyars closer to the camera at either side (Fig. 71).

This leads into Ivan's first assertion of power and his first movement towards being the center of the spatial organization. Shuisky crosses to the bed, and Ivan follows; this movement isolates the pair and sets up the subsequent one-on-one confrontation between them. Again this exchange is handled in shot/reverse shot until Ivan angers Shuisky. In shot 194, they are once more in the same frame, as the Boyar grabs Ivan and shouts at him. Two shots of Ivan in

the doorway follow, moving from a medium shot to a close-up, as Ivan's eyes narrow at Shuisky's suggestion that he is a bastard child. The seizure of Shuisky and the hurried departure of the other Boyars create a new spatial pattern. Significantly, Ivan is not left entirely alone: in the final shot of the flashback, he rises from the bed, watched intently by one of the kennelmen (Fig. 72). The film's equation of power with the position of being watched functions even in this presentation of an early point in Ivan's career. Ivan's final statement—"I will be Tsar!"—is made both to the audience and to a spectator within the scene (Fig. 73).

Ivan and Anastasia United

I suspect that many viewers tend to underestimate Anastasia's importance in the film because she participates in so little action. Aside from her resistance to the Boyars and Kurbsky during Ivan's illness and her one declaration that Ivan must be firm, she is a relatively passive character. But she is an important figure emblematically because she represents unquestioning loyalty to Ivan's cause.

Anastasia's importance also becomes evident in an examination of the structuring principles of the scenes in which she appears. In several of these, she functions together with Ivan to form a double organizational center. This happens in the wedding banquet sequence, in which the union of the couple begins as the principal subject matter. The coronation had specified only a little about her character; she gained virtually no clear-cut semes in her first shots. For all we knew at that time, her glances at Ivan during the coin pouring could have been leading up to a presentation of her as a mercenary character. Only in the shots of her during Ivan's speech do we get an indication that she shares and supports his vision.

The emphasis on the unity of Ivan's and Anastasia's relationship in the wedding banquet structures the space around symmetry. The introduction of Ivan into the scene begins with a device that echoes Anastasia's glance in the coronation sequence (25) just before the crane shot in which Ivan first appeared. Here, in shot 108, Kurbsky pauses on the steps as he enters the banqueting hall; he glances off left (Fig. 74). The next shot is a vertical crane down the wall to the kissing couple (Figs. 75 and 76). The wall, decorations, and chairs are all strikingly symmetrical. Throughout the scene, the cutting and framing proceed not from an orientation around Ivan alone but around the couple and their table. Most of the shots that include only the central table are perfectly frontal and centered; the objects

on the table and the elaborate triangular sideboard behind are mirror-images from one side to the other. In the course of the scene, the swans, the rows of double candlesticks, the two long side tables, and the stances of Kurbsky and Kolychev at either side of the head table all continue and reinforce the symmetrical arrangement of space.

By making Ivan and Anastasia the pivot for the space of the entire room, Eisenstein is able to organize the scene around its central narrative relationship. All elements in the interior shots group themselves evenly around the couple during the initial scene. In contrast, Efrosinia's foray into the corridors outside marks a departure from the symmetrical space. The compositions place her at the upper left in shots 131 (Fig. 77) and 132. The strong diagonals of the stairway arch and her posture as she leans over to listen differ markedly from the symmetry within the hall.

This symmetry is particularly apparent in the segment of the conversation with the two friends. An initial medium shot (134) of Kolychev brooding introduces the new line of action; then shots 135 (Fig. 78, a long shot) and 136 (Fig. 79, a medium-long shot) reestablish the symmetry of the setting by showing straight-on views of the head table. In the following series of shots, the orientation is always toward the center of the table; note how the action progresses from the right end of the table to the left:

137 MS – Kurbsky pouring wine, framed from his right (about the center of the table); he looks off left at Anastasia (Fig. 80).

138 MCU – A frontal framing of Anastasia, looking straight ahead; she turns and looks off right and up (Fig. 81).

139 MCU – Kurbsky, turning and looking left and down (Fig. 82).

140 MCU (as 138) – Anastasia shrinks back in her chair, turns, and looks off left with a slight smile (Fig. 83).

141 MS – Ivan and Anastasia. She looks at him; he looks right and up (Fig. 84), then down at her, pivots his body, and looks off left (Fig. 85).

142 MCU – Kolychev, looking abstractedly front and left (Fig. 86).

143 MS – Kolychev and Ivan; Kolychev turns and looks at Ivan.

144 CU – Kolychev looks front and up.

145 *CU* – Ivan looking off left, turns and also looks front and
 up, then off left.
146 *MS*(as 143) – Kolychev and Ivan, former kneels.
147 *MCU*(as 138) – Anastasia looks admiringly left.
148 *MCU* – Ivan looking off left, stands.
149 *MS* – Reverse, from behind the throne. Match as Ivan
 stands. Kolychev is at the right.

Here a two-shot of Ivan and Anastasia serves as the "hinge" of the
scene (141), allowing the cutting to proceed from a concentration
on Kurbsky to one on Kolychev.

The second return from the scene of Efrosinia's reconnaissance
outside involves the arrival of the swans. The lining-up of the swan
carriers on either side of the table climaxes the symmetry of the
scene (Fig. 87). Ivan gestures twice with his hand as if presenting
the swans for Anastasia's admiration. The cut-in to her pleased
reaction (165) does not simply emphasize Anastasia's naiveté (Fig.
88). It is important that she glances in several directions in the
course of this shot because symmetry is here presented as spectacle,
the object of contemplation and delight.

Previously in the scene, the couple had also been the center of
the spectacle, as Ivan had been during the coronation. Kurbsky's
glance (which we may already detect as envious after his exchange
with the Livonian ambassador) had initially been directed at the
couple's kiss. The scene then repeats this kiss, this time as the focus
of the guests' visual attention. Several times the assembly calls out
for them to kiss. The response has the quality of a ritual but also
that of a performance; they stand up to kiss and bow to the on-
lookers afterwards.

The entry of the rioters breaks up the symmetry, with the swans
seeming to look around and scatter in panic. The confusion at the
moment of dissolution is emphasized by the fact that each line of
swans crosses to the opposite side to exit, blocking off the view
temporarily. The servants remove the candlesticks from the ar-
rangement behind the couple; while the symmetrical lay-out of the
head table remains, it is deemphasized by the strong, diagonal light-
ing that casts irregular shadows to one side (Fig. 89). The next
series of shots of the crowd (174-178) and of the Boyars (179-180a)
all carry over the same screen direction, setting up a strong right-
to-left pattern that departs sharply from the symmetrical spatial
orientation of the previous segment.

The scene in which Ivan argues with the crowd begins with a reversal of some aspects of the spatial organization of the coronation scene, creating the suggestion of a threat to his hitherto invulnerable position of power and control. Here the cutting again moves between Ivan and the various members of the crowd, but now they speak and he listens, turning his head each time toward the speaker offscreen (Figs. 90 and 91). Yet Ivan remains the spatial center of the scene; the eyelines directed toward him still govern the cutting. In addition, the members of the crowd do not look at the fanatic as he speaks but continue to watch Ivan. In shot 212, there is a pause, after which Ivan begins to reply. At this point, the spatial organization returns to something similar to that of the coronation, with Ivan at the center of a ring of onlookers.

The entry of the Kazan ambassador breaks up this pattern much as the rioters had broken up the spatial pattern of the banquet scene. Here, instead of the swans scattering, Ivan turns, as the shadows of his guards move confusedly across the wall above him. The spatial organization of the confrontation with the ambassador is a simple one. Alternate shots of the ambassador and Ivan form a shot/reverse-shot pattern as the former presents his challenge. Ivan's defiance culminates in a close-up in which he flings his head back, looking up and left. The cut presents Malyuta in a similar shot, a medium close-up in which he stares off left and eagerly raises his arm. Malyuta replaces Ivan spatially and plays out a tiny scene of defiance of the Kazan ambassador that resembles Ivan's previous confrontation. There is no shot/reverse shot, but Malyuta rushes into the frame from the left (256, Fig. 92) as Ivan had done in shot 245 (Fig. 93). Ivan had forced the envoy to his knees; now Malyuta leads the crowd in sweeping him out of the hall altogether.

The parallelism of these two brief segments carries through the narrative developments introduced in the previous scene. The move of the people has been brought in earlier and has already undergone several changes. The people come decisively over to Ivan; Malyuta begins to act in his behalf. The crowd's invasion of the hall ends in an eager movement to begin the campaign against Kazan. At the very end of the scene (265), the spatial organization returns to its earlier footing, with a medium close-up of Ivan and Anastasia together (Fig. 94).

This specific concentration on Ivan's union with Anastasia drops out of the film for several sequences, but once Efrosinia has planned the death of Anastasia, the film returns to the couple for two scenes.

The first occurs in the bedroom as a preliminary to the actual poisoning; the second is Ivan's mourning by Anastasia's coffin.

The juxtaposition of Ivan's weighty duties of state with his brief moment of relaxation with Anastasia prepares the way for the poisoning, since the Boyars are attempting to curb Ivan's political ambitions by removing Anastasia. For this scene of their separation, she is dressed almost as she had been at the wedding, but he wears a black shirt that resembles in design his wedding clothes. About midway through the poisoning sequence, there is a shot of Ivan alone at his desk pulling his cloak about him (654, Fig. 95); the next cut moves the locale to Anastasia's bedroom with a close-up of a Madonna icon on her wall (Fig. 96). This introduction to the second scene of this sequence parallels the opening shot of the rooster emblem. The whole first scene had proceeded through abstract emblems and signs of Ivan's power and presence; now the Madonna icon becomes emblematic of Anastasia. The cutting in the first part of the bedroom scene leads from the icon to a general establishing medium-long shot of the room; the scene progresses through a series of shots containing elements that shift between dominant and overtonal status. Beginning with just the icon, these shots use the hanging lamps to introduce the components of the scene:

655 CU – The icon (Fig. 96).
656 MS – The same icon, with hanging lamps arching over it (Fig. 97).
657 MS – Anastasia's head on the pillow, with the lamps and icon visible behind (Fig. 98).
658 MCU – Efrosinia looking down and left, with lamps and two icons visible behind (Fig. 99).
659 MS – Efrosinia and Anastasia, with lamps and mirror behind (Fig. 100).
660 MCU – Anastasia's head on the pillow, with the icon barely visible behind (Fig. 101).
661 MLS – Efrosinia and Anastasia, with several icons and lamps (Fig. 102).

The revelation of Efrosinia by Anastasia's bed sets up both a balance and a sharp contrast between the two: their costumes are similar but in opposite colors of black and white. Later, in Part II, Efrosinia will don a costume similar to Anastasia's in this scene.

As Ivan joins Anastasia and Efrosinia moves away to the corner

by the doorway, the grouping sets up an opposition between the two parts of the room, with the short wall as a barrier. Each shot frames either the space on one side of the wall or that on the other, but not both. This continues until the moment when Ivan picks up the poisoned cup. Then a striking, slightly canted shot places Efrosinia in the lower left foreground, with Ivan in the upper right background, looking into the cup and carrying it out left toward Anastasia (Fig. 103). This brief union of the two spaces marks the passage of the cup across the barrier and the initial success of Efrosinia's plans. From this point, the scene again assigns separate shots to each space. Anastasia's hesitations over drinking from the cup do not necessarily suggests that she sees Efrosinia (Figs. 104 and 105); the eyelines are not clear enough for us to be sure. But her delay serves to allow our perception to linger on the act of raising the cup.[10] The cup's blocking of Anastasia's face serves to indicate the death itself, which is ellided by a fade (Figs. 106 and 107).

The sequence of Ivan's mourning by Anastasia's coffin ends in the final separation of the couple, and hence it acts as a sort of reversal of the wedding banquet sequence. This sequence also begins with a crane down; this time the movement begins with Anastasia and ends with Ivan, rather than ending on the united couple (Figs. 108 and 109). In the course of the action, Ivan never leaves the dais upon which the coffin rests but only moves up and down or around it. Thus once again he shares with Anastasia his position as the spatial center of the scene. This is reinforced by his frequent glances into the coffin and the resulting eyeline-match shots of her lying in state. These shots resemble the frequent inserts of Ivan's face after he has supposedly died in the sickbed scene; as we shall see, the inserts in that scene serve to maintain Ivan's importance in the narrative as others struggle to replace him. Anastasia is the only other character upon whom the spatial organization depends in this same way. Her absence creates a void that Ivan must fill before the action can continue; the insert shots of the coffin reassert this void until the point when Ivan decides upon establishing the Oprichniki. The final shot of Anastasia alone in the frame comes after this

[10] As Shklovski says in another context, "The motivation here is, of course, artistic: the necessity to create 'steps'." See Viktor Shklovski "On the Connection Between Devices of *Syuzhet* Construction and General Stylistic Devices," trans. Jane Knox, *20th Century Studies* 7/8 (December 1972): 60.

decision. It is closer and quicker than the others, and her expression has changed to a faint smile.

Ivan's immobility, his relative passivity in the first part of the sequence, and his repeated gesture of leaning against the coffin help create the important narrative turning point of the sequence—his first moment of doubt in his devotion to the goal. The various forces that seek to control his actions look on from different parts of the room. While Pimen reads, Efrosinia watches Ivan. Malyuta enters the scene by emerging from behind the coffin and standing at its lower end; he leans against it with his elbow while he reads. Malyuta and Ivan form a tight group around the coffin, which appears in soft focus in the background of all the shots of Pimen reading (Fig. 110). Ivan seems to sink to the point of despair; as he hears that the Boyars are rousing the people against him, he puts his head back against the edge of the coffin (729, Fig. 111). The composition, in profile and with Ivan's beard sticking up in the air, recalls a couple of the profile shots of him on his "deathbed" (519, Fig. 112, and shot 530). But as in the earlier scene, the illusion of defeat is only momentary. Ivan slowly rallies after this extreme of despair and hurls defiance at Pimen. A short series of shots (734-736) shows Pimen and Efrosinia leaving the cathedral. The fact that these are all long shots establishes the deserted spaces of the room and Ivan's realization that he has almost no support.

A simple repetition helps mark the stages of Ivan's progression away from a reliance on the Boyars toward the support of the people. As Basmanov outlines the formation of the Oprichniki guard, he pushes Fyodor to his knees beside Ivan; this echoes his own gesture of kneeling to the Tsar at the end of the illness sequence. Ivan's own suggestion that he leave the city and return only when recalled by the people is rejected by Basmanov and Malyuta. As often happens in the film, their disagreement with Ivan is expressed by the use of glances; they turn their backs on him. Fyodor's approval throws Ivan into energetic action, contrasting with his earlier inertia. Now, for the first time, he climbs above the coffin to look down on it and declare his purpose. This leads to a high-angle long shot (760) of the cathedral interior, with a crowd rushing in bearing torches. The narrative pauses for a moment of adulation, with separate close-ups of Fyodor, Basmanov, and Malyuta, leading to a medium close-up of Ivan. Ivan finally kisses Anastasia (766); this reverses the pattern of the wedding banquet, where a kiss had begun

the sequence. Their separation is complete, and Ivan must go on to become an "iron abbot" in future scenes.

Ivan Alone

Ivan is not always the center of an onlooking crowd, either by himself or with Anastasia. A few scenes show him alone or in conversation with a single other person, and here the emphasis on Ivan as a controller disappears or shifts.

During the first half of the sequence of Anastasia's poisoning, Ivan sends the Boyars out and confers with Nepeya, his ambassador to England. From that point, he dominates the scene through symbolic images of himself and his goal. There is almost no shot in the throne room that does not contain either an image of Ivan, a representation of his presence, or a symbol of his words (the two reaction shots of the listening Boyars are the only exceptions). The space of the scene is organized primarily around these emblems of Ivan rather than around eyelines, as in earlier scenes.

The action involves the progress of Ivan's plans to regain Russian land; the events themselves occur outside the plot of the film, and we merely hear reports of them. But the scene's expository function is worked out abstractly. Ivan's tirade against the Livonian blockage of English ships is first heard over the opening close-up images of a rooster (Ivan III's emblem) and the emblems of the three port cities, Riga, Revel, and Narva (Fig. 113); the cutting presents this series of shots twice before showing Ivan standing in front of them (Fig. 114). After the Boyars leave, the lighting creates further abstractions, so that the huge shadows of Ivan (Fig. 115) and the globe stretch over the walls of the vast, empty throne room. Even the cuts to Nepeya (643, 649) emphasize the shadows above him and make him a tiny figure (Fig. 116).

By placing Ivan alone among the emblems of his struggle (the globe, map, and chess set), the film prepares the way for the death of Anastasia: we become aware that she is his only support and that the burdens of his rule are already weighing heavily upon him. These emblems also recall the wedding scene, where the rooster was prominently visible in the crane down to the couple.

This scene also prepares the way for the later action in Part II, when Ivan momentarily gives in to Philip in his desire for friendship. We have seen how the seme of loneliness comes strongly into play only at that point, largely by means of the flashbacks. The second half of the sequence of Ivan's return in Part II again places him in

a large throne room; this time he speaks directly to Philip of his loneliness. But while the scene had begun with Ivan moving through the center of an onlooking crowd, Philip now pointedly refuses to face Ivan. As they find themselves alone, Ivan moves around, looking at Philip, but cannot get him into a face-to-face conversation (Fig. 117); Philip glances around over his shoulder at Ivan but looks away as their eyes meet. These gestures of turning away or looking into each other's eyes will mark the stages of the pair's relationship. Philip faces Ivan three times in the scene: twice to berate him for ignoring the wishes of the Boyars and again to accept Ivan's offer of the post of Metropolitan.

This coldness on Philip's part dampens Ivan's enthusiastic welcome. Ivan tries to soften his mood by offering him an explanation of the suppression of the Boyars in the form of information about his own childhood. I have claimed that the flashbacks function partly to establish the seme of loneliness by lingering on the point of its reintroduction. The flashback's first section begins and ends with close-ups of the terrified face of the young Ivan; in between, the mother abruptly appears and is then dragged away. By presenting the scene in this way, the film restricts the presentation to Ivan's point of view: the focus remains on the causes of the young Ivan's loneliness. Had the scene begun in another way—say, with Glinskaya on her deathbed and Ivan's entry to join her—the dominant focus would probably shift to some other aspect of the scene such as the Boyars' cruelty, the mother's suffering, the tender parting, etc. The placement of the boy in the hallway and the sudden intrusion and disappearance of the drama from his space permits a depiction of the mother's death as literally tearing her unexpectedly from Ivan.

The progression from this point in the flashback is complex in its implications for Ivan's present position. By the end of the flashbacks, Ivan has determined to reign alone, but he is no longer really alone: the kennelman now watches him. The latter serves as a reminder that Ivan reigns only because people from below help him defeat the Boyars. In his symbolic function, then, the kennelman is the forerunner of the Oprichniki, particularly Malyuta. (The narrative never suggests that this kennelman is a *companion* for Ivan. In general, the film creates a division along lines of rank; characters like the kennelman, the Basmanovs, and Malyuta are supporters of the Tsar, but he never accepts them as friends. In Part II, Ivan in his loneliness wants Philip as a friend but treats Malyuta as a

loyal "dog," a servant. This class distinction, curious to find in a Soviet film, results from the necessity for Ivan to reject his private persona. Since he cannot reject the people, the film must not link them to his private concerns.) Thus the scene's end suggests that Ivan must reject the Boyars. But in spite of the implications of the story he has just told, Ivan goes on to capitulate and turn away from his lonely role by acknowledging the influence of the Boyars in his arrangement with Philip.

This scene contrasts with the one directly following it, in which Ivan is alone in another chamber with Malyuta. The latter presents arguments against Ivan's concessions to Philip in the previous scene. Here Ivan turns away from Malyuta and at one point even pushes him out of the way. Ivan's surrender to Philip seems to have temporarily left him incapable of action. He remains stationary in this scene while Malyuta moves, approaching Ivan from the right in the first half of the scene (Fig. 118) and from the left in the second (Fig. 119). When Ivan does leave his throne, it is to seek refuge in Anastasia's chamber. There a similar pattern occurs; Ivan remains in one spot while Fyodor enters and moves about him, trying to spur him back into action.

The scenes of Ivan alone in Part II come at the low ebb of his struggle with the Boyars, the points at which he seems to give in to them or to use unacceptable means to defeat them. The structure of these scenes sets them apart from others in which Ivan is the center of a crowd.

Substitutes for Ivan

A number of scenes center around Ivan's absence or potential absence. In each, another character or other characters control the organization of the scene; these characters do so not in their own right, however, but as a replacement for Ivan. These scenes emphasize Ivan's absence by treating it as a structural void that must be filled, thus picking up and expanding upon the spatial pattern of the early part of the coronation sequence. These scenes fall into two general groups, those in which Ivan has no control over the nature of the substitution and those in which he designates his own replacement. I will examine the former type first.

The scene of Ivan's illness sets up a spatial opposition between Ivan's bedroom and the surrounding courtyard and two small chapels. This helps create a similar opposition between the presence and absence of Ivan. His potential absence throws everything into a

state of flux. In the course of the sequence, each major character tries in some way to fill the absence left by Ivan's illness and later his supposed death.

The opening shot shows the section of the courtyard with the icon above the cathedral entrance (Fig. 120). We have seen this icon before but never from such a close vantage point. The image resembles Ivan; moreover, a similar portrait was associated with Ivan through his standards in the Kazan battle. One such standard with a Christ icon appeared as an overtone in the background of the last shot of Ivan in that sequence (408, Fig. 158). As usual, the beginning of this new sequence introduces the structural pattern that will be dominant. In this case, the icon provides the first substitution of another presence—here a visual one—for Ivan's. Just before this sequence, we have seen Ivan at the end of the Kazan battle. There his decisive gestures and declaration that he is really the Tsar at last build the scene to a final high pitch; the icon shot then creates a sharp contrast to the strong "presence" of Ivan only a couple of shots earlier.

As at the very beginning of the film, Ivan's absence is first signified by a lack of consistent direction in the eyelines. The various Boyars and ambassadors stare in different directions but are simply waiting rather than watching. Consider the eyelines in the following series of shots, which follow the initial view of the icon:

411 *MS* – Boyar at right looks down and right. The center one looks toward the camera, the two behind have bowed heads (Fig. 121).

412 *MS* – Boyar at left looks front; others in soft focus behind (Fig. 122).

413 *MS* – Boyar at right looks front and left; the one at the left has his eyes closed, then opens them and looks left (Fig. 123).

414 *MCU* – The Basmanovs look off left (Fig. 124). Alexey lowers his head and closes his eyes; Fyodor glances right at him, then down.

415 *MS* – Three ambassadors stare down and in various directions (Fig. 125).

416 *MS* – Two foreground ambassadors stand with heads bowed; Boyars visible behind (Fig. 126).

417 *LS* – Kurbsky enters; the ambassadors turn to him for news.

The momentary orientation toward Kurbsky breaks up when he has nothing to report; again, the subsequent entry of Efrosinia and Vladimir orients the group only briefly. Vladimir and Efrosinia stop in medium close-up (423). They enter into the general pattern of glancing, as Vladimir gazes around aimlessly and Efrosinia stares up and right.

Two conversations between Kurbsky and Efrosinia occur in alternation with two scenes inside Ivan's bedroom. During the first conversation, Malyuta appears, first as a shadow, then directly. The unidentified voice that mutters, "the Tsar's eye," labels the new substitute for Ivan; Malyuta spies in order to protect Ivan during his illness—to compensate for his absence. Malyuta does not emulate Ivan so closely as to become spatially central during the sequence, however. Like the other characters who attempt to substitute for Ivan during his illness, he does draw the gazes of those around him. He interrupts Kurbsky and Efrosinia's tête-à-tête twice, and each time they turn and stare at him.

The procession and ceremony of extreme unction is organized in part as a grim parody of the coronation scene. Pimen blesses Ivan; the candle given to the latter and the book that covers his head parallel the scepter and crown. (The way Ivan's hand is framed in close-up taking the candle is particularly reminiscent of the earlier scene; Figs. 127 and 128.) But reverently as these actions are executed, the underlying purpose is to remove Ivan from power, and, as a necessary correlate, to remove his presence as spatial and visual center of the narrative. Hence the closed circle of priests that goes about their preparations at a distance from the bed (a spatial removal emphasized by a pan from the priests to the bed in shot 445; Figs. 129 and 130). And hence their hiding of Ivan from sight with the book—an action he struggles feebly against, first by lifting his head (454), then by peering out from under the book (458, Fig. 131). From this shot, the scene cuts to two views of an elaborately embroidered triangular hood, presumably to be used by one of the participants in the ceremony of extreme unction (Fig. 132). This forms a further parallel to the ritual of the coronation, with its resemblance, both in appearance and framing, to the crown (Fig. 39).

The second conversation between Kurbsky and Efrosinia resembles the first. The pair discuss the possible substitutes for Ivan: Dimitri or Vladimir/Kurbsky. Once again they are interrupted, this time by Malyuta's summons to the chamber. Although Ivan still

serves as the spatial center of the following scene, there are a number of new elements. This time not all those clustered around Ivan face him; the Boyars turn away at certain moments, openly signaling their treachery for the first time. A principal element of the scene also involves the frequent reminders of the possible substitutes for Ivan. The first shot introduces Dimitri in his cradle (Fig. 133); there is a cut to him as Ivan demands that the Boyars swear allegiance to his son (487). A shot similar to the first one of Dimitri also ends the scene in the bedroom.

As Ivan first speaks (beginning in shot 480), he attempts to assert his power as usual; at first, he successfully draws the attention of the onlookers. His struggle with the Boyars begins with conventional shot/reverse shots as he looks off right at them, and there follow shots of them looking off left at him. Then, as he says, "only an undivided, legitimate throne will save Moscow . . . ," he stares upward; his gaze recalls his original "vision" during his coronation speech. His movement from the bed continues this declaration and stare until his collapse.

From this point, the spatial relationships become less clear. The Boyars begin to turn away from Ivan, and the characters' eyelines become of little use as spatial indicators. The track backward in shot 501 marks the shift; at this point the Boyars cease to watch Ivan, turning away from him (Fig. 134). By the end of the scene, the Boyars are all oriented away from the bed, bowing to Efrosinia and Vladimir as they go out. Ivan is also forced to beg the individual Boyars for support on his knees. The end of the series of exchanges places Ivan in the background of a shot (509, Fig. 135), with Boyars in the foreground; the placement of Ivan deep in the frame shows him suddenly at a distance from the men he had been clinging to, indicating a new shift to a defiant tone.

His collapse signals the beginning of the real struggle among the potential substitutes for Ivan. But during the subsequent scene, the editing includes five shots of the motionless Ivan (Fig. 136), plus three of him as Kurbsky leans over him to see if he is really dead. So even though Ivan is apparently dead, the cutting pattern still returns to him at fairly frequent intervals in the action, maintaining him as a key spatial factor. Indeed, the editing here betrays a figure of distress; that is, the narrative introduces violence to a degree that almost causes it to overbalance itself. If Ivan were really dead—or if we absolutely believed he was—the film would have trouble continuing. In fact, the narrative stops short of entirely deceiving us

regarding Ivan's "death," for that would imply its own premature end.

At the same time, however, the editing shifts the action to the people who try to fill in for Ivan. After shot 519 of Ivan lying motionless, shot 520 shows Vladimir in close-up, looking anxiously down at Ivan, then shifting his glance slightly toward something else offscreen left. Shot 521 is an eyeline match on Dimitri in his cradle. Vladimir's glance has served to move the focus of attention. The series of shots that follows is:

522 *LS* – Efrosinia approaches the cradle from the left.
523 *MS* – Anastasia gets up from the bedside and moves left.
524 *LS*(as 522) – Anastasia pushes Efrosinia away from the cradle.
525 *MS* – Anastasia takes up Dimitri; threatened by Efrosinia, she runs out right. She begins to speak from offscreen.
526 *MCU* – Ivan's face. Anastasia's voice continues off.
527 *MS* – Anastasia with Dimitri, speaking.

The narrative logic of this cutting is quite plain, except for the shot of Ivan (526). Anastasia is taking up Ivan's argument, trying to assume his place by persuading the Boyars to swear loyalty to Dimitri. The cutaway from Efrosinia by the cradle (525) to Ivan (526) confirms this shift from Ivan to Anastasia and marks her role as substitute.

Kurbsky's entrance leads to a silent series of exchanged glances among Efrosinia, Kurbsky, and Anastasia. The moment is an extremely stylized one, with the simple compositions and gestures creating an abstract summation of the situation: Kurbsky is visually balanced between the mute appeals of Anastasia and the warning looks of Efrosinia (Fig. 137). Ostensibly, the scene follows Kurbsky's inner debate through his glances and expressions, but it also serves at least two other narrative functions. First, it suggests that Kurbsky might logically mistake Anastasia's tears and appeal for an indication that she might yield to him now that Ivan is evidently dead; this would motivate his choice of her over the apparently certain promise of power from Efrosinia.[11] Second, the text opts for

[11] This is not to suggest that Kurbsky has any psychological independence or really "chooses" his actions. But in presenting a set of plot events, a narrative film cues us in our mental construction of a chain of chronological causes and effects that constitute the story. Here we must posit a proairetic chain that would logically account for what we see Kurbsky doing.

silence in order to further deceive Kurbsky and the audience. Kurbsky's betrayal depends on his not knowing that Ivan is alive; since Anastasia is the only one who in fact knows this, she must not speak and reveal the truth.

The scene of Kurbsky's choice occurs in a hallway chapel that contains an icon which also resembles Ivan and serves to mark his absence. Kurbsky orients himself toward the icon as he debates with himself; it appears in the background of many of the shots of the scene. This is the one point in the film where Kurbsky attempts to imitate Ivan's visionary stare. In shot 553, he gazes upward in profile in front of the icon, trying to "read" the future as Ivan does (Fig. 138). Inevitably he chooses wrongly, since the only two options he sees are treacherous to Ivan.

The scene in the second chapel creates a brief initial orientation toward Kurbsky as he swears his oath. His glance off left holds those of the onlookers. After he kisses the cross, he and Efrosinia exchange a look that signals their break. Subsequently, as Ivan embraces Kurbsky, the glances exchanged between Kurbsky and Anastasia, and Kurbsky and Malyuta further indicate the impossibility of Kurbsky's deception. In betraying both the Boyars and Ivan, Kurbsky has left himself no way out but to betray Russia itself by desertion.

The return of Ivan brings about an elaborate reorientation of the characters in the chapel as all shift their gazes back to him. A slight temporal overlap on the action of turning (580-581) emphasizes the moment. In an instant, the whole structure of spatial orientation toward Ivan resumes, and all in the room become spectators again. Pimen and Vladimir can only stare in disbelief as Ivan bows to be blessed (587).

Ivan's appointment of Kurbsky to a position of high trust leads to another visionary gaze, as the two look off left to signify "the East" (Fig. 139) and front left when Ivan mentions the "sea" (590). This reaffirms the goal as set forth in the coronation speech; the stare toward an imaginary landscape particularly recalls the earlier speech. The narrative function here is to establish the direction for subsequent action: Ivan does not mention punishing the Boyars for their treachery during his illness; they will be free to go on plotting.

Ironically, Kurbsky does succeed to a degree in his attempts to substitute for Ivan. The Tsar appoints him as his representative to pursue the Livonian war. But Kurbsky has risked too much in his endeavor and must flee. Our next view of him is at the Livonian

court in the first sequence of Part II. There he tries a new tack to put himself in Ivan's place: he supports the enemy. The scene is something of a spatial parody of the coronation sequence, although it is briefer. Again the setting is an open space with a raised dais in the center. The onlooking figures are arranged in a wide horse-shoe-shaped group facing the space into which Kurbsky walks in the opening shot of the film proper (54, Fig. 140).

Once again the sequence alternates shots of the central action with shots of the onlookers—the monks, ladies, and knights. But the initial pattern of uncertain or confusing eyelines in the coronation sequence does not recur here; the space is clearly established at the beginning, and Kurbsky's arrival has no particular effect on the orientation of these onlookers. The eyelines are consistent, but some characters exchange knowing glances within their own little groups. The immediate strong conflict set up between Ivan and the Boyars as he glanced fiercely about the cathedral does not characterize Kurbsky's situation; the latter does not control his own position, nor does he seem aware of the listeners' reactions to him.

The central section of the scene has specific parallels to the moment of Ivan's crowning. The actions of handing sword and ribbon from Kurbsky to Sigismund and vice versa are accomplished in separate shots that frame each character to the exclusion of the other: Kurbsky passes the sword out of the frame; then there is a cut to Sigismund taking the sword from a point offscreen. Similarly, when Sigismund places the ribbon around Kurbsky's neck, only his hands extend into the frame; the gesture recalls the way Ivan's hands had come in to take the orb and scepter. Shot 61 begins with Sigismund in the lower right portion of the frame; the attendants enter with a cushion upon which the ribbon rests (Fig. 141). Again, the composition parallels that of Part I, shot 37, when Pimen took the orb from a cushion held by two men at the left of the frame.

The speech that follows is divided between Kurbsky and Sigismund. Its subject, of course, is the opposite of Ivan's: a desire to return Russia to its traditional form of feudalism. The cutting during Sigismund's portion of the speech follows the treatment of Ivan's speech to a certain degree, beginning with a medium-long shot and moving in closer (shot 77: Sigismund begins speaking/a medium shot of him/a medium close-up of the three women/a medium close-up of Sigismund talking/a medium close-up of one woman/a return to the medium close-up of Sigismund). The speech ends with a series of three shots moving further from Sigismund: shot 87, a medium-

long shot; 88, a long shot; and 89, a more distant long shot. This departs from the pattern of Ivan's coronation speech, where Ivan had remained in medium close-up until the end. When Sigismund refers to Russia's fertile resources, there is a cut to an admiring reaction from the woman onlooker who has clearly set her cap for Kurbsky. Ivan's parallel appeal to Russia's resources—specifically her rivers—was followed by the shot of Anastasia's empathetic reaction.

The arrival of the messenger with the news of Ivan's return to power breaks up the spatial pattern completely. By this point, Kurbsky has moved to the right front of the throne, listening to Sigismund. His movement to a place among the spectators has left the spatial arrangement of the scene very similar to that of the first shot of the sequence (Fig. 142). Now the messenger runs into the center of the group and makes his announcement. Quickly the group breaks up, with Sigismund signaling the onlookers to leave (Fig. 143). As in the illness scene, Kurbsky's attempt to set himself up as a substitute for Ivan fails. In each scene, the abrupt entrance of Ivan, or news of Ivan, destroys the group orientation toward Kurbsky, leaving him isolated and discontent as the sequence ends.

These attempts on the part of Ivan's enemies to replace him reflect an impulse toward a return to the status quo that existed before Ivan's coronation. In the opening sequence, Ivan had placed himself in power. Only later, in the flashbacks, do we discover that the earliest story events involved the Boyars' usurpation of Ivan's power. Kurbsky and Efrosinia seek to return to a situation where they may substitute themselves for Ivan without his interference, as the Boyars Shuisky and Byelsky had done in Ivan's youth. The middle section of the second flashback repeats several devices from other scenes to indicate the powerlessness of the young Ivan. The setting is the same throne room to which Ivan had come in the previous scene of his return to Moscow. The composition of the young Ivan peering in under the arch of the doorway and his entry into the room create obvious similarities to his original entry, although he now opens the right panel of the door rather than the left to look through. The shot of the Boyars bowing (151) after Ivan's entrance ironically parallels several shots of the Boyars in the initial scene of the adult Ivan's return. As before, the young Ivan walks the length of the room toward the throne, flanked by lines of onlookers.

Ivan again acts as an object of spectacle and the center of the

scene. But here the Boyars have manipulated the mise-en-scene within the plot, controlling Ivan's appearance of power for their own ends. While the control of the scene had come from the center in the coronation, the Fiery Furnace play, and Ivan's return, now the center—the throne and aisle—are essentially unheeded. Ivan is still a pivot in the scene in the sense that there are occasional shots of him listening and looking on; these inserts, however, somewhat resemble those in the scene by his bed after his supposed death in Part I: they assert his presence rather than show his contribution to the action. Although Ivan is in the middle of the space, the two Boyars argue *across* the throne as if he were not there (165-167, 169-170; Fig. 144). At the point where Shuisky strikes the ground with his staff and begins his declaration that Ivan has "reconsidered his decision" (160), Ivan is placed in the background of the shot, at the far left of the frame (Fig. 145); he is not present in any of the other shots of the actual presentation of the trade agreement. In these ways the scene reemphasizes Ivan's position as a puppet under the control of the Boyars. The irony of the bow toward Ivan that ends this portion of the scene also points up the spectacle function of his presence: he stands only as the emblem of power. The shot of his foot trying to reach the cushion by the throne underlines his physical inadequacy even for this symbolic function (Fig. 146).

A few other scenes center around characters who act for Ivan; in these cases, however, they do so by his command. The first case, the short sequence in which two messengers announce Ivan's wishes, is relatively simple. This marks Ivan's transition from faith in the Boyars to a dependence on the Oprichniki. The herald who reads the scroll wears rich robes and proceeds in a ceremonious fashion. The cutting is a rough alternation of shots of the herald and shots of the crowd; the people show respect to him as a representative of the crown by bowing to him. But as he completes his announcement, an Oprichnik steps out from behind the herald. His speech acts as a continuation of the herald's announcement but is treated differently. For one thing, he is more casual, dressed in a plain black coat, using his scroll to gesture with rather than read from, and moving about enthusiastically; clearly he is "of the people." This time the reaction shot is not a general view of the crowd as before but picks out two young men whose reaction must serve to suggest the entire process of the successful recruiting of the Oprichniki. (By

the next scene, they have apparently been entirely gathered together.)

In Part II, Malyuta goes beyond his former assumption of the role of "the Tsar's eye." He now volunteers to act entirely for Ivan when the latter's hands are tied by his capitulation to Philip. In the scene of the executions, Malyuta substitutes for Ivan; as with the herald, his authority for doing so takes the form of a scroll that he reads over the kneeling Boyars. But this time Malyuta has gone so far as to write the scroll himself, representing it as Ivan's decree. The execution takes place in the courtyard outside the cathedral. After a couple of shots of the struggle between the Kolychevs and their captors, shot 268 establishes a deep-space relationship with the Boyars in the foreground and Malyuta visible behind them. In keeping with his position as Ivan's substitute, Malyuta has dressed himself in a more elegant kaftan than he has worn up to now and stands under the Ivan-like icon over the cathedral entrance. (This icon appears in the background of five other shots of Malyuta as well.) He has also taken to wearing a black fur cloak similar to Ivan's (Fig. 147); this he shrugs off menacingly as he prepares to perform the executions.

The scene also creates a play with the positioning of the Boyars with their backs to Malyuta; this ironically echoes the previous sequence, where Philip's anger had been expressed through his refusal to face Ivan. Now the three Kolychevs (Philip's relatives) turn this into a defiant last gesture as they turn contemptuously away from Malyuta's reading of the scroll and proudly hold their heads high as they gaze forward (Fig. 148).

The cutting pattern of the scene moves gradually from general views to details, beginning with the establishing shots and ending with the extraordinary extreme close-up of one Boyar's neck (Fig. 149). This pattern of approach from a distance to extreme proximity emphasizes the important action of the first execution Ivan undertakes. Malyuta's hesitation and the shot of the neck also mark a shift in this scene toward a "Boyar-oriented" space and point of view—a shift that will become more prominent in the next scene. Had Malyuta simply struck the blow, the action would have been more straightforward. But by showing the neck, illuminated so as to bring out every detail of skin texture, the film emphasizes the executions as physical acts against individual characters rather than simply as tactics that play a causal role in Ivan's struggle with the Boyars.

In the next segment, Ivan's move toward Malyuta and then forward toward the bodies ends the pretense that Malyuta was actually removing all responsibility for the executions from Ivan's shoulders. Indeed, the ruse cuts no ice with the Boyars, who ignore Malyuta's part in the killings and concentrate on humbling Ivan. Ivan's stare offscreen seems at first to suggest that he believes he has gone too far. His last gesture and statement—"Too few!"—also hints at a growing madness and hence a new danger to the cause of Russian unity (Fig. 150). If Ivan has gone this far already, what excesses will he have to commit in defeating Philip when the latter really challenges him? His words also mark his considerable change since the last portions of Part I, where his "Too few" had referred simply to his lack of supporters gathered around Anastasia's coffin. Now he refers to his victims.

The major instance of a substitute for Ivan comes in the mock coronation and procession to the cathedral, with Vladimir dressed in the Tsar's regalia. In those scenes, Ivan sets up a situation for Vladimir that resembles his own coronation, but there are always ironic differences. The throne and red carpet define a central space around which the "admiring" onlookers gather. Vladimir takes Ivan's usual place as the center of this space and the group's attention, but the actions and framings of the "coronation" itself are very different from those of Ivan's. The ceremony of handing the orb and scepter are relatively perfunctory; rather than facing Vladimir respectfully as Pimen had done for Ivan, the latter stands smirking behind the throne. Nor does the crown fit Vladimir perfectly; Ivan mashes it down on Vladimir's head, making him look absurd in it (Color Plate 1). After this action, Ivan moves to the red carpet to bow to Vladimir. The new "Tsar" takes the homage as sincere, but Ivan has *not* completely relinquished his position in the center to join the crowd. Rather, he also remains in the open central space, leading the others in their bowing—only seeming to give up the position of power. Indeed, the long shot of the gathering (626, Color Plate 2) in which Ivan moves down the steps and bows to Vladimir places him in the center, the row of Oprichniki at the right, and Vladimir to the far left and background of the frame.

The procession continues the principle of Vladimir's apparent spatial control. In the long shot after he leaves the throne (648), Vladimir walks through the center of the scene, along the red carpet. His place seems to be that of leader at the head of the double column of Oprichniki. But the black figures are actually Ivan's

means of manipulating Vladimir; as Vladimir realizes his danger and appeals to Ivan, the Oprichniki gather in around him and force him toward the door (662, the last color shot of the scene). This relationship continues in the short series of shots in the courtyard. The first and last shots (663, Fig. 151, and shot 666) begin with Vladimir alone in the frame. The Oprichniki manipulate the space so that Vladimir constantly remains in an open space before them—the apparent place of the leader—yet has no choice but to go on. Unlike Ivan, Vladimir does not appear as the visual center in the procession scene; the Oprichniki's faces are hidden by their cowls, thus eliminating their gazes as significant factors in the action.

The first shot inside the cathedral opens the scene with a reemphasis on Vladimir's place as Ivan's substitute. This shot shows a close-up of the crown on Vladimir's head, with no portion of his face initially visible (Fig. 152). The shot recalls those close-ups of the crown in the initial coronation sequence (I, 34, 39) where it had seemed to perch on the frameline. Now, however, Vladimir's terrified eyes move into the shot (Fig. 153). His position at the head of the lines of Oprichniki continues through the scene as they force him gradually away from the pillars and into the open center area where the final portion of the scene will be played. Here occurs the only part of the substitution-charade that is in earnest, as Vladimir receives the blow that was intended for Ivan. Ivan's final triumph is that he is able to thwart the assassination plot precisely by doing what Efrosinia had hoped to do all along: put Vladimir in Ivan's place. But immediately after Efrosinia's assertion of Boyar dominance, Ivan steps forward to resume his place at the head of the Oprichniki.

In all these sequences in which other characters substitute for Ivan, the end result is the reconfirmation of his power. Two times Kurbsky sets himself up as a successor to Ivan, and both times he fails. Similarly, Ivan uses the people he intentionally places in his own position to his advantage.

Graphic Organization: The Ray Motif and Power Gesture

The space of the Kazan sequence is organized around the opposition of two heights: Kazan (especially the main pointed white tower) and Ivan's tent. The emblems of this opposition are the sun, which appears on Ivan's armor and standards, and the crescent moon, which decorates the top of the Kazan tower. By the end of the scene, Kurbsky has scaled the tower, and the sun emblem on his chest

takes precedence over the moon standard. Most of the action of the scene takes place in the valleys between these two heights and in the tunnels beneath them.

The sun emblem is one instance of a more pervasive graphic pattern that appears repeatedly throughout the sequence: I shall call this the *ray motif*.[12] As in many sequences of the film, Eisenstein introduces a central motif or spatial principle at the beginning; in this case, the ray motif appears in the first shot (267) as the huge, spoked cannon wheel rolls in front of the lens (Fig. 154). The ray pattern appears again in connection with Ivan in the sun emblem on his chest and shield and in several standards near his tent. It can also be seen in the five fuses running out from the candle in the tunnels (Fig. 155) and in the patterns of clouds that seem to radiate from Ivan as he awaits the explosions (especially in shot 380). Then the explosions themselves take up the ray motif, throwing up columns of smoke and earth from a central point (Fig. 156).

This succession of the ray motif's appearances does not have a single meaning but comes to associate itself generally with Ivan and his power. We may recall that the narrative function of the Kazan sequence is to prove Ivan's military capability without bringing his assumed ability to defeat Livonia into direct question. (Significantly, Ivan's own assumptions about the campaign—that it proves he is really the Tsar—are voiced only at the *end* of the sequence. This had not been the stated premise of the scene.) Ivan's unassailed position on the hilltop and his power are linked with the ray motif: the radiating clouds, the gunpowder he has planned, and the cannon that attack the town.

Finally, as the sequence ends, both Kurbsky and Ivan spread their arms in a gesture of triumph (Kurbsky in shots 404 and 405, Fig. 157, Ivan in 407 and 408, Fig. 158). Without the intervening shot of smoke (406), the cut from Kurbsky in 405 to Ivan in 407 would be a close graphic match on their gestures and positions. This is a development of the ray motif: the rays of the sun emblem on their chests are now represented by their outflung arms. The associations of power are transferred to this new motif, which I shall call *the power gesture*.

This gesture does not return until late in the scene by Anastasia's bier. There, Ivan stands above the coffin and flings his arms out to

[12] See David Bordwell, "Eisenstein's Epistemological Shift," *Screen* 15, no. 4 (Winter 1974/1975): 43.

the side (in a low-angle medium shot missing from American prints: 759, Fig. 159) as he shouts, "Two Romes have fallen. Moscow is the third," and lowers them abruptly as he continues, "She will stand firm, for there will never be a fourth!" This moment when the power gesture returns leads directly into the high-angle long shot of the crowd pouring into the cathedral. After this, the gesture disappears again for a considerable stretch of the film. Ivan's seme of power is reiterated time and again but always with other devices (e.g., with the main musical theme, the device of the stare, the organization of space around him). But at last it returns as a primary organizational principle in the feast scene of Part II and continues into the cathedral scene that follows. Again, the very first shot contains the gesture of outspread arms in the icon of God painted on the ceiling above the dancers (Color Plate 3). The dance itself emphasizes the gesture as two Oprichniki fling a third repeatedly into the air; the latter spreads his arms in close imitation of the icon's gesture (490, Color Plate 4). Shot 490a continues this action with a close graphic match on the same figure; the icon is visible in shots 490 to 497 and 500 to 501. Many of the subsequent dance steps involve this same basic gesture of spreading the arms; Fyodor in particular uses this movement a number of times (Color Plate 5).

The power gesture also enters the graphic pattern of the feast scene several other times. As Ivan claps for the regalia to be brought in (607), he spreads his arms in the gesture (Color Plate 6). Then, as he leads Vladimir to the throne, the camera is placed at a low angle to introduce the God icon into the scene once more (618-619, Color Plate 7). Several shots of Vladimir on the throne during the mock homage contain the icon (629, 632, 634), and it is prominent during the beginning of the procession to the cathedral.

Eisenstein has spoken of the feast sequence as an "explosion"[13] prior to the death of Vladimir. A part of this explosion is the reintroduction of the power gesture, which we have not seen since the mourning scene in Part I but which will soon become a central element. For one thing, the gesture is repeated in the fresco of the Last Judgment in the cathedral; this painting appears in a number of shots both before and after Vladimir's death. In the fresco, God

[13] Sergei Eisenstein, "Extrait d'un cours sur la musique et la couleur dans *Ivan le Terrible*," in *Au-delà des étoiles*, trans. Jacques Aumont et al., ed. *Cahiers du cinéma* (Paris: Union Générale d'Editions, 1974), p. 291.

sits with arms outspread, one hand holding the scales of judgment. From the figure of God emanates a series of even, spokelike rays of light (Fig. 160), thus signaling a reunion of the power gesture with its origin, the ray motif. The combination of rays with the power gesture of spread arms reiterates the links between the two motifs in preparation for Efrosinia's line over what she assumes to be Ivan's dead body; her words finally verbalize the symbolic material behind the two visual motifs. As she puts aside the hanging ends of her headpiece, she spreads her arms in the gesture (Fig. 161) and says, "Russia will begin to shine under the power of a Boyar Tsar" (literal translation). This recombination, both in word and image, comes at a moment of culmination for the entire move of Ivan's struggle against the Boyars.

The return to the banqueting hall after the death of Vladimir also brings us back to the original God icon on the ceiling, which now hovers over Ivan. As he raises his arms for the last time in the gesture (726, Color Plate 8), he once again echoes the position of the arms in the icon. His line, "My hands are free," also reinforces the association of the gesture with the concept of power.

The ray motif and its metamorphosis into the power gesture are important devices in tracing Ivan's progress in the accomplishment of his goal. They reiterate again and again the seme of power and its inevitable attachment to Ivan. Ultimately, the moment at which Efrosinia finally openly tries to seize power is the moment of Ivan's greatest power over her.

Characteristics of Boyar Space

The short scene between Kurbsky and the Livonian ambassador that opens the wedding banquet sequence sets up a pattern that returns at other moments when characters plot against Ivan. Generally the space is less clearly centered around looking and around a central spectacle than when Ivan is present. In simple conversations between two characters, they do not face each other squarely. The Livonian ambassador, for example, stands behind Kurbsky and speaks over his shoulder, while Kurbsky faces directly away from him, toward the front and slightly left (Fig. 162). An almost identical relationship occurs in the scene of Ivan's illness, as Efrosinia tries to tempt Kurbsky into supporting Vladimir (Fig. 163). In more complex group scenes, characters also tend not to exchange many glances while speaking; as a result the spatial arrangements become decentralized in scenes in Efrosinia's chamber. Only in the scene of

the Boyars' mourning do they achieve (briefly) a powerful focus around a strong figure comparable to Ivan.

The conference in Efrosinia's chambers in Part I is the first entire sequence in which Ivan does not appear. It has a relatively simple spatial organization, concentrating on Efrosinia as she formulates the plan to kill Anastasia. As in the scenes between only two characters, Efrosinia faces away from the other Boyars when they make their complaints to her; even on standing up, she turns and speaks with her back to them. Similarly Pimen enters and casts himself down on a bench so that he faces slightly away from the group. Most of the framing concentrates on these conversations. The only exception is the pair of shots in the cutaway to Vladimir, who does not enter into the talk. His frightened reaction to the idea of fighting Ivan helps motivate his future reluctance to take part in the assassination plot of Part II.

The function of this scene is primarily expository. Where a Hollywood film might provide a montage sequence of Ivan's progress in replacing the Boyars with officials drawn from the people, Eisenstein sums up these events in the dialogue. But aside from providing information, the scene firmly establishes a difference between the organization of scenes set in the Boyars' own space and those set in spaces controlled by Ivan's presence.

The pattern becomes somewhat more complex in the sequence of the mourning for the executed Kolychevs. Where the earlier scene had contained two central characters (Efrosinia and Pimen), the mourning scene represents the Boyars' attempt to place a single strong figure in opposition to Ivan. Now virtually the entire scene involves people organized around Philip, gazing at him as they await his decision. The first shots introduce the spatial pattern of supplication; initially the group of Boyars gesture pleadingly toward a point offscreen (288). The third shot (290, Fig. 164) reveals Philip staring fixedly away from the mourners.

Most of the shots of the latter part of the sequence emphasize the positions of the other Boyars behind Philip. As Pimen and Efrosinia try in turn to convince Philip that his duty is to help them, they move to stand above and behind him. One particularly striking composition (305) lines them up with Philip's head at the lower frameline to the left of center, Efrosinia behind him and to the right, and Pimen behind her, his head in the upper right corner of the frame (Fig. 165).

By the end of the sequence, Philip has responded to their argu-

ments and resolves to set himself up in opposition to Ivan. Up to
now, he has been sitting by the coffins with the others standing or
leaning over him; now he rises and fills the foreground of most of
the remaining shots of the sequence. At one point he leans forward
very close to the lens (310, Fig. 166); this gesture emphasizes his
stare, which becomes a key device for the next sequence, his con-
frontation with and defeat by Ivan. His visionary stare is the first
to really parallel Ivan's, suggesting that Philip *may* be powerful
enough to cow Ivan (which he has already done once in his earlier
conversation with Ivan in Part II). As we have seen, such a threat
is necessary in order to give the narrative the momentum it must
have to continue. The failure of the Boyars to respond at this point
would signal their defeat. Shot 313 shows Pyotr kissing Philip's
hand and staring front with great emotion; this serves to continue
reminding us of his presence and devotion to the Boyars, until the
time comes for him to become more prominent in the action. The
upward stare also links him with Philip; they both seem to have a
"vision" of the cause they now set up in opposition to Ivan's. The
other Boyars do not have this stare: they are not visionaries but
work only for self-interest (Efrosinia for her son's advancement,
Pimen to protect church property). Pimen indeed is willing to aban-
don Philip for his own ends and to send Pyotr to what appears to
be certain death in the assassination plot. But both Philip and Pyotr
are selflessly devoted to their cause. This perhaps also helps to
suggest a new and more formidable opposition to Ivan, one that
finally drives him to the point where he must renounce personal
ties.

The Boyars' assassination plot is formulated in Efrosinia's cham-
bers. More of the room is visible in the course of this sequence than
in the plotting sequence of Part I. Here various portions of the room
become the locales for the individual segments of the action. The
narrative involves many abrupt changes and realliances as the di-
visions among the Boyars suddenly surface: after the Boyars plan
Ivan's assassination, Efrosinia parts ways with Pimen, and Vladimir
reveals his reluctance to go along with Efrosinia's plans. Through-
out the sequence, the characters frequently enter and exit, often
unexpectedly, creating spatial shifts in the grouping and positioning.

No one character or group provides a spatial anchor for the
organization of space in this sequence. Instead the set contains a
single, low central pillar where the arches of the low ceiling meet,
creating several distinct sections within the room (Fig. 167). The

action shifts, often abruptly, from section to section. This sequence also contains more compositions in depth than most others, allowing it to set up links and contrasts between the actions in different parts of the room.

As usual, the opening shots introduce the pattern of the sequence. Initially the frame contains a closed door; no one is visible. Then Efrosinia comes running in to deliver her message that Philip has been arrested. A cut reveals a deep-focus view with her in the background and the Boyars eating at a table in the foreground (Fig. 167). The pillar is in the middle ground, and they duck past it as they run to meet her. The decision to have Pyotr kill Ivan leads the action to yet another section of the room, as Pimen leads the boy toward the icon set in the wall. As the blessing "ceremony" proceeds in another deep-focus shot (417), Efrosinia is in the foreground picking up the knife (Fig. 168).

Not all shots with planes of action in depth use deep focus, however; rack focus becomes an important device here for the first time in the film. Previously it had been used only five times, scattered throughout both parts; in this sequence, it occurs nine times. The new prominence of planes of focus follows and emphasizes the characters' movements from one section of the room to another, signaling shifts in the action. Often the racking process does not exactly follow the movement, and a character will pass through a zone of soft focus at the central portion of the movement; thus the different planes and sections of the room's space become particularly noticeable. Some examples of such rack-focus shots include Efrosinia's entrance in the first shot (399), Pimen and Pyotr's movement toward the altar for the blessing (415), Pimen's walk into close-up after he has blessed Pyotr (423), Vladimir's dash across the room to the table to escape Efrosinia's plans for his reign (462), and Malyuta's thrusting of the cup directly into the lens (475).

Several major elements around the edge of the room act in relation to the central pillar to define the separate spaces of the action: the icon, the table, the door, and the chair. Characters move from one to another around the pillar; note how Vladimir keeps scuttling around the pillar to escape Efrosinia, for example. The pillar also provides a spatial anchor by appearing in the background of several shots of Vladimir sitting on the chair as Efrosinia urges him to seize power (456-457).

Vladimir's exit brings the sequence full circle with the shot of the doorway resembling the opening shot (483). Again, the frame is

initially empty, and Vladimir moves into it. This leaves Efrosinia alone in medium close-up, with the pillar appearing in the background as she gazes down into the empty cup (488). The final shot of the sequence frames the cup on the table, recalling similar shots of the cup on the balustrade of Anastasia's room in the poisoning sequence in Part I and the scene in the same setting in Part II (Fig. 169).

In general, in terms of spatial organization, the scenes that are controlled by the presence of the Boyars are distinctly different from those in which Ivan is present. We have seen how many situations and characters are defined by eyes and looking: Ivan's piercing gaze that others cannot meet, Philip's failure to outstare Ivan, Malyuta's function as a spy, and so forth. Similarly, the treacherous plottings of the Boyars become associated with the failure to face each other. In addition, the strong orientation of the scenes with Ivan disappears in the two sequences in Efrosinia's chamber; here characters may group briefly about a single figure, but they shift and regroup in the course of the scene. To some extent this ties in with both their failure to oppose Ivan directly and their reliance on treacherous means; when they do set up Philip as a champion to fight Ivan, the group immediately ranges itself around him as if drawn by a magnet.

An Isolated Case: Direct Audience Address

The short sequence that ends Part II forms a special case. I have called it a "reaffirmation," since it functions only to redirect the narrative toward its original goal of war with Livonia; thus it puts a check on the extreme digression from the central proairetic move that occurs in Part II. The unusual thing about this sequence is its relative lack of motivation from within the narrative. We are given no definite cues concerning what is supposed to be going on in this sequence. Does it occur directly after Vladimir's death? The setting and lighting are similar to the feast scene, but Ivan wears a different costume. More interesting is Ivan's physical orientation away from the Oprichniki troops and directly toward the camera. This last scene has Ivan casting his eyes about toward the front as he speaks, but in the last shot he sits and apparently addresses the audience directly. The Oprichniki do not function as the recipients of the speech, since they apparently stand only behind the throne. They reinforce Ivan's words by raising their blades exactly as Ivan speaks of the "sword of justice" (726, Color Plate 9). Together, Ivan and

the Oprichniki form the spectacle of this last sequence. This is the only sequence organized wholly around the audience's view of Ivan.

As a result, this final sequence moves partially out of the main diegesis to implicitly acknowledge *Ivan*'s propagandistic function in the historical context of World War II and its aftermath. The effect is similar to that of the last scene of *Alexander Nevsky*, when Alexander faces the camera to give his speech about the invaders of Russia "dying by the sword." In each film, the final scene puts the entire preceding action on an abstract level: the protagonist speaks to the audience in such a way as to suggest a parallel between historical and contemporary situations. This is the only such moment in the finished portions of *Ivan*; as we have seen, it is stylistically distinct as well.

The Floating Motif

A great part of *Ivan*'s narrative redundancy seems to come from the film's profusion of visual motifs. A motif is not simply a recurring element. Something beyond repetition is necessary to create a motif as such. At least one occurrence of an element must be marked by a narrative motivation. Otherwise the repetition remains part of the general network of background mise-en-scene. Ben Brewster has called the marking of a cinematic element as pertinent "parallel motivation"[1]; that is, at least two cinematic channels serve to suggest the element's importance. As we shall see, *Ivan* frequently introduces devices (cups, eyes, birds) that vary in their direct relevance to the action from one repetition to another; each motif, however, plays a major narrative role at least once, thereby creating parallel motivation. Thus repetition suggests a play of motifs, while narrative significance confirms and foregrounds the motif.

In order to discover how the motifs support the narrative, we must be able to detect their salient structures, and this is difficult to do without a context. Here again I will need to use the background set of classical Hollywood cinema. Eisenstein's use of motifs differs from Hollywood's in at least three main ways. First, he uses a great many more motifs: eyes, candles, birds, bells, coins, icons, and other visual motifs combine with the repeated musical pieces to create a dense weave of motifs at play. Second, he seldom allows these motifs to become firmly attached to any one character or action: by the later portions of *Ivan*, the repetition of a single motif has considerable force, for it recalls a whole series of diverse moments in earlier scenes. Third, these motifs are not usually embodied in devices that play a major causal role in the action; instead, they exist in the mise-en-scene "alongside" the causal agents of the narrative. If all the birds in the film were removed, the basic proairetic

[1] Ben Brewster, "Notes on the Text 'John Ford's *Young Mr. Lincoln*' by the Editors of *Cahiers du cinéma*," *Screen* 14, no. 2 (Autumn 1973): 33-35.

code would remain virtually unchanged. The removal would, however, bring about a major change in the film's perceptual cues.

The previous cases, *Sergeant York* and *Mary of Scotland*, provide examples of the classical narrative cinema's use of motifs. Both have a relatively limited number of motifs, both assign these motifs specific, firm associations, and both motivate their motifs by making them causal agents in the actions.[2]

In *Sergeant York*, Alvin York has several characterizing motifs: drunkenness, lightning, books, guns, and turkeys. His fiancée, Gracie, has one association—the bottom land York wants to buy in order to marry her. The causal functioning of all these motifs is clear. York gets drunk because his life is so difficult that he must "cut loose" occasionally. Lightning causes his conversion, which is motivated in an earlier scene when the preacher says that religion may come to York "in a flash, like a bolt of lightning." York's experience with a gun becomes important in the first scene when he disrupts a church service by shooting his initials neatly into a tree outside; just before his conversion, he tries to win the bottom land by shooting turkeys in a contest. His conversion leads him to read the Bible, but after he resists fighting in World War I, he discovers that the Bible is in conflict with a book of American history. The resolution of the conflict in favor of fighting for his country leads to the scene in which he shoots the Germans, "just like a flock of turkeys." Not one of these motifs comes into the film except when it plays a specific and important causal role; each use of a motif assigns it a specific meaning.

Motifs are rare in *Mary of Scotland*, and they are more often musical than visual. Ford uses transitions that match shots of windows several times to suggest the common situation of Mary and her lover Bothwell when they are in prison. One such transition occurs after Bothwell dies and is accompanied by a lightning storm; a similar storm occurs as Mary ascends the scaffold in the last scene. Mary's comparison of herself to a star during a romantic discussion with Bothwell also recurs obliquely in the last shot as the camera tilts up from Mary's transfigured face to the dark sky. But most of these motifs occur only twice, functioning to create a parallel between the death scene and earlier scenes. In this way, the motifs support the general narrative pattern that suggests that Mary is

[2] I shall concentrate on visual motifs here and discuss the sound devices in Chapter Six.

finally triumphing over her political struggles by being allowed to join her lover in death. None of these motifs returns at any other point.

Eisenstein set down his views on motifs in various places; one good summary occurs in a transcript of his teaching, published as "Extrait d'un cours sur la musique et la couleur dans *Ivan the Terrible*." As the title suggests, he was mainly speaking of the color and musical motifs; these statements apply equally well, however, to the other motifs of the film. In speaking of the color motifs in the Part II color sequence, he says:

> The importance in the event is that they break their initial tie with the object. For example, the theme of red commenced with the red robe, it is repeated with the deep red of the tapers, and when Vladimir goes to his death, the theme of red turns into the carpet dividing the decor and interrupted by the door. You must detach the different red objects, take their common color and combine them in a function of this common sign.[3]

He goes on to say that he does not want to associate colors with people but with a "certain moment in the drama."[4] As an example, he points out that Ivan goes from red to black at a shift in tone of the scene. He presumably refers here to Ivan's resumption of his black cloak over his red kaftan at the point where he comes over to "crown" Vladimir, which does indeed seem a significant break in the scene. Later, the Oprichniki don their black cassocks at the shift to a more sombre tone. Eventually the move back to black and white film stock emphasizes the shadowy darkness of the cathedral. The combination of black elements marks a progression in the scene without having a fixed meaning. For Eisenstein, then, motifs float free of specific characters to a larger degree.

But the use of such motifs is not random. Aside from the wide range of associations that they pick up in their repeated uses, they provide added perceptual material for a scene. When several elements are presented simultaneously, the spectator must take some time to perceive them. This time is not the same as the temporal progression from cause to effect in the plot. On the contrary, it

[3] Sergei Eisenstein, "Extrait d'un cours sur la musique et la couleur dans *Ivan le Terrible*," in *Au-delà des étoiles*, trans. Jacques Aumont et al., ed. *Cahiers du cinéma* (Paris: Union Générale d'Editions, 1974), p. 288.

[4] Ibid., p. 291.

creates a "wedging" effect, breaking up the concentration on that progression.

I will begin by looking at some of the more conventional uses of motifs in *Ivan*: those motifs that are used specifically to create parallels between certain scenes and actions. This, I have suggested, is a classical use of motifs. From there I shall proceed to examine the more free-floating motifs that tend to pick up a number of associations rather than to create tight parallels.

THE CREATION OF PARALLELS THROUGH MOTIFS

One of the simple devices that recurs in similar situations throughout *Ivan* is a "sinking" movement of a character. Ivan's triumphs often lead to the defeated character sinking out of the frame. For example, as Ivan addresses the rioters in the wedding banquet sequence, he makes a fierce gesture and suddenly shifts his gaze to glare off right and front (I, 218). In the next shot, the fanatic stares fearfully off at Ivan and ducks down until he is entirely out of the frame (Fig. 170); the cross atop his staff is just visible at the bottom frameline as the shot ends. Shot 246 of the same sequence contains a similar device of a sinking character. Ivan towers over the Kazan ambassador, holding up the dagger the latter has brought him; Ivan's defiance seems to drive the ambassador, in the lower foreground, down out of the frame (Fig. 171). Near the end of the sequence (263), a variation on the motif appears, as Efrosinia reacts fearfully to the crowd's enthusiasm by moving back toward the wall. She moves directly away from the camera but remains facing front; the medium-shot framing prevents us from seeing any part of her body that is moving, making her seem to shrink within the frame rather than move back (Figs. 172 and 173). In each of these three cases, the image is clearly associated with Ivan's defeat (temporary, in Efrosinia's case) of a character. In the scene following Ivan's recovery in the illness sequence, Malyuta and Anastasia stare accusingly at Kurbsky as he embraces Ivan. Kurbsky then slips down behind Ivan (595); in the next shot, we see him coming to rest on his knees on the floor. A further variation on this motif occurs in the Livonian court scene. As the messenger announces Ivan's return to Moscow, a cut reveals Sigismund turning and signaling the onlookers to leave. As he turns, his high ruff swings around and covers his head (Fig. 174), blocking him out and signaling his (again temporary) defeat. The sinking motif is another

means of reiterating Ivan's power semes at moments of his assertion of control.

A lighting motif serves to connect the deaths of Ivan's mother, Anastasia, and Vladimir. In each of the scenes in which these deaths occur, a strong shaft of light from an open door picks out one of the central participants in the scene. As Ivan enters Anastasia's room, the offscreen door creates a patch of light around Efrosinia and casts her shadow on the steps leading up toward Anastasia (Fig. 175). Similarly, Ivan's mother staggers through a door and falls into the shaft of light cast on the floor of the dark hallway (Fig. 176); when the Boyars drag her away, they close the door and leave the young Ivan once more in darkness.[5] Finally, a high-angle long shot in the procession through the cathedral shows Vladimir stepping into a huge area of light and casting a large shadow as he moves toward the waiting assassin (Fig. 177). This limited use of a striking device allows the film to draw strong parallels among these three scenes.

The international intrigues in which Ivan engages are linked with the image of the chessboard. Initially Ivan compares the struggle to a game as he uses the chesspieces to demonstrate how English ships may elude the Livonians. The setting of the Livonian court resembles a chessboard not only because of its checked floor but because the furnishings and people resemble chesspieces—particularly the elaborate throne and large carved pillar at the left (see Figs. 140 and 142). The comparison is made even stronger by the mural of black and white knights in combat. As I mentioned in Chapter Two, the game motif was to have recurred in Part III as well.

One of the briefest motifs concerns the coins, which create a parallel between the coronation scene and Kazan. The ceremony of pouring coins over the new Tsar is quickly associated with "long life" by means of the choral voice-over; the tribute comes from the Boyar class in this case. Later, the coins dropped into large bowls by the soldiers are again connected with life. This time they enumerate the lives sacrificed in the upcoming battle. The important narrative difference involves the fact that the coins are now the emblem of Ivan's alliance with the people; their strength is allied

[5] Note that Efrosinia wears a black cloak in the poisoning scene that makes her look like these Boyar women.

with the symbolic strength indicated by the shower of coins over his head.

The use of kisses in the film is strongly marked, since the narrative is largely asexual. The sexually related kisses come at the wedding banquet, where they seal the union between Anastasia and Ivan. The union also ends with a kiss in the scene by Anastasia's coffin. But sexuality in the Anastasia-Ivan relationship serves primarily to signify Anastasia's position as utterly loyal to Ivan, and by extension, to his goal. His moment of departure from her is also the moment of decision to form a guard modeled on the idea of religious renunciation of worldly ties for the dedication to the goal.

Kurbsky twice kisses objects as a declaration of loyalty: in one instance, he kisses the cross in a hypocritical effort to keep Ivan's trust, and in another, his sword in his betrayal of Russia by his new allegiance to Livonia. A more earnest swearing of allegiance comes as Philip determines to humble Ivan, and Pyotr kisses his hand fervently; here the act serves to continue the motivation for Pyotr's later sudden willingness to die for the Boyar cause. In Part II, two kisses confer a mission of betrayal: these occur when Ivan sends Malyuta to kill the Kolychevs and when Efrosinia sends Vladimir to usurp Ivan's place.

The use of fur in the film is perhaps so pervasive as not to constitute a specific motif. At a few points, however, this element is marked enough to create narrative parallels. The trim of the crown sets up the idea of the adornment of the Tsar with fur; Efrosinia takes up this idea in her lullaby. She describes the beaver's fur as black, and black is the color of Ivan's huge fur cloak. The explicit union of crown and lullaby comes near the end of Part II, as Efrosinia continues to sing the song in a broken voice to the crown, which is left in her hands after Vladimir's body is dragged away.

THE ACCUMULATION OF ASSOCIATIONS THROUGH MOTIFS

More interesting, and specific to *Ivan*, are the motifs that avoid these clear associations. The eye motif is a particularly important structure in *Ivan*, since so much of the film's narrative depends on the symbolic status of different character's glances. Ivan is defined as supremely powerful because he is able to remain both the spatial and visual center of most situations. The gaze is emphasized in three basic ways in the film: 1) in the eyeline patterns of editing that we have examined, 2) in the prominence of stylized eye gestures in the

acting, and 3) in the motif of the "single eye." In this latter pattern, characters (and images within the frame) repeatedly have one eye covered as they glance at each other.

This single-eye motif is more prominent in Part I; we first see it in the scene of the Livonian ambassador's sly questions to Kurbsky at the beginning of the wedding banquet sequence. Every shot in the short segment, no matter which angle it is taken from, shows the ambassador with one side of his smoked glasses flipped up and the other side flipped down covering his left eye (Fig. 162). This might seem to connect the device with treachery, yet the next time it appears, it is Anastasia who covers one eye with her sleeve in her delight at the swans as she glances shyly at Ivan (Fig. 178). Clearly the two glances are very different, perhaps suggesting that the different uses of the single-eye motif characterize the persons and situations they are associated with.

Ivan glances with one eye from beneath the Bible as he supposedly lies dying (Fig. 131). There are no narrative cues to indicate that Ivan suspects anyone of trying to murder him; indeed, the following scene with the Boyars first reveals their treachery to him. Presumably he looks out simply in fear. As we have seen, the symbolic token of his death is his removal from the position as the visual center of the scene; the priests' huge Bible succeeds in blotting him out. His glance from beneath it is not only an effort to see but also a display of himself to be seen, a confirmation of his continued existence and reassertion of power.

A significant use of the single-eye motif bares it as a device (and consequently tends to bare the whole structure of glances). This occurs during the second scene in the courtyard outside Ivan's sickroom, when Efrosinia and Kurbsky hear Malyuta's offscreen approach and turn to look off left (470). Three shots then follow of Malyuta looking at them: 471, a medium close-up of Malyuta; 472 (Fig. 179), the close-up in which he raises an eyelid with one finger; and 473 (Fig. 180), an extreme close-up of his eye and finger. This unnecessary gesture of raising the eyelid manually when he was already looking at the offscreen characters in shot 471 combines with Malyuta's nickname, "the Tsar's eye," to bare the device.

The same scene includes another prominent use of the motif, as Kurbsky attempts to ally himself with Anastasia in front of the large Christ icon. His appeal to her ends with the words, "my Muscovite Tsarina," over a medium close-up of one of the large eyes of the icon (561, Fig. 181). This is the first time the icon has

appeared in a shot without a figure in the foreground; the next cut places this single eye in the background of the shot in which Anastasia informs Kurbsky that Ivan is still alive (562, Fig. 182). Shot 561 not only marks the shift in the scene's action but also begins an intensification of the initially vague connection between the icon and Ivan. The icon provides another substitute, another "Tsar's eye." This does not imply that Ivan knows what is going on in the scene. But the presence of the icon places Kurbsky's actions in a special context; we see Kurbsky as if there is an additional presence in the room. That presence provides an ironic reminder of Ivan's superiority.

This action leads immediately to the cross-kissing scene where Kurbsky's eye becomes part of the motif; the cross covers one eye while the other stares sideways (Fig. 183). The resulting grotesque image seems to link the eye device with the action's hypocrisy; Kurbsky kisses the cross only to save his power and influence with Ivan. Later, in the next scene, the single-eye motif functions in a similar way, marking a treacherous statement. There Efrosinia declares that she will perform the task of taking Anastasia away from Ivan; she then raises her hand across her face so as to block one eye briefly, gesturing to the others and turning away to end the sequence (Fig. 184). The moment is an exact reversal of the shot in the wedding banquet scene where Anastasia covers one eye (black/white costumes, right/left gaze, calculating/ingenuous demeanors). The device does not so much contribute narrative material as draw these moments of the narrative toward a unity through contrast.

After this intensive usage, the eye motif disappears until near the end of Part II. There, as Ivan prays, a cutaway to a close-up of Pyotr (720) shows him with his hands over his face. He slowly lowers one hand, revealing a single eye staring sideways at Ivan, off left (Fig. 185). Aside from providing a vivid image of his horror, the shot also puts considerable emphasis on Pyotr. By showing him this late in the action, the film begins to motivate his eventual shift of allegiance to Ivan in Part III. The shot leaves Pyotr's reaction to Ivan's sparing him completely undefined; this last use of the single-eye motif expands the hermeneutic concerning the character in preparation for his growing importance in the upcoming action.

Birds form a central graphic and verbal motif in the film. In this case, some of the early associations created by this motif are more fixed than usual; birds almost always relate to Ivan and/or Ana-

stasia. The first bird appears in the coronation sequence—a white, stylized bird with spread wings on the little round rug on the central dais, where Pimen stands to crown Ivan (Fig. 21). The immediate repetition of the bird motif in the form of the double-headed eagle on the scepter tends to fix the motif as an image of Ivan's power as Tsar. The same rug reappears in the Fiery Furnace sequence; this time Philip stands on it, claiming his own divine right to curb Ivan's power. Philip's usurpation of Ivan's own motif is one part of his attempt to replace Ivan spatially.

The climax of Ivan's coronation speech leads to the close-up of his determined face, with the eagle shadow cast on his cheek by the scepter (I, 95, Fig. 186). This leads into the wedding banquet sequence, which immediately picks up the bird motif and expands it to exemplify the union of the couple. The chorus sings of turtledoves "billing to each other," as Anastasia and Ivan kiss. The turtledove motif is picked up in the pairs of birds in each of the double-pronged candlesticks lining the tables (Fig. 187). The goblets used for the toasts in this scene have engraved birds shaped like the one on the rug on the cathedral dais. Finally, the chorus sings that "a white swan is gliding" into the palace. Clearly the reference is to Anastasia, whose costume now and in future scenes is white. (This is a major reason why the swans are painted black in the feast sequence of Part II; not only does the black fit the color scheme of that scene but it purges the swans of their primary connection with Anastasia—their silvery whiteness. Here they have the advantage of recalling the earlier scene while renouncing their former specific connotations.)

The use of the swans brings the opening third of the wedding banquet to an appropriate culmination, for it brings together one major visual motif—the birds—with the dominant spatial principle of organization—symmetry (Fig. 87). This is not the first time the birds have been arranged symmetrically; the two shots down the centers of the rows of candles followed this principle earlier. But there the center of attention had been diffuse: Pimen and Efrosinia had been visible initially, but the clinking cups had progressively blotted out the characters and the individual candlesticks. Now Anastasia and Ivan, the spatial pivots of the scene's symmetrical arrangement, appear as the center of the balanced rows of swans. As we have seen, his gesture and her glances of delight defined the display as spectacle; as the center of the arrangement, Ivan and

Anastasia are defined further as objects of visual attention them-
selves.

The frequency with which the characters themselves gaze at this
display of visual elements suggests a general principle under which
the motifs function: they draw into the space of the action elements
of the mise-en-scene that contribute almost nothing to the forward
movement of the narrative. They have certain semic and symbolic
significance (Anastasia/swan/grace/purity; Ivan/eagle/power/lofti-
ness, and so on), but this material is not causally linked to the story;
it is not necessary for the motivation of later action. We already
know Ivan has certain characteristics that might make him like an
eagle, but these semes are assigned to him time and again in the
film. The motifs, however, help create the delay in our perception
of the narrative that the Formalists believe to be necessary to the
fundamental defamiliarization process. Shklovski speaks of repe-
tition as basic to retardation:

> With retardation the same thing occurs as with parallelisms: a
> definite form seeks to be fulfilled, and, if in the process of creating
> steps, numbers [i.e., repetitions] are present, then one treats them
> quite distinctively.[6]

As long as repetition maintains enough variation to remain per-
ceptually engaging, it may serve as a delaying device.

The classic film has few characteristics so strong as the principle
of the unobtrusive setting, lighting, and other background elements
of mise-en-scene. Just as continuity editing creates a smooth spatio-
temporal flow precisely so that the audience will not be distracted
from the action, so it is expected that the mise-en-scene apart from
the direct causal agents of the scene's action will not intrude into
the spectator's perception. *Ivan* follows the opposite course; it cov-
ers virtually every surface with visual elements that draw the eye.
A mass of material vies with the action for attention.

Other birds enter into the pattern of motifs in the films. These
are often associated with Ivan's power and dedication to the goal:
the metal rooster, the emblem of Ivan's grandfather, Ivan III[7]; the

[6] Viktor Shklovski, "On the Connection Between Devices of *Syuzhet* Construction
and General Stylistic Devices," trans. Jane Knox, *20th Century Studies* 7/8 (Decem-
ber 1972): 58.

[7] Sergei Eisenstein, *Ivan the Terrible* (New York: Simon and Schuster, 1970), p.
94.

double-headed eagle throne, against which Ivan leans as he says, "My power is carried by the shoulders of the people, and their will is my strength" (II, 234); the birds (doves, apparently) in the fresco on the wall behind Ivan's throne in the main throne room.

The use of the black swans in the feast helps to create a parallel between that scene and the wedding banquet, a parallel necessary to the comparison of Vladimir's and Anastasia's deaths. The swans have lost their whiteness and their connection with Anastasia's semic qualities; they serve almost as a parody of the earlier scene (Color Plate 10). Vladimir's drunken delight in the swans, his absurd grimace of delight (596), and his collapse on the table all gain an ironic undercurrent in comparison with Anastasia's reaction in the earlier scene. Where Ivan had brought the swans out to delight Anastasia, he now produces them to confuse Vladimir and draw him into further indiscreet revelations.

In this same scene, one final bird appears that is so indirect and enigmatic as to be almost totally elusive to any of the patterns we have seen so far in this motif. This is the white dove (bathed in red light) that appears above Fyodor's head as he is flung up and down just before the end of the dance (576, Color Plate 11). The presence of the dove is motivated as the Holy Ghost emblem in the general pattern of frescoes on the walls and ceiling. The possible reference to the turtledoves of the wedding banquet is certainly a tenuous one, as is the function of marking the sudden shift from wild dance to tense suspicion in the scene. Indeed, this last use of the bird motif is a mysterious one, and would perhaps be more appropriately placed in the last chapter of this study, as stylistic excess.

Cups become associated at first with Ivan's prosperity. At his wedding, the guests toast him with large drinking bowls that resemble the bowls from which the coins had been poured in the coronation sequence. The wedding wine bowls have a close association with Anastasia as well: Ivan gives her a drink from one, and later Kurbsky smashes his bowl angrily as he reacts to Anastasia's warning glance at him. From this point, cups do not appear again (except perhaps as a variation at Kazan in the form of the dishes into which the soldiers drop their coins) until Anastasia's poisoning.

The poisoning itself is framed in such a way as to suggest Anastasia's death without having to show it. In the sequence's last shot (702), the cup slowly covers her face as she drinks: the obstruction of our view of her serves to signify her death (Figs. 106 and 107). Ivan's jewelled hand appears prominently as it helps lift

the cup; later he will make much of the fact that his own hands had given her the poison. This use of Ivan as the agent of Anastasia's death turns back upon the Boyars when he tricks them into killing Vladimir.

The use of the cups in Part II serves entirely to make explicit the parallels between Anastasia's death and Vladimir's, which in turn aids in the justification of Vladimir's murder, for there must be no sense that Ivan is acting wantonly or with unnecessary cruelty at that point of the narrative. Ivan's flight to the refuge of Anastasia's room precisely at the moment of his self-doubt in Part II brings him to confront the same two cups and the probability of her murder. The symbolic substitution of the cup for her death becomes clear in the conversation with Fyodor. When the boy says, "Some cups are full of poison," Ivan does not repeat the word "poison"; instead, he says "cup" twice as he glances left, then right. A shot of each cup follows each word and glance. Then Ivan glances back at the first cup on the table, with another eyeline match of the cup following (249-254). Again, the glance is the means by which Ivan becomes convinced that Anastasia had been poisoned. Although Ivan's belief in Efrosinia's guilt is delayed for several scenes, he finally sends the poison cup to her as a sign of his final realization. She fails to recognize its significance, but it serves as a signal to the audience that Ivan is ready to act against her.

With this preparation, the film comes to the final ironic parallel provided by the cup motif. In the feast scene, Ivan drinks from a flat wine cup as he watches the dancers; then he carefully gives the already drunken Vladimir more wine. A cut-in to a medium-close shot emphasizes the fact that Vladimir's face is covered by the cup, just as Anastasia's had been (Color Plate 12). The parallel is made stronger by the prominence of Vladimir's hand, with its large rings, spread over the bottom of the cup to support it; this recalls Ivan's hand in the final shot of the poisoning sequence. As a result of his drunken babbling, Vladimir enables Ivan to formulate a plan that will force Efrosinia and Pyotr to kill Vladimir themselves and create a perfect retaliation and retribution for Anastasia's death. Thus through relatively few repetitions, the cup motif creates a series of major parallels that aid in drawing connections between stages of Ivan's struggle with the Boyars. These are not, however, all the uses of the cup motif; again, it tends to float among several associations, particularly early in the plot.

Perhaps the best example of Eisenstein's refusal to pin a motif

down to a definite or single association is his use of candles, one of the most pervasive motifs in the entire film. The opening coronation sequence introduces this theme but never works the candles into a motif. Rather, it remains an overtone, contributing to the general pomp. But in the wedding banquet, the candle quickly comes to prominence as Kurbsky enters the hall (107). During his pause at the entrance, a large triple candlestick is visible to the right in the archway. The next shot emphasizes the candlesticks, as Kurbsky stops and places his hand on one to look across at the wedding couple (Fig. 74). An elongated shadow of a similar candlestick stretches across the frame to foreground the importance of the motif. From this point, the candles multiply quickly, appearing on the wedding couple's table, on the sideboard behind them, and down the centers of the side tables (Figs. 79 and 87). The entrance of the rioters breaks up the symmetrical use of the candles: those on the tables are blown out, while the servants rush away with the candles from the shelf behind Ivan and Anastasia. From this point, the larger triple candlesticks around the edges of the room and on the stairs gain prominence once again.

But now the candles are joined by a new variant on the motif—the torches of the crowd, introduced by several shots of the people rushing into the palace (Fig. 188). At first the candles and torches are opposed. But then, as Ivan wins the crowd over to his side, a spatial merging of torches and candles begins. Ivan's move to the center of the scene also places him beside the large candleholder on the landing (222). Shot 237 is the medium close-up of Ivan in which he speaks of helping workers, shopkeepers, and craftsmen; here the juxtaposition of candles and torches is very clear. The merging of the two motifs continues to the end of the scene, particularly in the next-to-last shot (264) of the crowd cheering Ivan and the Kazan venture. This union of torches and candles is reiterated at the end of the sequence by Anastasia's coffin as well. There the huge candles around the coffin signal the dissolution of the couple, as the smaller candles in the wedding scene had been associated with their union. The sequence ends with a brief series of shots once more juxtaposing the torches of the crowd and the candles (particularly 760-761, Fig. 189). Again the solution to the problems raised within the scene involves Ivan's alliance with the people.

At Kazan, the candle becomes associated with Ivan's power, both as the center of one instance of the ray motif (with the fuses) and as the means of setting off the explosion (Fig. 155). Then, in a

reversal that follows the general pattern of ironic contrast between the Kazan and illness scenes, the candle becomes the emblem of Ivan's expected death. Here the priests give Ivan a candle in a close-up that recalls the handing of the scepter in the opening sequence, with Ivan's hand pausing briefly in the same way before withdrawing from the frame (see Figs. 127 and 128).

Candles are also associated with the numerous icons. Kurbsky's debate following Ivan's apparent death takes place in a forest of large candles before a large icon of Christ (Fig. 138); two of the candles sit on the little altar where he kisses the cross. In general, the icons in the films have candles (or little hanging lamps) around them: the Christ icon over the cathedral entrance, the icon before which Pyotr swears to kill Ivan, and the icons in Anastasia's bedroom. The latter instance serves to identify Anastasia more firmly with the Madonna icon, since the hanging lamps appear in the beginning of the scene of her death, framing the little icon, then framing her head in a similar fashion (Figs. 97 and 98). There is no definite meaning assigned to these candles, but they also tend to occur in scenes where the Boyars betray Ivan or swear to betray him.

The Fiery Furnace play uses candles in a unique way. As the Chaldeans light the fire under the "furnace," the boys light their candles from other candles surrounding the platform; within the context of the play, the action signifies symbolically the burning of the boys (Fig. 190). This Kabuki-like use of indirect, emblematic means of signification fits into the other devices of the play (cartwheels for the moment of casting into the fire, twisted bodies and faces for the evil of the Chaldeans) rather than into any other pattern of uses of candles in the film.

Several scenes employ candles to create specific narrative parallels, aside from the ones already mentioned. The single taper that Ivan gives Vladimir to carry in the procession to the cathedral recalls the illness scene of Part I; the handing of the candle to Ivan (Fig. 127) is similar to the close-up of Vladimir dropping his candle at the moment of death (Fig. 191). The large candles around the chapel in which the Boyar bodies are placed creates a simple parallel to the scene by Anastasia's coffin in Part I (Fig. 108); the subtle reminder that the Boyars in fact were guilty of Anastasia's murder helps to balance the sudden apparent shift of sympathy to them. The candles of the wedding banquet appear in every shot of the tables in the feast scene in Part II. When Vladimir swears he will

prove his friendship to Ivan and reveals the assassination plot, the conversation pauses for a cutaway to two large candlesticks against the red ceiling (590). This device of a pause and cut to a shot not causally linked to the action recalls a similar moment in the previous sequence. There Efrosinia's declaration that the only solution left to the Boyars was to kill Ivan was similarly interrupted by a cutaway to the crucifix icon and hanging lamps; the crucial information about the assassination is in each case marked by a similar cutaway. This suggests that one of the general functions of candles in the film is to delineate certain narrative actions simply by their presence. Note in this context the little candles in the alcove where Efrosinia drops the poison into the cup or the cluster of candles on the altar toward which Ivan moves after Vladimir's death.

In summary, *Ivan*'s use of motifs contrasts with the classical norm in its creation of "floating" associations. In addition, films like *Sergeant York* and *Mary of Scotland* tend not to draw attention to space through the proliferation of motifs. Rather, the presence of any given motif element in the space of the action is typically motivated in causal or conventional terms. The visual profusion created by motifs in *Ivan* forms an important component of the film's visual style. But beyond this, the stylization of the mise-en-scene governs the appearance and relationships of many of these devices. This stylization may be generally characterized as expressionistic.

5 Expressionistic Mise-en-scene

I will be using a limited definition of the term "expressionism," unconnected with any idea of the direct portrayal of characters' inner states. (This portrayal may indeed be an occasional function of the expressionistic devices of the film, but it is not the necessary basis of those devices in general.) Rather, expressionism will here serve as a stylistic term applying to a general attempt to minimize the differences among the four aspects of mise-en-scene: lighting, costume, figure disposition and behavior, and setting. The expressionist film makes, as much as possible, a single visual material of these aspects; the result is an emphasis on overall composition.

Expressionism lends the expressivity of the human body to the entire visual field, while simultaneously trying to make of the body a purely compositional element. The latter effect is crucial; were the body to remain simply an actor, it would be distinctly separate from the rest of the compositional elements. This "homogenization" of the disparate mise-en-scene aspects takes place in a two-step process: 1) the film strips the body of its specific, distinctive qualities, making it into a visual element and 2) it then reinvests those expressive qualities into the overall composition, including the body.

This process transforms the mise-en-scene's expressive potential. First, the four mise-en-scene elements depart from their conventional representational functions. These functions become interchangeable among the four elements. For example, settings usually function to *suggest* character in a realistically motivated fashion. In expressionist style, a setting may contain a visual sign of the character, like a hieroglyph; here the motivation is compositional. The setting no longer suggests the character; it becomes in effect part of the character, carrying material usually assigned to the body of the actor. Second, the same sign may appear in several channels. Character expands systematically, diffusing into the overall mise-en-scene. Ordinarily the actor's body serves as the sole carrier of

character traits; here the body is only the hub or focus of a whole set of signification.

Expressionism is a style that appears in many films, but the German films of the early twenties use it in perhaps the most consistent and pervasive fashion. From these and other films that use the style, we can find a number of distinct characteristics of expressionist distortion. First, expressionist mise-en-scene motivates its devices compositionally rather than realistically. (In contrast, in a French impressionist film, for example, the heroine's dizziness may be suggested by a spinning camera; here the camera movement is realistically motivated as an imitation of the physical state of the character. This French usage gives more prominence to camera style than would a classical film. For example, a Hollywood film may motivate the presence of blotches on a wall by showing how poor the hero is—a realistic justification that subordinates style to narrative. But *Ivan* goes beyond either type of motivation. No cause dictates that Vladimir's face should go blue—rather than some other color—to indicate fear.) Second, an expressionist device does not follow logical patterns—it is arbitrarily chosen. Because the specific features of the mise-en-scene do not relate realistically to the action, they must call attention to themselves through visual deformation.

The moments of strong visual interaction of mise-en-scene elements occur only sporadically in expressionist films. In painting, the perfect composition is fixed; in film, change takes place. In order to call attention to visual patterns, the expressionist film introduces *tableaux*; at certain moments, the mise-en-scene coalesces briefly into a composition where separate elements align themselves in relation to each other. The film will involve an alternation between these tableau moments and the movement associated with the narrative action. During this action, the actors' bodies tend to separate from the surroundings in order to create narratively significant gestures. I don't wish to suggest that tableau moments are always static. Movements may occur, but they are primarily dictated by the overall composition. They resemble dance or pantomime. (Cesare's glide along the wall in *The Cabinet of Dr. Caligari* is a famous example.)

Several strategies characterize visual deformation in expressionism: 1) decorative surfaces, 2) symmetry and abstract shapes, 3) distortion and exaggeration, 4) justaposition of similar shapes and lines. In each case, the strategy will carry over several elements of the mise-en-scene, tending to minimize the differences among them.

The implication of a strategy that arranges several mise-en-scene elements to work together to embody the same material (proairetic, semic, or symbolic) is redundancy; the film achieves the same narrative progression through several channels that could theoretically be achieved with only one. But although the narrative logic may be unaffected, the perceptual effect of expressionist redundancy is different from that of other styles. Repetition of the same material tends to emphasize it; yet literal repetition also automatizes that material. How then to create strong narrative emphasis without inducing perceptual boredom? Clearly by formal variation—by placing the same basic narrative material in several different stylistic channels. Each new appearance of the material should then be defamiliarized. The same material recurs but seems perpetually new and strange. We shall see how *Ivan* uses this strategy to build up tremendous emphasis on certain traits of, for example, Ivan's character.

GRAPHIC "ECHOES" OF CHARACTERS

The settings of *Ivan* create an appropriate (that is, compositionally motivated) image of the treacheries and intrigues that surround the Tsar. Dark hallways provide low arches into which the Boyars can duck to confer, as Efrosinia does with her servant Demyan during the wedding banquet sequence. Or Malyuta can use these same archways to spy on the plotters, as during Efrosinia and Kurbsky's conclave in the illness sequence. Critics have noted the claustrophobic atmosphere created by the relative lack of outdoor scenes and by the ponderously thick walls and arches of the interiors.

But the specifically expressionistic elements of the decor go beyond the creation of atmospheric locales for the action. The appearance of the architecture frequently conforms to the appearances and gestures of the characters who inhabit it. Ivan in particular becomes the visual center around which certain sets are organized. As he moves through the scenes, he comes to a pause at intervals; at these tiny moments of rest, the lines and shapes of the set echo his shape. The effect is something like the lines of force around a magnet that bring iron filings into a pattern. No causal reason is given why several elements should resemble each other, yet the patterns of similarity occur frequently.

Arches dominate many sets in the film, often entering into this expressionistic relationship with Ivan (and occasionally with other

characters). During the archdeacon's chant in the coronation sequence, the long shot of Ivan standing above the congregation in the cathedral (I, 48) frames him against one of the massive square pillars (Fig. 25). The arches above come together at this pillar. In the composition, the lines of the arches and pillar all converge toward Ivan (or, conversely, emanate from him). In the close-up of the crown just after the actual coronation (34), the round shapes of the arches in the background echo that of the crown itself (Fig. 39).

Later in Part I, in the scene of Anastasia's poisoning, a dynamic low-angle shot places Efrosinia in the foreground and Ivan behind, picking up the cup (697, Fig. 103). The lines of the arches to either side of him repeat the curve of his body as he leans over the cup to look into it. The subsequent scene by Anastasia's coffin in the cathedral provides several examples of this device. As Ivan stands above the coffin and raises his fist (757), his body is framed and echoed by various parts of the set behind him: his head is centered in an arch, his raised arm runs along the curved side of a pillar, and his fist is framed by a round saint's icon on the pillar (Fig. 192). The long shot of the crowd swarming into the cathedral (760) places a large arch around the centered coffin.

The final scene of Part I structures itself to a considerable extent around expressionistic duplications of Ivan's shape. One instance is so clear-cut and foregrounded as to bare this device. As Ivan descends to meet the crowd, he pauses by an opening in the archways along the stairs. The crowd is visible through this opening. Ivan twists his body around to look left (a gratuitous gesture, since nothing is ever established as an object for this glance); the opening of the archway roughly duplicates the outline of his body (Fig. 193): its curved, pointed top matches his head and the squared-off portion on the right echoes his jutting collar and sleeve. In addition, the twisting line of the crowd outside roughly repeats the shape of his outstretched right arm and hanging sleeve. This brief moment provides the best illustration of how the mise-en-scene periodically revolves around Ivan. It also demonstrates the important part the baring of the device can play by calling attention to a subtle structure that might otherwise remain unnoticed or uncertain for the spectator.[1]

[1] If this shot were not in *Ivan*, the critic would have considerably less justification for presenting an analysis of structures of "echoing" mise-en-scene. After all, one can find coincidences among various graphic elements within many shots in any film

In this same scene, the close-up profile shots of Ivan (796, Figs. 194 and 195; 800, Fig. 196) set up a coordination between the line of the distant crowd and the shape of his face: the curves vaguely echo his beard or nose. When Ivan goes back up the steps, he pauses to turn and gaze back at the crowd (803, Fig. 197). Again the upward slant of the arch behind him frames his body and the train of his cape.

The device of "echoing" archways recurs in Part II. Ivan's return in the second sequence places him under the concentric arches framing the low doorway (103). In the course of this shot, the narrow vertical arch of the doorway frames Ivan when he is alone; as Malyuta and Fyodor move in to join him, the camera tracks back to include the broader arch that accommodates the three figures (Fig. 64). Later in this scene, as Ivan pauses on the steps to the upper portion of the throne room, he looks back and mutters, "And I will crush sedition"; here the side of the archway at the top of the steps closely echoes the curve of Ivan's back (Fig. 198). In the last shot of the scene in which Ivan gives Malyuta permission to execute the Kolychevs (243), he moves from his position at the throne to crouch in the doorway at the rear. He rests his hands against the wall, seeming to mold himself under the curved arch. Finally he pushes himself away from the wall in a convulsive movement and disappears offscreen (Fig. 199).

Arches are not the only devices that shape and are shaped by Ivan's appearance. As he stands pensively before his throne in this same scene (before Malyuta speaks, shot 226), the spotlight forms a curved shape behind him that delineates the line of his black fur cape (Fig. 200). This is also the case in the cut-in to a medium close-up of Ivan in shot 227. After Ivan retreats to Anastasia's bedroom, he throws himself down by the bed to pray. His lifted head is outlined in shot 247 by the series of hanging lamps that hover in a curved shape above him (Fig. 201). Later, he stands staring off at the bodies of the executed Boyars (286), removes his hat, and bows. The two figures in the left background (Malyuta and Fyodor) lean to the right at the same moment, as if attached to Ivan by invisible strings (Figs. 202 and 203).

Other characters occasionally engage in this pattern of visual

if one looks hard enough, but this does not mean that these are part of a systematic structure. Rather, they may be part of an *un*systematic formal play, the excess of the film, as we shall see in Chapter Nine.

interrelationship with the settings. In at least one case, the device serves to aid a narrative parallelism. The long shot of the three boys in the Fiery Furnace (II, 344, Fig. 42) places them in front of the same square pillar that had appeared in the shot of Ivan in the coronation scene (I, 48, Fig. 25). This contributes to the general visual similarity of these two shots and to the connotation that the play is the Boyars' visual replacement for Ivan.

In the scene between Kurbsky and the Livonian ambassador just before the wedding banquet, both are momentarily centered under separate arches in the courtyard/hallway. This occurs in the first long shot of the pair (I, 104), as Kurbsky moves away and the ambassador turns to look after him (Fig. 204). A similar framing occurs in the scene where Kurbsky and Efrosinia talk during Ivan's illness. Here Malyuta enters to stare at them, passing directly under a pointed arch. (These pointed arches are actually formed by the crossings of two curved walls in different spatial planes in the frame.) Since these framings occur in scenes of conspiracy in the hallway outside Ivan's quarters, they contribute to the general function of the shadowy, ponderous sets that suggest the conspiracies and treacheries that surround Ivan.

But for the most part, this device is used with Ivan. I don't mean to come to a simplistic conclusion about its function in relation to him—it doesn't mean, for example, that "the whole world of the film revolves around Ivan." Rather, the visual echoes of Ivan in the settings serve to project his character onto his surroundings. This is not a subjective projection, as in *The Cabinet of Dr. Caligari*. In the German film, the baring of the device of expressionistic settings comes when Francis enters the insane asylum lobby in pursuit of Caligari. As he waits to see the director, he stands in the middle of the room and looks around. The circle on which he stands forms the center of a radiating series of alternating black and white stripes that thrust outward like spokes and extend up the walls past the upper frameline (Fig. 205). Here the radiating lines form an image of the projection of Francis's mental vision in his act of gazing: he is a madman, and his surroundings are the product of his madness. Contrast this with the shot in the last sequence of Part I of *Ivan* that I have described as a baring of the device. Ivan stands beside a window that echoes his shape, but his mind has not created that window. Rather, the window extends Ivan's physical presence beyond the actor's body. The film uses devices to structure its characterizations beyond the conventional means of actor, make-up,

dialogue, and so forth. As usual, the implication is a redundant one, proclaiming Ivan's power, his grandeur, his appropriateness as an embodiment of the goal of Russian unity, his optical position as the spectacle toward which all must look. In much the same way as Ivan controls the glances of the other characters, he provides a center around which the architecture bends itself.

SHADOWS

Shadows are particularly suited to expressionist usage (recall *Nosferatu* or *Warning Shadows*), as their shapes are easily deformed and distorted. Shadows also provide a convenient way of linking figures and decor. In *Ivan*, one might expect the many large, striking shadows to function analogously to the "echoing" expressionistic arches, making the decor imitate Ivan's appearance. But this is so only in a couple of instances. Few of the significant shadows in the film are projected by Ivan, and only a couple are projected onto him. Instead, the shadows often involve other characters or objects.

Many of the shadows appear in the wedding banquet scene. The huge candlesticks that are visible when Kurbsky enters the hall are augmented in shot 108 by the long, distorted shadow of a similar offscreen candlestick; this serves to mark the importance of this motif in the sequence (Fig. 74). The swans cast shadows on the wall as the servants carry them toward the head table (162). Later, when the sounds of the riot disturb the feast, the shadows of the swans on the wall add to the general confusion as the servants carry them out. A similar disruption of a calm situation occurs as the Kazan ambassador enters. The crowd had entered the room in shot 182; at that point they had cast quickly moving shadows on the wall above the entrance. Later we see them all standing in a group listening to Ivan, their still shadows on the wall. When the ambassador enters, a long shot (241) shows Ivan and the crowd turning to look. Above their heads, the shadows of guards with halberds move swiftly from left to right. These guards are not visible onscreen, nor does their movement result in any physical confrontation with the Kazanians. Again the scurrying shadows serve to signal the quick shift in the scene's action. Shortly after this, the shadows of the offscreen crowd appear on the wall above Efrosinia as she backs nervously away, her plot thwarted (263, Figs. 172 and 173). The next shot is a general view of the room with Ivan, Anastasia, and Kurbsky in the background; the shadows of the crowd again

appear on the walls. In the final shot of the sequence (265, Fig. 94)—the medium close-up of Ivan and Anastasia—the shadows of the enthusiastic offscreen crowd are visible on the wall behind. Ivan's gesture of throwing up his arm echoes the gestures of the crowd, visible in the shadows' movements.

Shadows are a major overtone in this sequence. They function partly to emphasize the crowd at the point at which Ivan gains the support of the people. During the banquet itself, the high white walls of the room had been mostly blank; the composition emphasized the rows of Boyars seated at horizontal tables at the bottom of this huge space. With the entry of the people, the lighting change also alters the treatment of space, with the shadows filling the white walls. We have already seen how the candles and torches function to signal the growing accord between Ivan and the people. The smoke of the torches and the shadows they throw become part of this process. The shadows also permit the creation of a confused, swift movement in the space of the room without making Ivan a part of this confusion. He stands firm in the center, while the rioters, guards, and shadows seem to swirl about him. In this case, he shares this function with Anastasia, who occupies the other stable space of the room (the throne) and joins Ivan during the final triumphant cheering.

No other scene uses this type of shadow to such an extent, though the illness sequence has a few significant examples. Malyuta's first appearance there shows him only as a shadow on the wall of the courtyard stairway (431, Fig. 206). This introduces the idea of Malyuta as a spy, unseen but lurking nearby. This and one other use of shadows in this sequence relate to the dominant principle of Ivan's absence. Inside Ivan's chambers, the priests form a circle that has a bright light (unmotivated) in the center; this casts strong strips of alternate light and dark out between the black figures onto the floor in the foreground and the walls behind. The second shot of this grouping (Fig. 129) continues with a pan left to the bed. Strangely, Ivan is not in the bed, nor do we ever find out where he was at this point (Fig. 130). This inexplicable absence is important in relation to the dominant pattern of substitutes for Ivan's presence. The shadows project the figures of the priests over much of the room's space. Ivan's power is at a low ebb in this sequence; later he will crawl and beg before the Boyars. The contrast of empty bed and priests' shadows sets up this entry of treacherous power into Ivan's bedroom.

By the end of Part II, Ivan has set up his own "priests," dedicated to the cause of Russian unity. They, too, cast strong shadows in regular patterns, this time upon the Last Judgment fresco in the procession scene. This draws particular attention to the fresco itself, which, as we shall see shortly, is part of a general religious, allegorical imagery that culminates in this scene. These shadows also serve as reminders of the Oprichniki's presence without necessitating their actual appearance. Vladimir is thus able to be alone in the last few shots before his death. The Oprichniki have brought him to this spot, but they do not participate in his actual murder. As Ivan's agents, the Oprichniki can only maneuver Vladimir without participating in the guilt of striking his deathblow. The straight, regular shadows on the wall above Vladimir suggest that the Oprichniki are impartial judges, who help mete out punishment indirectly (Fig. 160).

In the recall sequence at the end of Part I, a shadow marks Ivan's taking of power—in this case, through the reaffirmation of the people's faith. Ivan faces away from the camera in medium shot (788). As an offscreen shutter or curtain opens, the shadow of a patterned lattice falls across the room (Fig. 207). This harks back to the use of the scepter's shadow at the end of the coronation sequence. Ivan turns upon hearing the offscreen chorus; Malyuta and Fyodor then hand Ivan a staff and place a black fur cloak over his shoulders. This, along with the later shot in which he puts on his fur hat, represents the new "coronation" that Ivan had predicted in the scene by Anastasia's coffin. What little we have seen of Ivan's exile has placed him in a bare, candlelit throne room. The opening of the offscreen window prepares for his move from this space to the bright sunlight of the exterior segment in which he greets the crowd. The lattice shadow also takes the form of multiple squared-off crosses similar to the one on the chain around Ivan's neck; he clutches this chain as he turns to face the window. The crosslike shadows are another channel of religious imagery in this scene. In this shot the offscreen chorus sings, "Have mercy, O Lord."

All these shadows are cast upon the settings, but one key shadow falls upon Ivan himself. This is the scepter's shadow that is cast on his face at the end of the coronation (I, 95, Fig. 186). Over this close-up, the offscreen voice of the Livonian ambassador declares, "He must not become strong." The juxtaposition is ironic because Ivan is already strong. This shadow links Ivan absolutely with the values he embodies: the Russian state, Russian unity, Russian

strength. It images the unquestionable basis of the film's narrative—
Ivan's capability for unifying Russia. The narrative sets forth its
own contradiction at this point: Livonian statement (no Russian
power) versus Russian fact (great Russian power). The explicit de-
piction of this contradiction would seem to imply that the only
possible step for the narrative to take is an immediate commence-
ment of battles between the two countries. In order to delay the
war, the film must create a digression to lead the spectator to con-
centrate on a different hermeneutic line. Without this need for delay,
the scepter-shadow shot would seem to be a likely last shot for the
sequence; it marks the culmination of the coronation, with Ivan
united with the symbol of power that he has accepted. But instead,
two final shots of Pimen and Efrosinia end the sequence, as Efrosinia
makes vague threats that substitute a new hermeneutic to threaten
Ivan's position of power.

Ivan himself casts relatively few of these expressionistic shadows,
but one scene—that in which Ivan sends Nepeya as ambassador to
England—does depend on this device to a considerable extent. Here
the shadows form part of the pattern of emblems of Ivan and his
power. The film creates a complex interplay by repeating and vary-
ing elements whose narrative significance is simple: the huge shadow
is yet another indication of Ivan's power; the globe's shadow serves
to introduce the idea that Ivan is alone and weighed down by his
duties. The scene maintains a subtle balance between these two
elements. As Ivan first sits at his table (642), only his profile is
visible on the blank wall beyond (Fig. 115); the wedding banquet
set now functions to emphasize his isolation. The globe does not
cast a shadow at this point; yet its shadow soon appears alongside
Ivan's without a motivated light shift. After the series of closer shots
in which Ivan begins to explain his plan to Nepeya, a cut reveals
Ivan's shadow on the wall above the ambassador (649, Fig. 116).
The shadow is not as large in relation to the rest of the room as
it had been previously. Now the globe also casts a large shadow
on the wall; Nepeya is visible, tiny at the bottom of the frame. In
the next shot, the composition remains virtually unchanged, except
that Nepeya is no longer onscreen. His little shadow is visible at
the right. This nonrealistic manipulation of human scale within the
frame resembles that of certain early painting traditions in which
the more important figures are larger than the peripheral ones (as
with Egyptian art or medieval religious art; in the latter, donors,
angels, and the like are often smaller than the biblical figures). As

Nepeya and the servant depart with the chess set, they and their little shadows pass under Ivan's huge profile shadow. Throughout the scene, no change in lighting motivates the changes in the shadows.

After the first series of shots in Anastasia's bedroom, there is a cut back to a medium-long shot of the throne room in which Ivan's head is visible at the lower left of the frame (662, Fig. 208); he leans back with closed eyes. But now his relative position to the globe has changed; the globe itself is not visible but casts a large shadow on the wall. This shadow seems to hover just above Ivan. Having commenced with a tiny globe and Ivan's huge shadow, the scene had progressed to a point where both Ivan and the globe cast relatively large shadows. Now Ivan is small and the globe's shadow larger than it had been. As Ivan stands and moves out frame left, his shadow appears; it is smaller than it had been, and seems briefly to be surrounded by the crisscrossed oval ribs of the globe's shadow. Shot 664 shows Ivan in long shot, leaving the throne room. As he approaches the small archway, his large shadow shrinks rapidly until it disappears in the darkness of the door. The shadow of the globe, however, remains constant in size at the left portion of the frame. In combination with the music that bridges this whole segment, these shifts in shadow size and relation prepare us for Ivan's weariness and loneliness in the following scene. In order to understand the significance of Anastasia's death in the context of the goal of unity, we must realize Ivan's complete dependence on her. On the other hand, we must never doubt that Ivan is still all-powerful. Thus the scene divides itself, presenting both Ivan and the "world" as immense in different shots.

The device of Ivan's huge shadow does not return until the cathedral scene after Vladimir's death in Part II. There his shadow moves across the fresco of the Last Judgment, just as those of the Oprichniki had done. Now there is no other shadow to compete with his. He remains central. Ivan's presence is linked to that of God in the fresco before which he stands as he delivers his own judgments on the punishments for each of the participants in the assassination plot.

The use of the expressionistic shadows in these two scenes has some significant contrasts. In the globe scene, Ivan's shadow projects onto a blank wall; in the assassination scene, it falls onto a painting. This painting contains the very device I mentioned earlier—varied figure scale. Here the most important figure, God, is

depicted as much larger than the angels and humans that surround him. In this case, Eisenstein bares his own device by juxtaposing it with an historically traditional use of the same device; he cites the conventional norm of varied scale in order to emphasize his own usage within the context of a single film. The Last Judgment fresco does more than provide a surface for an expressionistic shadow to fall upon, however. It, too, participates in a pattern of expressionistic devices—the allegorical religious paintings—that I shall examine shortly.

LIGHTING

Some of the uses of shadows resemble other expressionistic lighting devices in the film. Light casts color onto surfaces in the feast sequence of Part II. When Basmanov is arguing with Ivan during the feast, their faces appear a ruddy pink (Color Plate 13). Then, after Basmanov says, "Doesn't the blood we shed tie us closer to you?" the light on his face turns a deep, bright red (Color Plate 14); the light on Ivan's face, directly beside him, remains largely unchanged. This red light marks a shift in Basmanov's career. Up to this point we have seen him only as the loyal servant of the Tsar. Now his dissatisfaction hints at the causes that will lead to his downfall and execution in Part III.

Later in this sequence, a deep azure light falls on and tints Vladimir's face as he pauses in fear before the door leading to the courtyard (Color Plates 15 and 16). The moment is Kabuki-like, recalling Eisenstein's descriptions of Japanese aesthetic practice in his essay "The Unexpected":

> The Japanese in his, of course, instinctive practice, makes a fully one hundred per cent appeal with his theater. . . . Directing himself to the various organs of sensation, he builds his summation to a grand *total* provocation of the human brain, without taking any notice of *which* of these several paths he is following.
>
> In place of *accompaniment*, it is the naked method of *transfer* that flashes in the Kabuki theater. Transferring the basic affective aim from one material to another, from one category of "provocation" to another.[2]

[2] Sergei Eisenstein, "The Unexpected," in *Film Form*, trans. and ed. Jay Leyda (New York: Harcourt, Brace, and World, 1949), p. 21.

He then draws upon a Kabuki play for an example that resembles the device of the azure light and other moments in *Ivan*:

> Yuranosuke leaves the surrendered castle. And moves from the depth of the stage toward the extreme foreground. Suddenly the background screen with its gate painted in natural dimensions (close-up) is folded away. In its place is seen a second screen, with a tiny gate painted on it (long shot). This means that he has moved even further away. Yuranosuke continues on. Across the background is drawn a brown-green-black curtain, indicating: the castle is now hidden from his sight. More steps. Yuranosuke now moves out on to the "flowery way." This further removal is emphasized by . . . the *samisen*, that is—by sound!![3]

In this segment of *Ivan*, an unmotivated device in the one element (light) substitutes for a more conventional usage in another (acting). The actor does not express fear by frantic gestures or writhing features. Instead, he freezes his face into a stiff mask with a wide-eyed expression. The colored light then takes over the function of the actor's gestures. In both of these cases, the change in light is completely unmotivated by any ostensible source within the scene's space.

A couple of other lighting changes occur in Part II that have no motivation from diegetic sources. In the scene after Ivan's return, there is one close-up of Ivan between the two sections of flashback material (147); as Ivan turns to look off at Philip, the initial right sidelight goes out and a center bottomlight comes up. As a result, Ivan's face goes from gauzily backlit (Fig. 209) to slightly deformed by the underlighting (Fig. 210). The shift marks the transition from Ivan's memories about being an orphan to his explanation about how the Boyars had exploited Russian territory for their own benefit.

In the second shot of the final sequence (724), a similar lighting change occurs. Ivan sits looking right, with a tight spotlight from the right picking out only his face; he says, "A Tsar who hesitates in this will never make a Tsar." Then he turns his head to the left. As it turns, the spotlight goes out. Another comes on from the left, again focusing only on Ivan's face. In the interval, a tiny moment of near-darkness occurs. Again, the change functions to mark a shift in Ivan's speech; he goes on to begin his next thought: "Today

[3] Ibid., p. 22.

in Moscow, we have struck down the enemies of Russian unity."
During shot 725, a strong red light colors the whole ceiling above
Ivan. As he speaks, the red color passes off the ceiling to reveal its
predominantly blue and gold icon of God.

The closest the film comes to conventional expressionistic lighting
is the sourceless light that flickers on the young Ivan's face as the
flashback begins: the device serves to externalize his inner state in
the manner of the traditional German Expressionist films. On the
other hand, the light that frames Ivan and his throne in the scene
after he has given in to Philip (Fig. 200) is not subjective in function.
There is no attempt to motivate this from a realistic source. The
curved shape serves to pick up and echo the shape of Ivan's cloak.

All these lights function expressionistically. They have no realistic
motivation but work in conjunction with other elements of the
mise-en-scene to structure the narrative.

RELIGIOUS PAINTINGS

Ivan's settings come forward to play such an active role in the
narrative in part because some of them are covered by large paint-
ings. These paintings are in a sense a motif, but I have chosen to
deal with them here rather than in the chapter on motifs because
they relate to the narrative action in a different way than do the
various birds, candles, eyes, etc. These are not visual devices that
recur and pick up "floating," loose associations. Rather, the paint-
ings all appeal to identifiable, familiar narratives from religious
history and legend. They have their own meanings apart from *Ivan*,
relating to the film's narrative by analogy. They also serve to bring
the settings forward, lending them the prominence characteristic of
expressionistic mise-en-scene.

A few of the icons relate to elements of *Ivan*'s narrative through
visual resemblance, but for the most part the likeness is one of
parallel events. As a result, the paintings have a sort of allegorical
status that exists alongside the action of the film. The relationship
is not causal in any way; the spectator could fail to interpret the
paintings and still understand the story perfectly well. The paintings
set up a parallel meaning to that of the main narrative, but the
effect is difficult to define. They seem to function analogously to
the "sympathetic" strings of a viola d'amore, which vibrate in re-
sponse to the main strings' vibrations and set up a sonic resonance,
even though they are never bowed themselves. This quality of pick-

ing up and extending the meaning of a scene functions expression-
istically; narrative connotations emanate from the immediate center
of attention (usually Ivan) and permeate the entire scene. When the
actors, the lighting, the settings, and all the rest of the mise-en-scene
seem to participate in creating the same effect, the whole ensemble
gains "expressiveness." Although this expressive quality may ulti-
mately be pointless or redundant in terms of direct narrative cau-
sality, it fits into the pattern described earlier in which repetition
creates emphasis and expressionistic variation on multiple channels,
strengthening this emphasis through defamiliarization. The paint-
ings help roughen perception by calling numerous elements of the
scene forward simultaneously. Elements such as setting and lighting
that usually serve only as the locus for the action now become
important overtones of the scene.

The decor of the coronation scene is noticeable from the start.
Virtually every inch of the cathedral set is covered with paintings
and other decorative devices, such as the carved arms that form the
frame of the door through which Pimen emerges. But the first paint-
ing that functions allegorically is probably the fresco of the raising
of Lazarus on the wall behind the group of foreign ambassadors
(Fig. 15). The image is a familiar one. Lazarus lies wrapped in a
bandagelike shroud, his coffin standing vertically to allow us a clear
view of the corpse (the traditional way of representing Lazarus in
Russian icon painting). Christ stands beside the coffin, gesturing
for him to rise. The parallel to the coronation scene becomes clear
during Ivan's speech, as he speaks of Russia as a dismembered body
that he will seek to restore by seizing the port cities on the Baltic.
No explicit connection is ever drawn between the action of the
scene and the fresco; the film simply juxtaposes the main events
with the references in the frescos and allows the spectator to notice
and interpret the connotations of their analogous narrative situa-
tions.

Many of the cathedral paintings do not enter into such specific
relationships with the action. Some are undifferentiated pictures of
saints; others are never clearly recognizable enough to set up a play
of connotations. The scenes are arranged within the set so that the
relevant paintings become prominently visible at the correct mo-
ment. One large fresco, for example, pictures the Last Judgment.
At times, only portions of this fresco are visible. In the scene of
Ivan's mourning by Anastasia's coffin, the third shot of Efrosinia
looking on from one side of the cathedral includes a fresco on a

large square column to her left (Fig. 211). It depicts a damned soul suspended upside down over a flame. This juxtaposition helps define Efrosinia's role in the scene. In spite of her silence, she is colluding with Pimen in tormenting Ivan. (Again, the painting does not create this meaning. We know it already, and the painting reiterates the meaning in a perceptually new way without adding to it.)

This same fresco appears more prominently in the scene of Vladimir's death. The Last Judgment theme is generally meaningful in relation to the narrative of the film: the most direct confrontation between the two factions leads to the punishment of one and victory of the other. Vladimir stops and stares at this fresco for several moments before he is stabbed. After his death, Ivan metes out the punishments to the group assembled in front of the fresco. He pardons Pyotr, and the latter moves to the wall at the foot of the Last Judgment fresco. The lower part of the painting pictures a medieval hell-mouth, surrounded by flames into which the damned are falling. Shot 710 is a long shot of Pyotr, framed obliquely along this wall; he comes in from the left and moves forward along the wall staring off as Efrosinia's voice begins the lullaby. As Pyotr reaches the wall, his hand rests directly on the hell-mouth, and he continues to run his hand along it as he moves (Fig. 212). Again the reference within the fresco is somewhat analogous to the events of the scene but does not function directly in the scene's action. By showing magnanimity, Ivan allows Pyotr's own emotions to torment him and cause him to switch allegiance.

The cathedral contains one other small fresco that creates allegorical connotations. After Ivan has disposed of the Staritsky clan, he leads the Oprichniki to an altar to pray. In the background is a picture of an ocean with a man coming out of a fish's mouth, presumably depicting Jonah and the whale. The simple connotations that make the fresco appropriate to this scene are straightforward enough—emergence from danger, the triumph of faith. But the story of Jonah is also a traditional symbol of Christ's resurrection,[4] a fact that fits the painting into the resurrection imagery (the Last Judgment, the Archangel Michael on the throneroom ceiling, the raising of Lazarus) in other portions of the film. The overall implication of this resurrection imagery is the creation of unity for the dismembered torso, the Russian land. Ivan's triumph in this scene is a major step along the way toward that unification.

[4] See Matt. 12:40.

Another fresco that fits into this pattern is that of the huge angel stretched across the ceiling of the throne room in Part II. This angel is difficult to perceive, since it never appears in its entirety in any one shot, and we must therefore piece it together. It also provides a good example of the illegibility of some of *Ivan*'s shots; even in those shots where the angel does appear (as in the extreme long shot of the room, 119, Fig. 67), the spectator must look at other elements to figure out the space of the scene and keep track of the action.

The angel presents further difficulties because its iconography is unclear, or at least unorthodox. I have found no Russian icon remotely like this angel. Its primary distinguishing feature is the balance that the angel holds, which in European iconography typically indicates portrayals of the Archangel Michael. Michael was usually depicted in one of two ways: in armor, as the head of the church militant on earth, or with a balance, associated with his role in the Last Judgment. Michael was a prominent figure in old Russian religion as well; there was a cathedral dedicated to him in Moscow (where the historical Ivan IV was buried). According to one writer on Russian icons, "In Russia, St. Michael was regarded as the protector of princes and warriors."[5] All depictions of Michael I have examined portray him in the militant role, generally with armor and a sword. None shows him with a balance. Even in the Last Judgment icons, he is not the angel that wields the balance but instead stands to one side threatening the souls of the damned with a spear. No specific figure is associated with the balance in Russian iconography, as far as I could determine. (Indeed, all the Last Judgment icons were highly standardized and not at all similar to the big fresco in the cathedral. The only icons in the film that seem consistently authentic are the raising of Lazarus, the saints, the heads of Christ, and the Madonnas.)

We must thus assume that Eisenstein is mixing his iconography in this case. At any rate, the use of the Archangel Michael in this scene is highly appropriate as an allegorical juxtaposition to the action. Both of Michael's traditional roles come into play here: Michael is God's representative upon earth in the struggle against the devil. Both Ivan and Philip set themselves up in this scene as the representative of God's will. The throneroom scene initiates a struggle between them that will continue through the scene of the

[5] Tamara Talbot Rice, *Russian Icons* (London: Spring Books, 1963), p. 34.

Boyar mourning and the scene of the Fiery Furnace play; all these scenes also carry over the angel imagery as an important facet of the struggle for control. In instituting the Oprichniki, Ivan says, "Therefore as God created man in his own image, so I have created them in mine." Most of this line occurs in shot 119, the first long shot of the throne room proper and the first view of the angel fresco. This is the largest portion of the fresco that can be seen in any one shot; the scales are visible here. After Ivan finishes his declaration, Philip enters and stands directly under the angel's head and says: "These plans come not from God, but from the Devil."

We have already seen how Ivan and Philip symbolically exchange roles as monks. Philip attempts to seize Ivan's position of power by taking the center spatially in the Fiery Furnace play sequence, while Ivan approaches him dressed in a cassock. Their dedication lies with two different ideals—Philip's with the church, Ivan's with the cause of unifying Russia. In this struggle, Philip threatens to call down the wrath of the church upon Ivan, while Ivan's wrath will come wholly from himself, as the embodiment of the goal of Russian unity.

When Philip confronts Ivan alone in the throne room, he tells him, "I carry out the will of God, not the designs of the Tsar" (II, 130). After the flashbacks, Philip passes judgment upon Ivan: "You reject the counsel of your spiritual guide? Very well! Remain alone! Reviled! Condemned, accursed, and alone!" As he delivers this line and moves to leave the room (216, Fig. 213), the head of the angel is visible again at the opposite archway, in the upper right portion of the frame.

The next few scenes carry forward the idea that both Ivan and Philip have set themselves up as the messenger of God (the function of angels) in visiting his wrath upon the unjust. When Malyuta declares his willingness to damn himself for Ivan's sake, Ivan agrees to kill the Boyars: "By God's will, be judge and executioner" (241). It is shortly after this that Ivan takes refuge in Anastasia's room and prays, "Let me not drink of this cup" (247). This overt comparison of himself to Christ leads directly to the information about Anastasia's murder that justifies Ivan in all his subsequent actions in Part II.

But Pimen also plans to set up a messenger of God, an avenging angel, in the person of Philip. In the Boyars' mourning sequence, the painted walls and ceilings begin once more to enter into the action of the scene and affect its connotations. We first see Pimen

(290, 291, and 295) standing in front of a wall with a fresco of the fourth horseman, Death. This reference to the Book of Revelations picks up the Last Judgment motif from the throneroom angel fresco. Pimen is framed (291) in such a way that his crozier seems to form a scythe for the skeleton (Fig. 214); the painted scythe of the fresco is visible only in the initial long shot (290). In shot 297, Pimen steps forward to deliver his line, "By God's power invested in you, bring the Tsar to heel." As he speaks, he stands below an angel outlined in white on the dark ceiling above; the angel is partially blocked out so that its wing seems to be growing from Pimen's shoulder (Fig. 215). Philip resists at first. As Pimen and then Efrosinia persuade him, they move about the room in a strict relationship to the angels' haloes and wings in white above them. The effect is intensely stylized and schematic: each important line of dialogue accompanies an appropriate visual configuration of actor and fresco. In shot 305, Efrosinia stands behind Philip. Behind her head is an angel's wing, with the figure's face alongside Efrosinia's and turned in the same direction. After the cut to shot 306, Efrosinia's head has moved to a position in front of the angel's head. The wing now appears just above Philip's head and forms a halo for him. Finally Philip takes on the task and stands up. In shot 311, the angel fills the upper part of the frame; both wings are now visible. Philip stands in the center of the frame, with his head exactly in front of the angel's face—its halo and wings seem to be his (Fig. 216).

Although the angel frescos disappear after this point, they relate closely to later devices. The Boyars' spectacle in the Fiery Furnace sequence carries forward this same notion of the avenging angel— the role they hope Philip will embody for them in reality. This double implication of the play is made explicit in the discussion among the Boyars as the sequence opens. Efrosinia explains the story of the rescue of the three boys by an angel. An old Boyar remarks, "Nowadays such angels don't exist"; but Philip plans to take their place. The film makes extensive use here of the connotations set up by its biblical references, especially references to the Book of Revelations. Although the story of the three men in the furnace is not from this book, Nebuchadnezzar and Babylon do reappear in Revelations. The destruction of the city of Babylon is one of the main events there, functioning primarily to represent the general damnation of the heathens. The Fiery Furnace play emphasizes Nebuchadnezzar as the "terrible, pagan Tsar," and the child's question later in the scene transfers this title to Ivan. The

biblical reference is double. The painted flames on the furnace set are like those of the Last Judgment fresco itself (first clearly visible in this sequence). The Boyars seek not only to free themselves from their symbolic flaming prison but also to condemn Ivan by excommunicating him: "Dissolve the Oprichnina before it is too late" (385-386). Philip's speech threatens that the "avenging angel will descend from heaven" (380) to save Ivan's victims.

But the Archangel Michael is not simply militant; he also weighs souls, and this attribute is appropriate to the proairetic of these scenes. The struggle between Ivan and the Boyars is not only one for power—Ivan clearly has the upper hand there. Rather Philip strives to prove himself right and Ivan wrong. If Ivan is indeed wrong, he loses his status as the embodiment of the quest for Russian unity. Finally, at the end of the Fiery Furnace sequence, the answer becomes apparent: Efrosinia, whom Philip represents in his mission, is the guilty party. If she is guilty, then Ivan is innocent. His deeds have been justified.

Ivan's defeat of Philip turns the Boyars to more earthly means of eliminating him. Ironically, Pimen decides to recast Philip as a martyr for their cause. Ivan, on the other hand, continues in his monk's role and appears several more times in his cassock (including scenes in Part III). Ivan's dedication to the cause confirms Russian unity as the most pervasive value system at work in the film; Christianity is seen merely as a symbolic set of connotations that affirms the goal as just. Whenever Ivan begins to doubt, he expresses his uncertainty in religious terms, but the answer comes back in practical, earthly ones: those adverse events that would seem to be punishment from God are actually the wrongdoing of his enemies. The Boyars utilize the trappings of religion, while Ivan embodies the divine power usually attributed to the objects of Christian worship.

This divine power is further signified by another expressionistic device involving paintings: the Christ and Madonna icons that recur in the film. Ordinarily I would discuss these as motifs, but here again there is an extra element: the icons take on their narrative connotations in part by imitating the appearances of Ivan and Anastasia. In the course of the film, Ivan grows a beard that resembles those in the Christ icons. Similarly, his tightly curled hair gradually falls into thin, twisted locks that are also like the spiky representations of hair in the figures. His exaggeratedly pointed head and chin add to the resemblance. Some of the banners in the Kazan

sequence bear the device of the Christ icon (Fig. 217). This usage particularly emphasizes the resemblance because the picture is so ambiguous—it could be taken as an emblem of either Christ or Ivan.

But perhaps the main link between Ivan and the Christ icons is the stare: Ivan's power over others is largely bound up with his intense gaze. Similarly, the eyes of the icons stare straight out. In the scene of Kurbsky's inner debate before the huge icon of Christ, Eisenstein frames the eyes of the painted figure in a way which suggests that it is witnessing the action.

We have seen how the Christ icons in the illness sequence help create a dominant structure of substitutes for Ivan. This dominant becomes an overtone in other scenes. When, during the execution scene of Part II, Ivan hides in Anastasia's room, the icon above the cathedral door again substitutes as a reminder of him. Ivan becomes pervasive; his influence is signified by objects that mark his absence by resemblance. The same sort of thing happens in the scene of the procession to the cathedral, where Vladimir passes under the icon. Indeed, the cathedral is Ivan's principal space for asserting his power. No other setting appears so often. Throne rooms change and multiply in the course of the action; other rooms—bedrooms, chapels—are seen only once or twice. But the cathedral returns at intervals, providing the setting for some of the most important confrontations; here, the icon acts expressionistically as an emblem, attaching Ivan's semes to its space. As the arches and windows bend themselves to match Ivan's appearance, so the icons multiply his presence and the connotations of his character. (Significantly, the crucifix icon in Efrosinia's chambers looks nothing at all like the other Christ icons—or Ivan. Instead, it seems to be a ceramic relief with a light-haired figure; Fig. 218.)

Similarly, the icons of the Madonna resemble Anastasia. Once she has married Ivan, she invariably dresses in flowing white robes with a headpiece. We have seen how the hanging lamps frame Anastasia's head in the poisoning scene in the same way that they frame the icon (Figs. 97 and 98). The function of the icon that the crowd carries in their march to recall Ivan from Alexandrov is not easy to discern, since the scene does not involve Anastasia. The Alexandrov scene marks Ivan's shift of allegiance. In the poisoning sequence, he had declared that she was his only support ("I have only you." I, 669). By Part II, he is alone but at least can tell Philip, "The people support me" (II, 208). The crowd at the end of Part

I carries Anastasia's emblem, perhaps sharing some of its conno-
tations of her loyalty and support.

A more direct return of the icon as linked to Anastasia occurs
in the middle of the Fiery Furnace sequence when Ivan enters the
cathedral. He and his followers are initially seen at the lower right
corner of a long shot; the upper left portion of the screen contains
a large Madonna-and-child painting (Fig. 219). A lamp hangs into
the frame from the top right. The group pauses in front of this icon
as Fyodor begins to remind Ivan of Efrosinia's probable guilt in
Anastasia's death.

This network of religious imagery is an unusual device for a film
to utilize. Certainly other films make use of embedded narratives
and references to other works, but they seldom do so in such a
tangential fashion. Eisenstein's references to religious narrative seem
simply to touch his main story, leaving the spectator to construct
the logic of the juxtaposition. Such construction leads to multiple
connotations, most of which reinforce narrative relations on other
levels. The result is a rich device for roughening form. With one
mise-en-scene element placed in the background of a scene, the film
can open up a series of connotations that are entirely dependent
upon the spectator's active participation in a play with the work's
structures.

COSTUMES, ACTING, MAKE-UP

In the Boyar plotting sequence of Part II, Pimen abandons Philip
to a martyr's fate and departs; Efrosinia then delivers her line,
"White is the cowl, but black is the soul," as she throws aside her
own black cloak to reveal a white hood (434, Fig. 220). The irony
and implications are clear: Efrosinia is unaware that her statement
now applies to herself as well as to Pimen. But the moment also
holds implications for the structures of costuming in the entire film.
For one thing, it acknowledges conventions that associate black
with evil and white with good; much of the costuming has been
playing off these conventions. In his essay "Color and Meaning"
and again in "Extrait d'un cours sur la musique et la couleur dans
Ivan le Terrible,"[6] Eisenstein spoke proudly of having reversed these

[6] Sergei Eisenstein, "Color and Meaning," in The Film Sense, trans. and ed. Jay
Leyda (New York: Harcourt, Brace, and World, 1942), p. 151; "Extrait d'un cours
sur la musique et la couleur dans Ivan le Terrible," in Au-delà des étoiles, trans.
Jacques Aumont et al., ed. Cahiers du cinéma (Paris: Union Générale d'Editions,
1974), pp. 286-287.

traditional associations by clothing the Teutonic knights of *Alexander Nevsky* in white. Now, in *Ivan*, he creates a pattern more complex than a simple reversal by citing the conventions openly and by establishing a set of variations. Efrosinia's line serves as a baring of the device of black and white costumes. It also serves to suggest that the traditional black/white connotations do not hold for this film, even though they may appear to. She accepts the black/white, bad/good conventions, while simultaneously acknowledging them to be misleading. But even as she discovers that Pimen's white cowl conveys a false image of his character, she unconsciously asserts her own "whiteness" by throwing off her shawl. At this point, her costume resembles Anastasia's; she also attempts to play Anastasia's Madonna role by singing a lullaby to Vladimir. (Anastasia had been linked with her son Dimitri in the sequence of Ivan's illness.) In both of these scenes, the action involves an anticipation of Ivan's death: in the earlier instance, Anastasia had asserted Dimitri's right to the throne, and now Efrosinia does the same for her son. Throughout, the irony of the moment when Efrosinia revealed her white hood lingers on.

Anastasia herself demonstrates the opposite pole, the nonironic use of white costuming. After her marriage, she wears white exclusively. Since she is the embodiment of loyalty to the goal (Ivan), one might easily assume that white is associated directly with positive semes. This impression is likely to be particularly strong in the scene of Anastasia's poisoning, where her white clothing contrasts absolutely with Efrosinia's black. Similarly, in the scene of Ivan's illness, Efrosinia and Anastasia confront each other over Kurbsky's head in their black and white costumes; visually this confrontation seems to present Kurbsky's choice as absolute—between either the "good" or "bad" path (Fig. 137).

This use of black and white costumes fits into the general expressionistic style of the mise-en-scene by creating visual signs of narrative material. Rather than presenting characters' semes or situations by suggestion, the film transfers them to a new channel of expression, the costuming. But then it goes further and creates some moments in which the implication becomes more complicated. There is no set association, and the spectator must be able to keep track of shifts and nuances.

The overall challenge to this simplistic color opposition comes with just such reversals as Efrosinia remarks on. Besides Anastasia, Pimen is the other character associated frequently with white clothing. He is part of a whole schema in which the aristocratic characters

all have a limited range of costuming possibilities; they all wear brocade, fur, armor, black cloth, or white cloth. Other colors and materials are seen only among the crowds of common people (as in Malyuta's first appearance).

Ivan himself wears white early on in the wedding and illness sequences. Once he has discovered the Boyars' treachery, however, he takes to wearing black. The shirt he wears in the scene of Anastasia's poisoning is similar in style to that of the wedding banquet, but black. From this point on, all his costumes are black, except in the color sequences. He also dresses his Oprichniki in black uniforms, and they all wear black monks' outfits in the two cathedral scenes. This progression follows the gradual shift on Ivan's part toward abandoning personal happiness to dedicate himself completely to the goal of unifying Russia. The costume imagery of the monks' cassocks marks the completion of this change.

The progression in Ivan's camp is opposed to a different progression among the Boyars. In the Fiery Furnace sequence, Philip gives up his dark robe to dress in white embroidered finery; Efrosinia reveals her white hood. In each case, the change images the attempt at taking over the roles of Ivan and his supporters in order to replace them. Philip attempts to be Ivan and fails; Efrosinia attempts to be Anastasia and similarly fails. Once Philip's failure becomes apparent, Efrosinia tries to force Vladimir into Ivan's role. As he is departing for the feast, she calls after him, "Don't forget to wear your new kaftan" (II, 484-485). Malyuta's muttered reply, "I'll remind him" (485) has a strange irony. Although Vladimir does indeed put on his "new kaftan," the coronation robe, Ivan does not hatch the scheme to dress Vladimir in the robe until later; Malyuta's line anticipates upcoming events without his having any way of knowing what they will be.

The multiple strategies that depend upon assuming roles and forcing opponents into roles result in several uses of costumes within the context of the narrative. These all occur in the Fiery Furnace and feast sequences of Part II. As with Efrosinia's revelation of her own white hood in the following scene, in the Fiery Furnace sequence, the Boyars set forth their allegorical selves (the boys) in the white robes of "innocence." In contrast, Ivan and his Oprichniki wear black cassocks, indicating that they, too, are acting a part— one that complicates the imagery of the play considerably. Presumably the Boyars are hoping to lead Ivan into a reaction similar to that of Nebuchadnezzar in the original story. There the pagan king,

seeing the three Jews saved from the furnace by an angel in the form of the Son of God, blesses their God and gives them great power.[7] But after the Boyars have put such emphasis upon the "pagan" Tsar, Ivan enters in monk's clothing; their attempt to force him into a role that they can control fails.

In the banquet scene, Ivan uses the spectacle of the dance and song to dazzle Vladimir and confuse him into revealing the assassination plot.[8] Thus Fyodor's oriental costume becomes a part of Ivan's scheme. Vladimir subsequently dons a costume, the coronation robe, to play at being Tsar. The scene of Vladimir's death reverses several aspects of the earlier Fiery Furnace play. In each case, the outcome depends on one of the parties becoming aware of the specific nature of the drama. Ivan's recognition of the allegorical application of the Fiery Furnace play leads to his discovery of Efrosinia's guilt. He later places Vladimir in the role that deceives the assassin; here it is Efrosinia who eventually discovers the ironic significance of the events to herself. Ivan's power and victory are in large part dependent upon his superior ability to manipulate his own and others' roles.

As with the costumes, the acting style in *Ivan* consists of direct visual representations of characters' semes and motivations rather than attempts at suggesting inner psychological states. Most of the individual scenes are fairly straightforward; to interpret them in relation to the narrative action would be superfluous. Instead, I would like to sum up what seem to be the basic principles of acting in the film.

The pacing of the actors' movements differs from that of more conventional films. Some would call it "slow"; whether or not it is actually slower than most films is probably impossible to determine objectively. But the difference does create a strange sense of the temporal flow of the action. Rather than simply moving freely through the space of the scenes, the actors often proceed in stages. An actor will strike a pose in an expressionistic tableau of relations with the surrounding mise-en-scene and the frame. Then he or she changes position and reaches a new pose and a new tableau. These poses are often only small pauses in movement, occurring whenever the actor comes into a significant conjunction with other stylistic elements. The "echoing" archways and other devices of locale we

[7] Dan. 3:23-30.

[8] We shall see in detail how this happens in our examination of this scene in Chapter Seven.

have already examined provide good examples of this device. When Ivan stands beside the archway that echoes his shape and frames the distant crowd in the Alexandrov sequence, he must twist his body around and look to the left to make the conjunction work (Fig. 193).

Another example occurs in the scene of Ivan's return in Part II, where he is taunting the Boyars and telling them of his new governmental policy. Shot 110 is a long shot of a line of Boyars in the throne room. As the shot begins, Ivan stands just outside the frame, with his arm visible at the right (Fig. 221). He lunges suddenly into the frame, stopping abruptly in medium-shot profile, saying, "All right" (Fig. 222). After a brief pause in this position, he turns slowly and moves back toward the open space at the left of the frame, in front of the Boyars. As he reaches this space, Malyuta moves into the right foreground area Ivan has just left and stands with his back to the camera (Fig. 223). Ivan tosses his arm around and stands still to tell the Boyars he will give them land to govern. This shot contains several distinct temporal stages, in addition to making use of several planes of action in deep focus. The temporal divisions depend on the movement of the actors from one pose to another.[9]

This Kabuki-like principle of breaking the action into distinct stages is not confined to the movements of the actors themselves. Often a series of shots all show the same space, with an actor or actors present in static poses. The change in relationships between figures and surroundings then depends entirely upon the different frames (and, as we shall see in Chapter Eight, upon the elaborate shifts of mise-en-scene between shots). Minor characters in particular simply stand still, while the progression of the narrative is accomplished through cutting. This happens in such scenes as the series of shots that introduces the foreign ambassadors in the coronation sequence, the opening of the sequence of Ivan's illness (Figs. 121 through 126), and the cutaways to the onlookers in the Livonian court scene. Eisenstein treats actors as a part of an overall visual composition, to the point that it sometimes becomes unnecessary for them to move at all. When characters move, they do so intermittently; the audience gets a chance not only to notice the surroundings but also to perceive those surroundings as they relate visually to the characters.

[9] For Eisenstein's discussion of "disintegrated" and "slowed" acting, see "The Cinematographic Principle and the Ideogram," in *Film Form*, trans. and ed. Jay Leyda (New York: Harcourt, Brace, and World, 1949), pp. 43-44.

This style of movement in stages is paralleled by the tendency of the actors to break their speeches into distinct units. In the shot of Ivan talking to the Boyars after his return in Part II, he speaks his first line after he has come to a stop in medium shot; he then waits to give the rest of the speech until he has moved to the background plane of the shot's space. The pauses between lines are particularly apparent in this whole first scene of the return, before Philip's entrance. The relatively long silences set up an unusual rhythm that stands out even in the generally unconventional pacing of the film as a whole.

Ivan uses an exaggerated acting style consisting of broad gestures. The film provides simple, clear character motivations but is not particularly concerned to provide insights into the psychology of the characters. Critics who attempt to read the film as the personal tragedy of Ivan or as an expression of Eisenstein's personality make the mistake of trying to turn it into a psychological drama. The historical films of the classical tradition are typically primarily interested in character; they deal with historical events only as factors that affect the characters' lives. *Ivan* does the opposite. Historical events come first, while characters are important partly as they effect those events and partly as they symbolically embody aspects of them. I shall examine this idea further in Chapter Eight, in my discussion of the nonclassical narrative structure of *Ivan*. There it will become clear that this use of history is part of a different conception of causality at work in the film.

Subtleties of character do not arise, then, from nuances of inner states that the actors manage to suggest. Instead, the complexity of Ivan, Efrosinia, and the rest derives largely from the immense network of formal relations that the film creates among all aspects of the work. Numerous channels reiterate the same semes over and over but always with variations. The spectator must perceive the characters by noticing connections between semes displaced into the setting, into the music, into the use of eyelines, and into literally all the cinematic techniques employed.

In *S/Z*, Roland Barthes attempts to define how a character comes into being in a work of literature:

When identical semes traverse the same proper name several times and appear to settle upon it, a character is created. Thus, the character is a product of combinations. . . . The proper name acts as a magnetic field for the semes; referring in fact to a body, it

draws the semic configuration into an evolving (biographical) tense.[10]

In film, as we have noted, the body is literally present in the form of the actor (or occasionally just the actor's voice). The actor's body creates the character by serving as a repository of semes, in the way Barthes describes. It is probably the case that most films use objects and locales as a source of the characterizing elements (Sam Spade's "Dependable" brand of tobacco in *The Maltese Falcon*, the mountaintop upon which York meditates in *Sergeant York*) that go to make up their "semic configurations." But *Ivan* goes perhaps as far as any film in centering whole interlacing patterns of semic material around the actors' bodies.

One acting device that is implicated in a much larger formal system of the film is the use of eyes and glances. The actors use their eyes in an extremely exaggerated way, opening them wide to stare, narrowing them suspiciously, or rolling them to glance awkwardly to the side. Ivan's stare from beneath the huge Bible during his illness (I, 458, Fig. 131) or his sideways glance later in this sequence after his line, "The Holy Sacrament has cured me" (583, Fig. 224), are examples. But we have already seen how the device of the eye enters into other patterns. The nonclassical spatial structures of many scenes are partly dependent on the use of eyelines in the editing, as with the coronation sequence. Spying is a major narrative device. Dominance among characters is often symbolically conveyed by their ability or inability to outstare or look at each other. When the centrality of the eye device is bared in the scene of Malyuta as "the Tsar's eye," the final extreme close-up of the three-shot series has Malyuta place his thumb and fingers so as to frame three sides of his open eye (Fig. 180).

The direct external representation of character structures the make-up of the actors as well as their gestures. On the whole, the functions of the stylized make-up are self-evident. Perhaps the only cases that require any discussion are Ivan and Vladimir. These two, along with Philip, are the only characters who change in appearance during the course of the action. We have already seen how Philip's change between Parts I and II sets him visually against Ivan as a rival. In their first confrontation, they look remarkably alike; later

[10] Roland Barthes, *S/Z*, trans. Richard Miller (New York: Hill and Wang, 1974), pp. 67-68.

they symbolically switch places briefly in the Fiery Furnace sequence.

But Ivan goes through far greater changes, ranging from the intense, idealistic young man of the coronation to the monklike figure of the assassination scene. In the beginning, his hair is elaborately curled, shaping his head to fit the crown exactly. Gradually his hair loses this style, becoming thinner, lanker, grayer; the point of his head becomes more pronounced, until it fits the pointed monk's hood and cap he affects in the second half of Part II. One important aspect of Ivan's make-up is that, unlike the other characters, he changes strikingly from sequence to sequence. Between the coronation and the wedding, he grows a beard and generally looks more mature, while the other characters remain unchanged. In the Kazan sequence, he has a moustache as well. By the illness sequence, his hair has begun to be streaked with gray. At no point do Ivan's movements display a similar aging process, however: he remains as vigorous and flexible in the last scene as in the first (note, for example, his low bow to Pyotr, with one hand extended to the floor and one to the top of his staff, Fig. 225). He manages simultaneously to age and to remain youthful in his power and abilities. The aging process brings semes of maturity, craftiness, and fatherliness. There is also a hint of premature aging, brought on by the pressures and strains of the goal, since no one else seems to show many signs of the passage of time. This in turn supports the connotations of some scenes that Ivan is being driven toward madness: the action of Part II draws a thin line between craft and insanity as Ivan becomes increasingly erratic in his behavior and increasingly remorseful. The movement of the first two parts develops Ivan from warrior-king to monk-king, as he gradually isolates himself in his dedication to the goal. But at the same time, the warrior role is held in reserve, for eventually Ivan must be capable of returning to battle. This he does in Part III; sketches and production stills indicate that Ivan was to have aged still further but that he would resume his black fur cloak and hat to ride out to battle.

Vladimir changes only by growing a small beard between the plotting sequence of Part I and the Fiery Furnace play of Part II; there is a hint that he is trying to imitate Ivan's own changes (Figs. 54, 56, and 61). But Vladimir has not matured through conflicts with enemies, as Ivan has. He remains essentially childish. However, the beard helps to modify this seme in Vladimir, by preparing us for the more active role he will soon play, questioning and even

resisting the plans into which Efrosinia is trying to push him. Also, the beard helps make Ivan's part (indirect though it may be) in the killing of Vladimir somewhat more acceptable, since Vladimir no longer projects the simple-child image of Part I.

CONCLUSIONS ON VISUAL STYLE

One of the most striking things about *Ivan*'s overall style is the large number of devices that develop into entire systems in the course of the film. By using a variety of local structural dominants from sequence to sequence, Eisenstein is able to differentiate the stylistic treatment of individual narrative situations. At the same time, this strategy allows the film to set up parallels and contrasts between its specific parts, as we have seen with the coronation and Fiery Furnace play sequences, for example. The imagery of the motifs is similarly complex. Usually no one repetition of a motif has a definite, complete narrative function. As a result, each motif that returns diffuses the spectator's attention to other instances of the same device. The motifs are insistently systemic, creating links to other portions of the film. Finally, the use of expressionism activates the mise-en-scene to an unusual degree; backgrounds and causally inactive elements come into prominence to create multiple strands that combine in a redundant support of the narrative.

Eisenstein spins out these devices by developing them from their initial introduction through a shifting set of variations. In the process, they cross and recross other stylistic systems, so that each individual system of devices gains added complexity and further connotations from the others. The ray motif is an example. Beginning as a simple pattern in a shot of a wheel, it quickly attaches itself to Ivan, joins briefly with the candle motif, and, by the end of the Kazan sequence, is taken up into the acting to become the power gesture. Later it becomes a basic part of the choreography of the dance scene, crops up in the frescos, and participates in the culminating moments of the film as Efrosinia stands over Vladimir's body.

This theme-and-variations approach and the interweaving of multiple systems of devices creates complex interrelationships on every level, down to the most minute. Up to now the concentration has been on the more general structures. In the next two chapters, I shall show how these same patterns are at work in the soundtrack as well. There we shall be able to examine how these principles function in a single sequence just as they do over the entire film.

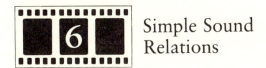 # Simple Sound Relations

FUSION OF MUSIC AND IMAGE

At the end of Chapter One, we looked at general Hollywood practice in the use of sound. *Ivan*'s sound structures often resemble those of the classical narrative film: it uses dialogue in synchronization with the actors' gestures, the dialogue usually determines the volume level of other sounds, blooping has eliminated the noise of splices on the track, and so on. Yet upon watching *Ivan*, we surely would consider its sound different from the accustomed norm. The frequent application of the term "operatic" to the film suggests its difficulty for us. By beginning with a more specific examination of *Ivan*'s musical structures, we may then be able to see the same formal principles at work in the other areas of sound. Again, *Sergeant York* and *Mary of Scotland* offer points of comparison.

Hanns Eisler has provided an admirable discussion of the typical musical structures of the classical Hollywood cinema. According to his book *Composing for the Films*, Hollywood had worked out a practical set of guidelines for film music:

> The character of motion-picture music has been determined by everyday practice. It has been an adaptation in part to the immediate needs of the film industry, in part to whatever musical clichés and ideas about music happened to be current. As a result, a number of empirical standards—rules of thumb—were evolved that corresponded to what motion-picture people called common sense. . . . They only seem to make sense as a consequence of standardization within the industry itself, which calls for standard practices everywhere.[1]

Eisler's characterization of Hollywood film music suggests that the classical cinema strove to make music a background element as much as possible. Such standardization as he describes would tend

[1] Hanns Eisler, *Composing for the Films* (London: Dennis Dobson, Ltd., 1947), p. 3.

to make perception of music easy; accompanying music (as opposed to musical numbers) would not call attention to itself but would remain an aid to the action. In general, Hollywood's assembly-line approach made a minimum of differentiation—and hence defamiliarization—desirable. With the continuity system and other "rules of thumb" in force for films with any type of subject matter, defamiliarization became possible primarily on the level of narrative. As we shall see, *Ivan* does not relegate its score to this background function but foregrounds it by using the music and other sound in unexpected ways.

Eisler describes how the rules of thumb concerning music encourage a simple set of perceptual cues for the spectator. His categories are not strictly logical, but they constitute the most extensive analysis that has been done of Hollywood music. The rules derive from Eisler's practical experience and are suggestive rather than definitive. I shall test them against the films of our background set, *Sergeant York* and *Mary of Scotland*.

Eisler's first rule relates to the use of a popularized version of the Wagnerian leitmotif. That is, composers introduce distinct and recognizable musical passages that quickly become associated with a character or situation; these musical passages then recur in the course of the action in relation to that particular character or event. (This is actually not typical of Wagner's original usage of leitmotifs. He tended to avoid this simple one-to-one correspondence, often juxtaposing a leitmotif with an unassociated object to create narrative connections. The device of the leitmotif probably filtered down into Hollywood practice through such popularizers of Wagnerian technique as Puccini.) Eisler states that leitmotifs were used to "patch together"[2] film scores. The extreme dependence of Hollywood composers on this technique has been a problem: "He [the composer] can quote where he otherwise would have to invent."[3]

Eisler also speaks of a strategy which he calls "Geography and History" that relates to films set in foreign countries or historical periods. These are automatically scored with clichéd, familiar pieces with relevant associations:

> When the scene is laid in a Dutch town, with its canals, windmills, and wooden shoes, the composer is supposed to send over to the studio library for a Dutch folk tune in order to use its theme as

[2] Ibid., p. 4.
[3] Ibid.

a working basis. . . . Related to this is the practice of investing costume pictures with music of the corresponding historical period.[4]

My own analyses of *Sergeant York* and *Mary of Scotland* have led to similar conclusions. The value of Eisler's analysis for this study is that it demonstrates that these qualities are typical of the classical films of the background as a whole.

One of the most striking characteristics of the motifs in these two films is their extreme dependence upon familiar tunes with stereotyped associations. *Sergeant York* begins with "You're in the Army Now" over the first titles of its credits sequence, then modulates into a passage that will become associated with York and his family. After York's religious conversion, he sings "Give Me That Old Time Religion" with the congregation; variations on the melody of this song accompany appearances of the preacher and return at every reference to York's religious convictions. *Sergeant York*'s score is a grab bag of familiar patriotic, popular, and folk tunes. At various times it includes "America," "La Marseillaise," "Rings on My Fingers," "Oh, You Beautiful Doll," "In the Sweet By-and-By," "Yankee Doodle," "Deutschland Uber Alles," "Pack Up Your Troubles in Your Old Kitbag," "Dixie," "East Side, West Side," "The Stars and Stripes Forever," and another Sousa march. A few of these ("Rings on My Fingers," "Oh, You Beautiful Doll") are diegetically motivated, coming from a player piano; the Sousa is played to welcome York home. But, for the most part these familiar tunes serve as a sort of shorthand reference to previously established cultural associations the songs have outside the film. "Deutschland Uber Alles" plays as the German troops come down out of their trenches to surrender to York; "East Side, West Side" accompanies his visit to New York City; "La Marseillaise" is first heard early in the film as a traveling salesman mentions "the war in Europe."

Mary of Scotland uses familiar music in a similar way, although it works with fewer different tunes. Over the credits we hear the well-known "You take the high road" passage from "Loch Lomond." This becomes a central musical motif that recurs on Mary's first entrance and in several scenes thereafter, always in relation to Mary. The rest of the credits music is a pastiche of real or fake Scottish folk tunes. Finally, in a crawl title that introduces the conflict between Mary and Elizabeth I, the tunes "Loch Lomond"

[4] Ibid., pp. 14-15.

and "The British Grenadiers" alternate and play in counterpoint.

Sergeant York's music is more sophisticated than that of *Mary of Scotland*; in the former film, the composer, Max Steiner, also creates some original motifs that become associated with individual characters. In addition to the York family motif, there are passages for the mother and for York's fiancée, Gracie. The mother's theme is a sentimental tune with violins and harps; Gracie's is more sprightly, with pizzicato notes played variously by light instruments—flute and xylophone with strings. These themes are tightly tied to the characters. Gracie seldom or never appears without a statement of her motif as an accompaniment. *Mary of Scotland*'s music tries for considerably less. Aside from the bagpipe band that always follows Mary's lover Bothwell about and Mary's "Loch Lomond" tune, the characters have little or no distinctive association with musical motifs.

Much Hollywood accompaniment serves to bridge transitions from one scene to another. During these transitions, which have no dialogue, the music becomes louder than it usually is during the middle of conversation scenes. This pattern becomes very clear at montage sequences, where the quick passage of time is likely to be accompanied by the loudest music of all. *Mary of Scotland* follows this pattern closely, seldom using music "under" dialogue. Exceptions occur in intimately emotional scenes: the dialogue between Mary and Bothwell on the tower of his castle has quiet, romantic music playing throughout.

Sergeant York has more music. Steiner has scored virtually every scene in the first two-thirds with music through most of the dialogue. This music is quiet and composed as a continuously moving line rather than as a distinctive melody with variations. This line modulates constantly to fit the actions on the screen, thereby making itself almost unnoticeable. For example, in the scene where York's mother throws a bucket of water over him to sober him up, the music shifts at nearly every shot and action. In a transitional lateral tracking shot, York rides home on muleback, with the rhythm of the music exactly matching the mule's walk. After a dissolve to the interior of the York house, the "mule" rhythm disappears and modulates to quiet oboe music as the mother goes about her tasks. At a cut to a medium shot of York in the doorway, a conventionally comic motif comes up, played by clarinets. This corresponds to his gesture of lowering his head. From this point, comically ominous

music plays through a series of shots as the mother asks for water and York prepares himself to be doused. The music comes to a climax on a loud, held chord exactly as the water hits York in the face, then fades down to a quiet accompaniment. The main family motif returns over the meal, and a musical transition leads over the next dissolve into "Give Me That Old Time Religion" as the preacher appears in the next scene. The use of music in this segment raises a question that we must deal with: Wherein lies the difference between this approach and Eisensteinian vertical montage?

Eisler confirms that Hollywood music is typically unobtrusive and closely matched to onscreen movement. Of unobtrusiveness he says: "One of the most widespread prejudices in the motion-picture industry is the premise that the spectator should not be conscious of the music. The philosophy behind this is a vague notion that music should have a subordinate role in relation to the picture."[5] The matching of music to image Eisler calls "illustration," and he describes it thus: "Music must follow visual incidents and illustrate them either by directly imitating them or by using clichés that are associated with the mood and content of the picture."[6] This latter point specifies the problem of distinguishing between vertical montage, with its emphasis on "fusion," and the practice of "illustration" in Hollywood films.

Eisler's descriptions of how Hollywood employs leitmotifs, familiar melodies, and illustration help to indicate the classical Hollywood cinema's avoidance of difficult and noticeable musical accompaniment. In Formalist terms, the implication is that Hollywood uses primarily realistic and compositional motivation for music, avoiding artistic motivation whenever possible; that is, music is always at the service of narrative. Aaron Copland's brief description of film music in *What to Listen for in Music* gives more evidence that this is the case. Copland lists five functions of film music:

1. Creating a more convincing atmosphere of time and place.

2. Underlining psychological refinements—the unspoken thoughts of a character or the unseen implications of a situation.

3. Serving as a kind of neutral background filter.

[5] Ibid., p. 9.
[6] Ibid., p. 13.

4. Building a sense of continuity.

5. Underpinning the theatrical build-up of a scene, and rounding it off with a sense of finality.[7]

The first two categories involve realistic motivation, the last three, compositional motivation. These are the norms of Hollywood musical usage.

Some devices in *Ivan* resemble, at least superficially, the close music-image fusions of the Hollywood cinema. In the scene where Kurbsky comes hurrying into the hall for the wedding banquet, he pauses briefly to turn and look back in the direction of the Livonian ambassador outside. Simultaneously with his gesture comes the first "hey" of the chorus's lullaby. Shortly after this, on the crane shot down the wall (shot 109), the chorus begins their first verse proper as the pointed thrones move into the bottom of the frame. Ivan and Anastasia break out of their kiss as the chorus section of the lullaby begins, and their bow to the guests coincides with this motif in the music:[8]

Example 1

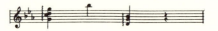

The first chord comes at the rise from their first bow (112), the second as they bow to the left, and the third just before the cut. This same three-note motif occurs over shot 116, on Pimen's gesture of leaning forward and looking off at Efrosinia and over shot 117, on Efrosinia's head and eye gesture in reply.

The music that accompanies the poisoning of Anastasia provides another clear example of how sound, particularly music, matches closely with the actions on the image track. This music first occurs over Efrosinia's declaration in the plotting scene that she will take the task of killing Anastasia upon herself. In shot 627, she says, "We must separate Anastasia from Ivan." A series of chords follows, and the poisoning motif begins:

[7] Aaron Copland, *What to Listen for in Music*, rev. ed. (New York: New American Library, 1963), pp. 154-155.

[8] All musical examples are from the piano score of A. Stasevich's oratorio adapted from Prokofiev's music: *Ivan the Terrible* (Moscow: Soviet Composers, 1962).

Example 2

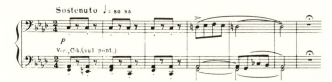

At the cut (on the held rest in the sixth measure), she says: "This task . . . I take upon myself"; on the second phrase of that statement, the chords begin again, leading to a descending figure that resolves the melody:

Example 3

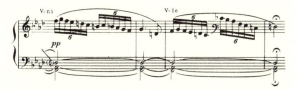

The final held note that resolves this passage coincides with Efrosinia's gesture with her hand across her face. The descending sixteenth note slurs begin again as she turns and the image fades, but this time they do not resolve. Instead, the music fades down as Ivan's voice begins over the darkness before the next fade-in. This suspended resolution leaves the piece uncompleted until the poisoning itself.

The actions of the poisoning scene coincide closely with the music. As Efrosinia uncovers the cup (693), the first of a series of sinister chords is heard; these chords continue as she places the cup on the ledge. Ivan picks up the cup as a soft, melancholy oboe solo plays:

Example 4

After he has taken the cup, he goes off left. The initial chords begin again as he does so. In shot 697, Ivan passes through the frame, right to left. He pivots slightly as he turns, holding the cup rigidly at arm's length in front of him; this movement corresponds with the slurred eighth notes that rise and then fall in measure 4 of Example 2. The chords return again in shot 698 as Ivan lifts Anastasia so that she can drink; shot 699, Ivan in profile, is again accompanied by the same slurred eighth-note motif (suggesting that not only the movement within the shots but also the rhythm of the editing corresponds to the music). In shot 700, there is a pause as Anastasia raises the cup to her lips, then the chords recommence. As Efrosinia raises her head above the wall to look in shot 701, the slurred eighth-note motif of Example 2 recurs. Shot 702 uses chords as Anastasia raises the cup again, moving to the final descending figure as she drinks. This time the music resolves as the image fades.

One of the finest uses of music in conjunction with image movement comes at the end of Part I when Ivan goes out and bows to the crowd that has come to call him back to Moscow. At first the chorus is heard softly, but as an offscreen window is opened, there is a sudden increase in volume. One phrase ends, and there is a pause as Fyodor puts the big fur cloak on Ivan's shoulders. As Ivan grasps his staff, the chorus resumes. On a crescendo and held chord, there is a cut-in to Ivan (789) as he throws back his head exultantly. He starts forward on another pause, and there is a match on action again at the cut, with the chorus resuming. In all this, there is a considerable coordination and resulting synthesis between sound and image tracks.

There is a general correspondence of sound and image as Ivan

descends to the landing in shot 794. In the following shot, he bows low to the first loud, tense chord of the "Oh, return" music. The chorus comes in again exactly on the cut to shot 796, the first close-up profile shot of Ivan (Fig. 194); this is the first entry of the lyrics, "Oh, return." Ivan raises his head as the note is held (Fig. 195). After the cut to shot 797, there is a decrescendo as the people kneel. In shot 798, the second loud strings chord matches closely the action of the people dropping to their knees. The second "Oh, return" carries over to the third shot of the crowd (799), and there is a decrescendo. This return to softer accompaniment prepares the way for the second profile shot (800, Fig. 196). Ivan's beard and face come down into the frame to the soft, plucked strings and women's chorus. These shots differ considerably from a classical style of "illustrating" sound. Here Ivan's movements have no specific function; they seem to exist primarily in order to be accompanied by the music.

After a long-held final note, there is a brief pause. Suddenly a loud chord begins the final fanfare. The cut to shot 801 (a long shot of Ivan) occurs during this chord. Then, in shot 802 (a profile medium shot), quivering strings and very low brass state the "Terrible" theme as Ivan puts on his hat. A flourish in the higher brass and an elaborate harp run coordinate beautifully with Ivan's broad gesture with his staff and sweeping sleeve as he turns. A restatement of the theme carries over to shot 803 (Fig. 197), as Ivan climbs the stairs; he pauses to look back when the trumpet flourish begins again, with the harp runs coming in over shot 804 as the people begin to stand. This sort of repetition continues until Ivan reaches the top of the steps. A final trumpet-and-harp passage occurs as Ivan moves toward the window, the people visible in the distance. The resolving chord comes just after the cut to the final shot. Here, as at the end of Part II, Prokofiev insists on the resolution of the music by repeating the same chord several times, into the final credits.

Another example of the coordination of music with action in Part II involves the music that punctuates the execution scene, becoming very loud at the moment when Malyuta shrugs off his cloak and takes up the sword. Similarly, the scene of Vladimir's death contains a particularly effective musical accompaniment. Instead of loud, "dramatic" music at Efrosinia's discovery of her mistake, the film uses a quiet, tense passage. This music includes short chords that

begin exactly as the Oprichniki move aside to reveal Ivan (693). The music contrasts sharply with the procession music and loud passages that had followed the stabbing; as a result, the scene offers a sort of winding down and pause after the main events. This lingering is appropriate because this is the end of the line of action involving Vladimir and Efrosinia.

More generally, there is a whole structure of musical usage scattered throughout the film that also bares the device of sound-image conjunction. This mainly involves gestures that seem in some way to be causally connected with the beginning or ending of music, when in fact such a connection is impossible. The first instance occurs in the wedding banquet, when Kurbsky throws down his cup; on the crash, the wedding music abruptly cuts out and the riot music begins, followed quickly by a cut to the rioters entering the palace courtyard. Later in the same scene, Ivan makes a slashing motion with his hand to illustrate his line, "First, it [a head] must be cut"; at the same time, his tone changes from mocking to threatening. This shift is marked both by a sudden change in the lighting and by the reentry of the riot music exactly on his gesture. In the Kazan sequence, the music that accompanies the whole scene of the prisoners' deaths cuts out precisely when Ivan angrily claps Kurbsky on the shoulder. The scene then continues without music until Ivan claps Basmanov on the shoulder after their conversation on the hill; on the gesture, the sappers' chorus comes in again, preparing the way for a cut back to the trenches. In contrast, classical films would tend to avoid the kind of ambiguous conjunctions between action and music that would call attention to the latter. In *Sergeant York*, the music modulates unobtrusively from one passage of music to another.

These instances all occur relatively early in the film. Then this use of gestures as a kind of false signal for the music largely disappears. Its use toward the beginning allows the film to point up the devices in the music that will continue throughout, particularly the strategy of fusion. Two things that make these conjunctions of music and gesture so noticeable are the volume and distinctive quality of the music involved. Some variations on this device do occur later in *Ivan*, as in the scene of the Boyar plot of Part II. As Vladimir sits cowering after fleeing from Efrosinia's harsh plans, a musical passage of tense strings and clarinets begins. As if alarmed by this (nondiegetic) music, Vladimir starts and turns around to

face the camera. Only after a considerable pause do we discover that what has made him turn is the opening of the door and not the music itself. We must conclude that music-image relationships of this type, which do not support a clear narrative flow, are artistically motivated.

DIALOGUE AND EFFECTS

Music is not the only type of sound that coincides closely with narrative actions on the image track. Often voices or noises work in a similar way. For example, the perceptual effect of the Kazan ambassador's entrance is largely determined by the fact that his initial line, "Kazan severs its ties with Moscow," is not spoken while his face is visible; instead, it coincides with his onscreen gesture of pulling aside his coat to reveal his shoes and elaborately embroidered trousers (Fig. 226). Ultimately the exact function of this juxtaposition is difficult to pinpoint. Perhaps the most logical explanation is that the arrogance contained in a device of one channel (the ambassador's line) combines with a moment of display in another (mise-en-scene). The juxtaposition is logical but not narratively necessary. As a result, form is roughened and perception made more difficult.

Another simple sound-image structure that varies only occasionally from classical Hollywood usage is voice quality. Typically this device functions to reinforce other narrative cues and create nuances. One such structure involves the timbre of the voices. Rather than using shifts in timbre to suggest the space within which the characters are located, Eisenstein sometimes varies the voices according to the narrative relations of the characters. In contrast, most classical films, including *Sergeant York* and *Mary of Scotland*, tend to use a similar timbre for voices in any spatial situation; in this sense, *Citizen Kane*'s use of an "echo" effect on voices was something of an innovation. Welles uses this device primarily to suggest large spaces. All characters in such settings have the same echo-effect in their voices. (Note the last scene among the reporters in the storerooms of Xanadu, for example.)

In the coronation scene of *Ivan*, on the other hand, Eisenstein uses voice timbre to set Ivan apart from the other characters. By standards of realism, all the voices of people addressing the crowd in this and other scenes in the cathedral should have similar qualities

of resonance. Pimen is presumably speaking loudly enough to be heard throughout the cathedral, yet his voice is weak and has no echo to it. Although the archdeacon's bass voice does have an echo, the reverberation in Ivan's voice is even stronger. Though he does not speak loudly in the first part of his speech, his voice seems to echo through a large space (the effect in fact becomes less distinct the louder he speaks). A similar shift in voice timbre occurs in the scene of Ivan mourning beside Anastasia's coffin. Of the voices heard in the first part of the scene, only Pimen's is loud enough to reach everywhere in the room. Prior to the outburst, "You lie!" his voice and Ivan's (731) have some resonance, but Ivan's angry shouting and pushing over of the large candlesticks (733-734) have a pronounced echo-effect. This not only marks Ivan's sudden defiance of the Boyars but also prepares us for the connotation of emptiness as Ivan looks around the room and says, "We are too few" (739).

This association of a "booming" voice with Ivan provides a neat reversal in the scene in Part II where Philip returns to confront Ivan. The latter's first lines, shouted from the opposite end of the hall from the throne, have an echo-effect. After his first greeting, however, Ivan's "Say no more" is delivered in a strangely muffled voice. In his appeal to Philip, his voice has a different quality than in previous scenes; it is quieter, less strong and deep. In contrast, Philip's voice is harsher and louder than Ivan's. When he finally moves to leave and reject Ivan's friendship, Philip's words again echo across the empty room between them.

In the Fiery Furnace play sequence, the piping voices of the three boys sound "thin" in the huge space of the cathedral. In contrast, Ivan's loud laugh comes in with considerable resonance, drowning their song. His laugh creates a sort of sonic "close-up," while the boys are heard as well as seen in "long shot." The sound quality of the boys' voices plays a part in their function as a spectacle the Boyars set up in Ivan's place. Not only do they sound vastly different from Ivan but they also contrast sharply with the archdeacon's bass chant in the coronation scene. This helps construct the network of parallels and contrasts between the two scenes that we saw at work in their respective spatial relations. In general, Eisenstein uses depth, volume, and resonance of voice in association with Ivan's power. At moments of doubt, when Ivan's voice becomes less strong, he also tends to sink down. In the scene with Philip in Part II, he sits on the steps before the throne rather than on the chair itself; by the coffin he remains drooping on the floor or against the catafalque

until his final decision, at which point he rises to a place above the coffin. Some of the sounds Ivan causes are similarly resonant: note the echoing stamp with which he dismisses the Boyars early in the poisoning sequence or the sound of the candles he knocks over in the sequence by the coffin.

Ivan also occasionally uses sound to punctuate and emphasize, much in the manner of the Kabuki theater. Films of the classical narrative background do not use this sound device because it necessitates minimizing any motivation for the sound and calling attention to the sound as a distinctive device. *Sergeant York* and *Mary of Scotland* tend to *de*emphasize the beginnings and endings of musical passages, so that they will blend in with the action. In general, the Hollywood practice of "illustration" means that effects and music act only as reinforcements to the action. *Ivan*, on the other hand, gives sound an unusual rhythmic prominence by using it for punctuation and emphasis. As we have seen, many of the individual chords and notes of the musical passages coincide closely with single bits of action. The punctuating sound devices do the same, but they stand out more from the larger pattern of sound. For example, the final shot of the Boyar plotting in Part II shows the empty cup Ivan has sent Efrosinia (Fig. 169). The sound over this shot is a short, loud drum roll that brings to an abrupt end the quieter music that had been accompanying the action. The contrast of the drum roll and the earlier music makes it seem almost like a separate sound and hence sets off the cup shot from those that preceded it. A similar but quieter drum roll occurs just after Vladimir is stabbed; this sound is even more distinct from the other music of the scene.

Probably the most spectacular use of sound for punctuation occurs in the courtyard segment at the beginning of the illness sequence in Part I. Here the bells call especial attention to themselves by their variety. Rather than using a single bell, or multiple bells of the same type, Eisenstein mixes four or five distinctly different bells. The rhythm of these bells is close to, but not identical with, that of the cutting. The opening series of shots demonstrates this slight irregularity:

409 – The last shot of the Kazan sequence: swirling smoke; a bell tolls one time as the music ends. Fade out.

410 – Its reverberations accompany the fade-in to a medium shot of the icon over the cathedral door. Another toll.

411 – Medium shot of two Boyars with the icon behind. One softer stroke of the bell.

412 – Medium shot of two other Boyars with the icon behind. (The two Boyars of shot 411 are also visible in soft focus.) A single toll.

413 – Medium shot of two Boyars. A single toll, the reverberations of which carry over to . . .

414 – Medium close-up of the Basmanovs. A single higher bell tolls once. (This bell sounds vaguely oriental because it is not tuned on the same musical scale as the deep bell heard up to this point.) Its reverberations carry over to . . .

415 – Medium shot of three foreign ambassadors. A third bell, of a more conventional church type, rings once, then another slightly lower one tolls once; its reverberations carry over to . . .

416 – Medium shot of two other foreign ambassadors. The original bell tolls once, reverberating over the cut to . . .

417 – Long shot of the Livonian and two other ambassadors. A jangly, chime-type bell rings once as the tall ambassador comes forward to speak to Kurbsky, who comes in from the left.

The bells continue throughout the scene, but this series of shots should give adequate indication of the rhythmic punctuating function that they serve. Certain variations signal changes and differences: the "oriental" bell sounds on the shift from shots of Boyars to a shot of the Basmanovs; Kurbsky's entrance is marked by the strange, jangly bell. Later bell tolls accompany specific actions as well: a bell tolls as Kurbsky exits from shot 418, as the tall ambassador turns his head in shot 421, as Efrosinia finishes crossing herself, and so 'on. But for the most part, and particularly in the sequence's opening portion, the bells are heard over static shots. Their tolling has a general rhythm—usually once per shot—but is also irregular and unpredictable. The mixture of different bells also seems random and startling; their rings sound strange since they are tuned at odd intervals to each other.

As we have seen, the static poses in the courtyard are part of a spatial pattern governed by Ivan's absence. The strangeness of the tolling bells emphasizes and makes tangible the static postures and

the passage of actionless time that result from his absence. Sound punctuates the plot's time and space in order to call attention to the strangeness of this absence, preparing us for the moment when its cause will be revealed. A tiny comic baring of the device comes in shot 423, when, on a repetition of the jangly bell, Vladimir suddenly looks up and off right, as if to see where it has come from. Since everyone in the scene has completely ignored the bells up to now, this gratuitous glance stands out particularly and renews the bell device, which has been used many times by this point in the scene.

All these uses of sound in coordination with image are bared in the Fiery Furnace play. The general music of the scene accompanies the play's action, of course. But in addition, cymbal clashes coincide with the Chaldeans' cartwheels; the cartwheels in turn stand for the action of placing the boys in the furnace. This substitution of gestures in such a stylized manner underlines the similarly stylized use of the sound that accompanies the gestures.

MUSICAL MOTIFS AND THE NARRATIVE

So far in this chapter I have looked at the specific structures of relationships between sound and image tracks. The musical score, however, has a structure of its own that relates to the narrative as a whole. In her study of Prokofiev's score, Mary Peatman has distinguished two general types of musical passage: the leitmotif and the single piece that occurs only to accompany a specific scene.[9]

The feast and procession sequence that will be analyzed in the next chapter uses primarily the latter type of musical passage. The procession music demonstrates how Prokofiev takes a simple set of musical materials and develops it in the course of a scene to fit the variations in the dramatic situation. The scene of Ivan's illness and the melody that bridges the intercutting between Anastasia's sickbed and Ivan's throne room are other examples. The remainder of this chapter will examine *Ivan*'s use of leitmotifs.

As with the visual motifs, there are a number of sound repetitions that create connections between scenes without being used frequently enough to become major leitmotifs. For example, the fan-

[9] Mary Peatman, "Sergei Eisenstein's *Ivan the Terrible* as a Cinematic Realization of the Concept of the *Gesamtkunstwerk*" (Ph.D. diss., Indiana University, 1975), p. 122.

fare that plays as the Kazan ambassador enters the wedding banquet hall (I, 239-240) returns as Ivan moves swiftly across to confront him (244-246); the music signals the ambassador's assertion of power and aggression, then returns at Ivan's defiance.

The scene of Ivan's illness contains a parallel within an extended piece of music. In the segment between Kurbsky and Anastasia in the little hallway chapel, she reveals that Ivan is not dead (562, Fig. 182); her line comes at the same passage in the music that had accompanied Ivan's collapse in the previous scene (515). This is similar to the device we saw earlier in looking at the Part II feast: there the use of the dance music over the bringing-in of the swans helped to establish the parallel functions of the dance and swans as types of spectacle to dazzle Vladimir.

A number of musical passages return repeatedly, conforming largely to Eisenstein's view of a floating motif that does not have a single, fixed association. This distinguishes these passages from the usage of the Hollywood historical biography. As we have seen, the classical narrative tends to create musical motifs that repeat in a simple one-to-one pattern to accompany certain characters and actions. Our background films also demonstrated a tendency to appeal to extremely well-known melodies, thus plugging the spectator into a set of already established associations—a sort of musical shortcut for the filmmakers.

Prokofiev does use some existing tunes as sources for parts of the score of *Ivan*. Peatman has pointed out that the music of the chorus, "Have Mercy, O Lord," at the end of Part I derives from an old Russian hymn.[10] The hymn is called "God Preserve Thy People." (It can also be heard at the beginning and in the triumphant climax of Tchaikovsky's *1812 Overture*.) Eisenstein himself says that both the tune and words of the beaver lullaby were derived from popular or traditional songs, although he seems to suggest that the sources for each were different.[11] Probably some or all of the hymns sung in the cathedral scenes are similarly derived from existing works.

The use of the hymn implies that the film is trying to tap automatic associations somewhat in the manner of the classical Hollywood narrative film. On the other hand, Prokofiev develops the traditional qualities of the lullaby, adding levels to it appropriate to the specific

[10] Ibid., p. 120.

[11] Sergei Eisenstein, "Extrait d'un cours sur la musique et la couleur dans *Ivan le Terrible*," in *Au-delà des étoiles*, trans. Jacques Aumont et al., ed. *Cahiers du cinéma* (Paris: Union Générale d'Editions, 1974), pp. 271-272.

scene. For the most part, the musical themes of the film seem to be original.

Foremost among these is the music generally associated with Ivan (although this music is not automatically repeated on his every appearance). There are three distinct pieces based on the same theme, which begins:

Example 5

The first I shall call the *main "Terrible" theme*, which consists of heavy, low brass; it first occurs over the credits of Part I in alternation with the "Black Cloud" chorus. A second version, the *slow "Terrible" music*, is really a very different piece, consisting of slow, high strings. Finally, the third theme forms the basis for the music of the finale of each part: extremely ponderous, low brass varied by trumpets and harp runs, ending in a series of extended chords on the resolving tone.

Rather than being associated simply with Ivan, these three separate versions of the "Terrible" theme recur in relation to certain aspects of his character and in certain kinds of situations. The main version occurs at moments of Ivan's assertion of power, while the slow piece accompanies more contemplative scenes. But within these generalizations there is considerable variation.

The main "Terrible" theme becomes associated with the crowd's acceptance of Ivan and his gaining of strength through their support. Its first recurrence after the credits comes in the wedding banquet scene; it begins over shot 254, the close-up of Malyuta enthusiastically shouting "To Kazan!" and starting to move with the rest of the crowd. Then this version of the theme disappears for a considerable portion of Part I. It does not return until the end of the scene by Anastasia's coffin. As Ivan stands above the coffin, a crowd rushes in and the music plays loudly (760-766). The situation is much as before: Ivan gains the support of the people in his new resolution, and the motif of a crowd with torches recurs at each of these two uses of the music.

The credits and summary section of Part II also use the main "Terrible" theme. The selection of this particular theme to accompany the credits privileges it considerably; it becomes associated with the film title itself, being the only passage used outside the narrative as well as over it. (These credits repetitions also make it the most frequently used motif of the entire score. Without them it would occur only five times—the same number as the slow version of the theme.) Thus, although we have only heard this music in two narrative contexts by the beginning of Part II proper, it has firmly established itself as *the* main theme connected with Ivan. In the Livonian court scene, the messenger's announcement that Ivan is returning to Moscow leads to another statement of the main theme as Sigismund and his followers leave (94-97). By this time, the associations with the theme are firm enough that it can be used to substitute for Ivan's presence. Here it is emblematic of his power, driving the Livonians out in a sudden swirl of activity.

All of these associations also permit the next use of the theme to be an ironic one, occurring at the moment in the flashback when the Boyars and ambassadors bow to the young puppet ruler. Aside from the inappropriateness of the vigorous music to the stiff formality of the men and the timid boredom on the boy's face, the juxtaposition of the "power" music with the young Ivan emphasizes his weak position.

The final use of the main theme occurs in the Fiery Furnace scene as Ivan and his Oprichniki enter the cathedral (353-359). It continues through the actions of Ivan and Philip as they move to confront each other in the central space. Once again the association is clear: the assertion of power, with each man supported by his own faction. Overall, this theme seems to have a distinct but flexible set of associations.

Not surprisingly, the slow "Terrible" music is heard in scenes of comparative repose. Its first statement occurs in the scene in which Kolychev and Kurbsky express their discontent and apprehension to Ivan during the wedding banquet (134-151). This is the first time in the body of the film that the "Terrible" theme heard in the credits has returned in any version, and here it forms part of a very different musical passage from the main "Terrible" music. The association is not clear, although the music seems to link up with Ivan's magnanimous gesture of allowing Kolychev to enter a monastery.

The slow version recurs twice in the Kazan sequence in two similar contexts that help to pinpoint its associations. Both uses

come at moments when Ivan stands atop his hill gazing silently over the surrounding land: the first occurs when we see him emerging from his tent to stare across at Kazan (275-282) and the second when Alexei Basmanov directs his son to look up at Ivan by his tent just before the explosions (374-381). Each series of shots creates a pause in the action during which attention is focused on Ivan.

The only other use of the slow "Terrible" music in Part I occurs in the scene where Ivan dismisses the Boyars and sends his ambassador Nepeya to England. The theme plays from the moment in shot 642 just before Ivan sits down and his huge shadow appears until shot 645, just before Ivan begins to speak about the chess set. Here one function of the music is to shift the tone of the scene. In the beginning of the sequence, Ivan was shouting at the Boyars; now, as they leave, he becomes quiet when he speaks to Nepeya. The use of this music as the huge shadow appears parallels the same theme played when Ivan stands atop his hill at Kazan. The "Terrible" motif in its various versions seems exactly that—a music passage that comes to embody the semes of Ivan that make him "terrible" (awesome, powerful, etc.). The slow version enters at moments of repose when Ivan's power is evident but in check. At moments when this power breaks out in action, the main version is used.

The last statement of the slow "Terrible" music comes in the second flashback of Part II, where it accompanies the beginning of Ivan's story of the Boyars' rule and lasts over the clouds and the entry of the young Ivan as the throneroom scene begins. In relation to the earlier uses of this music, this one creates a slight irony that is not humorous but points up the pathetic situation of the boy's powerlessness.

Finally there are the ponderous musical statements that occur in the last scene of each part. In both cases, the proairetic movement of the films comes to an almost total halt. In Part I, we simply watch Ivan walk back up the steps after acknowledging the people's appeal. In Part II, he sits in his throne room reiterating his determination to march against Livonia. Yet precisely because the narrative action is set aside briefly, the film is able to bring Ivan's character forward as the primary focus of attention by using this music in coordination with the action. In each case, a concentration on Ivan leads to a concentration on the all-encompassing idea of Russian unity. In Part I, Ivan's last line is, "For the sake of the great Russian land"; the resolving chord of the music begins just before he speaks

it. His closing line in Part II is, "By Russia we will stand"; in this case, the resolving chord occurs shortly after the line. In each case, the music builds up to a tremendous pitch during the scene. The tension is quite separate from any concern with forwarding the plot, involving only the most fundamental qualities of the central character and his symbolic function in the scheme of the entire film.

There are two motifs consistently used in relation to the Oprichniki. One is the humming chorus that first occurs in the scene at Alexandrov in Part I with the appearance of Ivan's new troops. This music eventually becomes the basis for both the procession to the cathedral in Part II and the Oprichniki oath that follows the defeat of Efrosinia. In contrast to this, the second piece of music is a vigorous tune that first accompanies the ride back to Moscow and later becomes part of the dance music in the feast scene. These two motifs are part of a general tension that exists in the Oprichniki between their humorous and threatening qualities (reflecting a similar tension in the character of their leader). There is always a suggestion that the dancing and song can suddenly transform itself into an attitude of attack. Malyuta's amusing conversation about himself as a dog leads into his ruthless execution of the Kolychevs. The singing of Fyodor's song begins lightly and becomes more ominous as it proceeds. Finally, the mock coronation scene dissolves rapidly into a funereal procession as midnight arrives. The contrasting motifs serve in part to suggest this potential for outbreak.

More general motifs attach themselves not to single characters or groups but to types of narrative action. Thus music that accompanies the rioters' invasion of the palace during the wedding banquet returns at several other moments of direct conflict. None of these later scenes specifically involves the people or a riot situation, but in each case the action depicts a crisis or confrontation. This music occurs over the entire first flashback of Part II, accompanying the swirling clouds and the scene of Helena Glinskaya's death. It returns a few scenes later as Ivan is about to leave Anastasia's bedroom; here the "riot" music signals the beginning of the executions, which Ivan sees as he moves toward the window. The music stops at shot 270 (the shot in which Malyuta begins to read the parchment), then returns in shots 278-286, the end of the reading and the actual executions. Finally, the music returns at the end of the Fiery Furnace sequence (385-398) over the argument that culminates in Ivan's declaration that he will become "terrible."

There is a different musical passage, consisting of tense strings,

that plays over several scenes of confrontation. We first hear it in the last portion of the second flashback as Ivan orders Byelski seized (200-210) and declares that he will reign without the Boyars. It next occurs in the scene where Malyuta enters the Boyars' chambers both to invite Vladimir to the feast and to deliver the wine cup. In this context, the music suggests not so much a confrontation as a vague threat. It commences before we see who is entering the room and continues as Malyuta advances ominously and mysteriously across the room. The threat is Ivan's determination to be revenged for Anastasia's death; its fulfillment will be a major step toward Ivan's independent rule. The music's final repetition comes in shots 577-589 of the feast scene as Fyodor, Ivan, and Malyuta all notice Pyotr's presence. Here again the context is a threat, the nature of which is unknown to the characters.

We saw earlier in this chapter how one motif—the one that accompanies both the planning and execution of Anastasia's poisoning—links several separate scenes. The motif returns one other time, during the scene in Anastasia's bedroom in Part II when Ivan discovers that she had been poisoned (255-260). The specific association of this theme with the poisoning is clear enough. But the same theme was previously used to mark Ivan's shift of dependence from Anastasia to Fyodor (as a representative of the Oprichniki) in the scene by the coffin in Part I. Now it is Fyodor who tells Ivan of the murder; thus the use of the motif in Part II has a double association and ties together several narrative threads.

These simple sound structures reveal some distinctive features in comparison with classical usage. *Ivan* tends not to subordinate sound to narrative at all times; sound may call attention to itself far beyond its function in the plot, as with the bells in the opening of the illness sequence. This suggests that Eisenstein goes beyond the realistic and compositional motivation of Hollywood films to motivate some of his sound artistically.

7 Vertical Montage

EISENSTEIN'S CONCEPTION OF VERTICAL MONTAGE

My purpose here is not primarily to explicate vertical montage as a theoretical concept but rather to use this concept to analyze sound and image relationships in *Ivan*. Unfortunately Eisenstein's writings on the subject are not entirely clear. This chapter, then, will necessarily proceed in two complementary directions: first, I shall use the theory of vertical montage as an analytical tool; second, the results of this process should in turn help to clarify what vertical montage is. All this depends on the basic assumption that *Ivan* does use vertical montage. Certainly Eisenstein's writings on this film indicate that this is indeed the case.

In his essay "Synchronization of Senses," Eisenstein defines vertical montage as involving "a 'hidden' inner synchronization in which the plastic and tonal elements will find complete fusion."[1] Repeatedly in the essays in *The Film Sense*, Eisenstein refers to this inner "movement," but it is difficult to define what he means by the term. Clearly it is not literal movement but some sort of thematic and/or emotional quality that may vary considerably in nature in different parts of a film.

Eisenstein's analysis of a twelve-shot segment from *Alexander Nevsky* in "Form and Content: Practice" reveals many problems in his own application of the concept as a critical tool. A number of commentators have written critiques of this essay; one excellent one is Eisler's short piece in the appendix of *Composing for the Films*. Here I will point out a few of the problems that make direct application of Eisenstein's method to other films difficult. For a start, Eisenstein at times takes music to have a literal visual composition. As Eisler says: "Eisenstein's graphs are supposed to prove that the actual movement of the music is similar to the picture sequence. What they prove in reality is that there is a similarity

[1] Sergei Eisenstein, "Synchronization of Senses," in *The Film Sense*, trans. and ed. Jay Leyda (New York: Harcourt, Brace, and World, 1942), p. 82.

between the *notation* of the music and the sequence."[2] Eisenstein believed that the most striking effects of sound-image juxtaposition could be gained with "*a congruence of the movement of the music with the movement of the visual contour.*"[3] Unfortunately he does not mean the movement of the image but refers to the underlying structure that it supposedly shares with the music. The problem here is apparent and has been pointed out often: Eisenstein is attempting to match temporal qualities of the music with largely static qualities of the images. He has deliberately chosen images with little movement, and many of the elements he emphasizes within the shots are unchanging. Eisenstein is primarily trying to show that there is a close "fusion" between sound and image in these shots. (Fusion is a key word in these essays.) He resorts to many tricks to prove his point. His types of examples are mixed: in one shot, a graphic pattern may match the music; in another, the layers of represented space will be the evidence for fusion, and so on. This in itself is not problematic, for surely vertical montage implies that a variety of devices can enter into relations with the music. But Eisenstein does not treat these as consistent structures through the whole segment. He fails to examine color contrasts, movement, lighting, and other possible examples in *each* shot, looking at them only in those shots where they provide him with a convenient coincidence with the music. The only element he treats consistently is the overall composition of the shots, and here he depends on the doubtful notion that the eye becomes "accustomed" to scanning from left to right and does so in every shot. The implication that vertical montage is a sort of random or scattered set of relations between music and image seems an unacceptable conclusion.

So these essays leave one a bit puzzled concerning how to proceed in analyzing *Ivan*. If there is to be any meaning in the term at all, we should be able to find a difference between the sound-image relations in *Ivan* and those in the classical Hollywood film. I in fact started out upon my analysis with the assumption that there would be a large and readily noticeable difference; this did not prove to be the case. Take, for example, the scene from *Sergeant York* I described in the previous chapter, in which York's mother throws

[2] Hanns Eisler, *Composing for the Films* (London: Dennis Dobson, Ltd., 1947), p. 153. Italics in original.

[3] Sergei Eisenstein, "Form and Content: Practice," in *The Film Sense*, trans. and ed. Jay Leyda (New York: Harcourt, Brace, and World, 1942), p. 173. Italics in original.

a bucket of water over him. If one were to write as intensive an analysis of the close relations between sound and screen action in this short series of shots as Eisenstein did of the *Nevsky* segment, I suspect one could make a far more convincing case for fusion than Eisenstein does for his twelve shots. Steiner's score corresponds to movements that *occur in time.*

One must conclude either that the distinguishing feature of vertical montage is not fusion or that Eisenstein uses "illustrative" fusion in a different way from Hollywood. Considering Eisenstein's insistence on fusion in his own analysis, I would tend to choose the latter possibility; an analysis of *Ivan* helps confirm this. The main structural difference seems to rest on a greater complexity of relations between sound and image in *Ivan.* To a certain degree, this is due to the excellence of Prokofiev's score. But the difference involves more than quality or expertise. Eisenstein also constructs his scenes around a play of overtones and dominants, both visual and sonic, so that the sound can have multiple relations to the elements of the image track. The classical narrative cinema, on the other hand, tends to "illustrate" the dominant action only. In Eisenstein's terms, the dominant of a segment is the most important structural line running through that segment; this may be an action, an attitude, or any important, repeated use of a stylistic device. (This idea is similar to the Formalists' concept of the dominant as the central organizing principle.) A scene may have any number of subordinate structures weaving through it; these are *overtones.* Again, any device may become an overtone: the structures are not restricted to narratively central elements.

In the previous chapter, I discussed only examples of simple structures between one sound and one image. With multiple sounds and multiple images (or multiple elements within images), the relationships become much more complex. We have seen, for example, how the central part of the Fiery Furnace scene pivots around the one long shot of the boys, over which their singing blends with Ivan's loud laugh from offscreen. In this same scene, the bells and choir proceed simultaneously at the same rhythm. Similarly, the goblets at the wedding scene in shots 123-124 of Part I (Fig. 187) clink in time to the music.

These are fairly uncomplicated examples, but in a scene that combines dominants and overtones on the sound and image tracks, the relations can become more complex. The beaver lullaby that Efrosinia sings to Vladimir sets up a tension between the literal

meaning of the words and the more sinister connotations that the acting and music introduce. The song begins as quiet music and humming in shot 439, a medium close-up of Efrosinia and Vladimir; the apparent implication is that the subject of Vladimir's future has been dropped. The song opens in shots 440-441 with a simple, pleasant melody, conventionally appropriate to a lullaby. With the cut to shot 442 (the end of measure 9), another medium close-up of the pair, the music changes key and introduces some dissonances: At this same point, Efrosinia's expression becomes slightly crafty. After the next line (measures 10-12), there is a dissonant oboe motif, and Efrosinia speaks the next line rather than singing it.

At shot 444 (the first shot of Efrosinia alone in the frame), she suddenly begins to look very crafty and sings louder. She smiles during a pause in the verse, while a shrill violin and oboe motif plays. Then the bouncy part of the music commences, and Efrosinia begins to move rhythmically to the music, glancing from side to side as she tells of the beaver shaking itself and looking around. Her excitement and the volume of her singing increase until the end of shot 445 (a medium shot of the two). During this loud passage, horn phrases enter the music, "illustrating" the hunt she describes. In shot 446, she leans over Vladimir to sing softly. The music is that of the song's beginning, but it has become less innocent sounding. The singing is more dissonant, and the song's ending is drawn out as Vladimir waits in suspense. In shots 450-452 (the two medium shots of the pair with an insert medium close-up of Efrosinia), the string accompaniment becomes very loud, while a chorus joins Efrosinia in singing a long, elaborate form of the name "Tsar Vladimir." After Vladimir's cry, there is a tiny pause as he leaves the frame. Very loud violin music begins at the end of this shot as Efrosinia rises to follow.

A close coordination of voice, music, and narrative action is apparent here. The music shifts to reflect the changing descriptions in the verse, and Efrosinia alters her voice and gestures to "act out" portions, such as the beaver looking around after its bath. Beyond the lullaby itself, the music and acting soon reveal Efrosinia's delight in viewing the beaver hunt as representative of her own plans for Ivan. In contrast to this, we watch Vladimir's more gradual realization of what his mother is implying by the seemingly innocent lullaby.

The music is tied primarily to Efrosinia's view of the song's connotations. Eisenstein has pointed out how the first dissonance enters

Example 6

the song at the word "black." This begins to suggest Efrosinia's linking of the verse with Ivan, since he is associated with the big black fur cape. In "Extrait d'un cours sur la musique et la couleur dans *Ivan le Terrible*," Eisenstein provides a short but admirable analysis of this song (from which several of the points I mention were derived).[4]

Again, the difference between the lullaby in *Ivan* and songs in classical narrative films is not readily apparent. Certainly the delivery of the song by the actress is strange and difficult in a way that distinguishes it from classical practice, but a Hollywood film would be equally likely to fit each phrase of the music to the words and might well use a horn to illustrate a line about a hunt. On the other hand, the lullaby seems more complex than the music of the classical norm because of its tension between a surface innocence and the underlying ironic reference to Ivan.

Another sequence that Eisenstein analyzes in some detail is Ivan's mourning beside Anastasia's coffin in Part I.[5] Eisenstein's choice of sequences is apt, for the dependence of the narrative upon the weave of multiple voices is as evident and impressive here as in any other scene. I will briefly summarize Eisenstein's argument before passing on to a more minute examination of another key sequence, the feast and procession to the cathedral in Part II.

Eisenstein's analysis of the mourning sequence begins with the words: "The fundamental theme—the despair of Ivan."[6] His main concern is to show how the sound works contrapuntally to propel this theme (which he treats as fundamentally equivalent to what we have been calling the "dominant") through a series of stages in the course of the sequence. He describes how this process commences:

> To this fundamental theme becomes braided the reading of the Psalms of David by the metropolitan Pimen and the reading by Malyuta of the reports . . .
>
> These two readings are unrolled in a sort of antiphonal chant—of two voices.

[4] Sergei Eisenstein, "Extrait d'un cours sur la musique et la couleur dans *Ivan le Terrible*," in *Au-delà des étoiles*, trans. Jacques Aumont et al., ed. *Cahiers du cinéma* (Paris: Union Générale d'Editions, 1974), pp. 271-272.

[5] The essay is actually part of a book-length manuscript entitled "Nature is Not Indifferent." The extract relating to *Ivan* appears in *Cahiers du cinéma* in abridged form as "La non-indifférente nature" (trans. Luda and Jean Schnitzer, *Cahiers du cinéma*, no. 218 [March 1970], pp. 6-14).

[6] Eisenstein, "La non-indifférente nature," p. 7.

In tone and rhythm they are alike.
In the text, they prolong each other . . .[7]

Eisenstein goes on to describe how the meanings of the readings
are clear only in relation to each other:

> Despite the apparent similarity of tone, of cadence, and of the
> manner of reading, the dramatic *tendency* of the two readings
> is diametrically opposed. . . .
> This struggle between two readings is a sort of interior combat
> "for a soul."[8]

He describes how these two readings mount in tension until the
revelation of Kurbsky's treachery, the final blow that leads to the
moment in shot 729 when Ivan leans against the coffin, his head
in medium close-up and profile, recalling the shots of him as he lay,
apparently dead, in the scene of his illness (Figs. 111 and 112).
This, says Eisenstein, is the turning point of the scene:

> Finish. Final point.
> Culmination.
> But so it is the rule (and as such arrives often) at the same
> instant as the culmination—that exact moment of the dramatic
> structure—a rupture is produced, the sudden change toward the
> opposite.[9]

Eisenstein speaks of the two opposing lines as "the line *of death
and the paralysis of volition*" and "the line *of the affirmation of
life*."[10] The first is embodied in the rhythmic insert shots of Anastasia
in her coffin, in Ivan's immobile positions, in Efrosinia as she stands
looking on, and in Pimen's reading. The second begins with Mal-

[7] Ibid. Note here the similarity of Eisenstein's analytical terms "braid" and "pro-
long" to those of the Formalists. Shklovski, for example, uses metaphors such as
"*pazveptyvat*" (to unwind) and "*priem nanizyvaniia*" (device of enfilade—i.e., device
of threading on a string) in writing on narrative structure in his *O teorii prozy*
(Moscow, 1929), p. 81; Formalist terms frequently derive from sewing and em-
broidery, with their connotations of complex and winding interrelationships of
elements. "Prolong" recalls the Formalist concentration on delay and retardation.
One even finds Eisenstein using the term "staircase shape" to describe the overall
construction of a film, in Vladimir Nizhny, *Lessons With Eisenstein*, trans. and ed.
Ivor Montagu and Jay Leyda (New York: Hill and Wang, 1962), p. 34.

[8] Eisenstein, "La non-indifférente nature," p. 7.

[9] Ibid., p. 8.

[10] Ibid.

yuta, then expands to the Basmanovs, and finally to the crowd that enters at the end of the scene.[11]

Eisenstein goes on to give a lengthy list of the different means employed in the scene: the acting, the voices, the arrangement of the figures in depth, the music, and so on. He says that these elements often have multiple aspects; that is, the music has a structure of its own, while also playing a part in the overall structure of the sequence. He also points out that this complex scene, like others in the film, "must not be simply *watched* and *listened to*, but it is necessary to scrutinize and give ear to it attentively."[12] This idea of difficult perception is, of course, central to Formalist criticism. Eisenstein goes on at a later point to elaborate on this idea and apply it to montage:

> Montage determines as well the alternation of *durations*, clearly delimiting the successive impressions that the systems of *rhythmic pulsations really collect across the wave of images.*
>
> At the same time, montage realizes the indispensible breaking-up of that wave of uninterrupted images.
>
> Without such a breaking-up, no perception is possible—neither emotional nor poetic—and, as a consequence, every way contrived to influence the spectator is impossible.[13]

Again, the strategy of which Eisenstein speaks is one of roughening form.

According to Eisenstein, the scene by the coffin is a central one for the narrative. The repetition of the line about the "third Rome" marks the end of "the first period of the reign of Ivan."[14] The similar repetition of the last line of Part I, "For the sake of the great Russian state," at the end of the scene of Vladimir's death in Part II marks off the second period.

This summary describes briefly Eisenstein's views of the complex sonic weaves involved in the creation of the scene's narrative progression. I would like to add a few details to his analysis.

One particularly close correspondence between sound and image occurs in shot 728; Pimen's voice starts reading, offscreen, exactly

[11] The two lines are not equally balanced in their opposition throughout the sequence. At the beginning, Ivan is already in despair; only after he dismisses Pimen does the second line emerge.

[12] Eisenstein, "La non-indifférente nature," p. 12.

[13] Ibid., p. 13.

[14] Ibid., p. 12.

as Ivan begins his despairing gesture of laying his head back against
the coffin. Prior to this, Ivan had been still, listening to Malyuta;
Ivan's sudden movement and the return to Pimen's voice are so
closely coordinated that they give a considerable impression of au-
dio-visual fusion. The voice and gesture both carry over the cut and
shot 729. The fact that this is also the culmination of the first part
of the scene suggests that it conforms to a pattern described by
Eisenstein in his essay "Word and Image":

> The picture plays the role of syntactical phrase and the musical
> construction the role of rhythmical articulation:
>
> > "Any non-coincidence of the syntactical articulation with the
> > metrical is an artistically deliberate dissonance, which reaches
> > its resolution at the point where, after a series of non-coinci-
> > dences, the syntactical pause at last coincides with the bounds
> > of the rhythmic series."[15]

Although Eisenstein speaks of music here, the idea can apply equally
well to a coincidence between voice and image. Certainly at no
earlier point in the scene does the cutting or onscreen action work
in such close conjunction with the sound.

Later in the scene, the music helps to signal a transfer of Ivan's
dependence from Anastasia to the Oprichniki. As Ivan seeks ap-
proval of his new plan to leave Moscow, he turns to look at An-
astasia. After shot 752 (which is differentiated from all other shots
of Anastasia by being printed noticeably darker), Ivan turns in shot
753 to look off at Fyodor; the violin phrase that had accompanied
the poisoning begins a split second before the end of the shot and
continues over the cut to shot 754, a close-up of Fyodor. The phrase
ends in shot 755 as Ivan leans into the frame to ask Fyodor if his
idea is right; Fyodor supports his plan. Exactly at the cut to shot
756, loud string chords begin and accompany Ivan's move around
the coffin to declare his plans exultantly. This is Ivan's first relatively
lengthy movement through space, marking his abandonment of his
despair. After a pause during which the onlookers gaze at Ivan to
the accompaniment of the main "Terrible" theme, he leans down

[15] Sergei Eisenstein, "Word and Image," in *The Film Sense*, trans. and ed. Jay
Leyda, p. 56. Eisenstein is quoting from a 1925 book, *Vvedeni v Metriku, Teoria
Stikha*, by Viktor Zhirmunski, who is generally considered to have been a member
of the Russian Formalist group.

to kiss Anastasia farewell. A harsh trumpet phrase heard nowhere else in the film coincides with this final break.

These examples all suggest something of Eisenstein's strategies in creating audio-visual relationships. But we still need to examine how the specific elements within a shot relate to the sound in a single, extended sequence. I have chosen the feast scene in Part II and the subsequent procession to the cathedral as an example demonstrating Eisenstein's small-scale sound-image structures. This sequence has several advantages. It allows us to see how Eisenstein incorporated color into the sound-image patterns. The feast is also a dense collection of elements, with a variety of musical interludes alternating or combining with the main narrative action. The subsequent black-and-white procession scene provides a useful contrast. Here one line of action proceeds without interruption; the number of elements is relatively sparse, and includes a powerful musical accompaniment that uses subtle variations of instrumentation to help create a steady increase in the scene's tension.

In analyzing the first few shots of the feast scene, I quickly discovered why Eisenstein chose to concentrate on only twelve shots of *Alexander Nevsky* in his essay "Form and Content: Practice." First, a detailed analysis of the vertical montage in a whole sequence would be quite lengthy. Second, the results of such an analysis on a limited number of shots would serve to demonstrate the principles at work without running as great a risk of becoming repetitious. Therefore I shall go through only the first dance segment and first dialogue segment shot by shot. Then, with the resulting conclusions in mind, I will analyze the remainder of the sequence more briefly.

Example 7 is the piano score of the music in the first section of the feast, a wild dance by the Oprichniki that ends with a shift to a conversation between Ivan and Vladimir. The dance involves shots 490 through 516. I have noted where cuts occr in relation to the music with an "X" above the score; the number of the new shot follows the "X." (Numerals at the beginning of each line indicate the number of the first measure of that line.)

This breakdown indicates that the shot changes do not usually occur directly between musical motifs. Instead, cuts come variously before, after, or directly on the beat. This frequent slight difference between the rhythm of the cutting and that of the music helps avoid

a simple one-to-one correspondence. As we shall see, this differs from the typical Hollywood musical number. Eisenstein sets this slight disjunction of cutting and music against a complex set of relationships between movement within the shot and the accompanying music.

The first few shots begin a pattern of play between a fixed set of elements that weave through the scene as dominants and overtones. In shot 490, a single Oprichnik clad in gold is hurled straight up into the air on the first beat of measures 1 and 3 and falls back on the notes in between these beats. Above his head, the blue-and-gold icon of God is visible on the ceiling; as we have seen, this icon is a major narrative overtone in the scene (Color Plates 3 and 4). The gold of the Oprichnik's kaftan and his up-and-down movement form the dominant of the shot. The red-clad figures visible at the bottom of the frame that are helping to throw the main dancer into the air form another overtone of the shot. This set of relationships quickly shifts at the cut to shot 490a; an excellent match on action continues the pattern of leaps, now on the first notes of measures 5 and 7. But the figure is now further away from the camera, and several red-clad figures are visible spinning in the foreground. Not only are these dressed in a different color and executing a different step but the dance step is approximately twice as fast as that of the leaping figure, that is, two turns for every leap. This spinning seems to match the rhythm in the tutti passage, a series of eighth-note patterns. Thus the musical counterpoint corresponds to a visual counterpoint of layers of color, direction, and speed. The red-clad figures briefly become a dominant, surrendering their previous position as an overtone to the gold dancer.

The cut to shot 491 continues this formal strategy of shifting dominants and overtones. Now the leaping figure is only barely visible in the background, and the spinning Oprichniki are placed in the middle ground. A group of men in black leap forward in the foreground. They are also leaping approximately twice as fast as the figure seen in shot 490, that is two leaps to every one of the jumping figure in gold. These three shots introduce three lines of color that will dominate the dances and most of the rest of the scene; they also create a rapid dominant-overtone play among the colors and their corresponding rhythm and direction of movement. The number of figures in each group has also steadily increased from shot to shot.

Once again, a systematic counterpoint of color and movement

Example 7

occurs in shot 492. Gold resumes its dominance, with two Oprichniki clad in that color passing in the foreground. A row of black
leaping figures goes by in the background. The gold figures leap
twice as fast as the black ones, and they twirl as they leap—approximately one turn for every leap of the men behind. Yet another
new rhythm has been added. At this point, the blue of the ceiling
is no longer visible; the black kaftans form the backdrop for the
gold.

This short segment of spinning and leaping gives way to an even
shorter passage of loud stamping on the cut to shot 493. As before,
gold-clad figures in one shot are followed by red in the next, with

one Oprichnik centered in medium close-up and several others visible behind. The blue ceiling returns as a background. The dance movement executed in this shot juxtaposes a slow gesture with fast aural rhythm. The central dancer passes each arm once across his face slowly. But at the same time he (apparently) stamps his feet along with the others; we hear almost two complete patterns of five stamps, arranged with a tiny pause after the first two. On the last stamp, the cut to shot 494 occurs. In this shot, only the black garb and flesh tones of the Oprichniki are visible; there is only one stamping pattern of two measures. This pattern is not identical to those of the previous shot, however, since the second stamp has been eliminated. This break in the initial pattern is countered by the fact that the cut occurs after the last stamp rather than on it.

As before, the completion of the gold-black-red sequence leads to another shot (495) of a gold-clad Oprichnik; he is centered in medium close-up with others visible behind him, all against the blue background of the ceiling. He makes wild circling gestures with his arms, then ends with a flourish and pose. The stamping enters yet another variation, four even stamps in 2/4 rhythm (measures 21-22 of Example 7). The arm flails do not match this; both arms are brought around, one after the other, on the first beat and then *after* the second beat (measure 21). In the second measure, the man throws his arms out to the side. He is almost still as the first note of the next motif is heard (the first note of measure 23), then there is a cut to shot 496. This is the first shot in the scene that ends after the dancer had completed his gesture. The flourish, combined with this cue for the completion of a section of the dance, prepares the way for Fyodor's first appearance in the scene, which occurs in the next shot.

The two shots of Fyodor move the dance briefly to a more conventional coordination of a dominant movement with the music. Shot 496 lasts almost exactly four measures (23-26) and contains two two-measure passages that elaborate on the dance music that opened the scene. On the first passage, the black-clad Oprichniki move into two lines with an aisle between them; Fyodor appears in the gold-and-white Oriental costume and moves forward on measures 25-26. On the first note of measure 27, he begins to spread his arms. The cut to shot 497 (Color Plate 5) is a close match on action, moving in from *plan americain*[16] to medium shot. The

[16] A *plan americain* is a shot framing a standing human figure so as to cut it off at the shin or knee while the rest of the figure extends almost to the top of the frame.

smoothness of the action over the cut is accompanied by a general graphic continuity: the gold figure is centered in each shot, with the blue ceiling above and black Oprichniki to either side slanting back in perspective into the center background. Shot 497 is comparatively short, with Fyodor twirling once to the two-measure passage of 27-28. After the sustained note of measure 29 there is a cut away from Fyodor.

Shot 498 returns to the stamping gestures of the dance. Now only the black-clad Oprichniki are visible again, and we can see almost none of the blue ceiling. The sustained note of measure 29 begins the shot, which proceeds quickly to a repetition of the initial five-stamp rhythm in measures 31 and 32. The Oprichnik centered in the foreground moves his hands down and across in rhythm to the stamping. On the initial two stamps, his left hand swings across and pauses; then, on the three stamps, both hands go across toward frame right. The left hand goes out frame right, but the right hand passes up in front of the body to the upper frameline. Thus the second hand gesture is more elaborate than the first and fits closely with the second part of the five-stamp rhythm pattern.

Shot 499 contains a simple coordination, uniting Fyodor and the stamping. He is spinning at the cut and continues to spin very fast for two measures; accompanying him is the pattern of four even stamps for every two measures. Fyodor spins one-and-a-half times in these two measures; he then moves to pose with his body bent left and hands held off toward the right. This gesture occupies measures 35-36; then he reverses his position on measures 37-38. The descending passage of measures 39-42 accompanies another spin, followed by a little leap and stamp at the sustained note of measure 43. After this note, there is a cut to shot 500 that closely matches Fyodor's movement of flinging out his arms. (Note, in relation to the discussion of the power gesture in Chapter Three, how Eisenstein several times emphasizes this arm movement by cutting in from a *plan americain* to a medium close-up and matching the action.) On the sustained note of measure 44, Fyodor bounces slightly and stamps as he comes down. This signals the entry of the black-clad Oprichniki into the foreground, moving left to right. They stamp in yet another new pattern, with five very quick stamps, a tiny pause, and one loud stamp. This pattern occupies two measures (as at measures 45-46). Fyodor turns slowly as they move past.

The cut from shot 500 to shot 501 would appear to be a 180° shift, since Fyodor has had his back to the camera and now faces it. The icon of God, however, is still visible overhead, indicating

that the positioning has been cheated. The black-clad Oprichniki have moved in on Fyodor (as part of the cheat) and now embrace him from the sides. The same stamping pattern continues, and Fyodor and the Oprichniki sway in time to it; Fyodor's head is at the side and snaps upward again on each single loud stamp (one sway per two measures).

There follow two insert shots of Ivan looking on and shouting encouragement to the dancers. The cut to shot 502 comes exactly at the end of measure 52, where the music shifts into a new passage. There is a pause at the beginning of the shot (not marked in the score) where a few piano notes keep up a quiet rhythmic accompaniment. Measure 53 (at number 4 in the score) begins as Ivan leans forward; this movement takes two measures, and there is a pause on the first beat of measure 55. On the second beat, Ivan begins to say "burn" repeatedly on the beat until the beginning of measure 59. The word "burn" suggests connotations for the dominant red that appears during much of this early scene. The word also is taken up in the chorus of Fyodor's song, where it is related specifically to the sacking of a Boyar mansion. On the last measure of music in the shot, Ivan leans back again.

As the scene shifts back to the dance, the background changes to a red-tinted portion of the ceiling. In shots 504 and 505, gold- and red-clad dancers mix together; they are squatting and leaping forward toward the camera in the approximate rhythm of one leap per measure. Fyodor is upright and moves along with them but at a faster pace. Once again the black-clad Oprichniki stay in a separate group. In the brief three-shot segment that follows (506-508), they are in a line that moves sideways with arms spread. The background is still red, with the line disposed diagonally in front of it. The line is unmoving at the beginning of the long shot (506); the ascending triplet in measure 76 signals the beginning of the new passage. Their movement begins to the left, with the men stamping once at the beginning of each measure. Shot 507 (a *plan americain*) continues this movement uninterrupted until the end of measure 84, when the men all clap, then start back to the right. Shot 508 moves in to a medium shot, which again continues the action until the second clap, as the passage ends after the first beat of measure 92. On this clap comes the cut to shot 509.

At shot 509, the dance becomes somewhat looser in relation to the coordination of specific gestures and musical passages. There is a general rhythmic synchronization, but only a few visual move-

ments match. In shot 509, the first dancer to leap into the center of the Oprichniki circle spins roughly in time to the sixteenth-note patterns that occur every other measure from 93 to 99. His stamps and kicks similarly come approximately at the strongly rhythmic eighth notes between. But this correspondence disappears as more figures leap out and join the dance, spinning and kicking wildly. Despite the apparent chaos, the three colors of the costumes form a distinct pattern. The circle is entirely of black-clad men as the shot begins. Then a single red-clad dancer leaps forward, followed by one in gold. The cut to shot 509a continues the same dance, but now a second red figure has appeared on the right to balance the gold one on the left. Then black figures leap into the foreground, largely blotting out the others.

In the section following the two shots of Ivan, the music has been predominantly played by strings. At number 9 in the score, however, trumpets enter to play the eighth-note passages pointed in the second staff at measures 101-102 and 105-106. The trumpet enters exactly as the black-clad figures join the dance. This association of black costumes and trumpet sounds becomes firmer in shot 510, where a single black figure is posed, leaps up, and comes back to the same position in time to the second trumpet passage. Shot 511 returns to the circle of Oprichniki around the group of wildly dancing figures. The visible men are dressed in black and red; they move in general rhythmic correspondence with the music. In shot 512, three figures in black wave their arms quickly on the beat of the music. Fyodor is visible against the red ceiling in the background, preparing the way for his return to prominence in the next segment of the dance. The cut comes at the last beat of this section, measure 116.

Fyodor leaps forward during the ascending pizzicato notes of measures 117-119. The faster eighth-note passage accompanies his subsequent short leaps into the air, one per measure. The red ceiling is visible overhead, and the Oprichniki in the background are mostly in black. Yet on the cut to shot 514, the surrounding men are mostly in red, with the ceiling still red. Fyodor's action is matched in midleap. He jumps up again, beginning on the ascending pizzicato notes of measure 125. As the shot ends, he spreads his arms once more in the power gesture.

The frenzied dance ends with two shots as the Oprichniki, led by Fyodor, run across and collapse on the steps in front of Ivan's table. In shot 515, Fyodor runs from right to left on the end of the

ascending passage, measures 127-128. As the eighth notes begin in measure 129, the Oprichniki come in and begin to collapse. As usual, the colors come in groups, with the first group in black, then mostly red. Shot 516 continues this pattern as the red Oprichniki come in, followed by gold, and a few more red. A single stamp ends this shot, coming directly on the last note of measure 144 (in the score, this is the second ending, not the repeat).

The remarkable thing about this segment and the later song and dance is not specifically the close correspondence of dance steps to music; we might expect this in any musical number. But the placement and frequency of the cuts and the nature of the elements carried over from shot to shot seem highly original and may help distinguish vertical montage from more classical audio-visual relations. Since the dance and Fyodor's subsequent song constitute a full-blown musical number, *Sergeant York* and *Mary of Scotland* are not a pertinent background in this case. Instead we need some idea of classical usage of musical numbers. Therefore I shall be drawing on several Hollywood musicals to demonstrate this usage.

Several features distinguish *Ivan*'s song and dance from the norm of the Hollywood musical. For one thing, musical numbers in the classical cinema tend to involve lengthier shots than do dialogue segments. Barry Salt, who has examined the average shot lengths of some Hollywood films of the 1930s, finds this average to be relatively consistent across genres, except in the case of the musical: "If one includes the musical numbers in the count, there is a definite tendency for a director to use longer takes than he would otherwise."[17]

A survey of a few Hollywood musicals confirms that the number of shots in a typical musical segment is not large. The MGM "Freedunit" musicals seem to have a fairly consistent pattern of between four and eight shots in many of their numbers. *Singin' in the Rain* (1952), for example, has the following distribution in several of its major numbers: "All I Do Is Dream Of You," six shots (plus one cutaway to Gene Kelly looking on); "Singin' in the Rain," eight shots; "Moses Supposes," seven shots; and "Good Mornin'," eight shots. The "Broadway Melody" number is much longer, with fifty-two shots; this is presumably due to its internal narrative structure— it even has its own montage sequence. Shot counts for numbers in

[17] Barry Salt, "Film Style and Technology in the Thirties," *Film Quarterly* 30, no. 1 (Fall 1976): 29-30.

The Band Wagon (1953) and *Meet Me In St. Louis* (1944) are similar. An earlier musical, *Top Hat* (RKO, 1935), also uses relatively few shots for several of its numbers. The singing of the songs typically takes place in one or two long takes at the beginning; then the dance occupies the remaining shots. The "It's a Lovely Day" number has only four shots, "Cheek to Cheek" has six, and "Top Hat" has fourteen. The initial "Fancy Free" number has nineteen shots, but eight are cutaways that do not show Fred Astaire dancing. The "Piccolino" number in *Top Hat* is perhaps the most comparable to the singing and dancing in *Ivan* in that it divides into distinct sections; it involves an initial segment of dancing by a large number of couples, then a song by Ginger Rogers, another dance by the chorus, and finally a solo by Astaire and Rogers. Even with these various segments, the entire number occupies only twenty-one shots. (Many are linked by wipes outward from the center; this has the effect of smoothing over the rather choppy choreography as well as allowing the repositioning of the chorus for new patterns.)

The cuts in these numbers virtually always either match on action (as seems invariably the case in dances involving only one couple) or provide transitions from one entire segment to another. Thus in a Busby Berkeley number, for example, the chorines will go through one section of a dance before a cut or more elaborate transition will proceed to a new section. The same thing happens in the first "That's Entertainment" number in *The Band Wagon*. This number has five shots. The first is a long take of the singing of the first part of the song. Then the four singers begin to act out little skits to illustrate the idea of entertainment as they continue to sing. The cuts come at the end of each skit, with no cut between the last skit and the finale of the song.

Ivan does not follow these patterns. It has twenty-six shots in the first dance (plus two shots of Ivan encouraging the dancers). Fyodor's song and the accompanying dance occupy thirty-four shots (not counting any of the shots of Ivan and Vladimir's conversation during the pause in the song). Hollywood musicals tend to display whole verses or dance steps in single shots. In *Ivan*, the pattern of quicker cutting has the effect of fragmenting the movements, particularly since the same figures seldom carry over for more than two or three shots.

Another odd thing about this scene is the film's failure to establish the space clearly enough for the actions of the individual Oprichniki to make much sense as part of an ensemble dance (especially given

the frequent cheating of position). Nor are the dancers all doing the same step. Eisenstein never carries the same element over more than three shots in a row but cuts instead to another portion of the dance whose relation to the previous shot is unclear. The three-shot segment (506-508) in the first dance of the feast represents the upper limit of coherence within the dance. In these shots, the "chorus line" of stamping figures in black against the red ceiling creates one of the most distinctive steps of the entire dance. Not only does the moving line appear in three shots in a row with matches on action but it begins its movement after the cut to shot 506 and ends with a flourish before the cut to shot 509. But significantly, the portions of the dance before and after this segment are quite frenzied, and, as we have seen, the relatively tight patterns of the early part of the dance begin to break down in shot 509. I have known people to find this "chorus line" segment rather ludicrous in comparison with the rest of the dance because it seems so much closer to conventional musical choreography than the rest of the scene. There may be some truth in this, as Eisenstein does seem to move toward and away from the norm throughout this scene. This is perhaps his closest citation of the norm within his own structures.

Most Hollywood numbers do carry over the same dominant pattern from shot to shot, mainly through matches on action or position. Eisenstein cuts on overtones of color patterns, rhythmic contrasts, directions of movement, and so on, but there is no one dominant that carries through for very long. Even Fyodor, who seems to be the main figure, recedes and disappears frequently. Editing creates the dance by interweaving these overtones and dominants in a rhythmic relation to the music. A conventional choreographer would probably find this disturbing, for one cannot really watch the dancers or determine what the whole dance is like with the actions cut into bits. Hollywood musical numbers involving groups of dancers tend to stress large, overall patterns formed by the interrelated movements and positions of the bodies. Berkeley numbers with dozens of perfectly synchronized dancers provide an example. Other film techniques such as color and editing function to support, enhance, and display these patterns. Eisenstein, on the other hand, makes music, color, movement, and editing equal in importance; none—not even the dancers' bodies—takes precedence. As a result, *Ivan*'s dance is dependent on the fusion of these several "voices" acting in conjunction with each other. The overall pattern

becomes apparent only if the spectator notices other devices along with the choreographed movements of the bodies.

The dialogue sequences among Ivan, Basmanov, and Malyuta avoid such close conjunction between gesture and music. The accompaniment is drawn from passages of the preceding dance music. Yet Eisenstein creates a number of correspondences within the dialogue scene that make this music seem as "appropriate" here as if it had been specifically written for this segment as well. For example, after the stamp on the cut to shot 517, Ivan immediately calls out "bravo," leans back in his chair, and throws his arm up. At the same time, Vladimir's head appears in the lower right of the frame. Ivan shouts again, and immediately the dance music resumes. At the second phrase, Ivan pushes his black fur cape off his shoulder. His gesture of giving Vladimir the cup of wine begins with the shift (at number 1 in the score) to quieter, more steadily rhythmic music. Shot 518 continues this action, cutting from medium to medium close-up. Ivan takes the cup away. As he places his hand on Vladimir's shoulder and begins to speak, the music shifts again, back to the variation on the original motif (number 2 in the score). The cut to shot 519, revealing Basmanov, takes place during the descending pizzicato notes of measures 40-41. (This pattern confirms that the dance was cut more quickly than the dialogue segment; the first three shots here have occupied as much music as the first eleven of the dance.) He strikes the plate with his fist on the last of three sustained notes, measure 44; this signals a change to faster dance music with the piano reentering as the argument with Ivan begins. This in turn ends at number 4 in the score as Ivan begins his reply to Basmanov.

Aside from these correspondences of main actions to musical segments, Eisenstein sets up a rhythmic play with overtonal elements of the shots. In the background of each shot, servants pass by carrying large pitchers. During all but the last few shots of the dialogue, these pass from right to left in shots of Ivan and from left to right in shots of Basmanov. In the course of shot 519, two groups of evenly spaced servants pass through the background (left to right, since Basmanov dominates this shot). The first set begins with two servants entering on the descending notes of measures 40-41; two more follow, one at each of the sustained notes of measures 42 and 43. No servant comes through as Basmanov strikes the plate and shouts. His outbreak occurs during the first of four piano repetitions of a two-measure motif (first at measures 45-46, and so on). At the

first note of each of the three repetitions, a servant enters the frame in the background. The visual rhythm of their passage through the frame and the musical rhythm match quite closely. Servants continue to pass through in subsequent shots, but there the movement has no particular correspondence with the music. Instead, the graphic conflict of the different directions continues between shots of Ivan and shots of Basmanov.

The next series of shots creates slight disjunctions between sound and image. The music stops at the end of shot 520. The next series of shots involves dialogue overlaps. In a couple of cases, these are tiny overlaps. For example, at the very end of shot 524, the first word or two of Ivan's line begins. Similarly, his line, "Know your place, Basmanov," of shot 531 overlaps into shot 532 by only part of a word, "-asmanov." On "Know your place," the music picks up exactly where it had stopped before, at number 4 in the score. This creates a rather strange effect, juxtaposing the fast descending passage from the middle of measure 76 to measure 92 over Basmanov's lines in shot 535; the quick musical rhythm (previously used over the "chorus line" shots) does not match any other aspect of the shot. This odd juxtaposition suggests another way in which vertical montage differs from Hollywood usage: in spite of the frequent rhythmic correspondences, the music does not constantly change in order to subordinate itself to the dominant narrative action. Music that returns often repeats in its original form, even though the context may be quite different. In this way, Eisenstein avoids the strictly "illustrative" usage of much film music.

After these slight disjunctions, the scene returns to a close correspondence between music and image. The visuals pick up the music again in shot 538. The shrill whistle of measure 13 comes just before Fyodor removes his mask, and the softer music of number 1 in the score begins as he stares off at Ivan. The cut to shot 539, a medium close-up of Ivan, occurs exactly at number 2 in the score. He glances off toward Fyodor at the end of measure 30, narrows his eyes, and makes a brief head gesture at exactly the beginning of number 2 in the score, the repetition of the motif that had originally accompanied Fyodor's first dance. Measure 39 begins in shot 541 as Fyodor replaces the mask over his face and begins to move. His hand hits the table, corresponding with a cymbal crash at the first note of the descending passage of measure 40. At the end of measure 41, there is a cut back to Ivan; instead of a second chord in measure 42, a cymbal crash occurs. Directly before

the crash, Ivan removes his hand from Vladimir's head; directly after it, he glances down at Vladimir and moves his head to the side to listen. Another cymbal crash leads directly to Fyodor's song.

This analysis should suffice to indicate how Eisenstein is structuring his cutting and movement in relation to the soundtrack. He balances exact correspondence with slight disjunctions, often having one element that fits the music exactly occur simultaneously with another that does not.

The remainder of the scene derives much of its strength from its staircase construction; it alternates simple dialogue scenes between Ivan and Vladimir with the verses of the song and with the dance. As Pimen had used his readings from the Bible to try to break Ivan's spirit in the scene by Anastasia's bier, so Ivan uses the music in this scene to influence Vladimir. In both cases, the juxtaposition of music and several voices creates a braiding effect that ultimately leads in a single direction. In this case, Ivan dazzles Vladimir with wine and spectacle to get him into a state where he will be willing to talk. This is one reason why the dialogue with Vladimir is split up into several small scenes that are interrupted by the song and later by the arrival of the swan platters. In each return to Ivan and Vladimir, they begin their conversation exactly where they had left off, and in each interchange, Vladimir gradually concedes more and more until his final revelation.

Their dialogue prepares the way for Ivan's decision to stage a mock coronation of Vladimir in order to create a trick for the assassin. The entry of the swans and subsequent conversation provides the next "landing"[18] of the staircase structure of the scene. As Vladimir coyly replies, "You couldn't guess," to Ivan's facetious inquiry about who would replace him, the fast dance music begins once again, accompanied by the entrance of the swans. The use of the music helps confirm the swans' function as a spectacle similar in purpose to the song and dance. Rather than use a fourth verse of the same song, Eisenstein differentiates this part of the scene by introducing the swans. The song had originally led up to the revelation of the assassination plot, but it had reached its highest pitch at that point, with the tearing off of Fyodor's costume, his leaps into the air, and his sudden cessation upon seeing Pyotr. The swans provide a fresh type of accompaniment for the new line of action

[18] The term is Shklovski's. See Viktor Shklovski, "La construction de la nouvelle et du roman," in *Théorie de la littérature*, trans. and ed. Tzvetan Todorov (Paris: Seuil, 1965), p. 177.

that culminates in the decision to crown Vladimir. As we have seen, the swans also help create a parallel between Vladimir and Anastasia, preparing the way for the idea of his death as revenge for hers. Finally, the mock coronation is the last "landing" of the scene before Ivan sends Vladimir to the cathedral. This segment convinces Vladimir that he is a substitute Tsar. The comparatively lengthy series of shots of the "homage" to Vladimir allows the film to weave together and emphasize the humorous and ominous aspects of the scene.

THE PROCESSION SCENE

Eisenstein has claimed that "the following sequence in black and white continues the 'theme of black'."[19] Indeed, the last portion of the color sequence seems to shift slowly toward black, as if trying to prepare for the shift back to black-and-white stock. This process begins at about shot 641, where the black-cowled Oprichniki pass in front of a red-lit wall and gradually fill most of the frame. These black figures also move forward as well. As Ivan approaches Vladimir in long shot, the line of black Oprichniki are seen in the background, against the red of the walls. As Vladimir walks along the red carpet toward the door (shot 648), the wall behind him is lined with the black figures, and as he exits right, another line of Oprichniki begin to step into the foreground. In each case, the advance of the Oprichniki blackens a more prominent element of the space. Shots 658 and 660 show a mass of black figures bowing to Vladimir. In shot 659, they begin to move into the medium shot of Vladimir against the blue wall, gradually blotting it out. In the last color shot, the black figures move in front of Vladimir, hiding him from view. The blue-and-gold pattern has become subordinate to the black.

A large part of the procession scene's effectiveness stems from the variety of its orchestration, particularly in relation to the classical norm. Eisler gives a number of reasons why Hollywood scores were so uniform and standardized. The common assumption was that the music for a film had to be melodic and euphonious. But the types of acceptable melodies were limited. According to Eisler, Hollywood films usually used

[19] Eisenstein, "Extrait d'un cours sur la musique et la couleur dans *Ivan le Terrible*," p. 289.

the uninterrupted flow of melody in the upper voice, in such a way that the melodic continuity seemed natural, because it is almost impossible to guess in advance exactly what will follow.
. . .

Today the conventional concept of melody is based on criteria of the crudest sort. Easy intelligibility is guaranteed by harmonic and rhythmic symmetry, and by the paraphrasing of accepted harmonic procedures; tunefulness is assured by the preponderance of small diatonic intervals. These postulates have taken on the semblance of logic, owing to the rigid institutionalization of prevailing customs, in which these criteria automatically obtain.[20]

This narrow range of possibilities for melodic play is matched by what Eisler calls clichéd techniques.[21] This he describes as Hollywood's tendency to use musical approaches that are far behind those of the avant-garde; hence films tend to adopt influences from types of music that have long been accepted and are therefore familiar and safe.

It is well known that the Hollywood studios separated the duties of composing and orchestrating. According to Eisler, "Even among the highly qualified composers in Hollywood, hardly anyone orchestrates his own works."[22] This assembly-line process would scarcely lend itself to a great variety of scoring possibilities. Eisler states that "the emergence of specialized arrangers has led to the standardization of instrumentation itself. All this results in a tiresome uniformity of all motion-picture scores."[23] This standardization is intensified by the fact that most orchestras that were used for recording soundtrack music were similar. According to Eisler, they consisted of a preponderance of violins, all playing in unison, and small numbers of other instruments in standardized groups of twos or threes.[24]

Again, the scores of our two sample films tend to support these generalizations. The score of *Sergeant York* is primarily quasi-nineteenth-century string music with conventional accompanying instruments like clarinets or oboes. The mother's motif has strings and harps, while Gracie's has strings and flute. The army scenes

[20] Eisler, *Composing for the Films*, p. 7.
[21] Ibid., pp. 16-17.
[22] Ibid., p. 106.
[23] Ibid., p. 105.
[24] Ibid., pp. 106-107.

tend to have brass bands and snare drums. Most of the music under dialogue scenes ("under" in the sense that the relative volume makes the dialogue predominant) is an unobtrusive murmur of strings. In *Mary of Scotland*, a bagpipe band appears in several scenes; otherwise strings play most of the accompaniment, although they sometimes go so far as to imitate bagpipes in a Scottish or pseudo-Scottish folk tune. Prokofiev, on the other hand, uses a variety of orchestration, beginning with an unaccompanied male chorus. In the last color shot, the sound of the male chorus humming begins the music that will last until the shot before Vladimir's death. This passage is a set of developments on a simple series of motifs (see Example 8). The procession scene warrants closer examination, since it provides a contrast to the dance segment we have already looked at.

Here the main pattern of the music is a gradual building from a quiet beginning to a dramatic culmination. In shot 662, the humming is very quiet, ending after measure 2. The men's voices hum in unison, beginning just as they pass in front of Vladimir. The continuation of this music over the cut helps to somewhat smooth the transition back to black and white, as does the prominence of black at the end of shot 692. This is particularly important since the cut out to the courtyard is a considerable temporal ellipsis—yet the apparently diegetic music indicates temporal continuity between the shots. The humming gets slightly louder about one second after the cut to shot 663. Initially only Vladimir is visible in the foreground of the shot. (A few Oprichniki can be glimpsed at the top of the stairway in the background; during the ellipsis at the cut, Vladimir has presumably come down this entire stairway and partway across the courtyard.) As the Oprichniki enter the frame from the left, they move slowly and sway approximately in time to the music. The cut to shot 664 comes on the half note of measure 8.

The next short series of shots continues this pattern, with periodic increases in the volume of the humming accompanying the steady, rhythmic advance of the Oprichniki. Shot 664 places Vladimir smaller and deeper in the frame than he had been in shot 663; the Oprichniki now dominate the foreground. The music in this shot proceeds to the end of measure 9, then returns to the beginning and ends on the held slur between measures 4 and 5. As it returns to measure 1, the humming increases slightly in volume again.

Shots 665 and 666 generate suspense regarding whether Vladimir will enter the cathedral or not. He has reached the door and pauses

Example 8

to look back uncertainly; here he is placed alone in the frame in a low-angle, medium-long shot. Just after the first shot begins (at the pause in measure 5), the volume of the humming increases slightly again. The shot ends at the half note in measure 8. Here the close coordination of music and editing becomes very apparent; the first time this musical passage was played, the cut (from shot 663 to 664) had come at this same note. In shot 666, the music once more proceeds to the end of measure 9 and returns to the beginning. As before, the volume increases at the return. At about the second measure, a new element enters: bass voices singing open-mouthed in harmony with the humming. This pattern coordinates closely with the onscreen action. As with the first black-and-white shot (663), Vladimir is at first alone in the shot; over this portion of the shot, the humming completes measures 8 and 9. A tiny pause ensues, occasioned by the return to measure 1, which has only two quarter notes for a 3/4 rhythm. Just after this one-beat gap, the Oprichniki begin to enter the frame, and the volume increase occurs.

This four-shot series (663-666) places an emphasis on Vladimir's isolation as the "leader" of the group and on the Oprichniki's

advance through space, forcing him onward. The four-shot series is subdivided into two sections, with the second pair of shots similar in pattern to the first. In shots 663 and 665, Vladimir initially appears alone, looking fearfully back. Shots 664 and 666 place him in the depth of the shot, with the Oprichniki in the foreground blocking off his retreat.

The next series of shots begins to develop the instrumentation of the music. The cut from shot 666 to the interior of the cathedral takes place on the second quarter note of measure 6. Shot 667 is a close-up of Vladimir's head as he comes up the steps in the cathedral and begins to look around. At the three notes of measures 8 and 9, a single bass voice becomes very prominent, singing a distinct pattern with a very low note at the end. (See the lowest notes of the bass clef at these two measures.) This coincides with Vladimir's turning his head nervously. At this point, the music skips to the beginning of the new passage at the second note of measure 14. This passage is instrumental rather than vocal; clarinets and what seem to be tremolo strings predominate at first. The chord in the lower staff of measure 15 comes just as Vladimir starts to move his head around to look into the cathedral. At the first note of the new passage—the second quarter note of measure 16—an oboe replaces the clarinet. This, in combination with the steady low string accompaniment, creates an eerie effect. The shot ends at the third note of measure 16.

Once Vladimir is inside the cathedral, the emphasis shifts from the threat of the menacing Oprichniki to that of the unseen assassin. The delay before Vladimir's death creates suspense not so much through the action alone as through the building tension of the music. Increasing volume and startling combinations in the orchestration help create this tension. Shot 668 is a medium shot of Vladimir getting up from a crouch to walk through the cathedral with the Oprichniki following. The clarinet and oboe continue to alternate over the string accompaniment. The first appearance of the Oprichniki in the frame corresponds to the beginning of the motif in measure 18. Again, this series of shots within the cathedral is accompanied by music of a gradually increasing volume that involves both an addition of new instrumental voices and greater loudness in the individual human voices. In addition, every other measure between 14 and 26 contains a sustained, dissonant chord (in the lowest staff of the score). Different instruments play the individual chords, usually coming in loudly to create a startling

effect. (Unfortunately the quality of the sound recording of the film is not always good enough to distinguish the instrumentation clearly.)

Overall, the procession scene uses a continuous flow of only one kind of sound—music. The simple, basic motifs are varied in such a way as to build gradually during the scene. This building effect is necessary to the scene if the murder itself is to be delayed at all. The murder must occur, but the action that takes place between Vladimir's departure from the banquet hall and his death is simply that of characters walking; the walk is one large "landing" in the staircase construction of the scene. The cut from shot 668 to 669 takes place after the motif that ends one beat into measure 22. Following the next two notes, a large, low, reverberating gong of some sort plays a single note on the chord of measure 23. This coincides with the large step to the side that Vladimir takes; otherwise the slow rhythm of the music corresponds only generally with the speed of the action and the lateral tracking movement of the camera. On the slurred, ascending passage of measures 26-27, Vladimir passes behind a pillar, and pulsating notes accompany the interval during which he is not visible. Trumpet notes in measure 31 coincide with Vladimir's startled glance at an Oprichnik on the left who is just entering the frame. Behind him a series of other black-clad figures come into view; their entrances are generally coordinated with the pulsating rhythm of the music. The cut occurs as the last note of measure 33 begins.

The series of interior shots had begun with a close-up. Shot 670 is the first long shot inside the cathedral, showing Vladimir walking at the head of the double line of Oprichniki. This framing suggests a move away from Vladimir toward a potential revelation of the assassin or even a point-of-view shot from the assassin's position. A tiny pan right to reframe on the Oprichniki at the beginning of the shot is rather gratuitous, except perhaps in building suspense by suggesting (falsely) that Pyotr is lurking in the doorway at the left, ready to strike as Vladimir passes. The ascending series of chords from the last note of measure 33 to the first of 35 introduces another rise in volume.

The move away from Vladimir does indeed lead to the revelation of Pyotr. In shot 671, he stands in medium shot, moving little until just before the cut. His motion right, almost out of the frame, corresponds with the end of the pulsating music. The music then returns to the beginning of measure 18; there a one-beat rest co-

incides with Pyotr's motion. The repeat also involves a return of the chorus. After one note (the second beat of measure 18), the cut to shot 672 occurs. The end of the music, combined with the tiny pause, briefly suggests again that Pyotr is moving to strike Vladimir, but this is another suspense device.

The cut on Pyotr's movement leads to shot 672, which is distinguished from the others because for the first time neither Vladimir nor Pyotr is visible. The action of the shot simply involves the line of Oprichniki moving from right to left. In the music that begins in shot 671 and continues into shot 672, the humming now combines with string accompaniment. At the half note in measure 19 and the first two beats of measure 20, a weird, rising slur occurs, perhaps created by strings played with the wood portion of the bow (see the higher bass clef of these two measures in Example 8). The volume of the music increases at measure 19; an oboe comes in before the end of the shot, after the first note of measure 22. The strange effect of the rising slur, combined with an uncertainty as to where Pyotr and Vladimir are in relation to each other, continues the tension of our expectation of an encounter between the two.

Shot 673 further delays this expectation; it is a high-angle, long shot of Vladimir stepping into a long shaft of light and casting a dark shadow as he proceeds (Fig. 177). The accompaniment returns immediately to measure 18; it initially involves the same alternation of clarinet and oboe that had occurred in shot 667. The music is generally dissonant, with the same rising slur at measures 19 and 20 as Vladimir steps out into the light. A loud trumpet chord comes in at measure 25, and the volume rises again as the pulsations begin in the low strings in measure 27; the cut comes after the first note of measure 27.

The music becomes rhythmically and instrumentally intense and simple in the last few shots before Vladimir's death. In shot 674, Vladimir comes forward toward the camera from the lower left corner; behind him in long shot, the shadows of the Oprichniki pass across the Last Judgment fresco. The vocal and string parts have a strange, throbbing effect, created by a quick crescendo/decrescendo over the last two notes (measure 27) and decrescendos over the next three notes, before going on to a steady beat of even quarter notes for the rest of the scene. The shadows do not appear at exactly every beat, but they move in a similar rhythm that gives an impression of conjunction.

The last four shots that accompany the procession music alternate

between shots of Malyuta looking on (675 and 677) and of Vladimir looking around anxiously (676 and 678). The transitions between these shots are smooth, with the steady beat of the music carrying over the cuts and the rhythmically moving shadows providing the background for each shot. The graphic matches on the vertical shadows and the emergence of Malyuta from the darkness at the side of the cathedral create a somewhat confused sense of space in these shots. This combines with a slight increase in the tempo of the cutting to lead up to Pyotr's move to attack in the next shot. The cuts occur at these points in the music:

675 – (Malyuta) Begins on the last note of measure 30 and ends on the second note of measure 33.
676 – (Vladimir) Ends on the first note of measure 35.
677 – (Malyuta) Ends on the first note of measure 36.
678 – (Vladimir) Ends after the last note of measure 38. A cymbal crash begins a split second before the cut.

The middle two shots are particularly short, only about a measure each. Again, we do not know where Pyotr is. He has moved considerably since we last saw him. He had been on Vladimir's left—on the same side as the Last Judgment fresco. He now approaches from the opposite side, coming up behind Vladimir as the latter faces the fresco. The procession music ends before he strikes.

CONCLUSION

This analysis shows that Eisenstein is continuing the kind of audio-visual structuring he talked about in his analysis of *Alexander Nevsky*, but is taking that structuring a step further. Instead of expecting the spectator's eye to pass across static compositions, Eisenstein creates relationships in *Ivan* where movement is a specific device that cues a correspondence between pictorial composition and musical accompaniment. The coordination of sound to image is not limited to the dominant action, nor does the sound relate only to one or two elements in each shot as would typically be the case in classical Hollywood films. (The scene of York's mother throwing water in his face is a clear example of music that accompanies only the dominant.) Instead, a number of formal devices in *Ivan* form a set of parameters that can be varied in the course of the scene, weaving in and out as dominants and overtones. Eisenstein's analogy between audio-visual montage and an orchestral score is ap-

propriate; the construction of scenes around lines of color, movement, graphic play, and so on, indeed resembles musical composition (with the word "vertical" deriving from the fact that notes in a score combine vertically to create harmony). In tonal music, the composer chooses a key and creates a series of permutations around the elements (notes, intervals, etc.) possible within that key; the composition may depart from the key, but the latter continues to provide a point of departure for the rest of the piece. In serial music, the composer chooses a tone row that will provide the set of parameters around which the piece will be arranged. Eisenstein's creation of a complex set of formal interactions in these scenes from *Ivan* demonstrates that these types of play with multiple cinematic elements within a scene, all relating structurally to the sound, characterize vertical montage.

We are now in a position to go back to our question in Chapter Six, How do *Ivan*'s sound-image relations differ from those of the classical Hollywood cinema? Clearly in some ways Eisenstein's purpose is similar to that of Hollywood—to achieve a match between image and music. Some of the differences might be attributed not so much to distinct approaches in structuring sound as to varied production circumstances. Eisenstein had the good fortune to be working with Prokofiev, a composer much superior to the average Hollywood composer. Prokofiev did his own orchestrations, and, although he worked quickly, the total project was spread out over years rather than weeks or months. The pair presumably had considerable choice concerning instrumental ensembles, and they worked together through a great part of the film's production process.[25]

Earlier I mentioned Hanns Eisler's critique of Eisenstein's essay on the *Alexander Nevsky* score. The Eisler discussion is not particularly relevant to the current study—his primary thrust is an attack on Eisenstein's specific approach to analysis rather than on the theory of vertical montage itself. But Eisler comes to the surprising conclusion that Prokofiev's score for these twelve shots of

[25] For information on the creation of the score for *Ivan*, see Mary Peatman, "Sergei Eisenstein's *Ivan the Terrible* as a Cinematic Realization of the Concept of the *Gesamtkunstwerk*" (Ph.D. diss., Indiana University, 1975); Eisenstein, "Extrait d'un cours sur la musique et la couleur dans *Ivan le Terrible*"; Sergei Eisenstein, "P-R-K-F-V," in *Notes of a Film Director*, trans. X. Danko (New York: Dover, 1970); and Ronald Levaco, "The Eisenstein-Prokofiev Correspondence," *Cinema Journal* 13, no. 1 (Fall 1973).

Alexander Nevsky "completely follows the beaten tracks of good old cinema music."[26] On the basis of my analysis of *Ivan*, can we conclude that Prokofiev is the Russian Max Steiner?

The score for Ivan does avoid some of the guidelines that I laid out in the first section of this chapter in discussing the classical norm. For the most part, it does not use common short-cut strategies of the Hollywood film such as the frequent use of leitmotifs with set associations. It does not rely so heavily upon clichéd tunes, nor does it use them as a substitute for inventiveness. Instead, *Ivan* uses nonclassical devices like the punctuating bells at the opening of the illness sequence.

But the analysis of the feast and procession confirms my earlier statement that the main thing that distinguishes Eisenstein's practice from that of the Hollywood model is the complexity added by the structures of visual and sonic dominants and overtones. Eisenstein has accorded his sound far more structural importance in determining what he does with the other elements of the film without detracting from the importance of those elements themselves. That is, *Ivan*'s cutting, mise-en-scene, and camerawork all set up multiple relationships to the music on different levels, down to the most minute. This is accomplished primarily through the use of overtones. In a Hollywood film, the music fits the dominant action of the scene; it may fit that action perfectly, but it seldom goes beyond this level. Eisenstein, on the other hand, often sets up relationships between the music and several distinct elements of the image track. We saw this in examining the first several shots of the color sequence. There the separate devices of costume, color, rhythm of movement, type of movement, number of figures per group, and depth in the frame all varied consistently from shot to shot, and all changes occurred in relation to the same music. This is undoubtedly a privileged example; not all scenes of the film contain this almost mathematical correlation of elements. But the success in going beyond dominant action to overtonal devices in relating sound to image is certainly one of *Ivan*'s primary differences from the classical film.

Perhaps this difference is also one source of the common claim that *Ivan* is operatic, implying that the music plays a particularly important role. This is not the case simply because Eisenstein's film contains *more* music than classical films do; many Hollywood films

[26] Eisler, *Composing for the Films*, p. 157.

of the thirties had almost continuous accompaniment. On the other hand, *Ivan*'s music does not gain its importance by taking over to the extent of making the film a musical as such. Rather, it integrates its music so thoroughly at every level that music becomes an important structure—just as many other techniques that ordinarily play a background role become important in *Ivan*.

My analysis of vertical montage also suggests that the music is artistically motivated. Its presence does not add verisimilitude, as realistically motivated music would, nor does it emphasize different aspects of the action at all times, as it would if it were compositionally motivated. Instead, at some points the music supplies the *primary* organizational principle for all the cinematic devices, so that they do indeed behave like the vertical notes on a printed score. They combine into one overall musical form in which music is only one participant. This differs from the classical background set, in which, as we have seen, realistic and compositional motivation are the rule.

Vertical montage may be more complex than the Hollywood norm, but one might well ask what end is served by having all this additional fusion between sound and image. The device has different functions in varying contexts, of course. But we can generalize enough to say that a cluster of simultaneous but distinct devices would typically cause a roughening of perception. The spectator must be able to perceive the multiple devices and also to create the connections among them. In writing of the silent cinema in 1927, Tynjanov already saw this "vertical" complexity as characteristic of the cinema. He distinguished the novel and cinema from other forms as "large genres" because of their complexity. Of the cinema, he said: "The 'large genres' are distinguished from 'chamber' genres not only by the number of lines in the story, but also by the quantity of obstructing material in general."[27] One reason some spectators find *Ivan* boring, I suspect, is that they factor out the "extra" devices, down to the basic narrative action or information at hand. In this way, they perceive enough of the film to understand its logic but not enough to keep their perception engaged in an interesting way. If, as Jonathan Culler has claimed, the perception of art is a constant process of naturalizing the strange aspects of the work, then this process is at least part of what engages our attention in

[27] Juri Tynjanov, "Des fondements du cinéma," trans. Sylviane Mossé and Andrée Robel, *Cahiers du cinéma*, no. 220/221 (May-June 1970), p. 68.

viewing a film.[28] If the film creates a network of elements that are strange but still capable of being naturalized with some effort, it succeeds in defamiliarizing its form. Vertical montage is a structural strategy for creating this network.

Eisler has criticized Hollywood's use of "illustration" in his statement: "Illustrative use of music today results in unfortunate duplication. It is uneconomical, except where quite specific effects ..., or minute interpretation of the action of the picture [is intended]."[29] This complaint depends on the assumption that films are supposed to be "economical" in their construction—an assumption the current study does not make. Indeed, we must conclude that *Ivan* is "uneconomical" to a greater degree than Hollywood films are. But this makes perfect sense if we look at *Ivan*'s dominant as I have previously stated it. The vertical montage becomes part of the extremely redundant stylistic pattern that supports the narrative. Sound becomes one more channel for confirming and reconfirming Ivan's power, his wisdom, his strength, and so on. As with the narrative and the other stylistic devices, *Ivan* creates some sound structures that are disturbing and disruptive and that run counter to this redundancy. These devices will also help to indicate how *Ivan* departs from the classical Hollywood norm.

Once we begin to speak of disruption and of disturbing devices, however, we move out of the realm in which style works smoothly in support of the narrative. For six chapters, I have been examining many unifying devices. The time has come to ask, What is there in the film that *needs* unifying? What elements are being held in check? And what elements have escaped this unification? The task of pointing out complementary relations between style and narrative could go on forever, dealing with more and more scenes on a level of greater and greater detail. What we need to do now is point out the gaps and excess that exist along with these connections.

[28] Jonathan Culler, *Structuralist Poetics* (Ithaca: Cornell University Press, 1975), p. 73.
[29] Eisler, *Composing for the Films*, p. 13.

 Disjunctions and
Discontinuities

So far my analysis of *Ivan* has suggested that its structures tend largely toward narrative and stylistic coherence. The previous chapters have discussed repetitions and relationships as they bind the film together with a quality that is usually called "unity." But looking at the unified aspects of an artwork is not the only possibility criticism offers, although it has been the most common approach. A film has other aspects besides its unifying structures. Recent critics and theorists have suggested that unity is not even a property of the work itself but a product of the process of perceiving the artwork. In his book *Structuralist Poetics*, Jonathan Culler suggests:

> It may be misleading to think of texts as "organic wholes." Their unity is produced not so much by intrinsic features of their parts as by the intent at totality of the interpretive process: the strength of the expectations which lead readers to look for certain forms of organization in a text and to find them.[1]

Culler's book is particularly useful to this study because his approach to structuralism develops concepts present in the Formalists' writings. Consider the following passage in relation to the Formalist concept of defamiliarization. Culler says that literature "fragments the ordinary signs of our world. . . . challenges the limits we set to the self as a device or order and allows us, painfully or joyfully, to accede to an expansion of self."[2] This suggests that the artwork changes perception by creating difficult, unfamiliar conjunctions of signs. The trace of a phenomenological viewpoint in this passage from Culler is also present in the Formalists. Recall Shklovski's discussion of defamiliarization quoted in Chapter One: "Art exists that one may recover the sensation of life; it exists to make one feel things, to make the stone *stony*. The purpose of art is to impart

[1] Jonathan Culler, *Structuralist Poetics* (Ithaca: Cornell University Press, 1975), p. 91.
[2] Ibid., pp. 129-130.

the sensation of things as they are perceived, and not as they are known."[3] In this chapter, we turn to the fragmentation, to the difficulties that may not fit into a neat explanation of the artwork as a unified whole.

Culler calls the process of creating patterns of unity during the perception of an artwork *naturalization*, a term sometimes used with a negative connotation by structuralist critics. To the latter, naturalization implies that the analyst or perceiver is striving to ignore the difficult aspects of the work in an effort to make it easy to comprehend. A frequent example cited is the attempt by certain critics to find coherent explanations for the strange qualities of Robbe-Grillet novels.[4] No doubt some critics do oversimplify their subjects by concentrating on those aspects that fit nicely together or by building elaborate rationales to "explain away" unclear aspects. But naturalization, Culler believes, is necessary to a certain extent in the perception of an artwork if we are to be able to comprehend it. In this connection, he speaks of the "fundamental paradox of literature":

> We are attracted to literature because it is obviously something other than ordinary communication; its formal and fictional qualities bespeak a strangeness, a power, an organization, a permanence that is foreign to ordinary speech. Yet the urge to assimilate that power and permanence or to let that formal organization work upon us requires us to make literature into a communication, to reduce its strangeness. . . . The strange, the formal, the fictional, must be recuperated or naturalized, brought within our ken, if we do not want to remain gaping before monumental inscriptions.[5]

This urge to naturalize may lead some critics to offer interpretations of themes or meanings. In the last six chapters, I have been taking another approach to naturalization by performing a narrative and stylistic analysis of *Ivan*.

But a Formalist methodology needs to avoid using naturalization as its only tool. Certainly to point out structural relationships that contribute to unity can be of great use in opening the work out for

[3] Viktor Shklovski, "Art as Technique," in *Russian Formalist Criticism: Four Essays*, trans. and ed. Lee T. Lemon and Marion J. Reis (Lincoln: University of Nebraska Press, 1965), p. 12.

[4] See, for example, Culler, *Structuralist Poetics*, p. 200.

[5] Ibid., p. 134.

viewers; if they see *more* in the work, their viewing will be made more elaborate and hence more defamiliarized. But if in this process of analysis, critics struggle too hard to make the work cohere, they may end by trying to ignore or explain away some of its more difficult and unique devices. Such an analysis also unnecessarily risks making the work seem banal. At this point, naturalization goes too far, hampering the critic and doing a disservice to the reader.

The current tendency of certain critical approaches to concentrate on the difficulties and gaps of artworks runs counter to the old notions of unity and organicism as the primary aesthetic virtues. This tendency is inherent in Russian Formalism from its very beginning. As early as 1914, Shklovski can speak of the language of poetry as "not a comprehensible language, but a semicomprehensible one."[6] Applying the same concept to cinema, we can say that we have so far been looking at the comprehensible structures of *Ivan*. But the time has now come to look at the "semicomprehensible" aspects.

Shklovski's view of poetry as semicomprehensible language suggests that a tension between unity and disunity exists in art; certainly this view has the advantage of concentrating not so much on individual devices of the work but upon basic structural relationships. If we view artworks as structured around tensions between unifying and disrupting elements, we have the basis for a mechanism by which the audience's perception is actively engaged.

At this point, we can extend the discussion of Stephen Heath's concept of narrative "violence" (see Chapter One). Heath's view is that narrative generates itself by introducing an initial homogeneity, then creating a violence; violence and homogeneity then strive against each other until the end of the narrative. He describes the conflict that results as constantly threatening to throw the narrative off balance. The narrative must thus strive to "contain" the violence.

A similar structure may be seen at work on the level of stylistic elements. Indeed, we will see in the next chapter that Heath himself tends toward this view with his formulation of the concept of "excess." Many texts introduce "difficult" structures systematically. Here, too, the unifying devices must strive—and never wholly succeed—to "contain" the film's strange stylistic devices. The intro-

[6] Viktor Shklovski, "The Resurrection of the Word," trans. Jane Knox, *20th Century Studies* 7/8 (December 1972): 46.

duction of any one device into a film immediately creates a challenge. The film must either motivate that device by creating a cue that will allow the perceiver to relate it to the narrative or it must create other, similar devices to make the initial appearance seem part of a larger pattern. Imagine if Eisenstein kept using images in the mise-en-scene—a candle, a bird, an eye, and so on—without ever using any of them more than once. If he kept up such proliferation of imagery without repetition or motivation, we would probably call *Ivan* a messy film, lacking in unity. As it is, I have been able to show fairly systematically how unified the film is by pointing out numerous repetitions. Not all of these, however, have any substantial function in relation to the narrative—they simply exist alongside it. The film has "contained" its stylistic devices by creating an impression of unity.

One common way films have of controlling their stylistic devices is by repeating those which have become familiar through their use in previous films. A technique that has become a convention will not seem particularly strange or disturbing, even though it may have seemed so when first introduced. (It may regain its strangeness after its use has been discontinued: the familiar, elaborate montage sequences of the thirties, for example, seem strange to many viewers today.) Every film must draw upon some traditions of previous filmmaking; similarly, each must be at least slightly original, differentiating itself from other films. Thus a film's relation to the background of other works is also a balance between breaking away from convention and striving to contain that impulse by appeal to convention. A standard "B" western may differentiate itself only slightly. A film like Straub and Huillet's *Nicht Versöhnt* (1965) depends so much on different, difficult elements that most viewers must expend considerable effort in learning how to deal with it. Over the years, *Ivan* has gained the stature of a "classic," thereby losing some of its original strangeness. But a 1947 interview with Carl Dreyer (another director far removed from the classical tradition of Hollywood) suggests the position *Ivan* occupied for early viewers:

> It is overall a great film, because it is a film different from others. Eisenstein resolutely turned away from his habitual manner in order to develop a new technique. Even if this attempt does not

lead the cinema into productive paths, such essays are nonetheless hopeful.[7]

Even now it is possible to look at *Ivan* and realize how different its form is from the forms of other films.

The Hollywood continuity system is one common norm of film form that we learn by repeated viewings of conventional films; we perceive discontinuities as a departure from the acceptable norm. These discontinuities then become difficulties for perception, problems that set certain films apart. *Continuity* is at once a specific historical system and a general aim at naturalization of the film narrative. The term itself implies its meaning: a specific element *continues* uninterrupted by other devices. Hollywood-style cinema privileges narrative and makes it the central concern of continuity. Action is what continues. Continuity, in short, is one specific aim. It involves a series of "rules," or tactics, that were formulated to ensure that stylistic techniques would not interfere with continuous narrative progression.

Discontinuity, on the other hand, is a nonspecific term. It can apply to virtually any structure that is *not* part of regular continuity. Some discontinuities are mistakes, lapses in the creation of continuity. Hawks makes no such mistakes in the relatively lengthy *Sergeant York*. Ford is not as careful; one scene in *Mary of Scotland* includes a shot/reverse shot during which the two camera set-ups are on opposite sides of the 180° line. This is the scene in which the Italian secretary urges Mary to marry a man of her own religion. The two face each other, yet in their respective shots they are both looking off right; in Hollywood's terms, this implies that they are both looking off in the same direction. For some directors, such as Yasujiro Ozu, this kind of cutting is systematic; we would not speak of this as a mistake in one of his films. In *Mary of Scotland*, where no other cuts break the rules of continuity, it is apparently a lapse; there is no motivation in the scene (no attempt to conceal another character present in the room, to reveal something about the character of the secretary, to see from the point-of-view of an onlooker, etc.) for the breaking of the axis. The lapse is not foregrounded, in spite of its uniqueness. There are several reasons for this. First, the classical film calls attention to narrative action and away from

[7] Quoted in Judith Podselver, "Carl Théo Dreyer et sa situation en 1947," *La Revue du Cinéma* (Autumn 1947), p. 27.

space. Many Hollywood films of this period occasionally break continuity rules, but this usually goes unnoticed because continuing dialogue and character movement over the cut create a prevailing sense of continuity. Second, there are no other cues to call attention to *Mary of Scotland*'s lapse of continuity. Ozu, on the other hand, accompanies his cuts across the line with other unusual devices: low camera height, graphic matches (which call attention to space), or characters who face directly into the camera.

Once a filmmaker sets out to make a film that does not use Hollywood continuity editing, he or she can formulate any number of alternative approaches for creating spatial and temporal relations. All of these, if seen against the background of the classical Hollywood cinema, will seem discontinuous.

One bit of evidence of this is the case of Alfred Hitchcock's *Rope* (1948). Working in Hollywood, Hitchcock made a film that would seem to approach the ultimate in continuity: *Rope* consists of eight lengthy takes, each as long as the reel of film in the camera. This device largely guarantees that there will be no crossing of the axis of action (a violation that can only take place at a cut) and little necessity to match action. It also tends toward a plot with no temporal gaps. But ironically, the film is taken to be a failure by some experts on continuity because it moves too slowly. Space and time may be continuous, but they begin to take too much precedence over the narrative. Karel Reisz and Gavin Millar's book *The Technique of Film Editing* is one of the definitive explications of the "rules" of continuity editing. In their section on timing they declare:

> The control of timing which the film-maker gains through editing can be used for more positive purposes than the mere cutting down of unnecessary intervals. It enables him to present a series of consecutive events in such a way that each new development is revealed at the dramatically appropriate moment.[8]

Reisz and Millar use *Rope* as a negative example, trying to show that the use of tracking movements to replace editing is a detriment because it slows down the narrative. They speak of various scenes in the following terms:

> The timing of effects is dulled by the inability to use cuts.

> In the way the scene has been managed, there is a dramatically

[8] Karel Reisz and Gavin Millar, *The Technique of Film Editing*, enl. ed. (New York: Hastings House, 1968), pp. 232-233.

meaningless interval between the time Rupert sees the initials and the close-up.

The slow retreating of the camera merely blunts the effect.

The five feet of camera movement which the camera takes to burrow into the hat is a complete waste of screen time.[9]

These opinions may or may not be valid for this film (in my opinion they are not), but the manner in which the authors lay out their argument has several implications. First, they assume that a device that has no apparent narrative function has no function at all and is therefore a waste. The current study, as I have previously stated, assumes that *all* devices of a work have a function because they produce perceptual effects. Second, Reisz and Millar clearly have never considered that there might be significant structures in the work that do not contribute to the narrative, that is, that narrative is not always the most important structure in a given film, scene, or segment. *Rope* is, in one sense, perfectly continuous, but it sets up an alternative spatial system to that of the conventional Hollywood film. Continuity editing, the norm, is seen by Reisz and Millar as more efficient for presenting a continuing narrative.

We have already seen how Eisenstein varies certain classical devices in his construction of space. In the coronation scene, for example, the instability of the eyelines and the lack of establishing shots in the first part of the scene prepare the way for Ivan's introduction as a spatial center. This scene uses continuity devices but makes them function differently than they would if they were setting up a coherent narrative locale. Now it is time to proceed with an analysis of the system of discontinuities of editing and disjunctions in other devices. In this way, we will be able to confront the difficult aspects of *Ivan* and avoid the risk of making it seem too unified, too easy to grasp.

"CUBISTIC" EDITING AND CONFUSING SPACE

In Chapter Two, I mentioned Noël Burch's point that the separate shots in *Ivan* often do not join together at the cuts to form a consistent or even wholly coherent space. His comparison of this device of building up space from ill-matched separate shots to a painting by Gris led me to label it *cubistic* editing.

[9] Ibid., pp. 233, 234, 234, 236.

One common kind of cubistic editing in *Ivan* involves the intro-
duction of a number of consecutive shots of the same space with
a rearrangement of items of mise-en-scene between shots. This
would usually be considered a mistake in continuity in Hollywood,
but it becomes a central spatial principle in *Ivan*. This is perceptual
play in a literal sense, for the film flaunts its inconsistencies, inviting
the spectator to pick up on the "mistakes."

The temporal discontinuities of *Ivan* are largely bound up with
the cubistic editing. Theoretically, when elements of the mise-en-
scene shift at a cut, the implication is that there has been a time
lapse. This is not the case in practice, however; the *cheat cut* is a
classical convention used when no time lapse is to be signified.
Hollywood typically makes cheats unnoticeable by carrying diegetic
sound over the cut or by matching on action or both. Eisenstein
does not use shifting spatial relations to indicate gaps in plot time,
either. But he frequently calls attention to his "cheats" by failing
to match on action or to carry over a line of diegetic sound; he also
uses many more cheat cuts than Hollywood films do. In this way,
the contradiction between shifting space and continuous time be-
comes more noticeable. Indeed, the device of cubistic editing is
largely dependent upon our knowledge that no time has elapsed;
the spatial relations from shot to shot are impossible precisely be-
cause of this fact. For this reason, temporal considerations create
part of the effect in all examples of cubistic editing.

The first pair of shots in the film establishes this pattern of cubistic
editing. First the crown appears in close-up, framed straight-on
against the centered corner of the table. In the second shot, a me-
dium close-up of the crown, orb, and scepter, the crown still faces
front but is now seen against the flat side of the table. Either the
crown or the table has been shifted, but the continuous bells indicate
that no temporal gap has occurred to explain such a change.

In Chapter Three, we saw how the eye positions of Efrosinia and
the other Boyars consistently change from shot to shot in the cor-
onation sequence (I, 17-19, Figs. 16 through 19). Their body po-
sitions also shift, with Vladimir's shoulder behind Efrosinia's in
shot 18, while he is standing directly beside her in shot 19. In
general, the coronation sequence quickly accustoms us to mis-
matches. After the crane shot (26), Ivan is about twelve feet from
the dais, while a cut suddenly creates a completely different situ-
ation: Pimen, who has been standing still with a crozier in his hand
is now in the act of turning and has no crozier; Ivan is now only

a few feet away from him. Ivan shifts several times in relation to the people around him: the culminating long shot of him in the center of the crowd (48, Fig. 25) shows him towering above the onlookers, even though in closer shots the others around him are almost as tall and hold large candles and ceremonial poles.

A detailed catalogue of the film's mismatches would be pointless and probably impossible. I would, however, like to point out several patterns, with examples of each, to demonstrate how pervasive this technique is.

Perhaps most obviously, discontinuous editing creates an impossible space by means of an appearing or disappearing object. In the initial crane shot down to the wedding feast (I, 109, Fig. 76), there is nothing on Ivan's chair. The cut reveals the same scene, except that an embroidered coat is now draped over the chair (Fig. 227) and remains there throughout the rest of the sequence.

A more flagrant appearance than this comes at the cut from one shot of the Kazan tower to another (I, 332-333) as the prisoner shouts for the city's surrender. In the first shot (Fig. 228), there is no one on the upper portion of the tower, but in the second (Fig. 229), the old man in white has materialized. Similarly, as Efrosinia starts to get up in the plotting scene of Part I, her crutch is leaning on the arm of her chair (I, 611); in the next shot, it is gone. One of the clearest instances of this sort of mismatch is the mysterious and sudden reappearance of Vladimir's pearl-embroidered cap in the middle of Efrosinia's lullaby (at the cut from 440 to 441 in Part II; Figs. 230 and 231).

But this now-you-see-it-now-you-don't cut is not common on the whole. More frequently, figures simply shift in space from shot to shot, as we have seen already with the coronation sequence. The area around the wedding couple's table in Part I is an instructive locale for noticing this device. The crane down past the sideboard behind the double-pointed thrones reveals a rooster emblem at the top of an inverted "V," with a pitcher at either side and a triple candleholder in the lower center. After the cut, two candleholders have been put beside the original pitchers and one of the Baltic city emblems has taken over the place in the lower center. The rooster begins facing left and switches to face right in the course of the first scene. The couple is also cheated much higher in relation to their thrones at the cut that ends the crane shot (compare Figs. 76 and 227). This scene also ends with what must be one of the most flagrant cheats in the history of the cinema. Anastasia leaves the

pointed thrones with Kurbsky trailing along as she goes out frame right (261). In the next shot, she immediately joins Ivan, even though he is on the steps at the opposite end of the huge hall from the thrones!

This shifting is particularly apparent in static shots. The first shot of Ivan emerging from his tent at Kazan (I, 275) ends with him standing in the doorway, staring across at the city (Fig. 232). In the next shot, he is slightly in front of the tent (Fig. 233) and cheated noticeably upward in relation to the door. Finally, the third shot places Ivan at a short distance in front of his tent (Fig. 234). The effect is almost that of a pair of jump cuts in which the character has leaped suddenly forward. This three-shot pattern recurs in the scene where Kurbsky inspects the apparently dead Ivan. Kurbsky's face comes into medium close-up and stares down at Ivan's face (I, 537, Fig. 235). A cut-in to a close-up cheats the two faces closer together but neither moves through space (Fig. 236; Kurbsky moves his eyes in the course of the second shot). After a pause, a cut back to the original medium close-up framing repeats the cheat in reverse (Fig. 237).

The scene at the Livonian court combines this cubistic shift with disappearing acts on the parts of the figures. The foreground groups of ladies on the right and knights on the left are fairly stable. But the two rear sections of the room form the site for considerable permutations. In the initial establishing long shot (II, 54, Fig. 140), three monks stand in the left background, one in black on the left and two in white; opposite them on the right are the two puffy-sleeved men who later hand Sigismund Kurbsky's medallion. In shot 55, the monks are still present as before. Shot 57, however, presents the same space, but now only two monks, one in black on the left and one in white, are visible, and the Livonian ambassador now stands where the two men had been on the right (Fig. 238). By shot 66, both monks are in white. In shot 77, one again wears black but stands right of the one in white. In shot 86, they are both in white, and shot 88 has one in black, with the spatial position much shifted. In shot 92, the third monk has returned, but now one of the monks wears a white cap (as does one in the insert reaction shots), and the two puffy-sleeved men have replaced the Livonian ambassador once more, having previously sneaked around to hand Sigismund the medallion from the left. Finally, in shot 94, Sigismund turns to leave, and there are still three monks visible, but one now has a black cap and white robe on. (As far as I can

tell, in some shots the monks are also played by different actors from the ones in the insert shots.) If we wished to posit a logical series of actions that would lead to this set of changes, we must imagine the monks standing still when the camera is on them but constantly slipping in and out while their area of the room is off-screen. The resulting hypothetical situation is ludicrous in relation to the scene's narrative. This lengthy description may indicate how elaborate and extended some of the cubistic space in *Ivan* is.

A few other examples include: the constantly shifting eye-flaps of the Livonian ambassador's glasses as he talks to Kurbsky outside the wedding banquet (I, 99-103); the mismatched cut from Ivan clutching Fyodor to his chest to the pair both looking left and talking in the scene in Anastasia's bedroom (II, 256-257, Figs. 239 and 240); Philip's shifting position during the mourning by the dead Boyars, where he remains motionless but is sometimes at the lower end of the coffins and sometimes not (note especially the cut from 293 to 294); a cheat in the same scene, with Efrosinia initially standing behind Philip and to the right as she speaks, then suddenly behind him and to the left after the cut-in to his face (305-306; compare Fig. 165 with Fig. 241).

At times the temporal contradictions at the cuts are the most important cue in creating the cubistic editing. Usually this involves overlapping cuts, where the represented time of one shot partially repeats that of the previous shots. The most famous instance of this in *Ivan* occurs in the coin-pouring segment of the coronation sequence. The diegetic sound of the archdeacon's chant and the accompanying "Long Life" chorus continues uninterrupted over the cuts, indicating temporal continuity. Yet the length of time occupied by the pouring is unreasonably long in relation to the number of coins in the bowls and the speed at which the men empty them. Although the bowls are seen to be rapidly emptying in the two medium close-ups of Kurbsky and Philip (I, 55-56, Figs. 26 and 27), the pouring goes on for another seven shots. Because of the temporal continuity indicated by the sound, we must conclude that two different kinds of time are passing in the film at this point: that of the song and that of the pouring. This contradiction is structurally parallel to the impossible spatial cues, creating a similar cubistic effect.

This kind of temporal overlap never occurs again in such a clear-cut fashion. There are numerous small overlaps of the type acceptable to continuity matches on action but only a few that create

distinctly contradictory temporal relations. A major overlap occurs just after Vladimir is killed. The stabbing happens in long shot in shot 683. As Pyotr moves away from Vladimir, both Fyodor and Malyuta run across from the left to catch him. Their huge shadows cross as well, emphasizing the movement. Fyodor has shed his black cassock and is wearing his elaborate kaftan from the feast. Yet the cut to shot 684 reveals Fyodor, in medium close-up, standing in the line of Oprichniki; he tears off his cassock and looks off right. In shot 685, Malyuta runs from the little side doorway straight toward the camera. Shot 686 shows Pyotr in long shot. Then Malyuta and Fyodor run in from the left to capture him (again their huge shadows cross the wall behind). Later a slight overlap occurs as Malyuta reaches down to take the crown from Efrosinia. One important cut involves a contradiction between ellipsis and temporal continuity: How does Malyuta kill three Boyars with one blow in the execution scene of Part II? The sound of the offscreen blow carries over the cut to Ivan's arrival on the scene (284-285); this seems to indicate no temporal ellipsis. Yet all three Boyars are clearly supposed to be dead; Malyuta displays his work proudly and Ivan speaks of "Too few," indicating that these executions are completed and that more are necessary.

These examples do *not* imply that Eisenstein simply didn't care about keeping continuity or was incapable of doing so. There are many excellent matches on action in the film: the cut as Efrosinia crosses herself in the illness sequence of Part I (422-423); as Ivan mounts the stairs to his throne after his return in Part II (119-120); as Ivan lowers his head onto Anastasia's breast in the scene of her poisoning (I, 668-669). There are numerous correct eyeline matches, and the shots in the attack on Kazan all maintain the screen direction of troops moving from left to right. *Ivan* draws upon the norm of continuity editing but balances this with editing structures which violate that norm.

In some scenes, insufficient or ambiguous cues create confusing spatial relations between shots. As a result, spectators cannot simply allow space to exist as a container for the action; instead, they need to question actively the spatial cues and try to construct mentally a hypothetical space that could exist and account for all the individual shots taken together. This device seems to be a variation and development along the same lines as the cubistic editing. In the latter, the basic continuity rules of matching were violated; the

scenes with confusing spatial patterns break other rules, such as eyeline direction and the 180° rule.

This type of disjunction differs from the systematic creation of a "spatial lack" that I analyzed as basic to the first half of the coronation sequence (see Chapter Three). There I spoke of shifting eyelines and uncertain distances that implied an unstable central space into which Ivan would move. The scenes of which I am speaking now do not make confusing relations the dominant of the scene; the problematic space remains an overtone. In the coronation sequence, the spatial relations served an important narrative function by preparing for Ivan's first appearance. This new pattern of confused space does not enter into relations with the narrative action, except to distract from it.

An example of confusing eyelines occurs in the scene of Ivan's mourning by Anastasia's coffin. Ivan begins on the side of the coffin to Anastasia's left; he is still there when he collapses in shot 717. After the entry of the Basmanovs in shot 719, there is a cut to Ivan pulling himself up to glance into the coffin at Anastasia. The camera frames him from a position at about the center top of the casket. Spatial logic would demand that he look left to gaze into her face; instead he stares right. By the same logic, the medium shot of her that follows is a reverse shot (721), and she should face left; she in fact faces right. Thus the shot of Ivan places him on the wrong side of the coffin. He is to her right in shot 720 (presumably) but to her left in every other shot up to shot 756, when he moves to the other side of the coffin to make his triumphant speech. The apparent point-of-view reverse shot of Anastasia confirms the placement of Ivan to her right in shot 720. The next shot of Ivan looking toward Anastasia's face (726) has him on her left; the following shot of her is from the correct side, with her facing left. This view would be the logical one from the side of the coffin to her left. Further play with space occurs in this scene after Ivan shouts "You lie" to Pimen. Previously we had seen Pimen reading, with Ivan out of focus in the background (718). At that point he had turned to look to his left at Ivan. In shot 732, Pimen is in medium shot, reacting to Ivan's shout by snatching up his Bible; he looks to his right at Ivan. In the next shot (719), a long shot reveals the entire space, including both Pimen and Ivan once again; Pimen now stares to his left as he defiantly knocks over his lectern and begins to stalk out. The medium shot (718) completely reverses his position in

space. The result is a contradiction involving eyelines and spatial relations.

At another point, shots that confuse spatial relations are inserted into the main action, breaking it up. In the scene of the killing of the prisoners at Kazan, Malyuta's eyelines create ambiguous spatial cues. He arrives on the scene to witness Kurbsky's confrontation with Ivan but never appears in the same shot with the other characters. Malyuta first appears in shot 347, coming in from the left and standing in front of the wooden barricade to stare off right, apparently at Ivan and Kurbsky (Fig. 242). After the two shots of Kurbsky "raising his hand" against Ivan, there is another shot (350), framed as before, of Malyuta looking off right and tearing down a plank of the barricade angrily. But in a later shot—a medium close-up of Malyuta spitting contemptuously at Kurbsky's excuse (356)—he is staring directly off left (Fig. 243). The apparent objects of his gaze are still Ivan and Kurbsky, who both appear in shots 355 and 357, setting up a strong cue for an eyeline match from Malyuta's gaze to the two men. Nor has there been any suggestion that Malyuta has moved; on the contrary, he still stands by the barricade holding the plank. At no point in the scene do we get any cues, beyond these contradictory eyelines, to suggest where Malyuta is in relation to the main action.

In the scene just before Efrosinia places the poisoned cup for Ivan to find, the cutting frames the separate actions so as to make it unclear where Efrosinia is in relation to Ivan as he receives the scroll and makes his speech against the Boyars. He stands above, leaning on the low wall and looking down and right to speak (I, 679). In shot 681, he moves even further right and continues speaking. The intervening shot, 680, is a medium close-up of Efrosinia listening at the corner where the low wall meets the main wall of the room, by the door; she faces left, setting up a classic shot/reverse shot situation. In shot 682, Efrosinia stands as before, in long shot. The messenger moves through the shot, left to right, as he exits. Because the messenger has not been visible during Ivan's speech, it is not entirely certain whom Ivan was addressing, Efrosinia or the messenger. Logically it was the messenger, but the cutting strongly implies that it was Efrosinia. As a result, it is not clear whether Ivan is aware of Efrosinia's presence during any of the rest of the scene. In Part II, he reveals that he knows who gave him the cup, but this is not apparent to the spectator at the time.

The sequence of Ivan's illness also contains some confusing space.

As Ivan falls to the floor and begins his appeal to the Boyars, the entire group is in long shot (501). The spatial relations are fairly clear, with Ivan far from the bed in the center of the group of Boyars (Fig. 134). The following series of shots ranges from medium shot to close-up, always isolating parts of the bodies of Ivan and the Boyars he speaks to from the general space of the room. Aside from Ivan's eyelines as he glances off toward each new possible ally, there are no new spatial cues. Then suddenly a medium shot of two Boyars (509) places Ivan on the floor in the background, sitting isolated on the floor by the bed (Fig. 135). One moment (shot 507) Ivan is leaning back against one of the Boyars to gaze up at him; then he has returned abruptly to a space by the bed. In such a situation, the Hollywood continuity guideline would be to reestablish space often enough to keep Ivan's progress clear. Here the reestablishing shot (509) comes only after a series of closer shots that do not allow the spectator to understand where the characters are.

These are the only major examples of confusing spatial cues. The structure is interesting mainly as a supplement to the more pervasive pattern of cubistic editing. Together, these two devices create the unstable, constantly shifting space that is one of the main characteristics of *Ivan*'s style.

SOUND DISJUNCTIONS

Sound-image relations in *Ivan* follow the patterns of the dominant: an extreme redundancy and overdetermination within each structural level, countered by disjunction and digression. In spite of the considerable fusion that vertical montage creates between sound and the visual elements, *Ivan*'s soundtrack contains many disturbing devices. As with the other stylistic components I have examined, the tension created by these counterforces helps simultaneously to intensify and roughen perception.

One common sound disjunction in *Ivan* is difficult to notice, or even to be certain of once one *has* heard it; it works on the extreme limits of perceptible difference. At many of the cuts, the sound from one shot overlaps into the other by only a few frames. As a result, the rhythm of sound and cutting are thrown slightly off but only by a split second. (I say this effect is only barely perceptible, since in watching the film projected, I suspected something of this sort was going on but could never be entirely sure. Viewing on an editing

machine and running the film frame-by-frame confirmed that tiny overlaps were indeed present and quite common.)

The conversation between the Livonian ambassador and Kurbsky uses this device repeatedly. Within each shot of the pair, the ambassador says a line, then pauses. Rather than coming during the pause, the cut is delayed until the ambassador has begun the first word of his new line. This happens on the cuts to shots 100 through 103. (This device of cuts at the beginnings of lines occurs rhythmically during the deacon's song in the coronation sequence as well.) In the wedding sequence, the Kazan ambassador has made his challenging speech and offered the dagger in shot 244 (a medium shot); at the very end of this shot, the fanfare begins, and there is a cut to a *plan americain* as Ivan rushes to him. Again the overlap is only a split second. At Kazan, the sappers' chorus begins just before the cut from shot 292 (a long shot of a row of cannons) to shot 293 (a high-angle, medium-long shot of the men digging). As with many such cuts, the overlap is so tiny that the Simon and Schuster shot breakdown overlooks it, notating the chorus as starting "on the cut."[10]

In the shot of the procession of priests entering Ivan's bedroom through the little arch during the illness sequence (I, 443), the priests' chant begins just before the cut. This is particularly disjunctive since the volume does not change on the following cut to the inside of the room, even though the heavy door has been closed in shot 443. Similarly, the cymbal crash that begins the Livonian court waltz begins at the very end of shot 57 of Part II (the long shot in which Kurbsky walks to the throne and kneels). At the end of shot 353 of the Fiery Furnace scene, the main "Terrible" music comes up very loud. This is the shot in which Ivan warns Fyodor to keep silent about his suspicions. The music enters to accompany the action of the next shot, the medium-long shot of the Boyars drawing aside to form an aisle for Ivan's entry.

These and the numerous other little sound overlaps in Ivan differ considerably from Hollywood usage, where cuts come either between sounds or distinctly in the middle of them. (Hollywood's guideline is to cut at no point less than a syllable from the beginning or ending of a phrase. *Ivan* frequently has only a single phoneme overlapping the cut.) Indeed, I have never noticed a similar structure

[10] Sergei Eisenstein, *Ivan the Terrible* (New York: Simon and Schuster, 1970), p. 59.

in any other film, whether of the classical tradition or not, except perhaps for Godard's *La Chinoise*. Many of *Ivan*'s cuts are conventionally placed between or in the middle of sounds, so that the overlaps come only intermittently, as a disturbing force. They are blocks to smooth perception but so tiny that they work almost unnoticeably. The result is a slight disturbance and strangeness in the sound-image relations.

Other instances of overlapping sound are more distinct but are strange for other reasons. A few times, characters that have not yet been established as present in the scene begin speaking offscreen. The first shot of the wedding banquet sequence (99) is a long shot of the courtyard in front of the cathedral; the Livonian ambassador's voice speaks several words before the cut to the first shot of Kurbsky and the ambassador. In the scene of Anastasia's poisoning, Malyuta's voice is heard over shot 684, the shot in which Efrosinia puts the poison in the cup. Earlier in the scene, Malyuta had not been present; he has presumably come in while we have been watching Efrosinia. The same device occurs in the Boyar plotting sequence in Part II. After Vladimir asks who will kill Ivan (framed in medium shot, 412), Pimen's voice comes in saying, "Only he who is pure in heart." A cut to Pimen follows, but no previous shot in the scene had established him as present, even though he has presumably "been there" since the start of the scene. These instances of overlap are comparable to the spatial confusion created by editing.

Another device that serves to help confuse space is the lack of volume shifts at cuts. As we have seen, classical continuity editing does not vary volume to suggest spatial change at cuts, either. But Hollywood films are able to do this primarily because they set up clear spatial relationships with establishing and reestablishing shots. Thus volume is unnecessary as a spatial cue. Once Eisenstein eliminates or confuses the establishment of space, other spatial cues such as eyelines and sound become more important to the spectator's mental construction of narrative space. But *Ivan* refuses to provide clear sonic indications of space in many cases; here constant volume contributes to spatial uncertainty. Hollywood films also tend to use constant volume only for cutting within a relatively small space, while Eisenstein cuts between widely separated points without varying the volume of a diegetic sound that carries over all shots. In the coronation scene, one ambassador explains the Russian court politics to another over the shots introducing the Staritskies, Glinskies, and Zakharins; we have seen how the cutting

pattern in this scene moves around the cathedral without establishing the distances between any of these groups. Were the voice that of Pimen, the motivation of the sound would be less problematic because all the onlookers have presumably been listening to Pimen's speech, which was addressed to the entire crowd. But the ambassador speaks only to his neighbor, yet the volume of his explanation remains constant over close shots of people who do not seem able to hear his voice.

Sometimes an even larger spatial shift is accompanied by (apparently) diegetic sound that does not change volume at the cut. A classical narrative film would be likely to accompany a move from interior to exterior with a volume modulation, yet *Ivan* maintains constant volume at several such changes. The cut from the hallway to the banquet room (106-107) as Kurbsky goes into the wedding celebration carries over the bells and the introductory music of the lullaby unchanged. Similarly, as Efrosinia goes out the little door to check the situation with the riot, the cut to the hallway outside (130-131) carries over the bells and the lullaby without alteration. Indeed, the device is stylized even further because the film continues the wedding music for several seconds before the riot bells come up and begin to drown it out; the sonic dissolve is not completed until the next shot (132), a slightly closer shot of Efrosinia listening to the bells. In the sequence of the recall from Alexandrov, there is no shift in the volume of the diegetic hymn at the first cut from Ivan to an exterior shot of the crowd (779-780). As if to emphasize this, the singing *does* become louder in the course of shot 780.

Several other sonic devices contribute to spatial confusion. In a couple of shots, characters speak without moving their lips. During the first segment of the Boyars' plotting in Part I, Kolychev the Wise says, "He strips us of our hereditary possession." This line begins in shot 607. Efrosinia is in the foreground; Kolychev is visible in the background, slightly out of focus and moving forward as the line begins. He does not open his mouth in this shot, yet after the cut to shot 608 (a *plan americain* of the group), he is gesticulating and moving his lips. In the Boyar mourning scene of Part II, Efrosinia stands behind Philip, exhorting him to attack Ivan's power. In shot 305 (Fig. 165), her lips clearly move as she speaks. After the mismatched cut to shot 306 (Fig. 241), she is now out of focus and does not move her lips; her voice, however, continues into the second shot. In both these cases, the lack of lip synchronization

combines with planes of focus, but this is not always the case. In the Fiery Furnace play, there are several shots where the boys' lips do not move even though their voices are heard; they are in crisp focus. The dialogue between the two Chaldeans also contains a cut in which the overlapping line has no lip sync in one shot. In shot 331, the first Chaldean leans forward and calls the second; the second begins to answer, "What is it?" This line overlaps into shot 332; the second Chaldean enters the frame from the right immediately, but his lips are not moving when the end of the line is heard.

The film has only one use of diegetic speech that has no identifiable source; the effect is quite disruptive. It occurs in the illness scene, when Malyuta comes into the courtyard and stares off toward Kurbsky and Efrosinia. As he pauses (433) in long shot, an offscreen male voice says: "The Tsar's eye. . . ." A cut follows these words, but it is a cut-in to a close-up of Malyuta's face; the same voice says, "Malyuta." Rather than revealing the identity of the speaker, the cut simply reinforces the mystery by keeping him offscreen. (The voice is not Kurbsky's.) We never find out who spoke the line.

Related to this is the questionable diegetic status of many of the choruses. Some seem to come from the space of the scene, yet no source is visible. This is less problematic during the cathedral scenes, where it is easy enough to posit a concealed choir. The wedding banquet, on the other hand, contains several choral interludes that might seem at first glance to be sung by the assembled guests. Certainly the Boyars wave their goblets in time to the music and move their lips as though singing. But the guests are all males, except for Efrosinia, and the songs are sung by a female chorus. And what of the choir that begins singing a hymn as Ivan stares off at the dead Boyars at the end of the execution scene? It seems to be nondiegetic yet continues to play through the scene of the Boyars' mourning, where it appears to be diegetic. One of the most problematic moments in the whole film comes at the end of the beaver lullaby, when a chorus enters to sing the final words with Efrosinia. Here there is no doubt that the choir is not present. The brief introduction of a nondiegetic chorus as an accompaniment to a diegetic voice occurs only this once in the entire film and therefore calls attention to itself. As at certain other points in the film, the spectator is cued specifically to puzzle over the diegetic status, and this necessarily leads him or her away from a simple concentration on the narrative significance of sound devices.

The lack of music as a bridging device prepares the way for several other disturbing uses of sound. In these cases, voices carry over from one scene to another or begin in the darkness between scenes in completely unmotivated ways. In some cases, this gives the impression that the sound has somehow outrun the image and begun too soon; the close fusion is destroyed as the sound accompanies unrelated images. The simplest and least unusual of these overlaps comes at the beginning of Part II, when the nondiegetic narrator's voice carries over the fades and slightly into the establishing shot of the Livonian court. Although the narrator speaks of Kurbsky's desertion—a topic appropriate to the new images—there is a strange, "rushed" quality to the sound. The fanfare of the court begins over the darkness and during the narrator's speech; the music is so loud that it competes with the voice. It signals the beginning of the new scene before the narrator has had time enough to finish setting it up. This sense of the timing of sound and image being "off" is reinforced by the fact that the voice stops very shortly after the shot has faded out, as if it were not supposed to overlap into the shot at all.

We have already seen how the bells of the illness scene begin over the last shot of the Kazan sequence and the darkness between. The opposite happens with the speech of the Oprichnik in the scene of the heralds in Part I. The Oprichnik's voice carries over the fades and into the initial medium shot of Ivan sitting in despair (777). His words about following Ivan to Alexandrov serve as a dialogue hook and identify the next scene. But a conventional dialogue hook would not extend over a fade-out and fade-in in this way. In another instance, Ivan's rant against the Boyars at the beginning of the poisoning sequence in Part I begins in the darkness that precedes the fade-in to shot 629, the rooster emblem, but here there is no dialogue hook to cue us as to the narrative situation that will accompany his words. Similarly, in the Part II Boyar mourning sequence, the hymns that will continue through the scene resume in the darkness before the fade-in.

Strange, abrupt transitions between sounds take place within scenes. The dissolve from the wedding lullaby to the alarm bells was mentioned earlier. Another, more abrupt sonic transition takes place as Efrosinia reenters the hall. The riot music has been playing during her conversation with her servant. It continues into shot 158, the cut inside the hall, but after a second or two it stops abruptly to be replaced immediately by the "white swan" chorus.

In another scene, the music that accompanies the shots of toiling soldiers at the beginning of the Kazan sequence gives way to the slow version of the "Terrible" theme in shot 275 (the first view of Ivan's tent). This time the transition is not an abrupt shift but a sonic dissolve, as the initial music dies down and the new passage is turned up at the same time. These and other similar transitions— or lack of transitions—help to break down the conventional usage of music as unobtrusive, continuous accompaniment. Whereas most Hollywood musical usage would create a transitionary passage to move from one piece of music to another, *Ivan* emphasizes the nature of the music as separate, recognizable pieces by these abrupt juxtapositions.

Some of the devices I have been describing appear only once or a few times in the film. They are perhaps the more striking for their isolation against the general approach of fusion of sound and image. Other techniques, like the tiny overlaps, are more pervasive. By varying the kinds of sound disjunctions it uses, *Ivan* is able to keep each individual device striking and hence more effective in its de-familiarizing capacities. Taken together as a whole level of stylistic disruption, this aspect of the sound becomes a major part of the film's counternarrative structure. Eisenstein balances these devices against the "fusion" elements to create sound that is intricately bound to the images yet still strange enough to constantly come forward and call attention to itself.

NONCLASSICAL AND DISJUNCTIVE NARRATIVE DEVICES

For all its stylistic discontinuities and ruptures, *Ivan* has a relatively straightforward narrative. As I pointed out in Chapter Two, the progression from the coronation scene to the shore of the Baltic creates a tight closure. The digressions that lead the film away from a concern with the Livonian struggle are all motivated. Although they do not always seem *causally* necessary, they are reasonable given the semic and symbolic structures concerning Ivan and the goals that are at work in the film.

The causal structure as such does not seem to depart greatly from the norm of the classical Hollywood cinema. The difference comes, perhaps, in the *types* of causes that are seen as the fundamental motivating devices of the story. In the two Hollywood films we have been using as a background, the basic causes arise from the personalities of the characters, and the narrative interest lies in

seeing how historical events affect the lives of the protagonists. In *Sergeant York*, York's primary desire is to buy a piece of land that he dreams of building into a farm for his fiancée Gracie; in the course of this struggle he experiences a religious conversion. World War I then becomes a block to his desires: he can neither build the farm nor hold to his religious beliefs if he must go into combat. By changing his own goals, he fulfills the demands of society; by deciding to fight, he becomes a hero. In gratitude, the state of Tennessee builds him his farm before he returns home. Hence the overall effect of the historical events is to take York from his initial state of poverty and bachelorhood to a final one of plentitude and approaching marriage. This movement of his personal life forms the all-encompassing structure to which the historical events are subordinated.

The pattern is even clearer in *Mary of Scotland*. The film alternates between scenes in England, with Elizabeth I, and scenes in Scotland, with Mary. Elizabeth fears that Mary will become too powerful—a fear that is motivated by her jealousy of Mary's youth and beauty. Elizabeth spends most of her scenes staring into mirrors and exhorting her handsome ambassadors to Scotland not to fall in love with Mary. For her part, Mary falls in love with the one man who has enough power to protect her claim to the throne, Bothwell. She is willing to leave her throne for a happy life married to him; the couple sees her power as a painful duty that separates them. Bothwell finally dies in a foreign prison. This permits the film to present Mary's execution as her final triumph. In prison, she exults over Elizabeth, saying she is happier to have had a short period of love than to have reigned a queen. The final scene is handled as a reunion in death, with Bothwell's bagpipers playing on the track as Mary ascends the scaffold. The entire film concentrates on the romantic aspects of Mary's relationship with Bothwell, treating historical events only as they affect this romance.

Ivan takes the opposite approach, making its all-encompassing causal structure the movement from disunified to unified Russia. Within this movement, the actions of the individual characters are important only as they affect the outcome of the struggle toward this goal. The goal does bring about historical events that affect the lives of the characters, but there always comes a point where these effects are seen as significant primarily for their causal role in relation to the goal. (Anastasia's death leads to Ivan's despair, but despair causes him to renew his resolution and form the Oprichnina.)

This difference from the classical narrative's use of historical personages may be a way in which one could distinguish a specifically Soviet ideology in Eisenstein's approach to structuring his film.

But even though *Ivan* has a fairly tight narrative structure, there are a number of disjunctions that work in a way similar to the discontinuities of style. The most consistent of these is a lack of transitions between sequences. As we have seen, each sequence is marked off by fades, and none has the conventional musical bridges of the classical Hollywood narrative style. However, the causal relations between one sequence and its neighbors are usually clear because *Ivan* uses the common Hollywood device of the dialogue hook. As the coronation ends, Efrosinia mentions the wedding day, and the subsequent sequence is the wedding day. The wedding sequence ends with the crowd shouting "To Kazan!" and the next sequence takes place at Kazan, and so forth. Even when no dialogue hook is provided, as between the Kazan battle and the illness sequences, exposition quickly fills in the gap: "The Tsar fell ill on his way back from Kazan." But these transitions do create an unusual uncertainty about the spatial and temporal shifts. Spatially this is relatively inconsequential, since much of the action takes place in different areas of the Kremlin. But temporally the effect of uncertainty is cumulative: because we have little information about the gaps between sequences, we end up with an indistinct sense of how long the whole narrative has taken in story time.

The main reason for this uncertainty is Eisenstein's avoidance of the conventional devices that a system like the classical Hollywood cinema uses frequently in transitions. Primary among these are the explanatory title (often motivated as a sign or newspaper heading) and the ironically named montage sequence. Both *Sergeant York* and *Mary of Scotland* make liberal use of these devices to create an extremely clear narrative progression in the lines of causality, space, and time.

Interestingly, both of these films and *Ivan* use introductory titles to set up the basic historical situation. But *Ivan* only makes use of titles this one time, in explaining the importance of Tsar Ivan in the unification of Russia. The two Hollywood films use similar titles and other written explanatory material on numerous occasions throughout the films. *Sergeant York*'s final introductory title states the locale and year of the opening section. Later, a line of dialogue suggests that York has gone to a bar on the Kentucky-Tennessee border. This dialogue hook leads to a wipe. The new shot frames

a sign saying, "Tenn/Kentucky," with a tavern in the background. (The interior of this tavern also has "Tenn/Kentucky" scrawled several times on the walls.) When York goes into the army, a superimposed title announces the new locale, "Camp Gordon, Georgia." As the troops sail for Europe, another superimposed title explains the progression of narrative events: "Soldiers now—fully trained and equipped for battle—the all-American division sails for France." *Sergeant York* also contains a number of montage sequences: York doing a series of odd jobs to earn money, various events at the turkey shoot, the news of York's capture of a German position spreading through the troops, and York's triumphant return to America and visit to New York. These last actions take place very quickly, supplemented by the standard spinning newspaper headlines, maps, shots of applauding crowds, stock footage of ticker-tape parades, and so on.

Sergeant York also uses one standard device of the classical Hollywood cinema to measure the passage of time: the deadline. A deadline permits frequent reference in the dialogue to time and hence enables the narrative to proceed in clear stages. York has sixty days to get the money to buy the plot of land he wants. Later his induction into the army is marked into stages by a series of appeals to various boards on the grounds of religious beliefs.

Mary of Scotland uses title cards for its transitions. Because the film involves a series of lengthy scenes in distinct locales (a legacy of its origin as a stage play, presumably), it needs to identify each new place. Several titles read simply, "England." At one point Bothwell abducts Mary. When she asks where he is taking her, he replies, "Dunbar Castle." From this dialogue hook, a dissolve leads to a shot of the castle, with a title: "Bothwell's Stronghold—Dunbar Castle." A number of other titles identify locales, and one describes action: "The rebels under Moray lay siege to Holyrood." This large number of titles largely does away with the use of montage sequences. The only one that does occur is, interestingly enough, used purely to transport the viewer a long distance through space rather than time. This occurs at Bothwell's death, which is followed by a series of superimpositions of storm scenes of trees and ocean waves ending finally in Mary's chamber as she wakes in horror at the storm.

Mary of Scotland's temporal relations are somewhat obscure. No deadlines arise, and there is little mention of the duration of events. A certain sense of time passing is set up by the constant travels of

ambassadors from Scotland to England and back; the film's scenes tend to shift correspondingly. The film does employ a device of guards who call out the time and an "All's well" at intervals. These serve to establish at least the time of day, even though the number of days between events remains vague. The main cue for duration is Bothwell's reference to his and Mary's twenty days together.

Ivan does, of course, provide some indications of temporal relations, primarily Ivan's beard and graying hair. But is this an index of time's passage or of the strain of the job? Other characters remain relatively unchanged. The film ignores the logical places for transitionary titles or montage: the trip to Kazan, for example, or the stay at Alexandrov, with the forming of the Oprichniki guard. How long *did* Ivan sit there waiting for the people to call him back? At Kazan, he has waited a month for the sappers to dig their tunnels, but does this tell us how long the army has camped on the plain? Did Ivan conceive his gunpowder plan after the arrival at Kazan? (The moment of his inspiration would be a scene the classical narrative would be likely to include.) Nor does Eisenstein always use fades to mark significant changes in time and space. What is probably the most transgressive cut in this sense is the move from Ivan's coach galloping through the countryside (Fig. 244) to his entry into the throne room in Moscow (Fig. 245). A classical construction would undoubtedly use a dissolve to smooth over this gap, but *Ivan* uses a straight cut. The effect is particularly jarring since we have never seen this room before and have no idea whom Ivan is addressing as he enters; the reverse shot of the Boyars comes only at the fourth shot of the interior scene.

This lack of clear spatial and temporal transitions between sequences creates a montage structure in Eisenstein's sense of that term. That is, the film juxtaposes elements abruptly in order to engage the spectator's attention and encourage an active perceptual process. Viewers must figure out the transitions in much the same way as they must build up a sense of the space of a scene by piecing together cues that don't quite fit.

Beyond this consistent strategy of eliminating smooth transitions, the film contains a number of individual causal contradictions that tend slightly to break apart the smooth narrative progression. One question we might ask is what happens to little Dimitri, Ivan's son, who is never heard of again after his near-ascension to the throne in the illness sequence. Efrosinia assumes that Vladimir would automatically become Tsar if Ivan is killed in Part II, but the question

of Dimitri's claim is passed over. Why is Pimen always around in Part II even though Ivan sends him to be Metropolitan of Novgorod in Part I? (He does indeed turn up in Novgorod in Part III.) More startling, the crowd that rushes into the cathedral with torches at the end of the scene by Anastasia's coffin is dressed in Oprichniki uniform. Ivan has just that minute decided to form such a group, and in the next scene we see a black-uniformed guard recruiting in a Moscow street. Who, then, are the figures in the cathedral? Their causal status in the narrative is highly problematic, entailing one of the largest logical lapses in the film's narrative.

Another kind of logical lapse occurs in the scene of the execution of the Kolychevs, when Malyuta pauses and stares at the neck of one victim before striking (Fig. 246). The pause itself, with its emphasis on the physicality and individuality of the Boyars, is important in the general motivation of the next few scenes, with their movements toward the Boyars' viewpoint. But although the pause is compositionally motivated, the fact that it takes the specific form of a close-up of Malyuta pausing does seem problematical. Our look at the extreme close-up of the neck (Fig. 149) is motivated by his glance, yet this does little or nothing for his part in the narrative. It seems on the surface to set up a seme of pity, regret, or sensitivity that in fact never returns. Thus it creates a small red herring in the text. In the next shot, Malyuta is already in the act of striking (Fig. 247); his pause has been short indeed. Here the necessities of the narrative have forced a scene into a contradiction: in order to accomplish one purpose—a look at the Boyars as victims—the text must use a character in a way that is inconsistent with his other narrative functions. This is one of the few times in the film when we can see what Heath calls "figures of distress," those gaps that reveal the glossed-over struggle of narrative unity to contain the disjunctive factors of the film.

I do not wish to imply that these logical problems are mistakes. They fit in quite well with the structures of disjunction on the stylistic levels of the film. But on the whole, the narrative's tight logic makes it somewhat closer to the classical model than is, say, the cubistic editing. Certainly if one were to make claims about *Ivan* as a "modernist" text, the narrative would provide only slight supporting evidence.

9 Excess

THE CONCEPT OF CINEMATIC EXCESS

"Analytically there is something absurd about it."—ROLAND BARTHES[1]

In my analysis so far, I have tried to point out relationships in *Ivan* with an aim to opening up and/or renewing the film for the reader. But lengthy though this analysis has been (in comparison with most traditional film criticism), it has mostly proceeded in one direction: the demonstration of the film's striving toward organized structures. Such discussion, no matter how lengthy, cannot take into account certain aspects of *Ivan* that comprise much of its strength. Unfortunately these aspects are almost undefinable. Critics usually flounder when trying to explain the qualities *Ivan* has: its beauty, its strangeness, its overwhelming density of textures. These attributes can hardly be fully explained by any analysis of motifs, spatial patterns, acting styles, and the rest, however detailed.

Recently certain writers have moved away from the traditional concept of criticism as an activity designed purely to explain the narratively functional aspects of the work. Following essentially the same direction established by the Russian Formalists, these critics have suggested that films can be seen as a struggle of opposing forces. Some of these forces strive to unify the work, to hold it together sufficiently that we may perceive and follow its structures. But other forces work against this unity, as we began to see in the preceding chapter. *Ivan*'s discontinuities of editing and its refusal to provide more than artistic motivation for many of its stylistic devices tend to roughen the form of the neat relationships set up in other formal levels of the film. But even here the discontinuities are structured, creating their own unified system within the work.

Outside of such structures lie those aspects of the work that are not contained by its unifying forces—the "excess." The term is used

[1] Roland Barthes, "The Third Meaning," trans. Richard Howard, *Artforum* 11, no. 5 (January 1973): 47.

by Stephen Heath in his article "Film and System: Terms of Analysis." There he asserts:

> Just as narrative never exhausts the image, homogeneity is always an *effect* of the film and not the filmic system, which is precisely the production of that homogeneity. Homogeneity is haunted by the material practice it represses and the tropes of that repression, the forms of continuity, provoke within the texture of the film the figures—the edging, the margin—of the loss by which it moves; permanent battle for the resolution of that loss on which, however, it structurally depends, mediation between image and discourse, narrative can never contain the whole film which permanently exceeds its fictions. "Filmic system," therefore, always means at least this: the "system" of the film in so far as the film is the organisation of a homogeneity *and* the material outside inscribed in the operation of that organisation as its contradiction.[2]

"Homogeneity" is here the unifying effect I have mentioned. Heath suggests that the material of the image in film creates a perceptual play that goes beyond this unity. A film depends on material for its existence; out of image and sound it creates its structures, but it can never make all the physical elements of the film part of its set of smooth perceptual cues. The critic concentrates neither wholly upon the coherent elements nor wholly upon the excess; rather, he or she deals with the tensions between them. Heath is talking about the classical Hollywood film, which typically strives to minimize excess by a thorough-going motivation. Other films outside this tradition do not always try to provide an apparent motivation for everything in the film, and thus they make their potentially excessive elements more noticeable.

That *Ivan* is a film with interesting and apparent excess is suggested by the fact that Roland Barthes chose it as one of the major examples in his essay, "The Third Meaning" ("Le troisième sens"), which lays out a similar idea that the physicality of the image goes beyond the narrative structures of unity in a film. The choice of the term "meaning" is a misleading one, since these elements of the work are precisely those that do not participate in the creation of narrative or symbolic meaning; Barthes himself calls it "the obtuse

 [2] Stephen Heath, "Film and System: Terms of Analysis," *Screen* 16, no. 1 (Spring 1975): 10.

meaning" and says: "It does not even indicate an *elsewhere* of meaning . . . it rather frustrates meaning—subverting not the content but the entire practice of meaning."[3] For this reason I prefer to use Heath's term, "excess," rather than Barthes's.

But Barthes is ultimately clearer about what he considers part of this filmic excess. Heath's analysis of *Touch of Evil* provides examples that tend to confuse his term rather than clarify it. He calls the scenes in Tanya's place in that film excess because they "have no narrative function,"[4] even though this is clearly not the case. In comparison with the other scenes of the film, these scenes provide *relatively* little causal material to forward the proairetic. They do, however, contain a considerable amount of semic material about Hank Quinlan and hence provide motivation for his behavior throughout the rest of the film; Tanya's place provides the connection between Quinlan and Menzies that allows the latter to engage Quinlan in the final incriminating conversation. These are not the only narrative functions these scenes play, but they will serve to indicate that Heath has chosen a rather easy way out of the problem by dismissing whole scenes as excess when they are simply different from more causally dense portions of the narrative. Heath also resorts to a psychoanalytic explanation for excess, indicating that it is the material that must be repressed by the film (see, for example, his discussion of the character of the "night man" as a figure of excess[5]). But none of this comes to terms with Heath's own claim

[3] Barthes, "The Third Meaning," p. 49.

[4] Heath, "Film and System: Terms of Analysis," p. 67.

[5] Ibid., pp. 73-74. Some critics see excess as the product of an unconscious activity of the mind. This view is based in part on Freud's writings on everyday mistakes in speech and memory. This type of creation is not the same as excess as I am describing it here. Freud's examples as given in *Psychopathology of Everyday Life*, trans. A. A. Brill (New York: New American Library, n.d.), do not suggest a free play with a material object outside the self. On the contrary, the substitutions and changes discussed in his anecdotes are logical once the analyst finds a correct series of connections made by the unconscious to reach the substitution or blockage. These connections turn out in each case to lead to a rational explanation for the apparently random change or omission. Indeed, Freud does find cases where the connection is based purely on the material aspects of the language—that is, a similar-sounding word is used in place of the correct one. Freud's activities in analyzing the various stories is somewhat similar to that of the critic of the aesthetic object—he finds unified and reasonable relationships and outlines a chain of causes not unlike a narrative. When the original source of the mistake is found, closure occurs. If the persons in Freud's examples were truly engaged in a free play of unconscious mental processes, he would presumably be unable to find an end to the chains of associations,

(possibly derived from Barthes's) that excess arises from the conflict between the *material* of a film and the unifying structures within it. Heath in fact never analyzes a scene into its material and structural components to find examples of excess.

Barthes's entire essay, on the other hand, is based specifically on the physicality of film as the source of its excess. He in fact only analyzes still photographs, but his conclusions are applicable to film (and also to the material qualities of the film's sound, which he ignores). At one point, Barthes claims that excess does not weaken the meaning of the structures it accompanies: "If the signification is exceeded by the obtuse meaning, it is not thereby denied or blurred."[6] This seems doubtful, however. Presumably the only way excess can fail to affect meaning is if the viewer does not notice it. Certainly a steady and exclusive diet of classical narrative cinema seems to accustom people to ignore the material aspects of the artwork, since these are usually so thoroughly motivated as to be unobtrusive. But the minute a viewer begins to notice style for its own sake or watch works that do not provide such thorough motivation, excess comes forward and must affect narrative meaning.

Elsewhere Barthes acknowledges that his "obtuse meaning" does indeed affect our perception of meaning in a distractive way. Speaking of certain qualities of a photographic image, he asks, "Are they not a kind of blunting of a too-obvious meaning, a too-violent meaning? . . . Do they not cause my reading to skid?"[7] This image of a skidding perception is interesting, because it is not far from the kinds of metaphors the Formalists chose to describe the effects of delaying devices in a narrative, such as "staircase construction." In each case, there is an attempt to describe a movement away from a direct progression through an "economical" structure. Barthes also speaks of the obtuse meaning as separate from the diegesis of the film:

> The obtuse meaning is clearly counternarrative itself. Diffused, reversible, caught up in its own time, it can, if one follows it,

or at least that end would be randomly arrived at. In the current study, I am assuming that excess is a potential product of the uniquely aesthetic mode of perception and results from the nonpractical nature of this perception. Perception as a game, experienced for its own sake, drifts away from the requirements of logic. For Freud, the mental processes of unconscious slippages and blockages were highly practical—they stem from the need to repress sexual and morbid material.

[6] Barthes, "The Third Meaning," p. 47.
[7] Ibid.

establish only another script that is distinct from the shots, se-
quence, and syntagmas. . . . Imagine "following" not Euphro-
sinia's machinations, nor even the character (as a diegetic entity
or as a symbolic figure), nor even, further, the countenance of
the Wicked Mother, but only, in this countenance, that grimace,
that black veil, the heavy, ugly dullness of that skin. You will
have another temporality, neither diegetic nor oneiric, you will
have another film.[8]

We probably never watch *only* these nondiegetic aspects of the
image through an entire film. Nevertheless, they are constantly pres-
ent, a whole "film" existing in some sense alongside the narrative
film we tend to think of ourselves as watching.

The idea that the critic's job might include pointing out this excess
may startle some. But we have been looking at the neat aspects of
artworks so long that we may forget their disturbing, rough parts.
As Barthes says, "The *present* problem is not to destroy the nar-
rative, but to subvert it."[9] For critics, this means the realization that
they need to talk about those aspects of the work that are usually
ignored because they don't fit into a tight analysis.

The concept of excess is useful to the current analysis and fits in
with the methodology formulated at the beginning of this study.
For, while the Formalists did not come up with the idea of excess
as such, they did move in a direction that strongly implied it. When
Shklovski says, "The language of poetry is not a comprehensible
language, but a semi-comprehensible one,"[10] we must assume that
the incomprehensible elements are so because they do not fit neatly
into the unified relationships in the work; they may be explained
as tending toward excess. Shklovski also makes a distinction be-
tween "material" and "form"; in speaking of music he says, "We
have found, not form and content, but rather material and form,
i.e., sounds and the dispositions of sounds."[11] The process of "dis-
position" of materials into structures does not eliminate their orig-
inal physicality. Thus the Formalists seem to have at least ap-
proached the realization that excessive elements provide a large

[8] Ibid., p. 49.

[9] Ibid., p. 50. Italics in original.

[10] Viktor Shklovski, "The Resurrection of the Word," trans. Jane Knox, *20th
Century Studies* 7/8 (December 1972): 46.

[11] Viktor Shklovski, "Form and Material in Art," trans. Charles A. Moser and
Patricia Blake, in *Dissonant Voices in Soviet Literature*, ed. Patricia Blake and Max
Hayward (New York: Harper & Row, 1964), p. 21.

range of possibilities for the roughening of form. The material provides a perceptual play by inviting the spectator to linger over devices longer than their structured function would seem to warrant.

Of course no element in a work is strictly excessive to the degree that it has *no* connections to other elements (except perhaps simple technical errors—the airplane in the sky of a biblical epic scene). As the Soviet filmmakers of the postrevolutionary period realized, simply to place two things together is to create a perception of them as related. This is one reason why excess is so difficult to talk about: most viewers are determined to find a necessary function for any element the critic singles out. For some reason, the claim that a device has *no* function beyond offering itself for perceptual play is disturbing to many people. Perhaps this tendency is cultural, stemming from the fact that art is so often spoken of as unified and as creating a perfect order beyond that possible in nature. Another related cultural belief sees art as "economical" in its structures; economy becomes a positive attribute in an artwork. Excess is an uneconomical factor in creating and viewing films, so critics who believe art is economical tend to ignore it.

But if part of the difficulty of talking about excess stems from its novelty as a concept, the critic is also faced with the fact that excess innately tends to elude analysis. For example, take Barthes's description of Efrosinia in the previous extract. That one *can* look at the visual figure in the images quite apart from her narrative function seems reasonably certain; we may go further and say with some confidence that one can perceive the visual figure even while following the narrative function it fills. But a discussion of the *qualities* of the visual figure at which we look seems doomed to a certain subjectivity. We may not agree that the texture of Efrosinia's skin has a "heavy, ugly dullness." The fact, however, that we can agree that it has *some* texture opens the possibility of analysis. Critics and their readers must resist the learned tendency to try and find a narrative significance in every detail, or at least they must realize that a narrative function does not exhaust the material presence of that detail. Our conclusion must be that, just as every film contains a struggle of unifying and disunifying structures, so every stylistic element may serve at once to contribute to the narrative and to distract our perception from it.

This is one of the shorter sections of my study, even though there may well be more potential for excess than for anything else in the

film. Excess is not only counternarrative, it is also counterunity. To discuss it may be to invite the partial disintegration of a coherent reading. But on the other hand, pretending that a work is exhausted by its unifying structures robs it of much that is strange, unfamiliar, and striking about it. If the neoformalist critic's task is to renew and expand the work's power to defamiliarize, one way to do this would be precisely to break up old perceptions of the work and to point up its more difficult aspects.

This action of "pointing" must be my principal tool here, since other means of analysis are designed for nonexcessive structures. (Barthes says in his essay, "I am not describing, I cannot manage that, I am merely designating a site."[12]) Analysis implies discovering relationships between devices. Excessive elements do not form relationships beyond those of coexistence. The Russian Formalists, however, give us a tool that may at least make the process of pointing somewhat systematic: motivation. Strong realistic or compositional motivation will tend to make excessive elements less noticeable, and, as a result, the perception of the narratively and stylistically significant will dominate. But at other times, a lack of these kinds of motivation may direct our attention to excess. Thus excess seems to be a portion of artistic motivation, that general category which includes all devices with neither realistic nor compositional motivation.

More precisely, excess implies a gap or lag in motivation. Even though the presence of a device may not be arbitrary, its motivation can never completely control our perception of the film as material object. To a large extent, the spectator's ability to notice excess is dependent upon his or her training in viewing films. The spectator who takes films to be simple copies of reality will probably tend to subsume the physicality of the image under a general category of verisimilitude: that shape on the screen looks like it does because "those things really look like that." Another spectator, trained to look at films as romantic expressions of the artist, might attempt to see every aspect of every shot as conveying "meaning," "personal vision," and the like: the image looks the way it does because that is how the artist perceived the world. At the other extreme, the "art for art's sake" viewer—the "empty" formalist—will tend to ignore motivation in favor of a totally free play of the "aesthetic" elements. All these approaches tend to vitiate the tension in the

[12] Barthes, "The Third Meaning," p. 48.

work between unified and excessive elements. The current study attempts to suggest an alternative: excess provides a potential way of viewing films that spectators can adopt as easily as they can any of the attitudes I have just mentioned.

I have been looking at film as a struggle by the unifying structures to "contain" the diverse elements that comprise its whole system. Motivation is the primary tool by which the work makes its own devices seem reasonable. At the point where motivation fails, excess begins. To see it, we need to stop assuming that artistic motivation creates complete unity (or that its failure to do so somehow constitutes a fault). There are at least four ways in which the material of the film exceeds motivation.

First, narrative function may justify the presence of a device, but it doesn't always motivate *the specific form that individual element will take*. Quite often, the device could vary considerably in form and still serve its function adequately. Perhaps its color is vital, but its shape could be different. With an infinite number of points in space, we must assume that there is some range of camera placements that would frame the scene adequately to its function. Ivan must be an impressive character, but his impressiveness could be created in many ways. The actual choices are relatively arbitrary: a pointed head, three versions of a musical theme, close-ups with a crowd in deep focus, and so on.

Second, the medium of cinema is such that its devices exist through time. Motivation is insufficient to determine *how long* a device needs to be on the screen in order to serve its purpose. (Indeed, for different spectators, the requisite time is probably different.) We may notice a device immediately and understand its function, but it may then continue to be visible or audible for some time past this recognition. In this case, we may be inclined to study or contemplate it apart from its narrative or compositional function; such contemplation necessarily distracts from narrative progression. (Perceptually, narrative progression involves the spectator's mental construction of the story "behind" the presentation of plot.) On the other hand, the device may be more obscure and require a longer process of interpretation to make sense. How can motivation determine the length of time necessary for this perceptual activity? The concept of legibility provides a rough guide. A large number of items within a single space will require a greater duration for complete scanning than a smaller number of items. But this determination can only be relative; the specific length must always be

arbitrary to a certain degree. Repeated viewings of a film are likely to increase the excessive potentials of a scene's components. As we become familiar with the narrative (or other principle of progression), the innate interest of the composition, the visual aspects of the decor, or the structure of the musical accompaniment may begin to come forward and capture more of our attention. The legibility has shifted for us; we can now simply *recognize* the unifying narrative elements rather than having to perceive them for the first time. As a result, we now have time to contemplate the excessive aspects. The function of the material elements of the film is accomplished, but their perceptual interest is by no means exhausted in the process.

Third, as we have seen amply in this study, a single bit of narrative motivation seems to be capable of *functioning almost indefinitely*. It may justify many devices that have virtually the same connotation, even though they may vary greatly in form. Thus Ivan's basic function as the embodiment of the goal of Russian unity permits the extremely redundant expression of his semes in every cinematic channel. This redundancy does not advance the narrative in every case; rather it tends to expand the narrative "vertically." After a point, the repeated use of multiple devices to serve similar functions tends to minimize the importance of their narrative implications; instead, they become foregrounded primarily through their own innate interest.

Fourth and last, a single motivation may serve to justify a device that is then *repeated and varied many times*. By this repetition, the device may far outweigh its original motivation and take on an importance greater than its narrative or compositional function would seem to warrant. This kind of excess is extremely common in *Ivan*. The introduction of the bird motif, for example, is realistically motivated: a couple of the objects in the coronation ceremony have historically authentic bird emblems on them (the scepter, the little rug on the dais). But later the birds become less integral to the action at hand. They have associations, but, as we have seen, these associations are relatively arbitrary. We cannot say that these birds are unmotivated, for they all relate to each other and hence form a unified structure. But they do draw attention to themselves far beyond their importance in the functioning of the narrative. Indeed, by the time the last bird appears in the film—the white "Holy Ghost" icon on the ceiling of the feast hall—I am hard put to assign it any function at all.

EXCESS IN *Ivan*

With these characteristics of excess in mind, let us look at some examples from *Ivan*. Some of these may seem trivial; they will certainly not always be the kind of thing the critic ordinarily points out. But taken together, they should suggest the wealth of excessive details that help make the film a rich perceptual field.

Ivan's excess becomes readily apparent if we compare it with the norm, our background of Hollywood cinema. One critic whose approach is largely tied to the classical Hollywood narrative style, Pauline Kael, finds *Ivan* difficult to enjoy. While admitting its grandeur, she says: "We may stare at it in a kind of outrage. True, every frame looks great—it's a brilliant collection of stills—but as a movie, it's static, grandiose, and frequently ludicrous."[13] In our terms, this "outrage" is in part the rejection of excess, the reluctance to consider the uneconomical or unjustified. With its broken rhythms of acting, its shifting space, and its constant heightening of stylistic devices, *Ivan* stands in contrast to the Hollywood cinema. Here style becomes foregrounded to an unusual degree, necessarily calling attention to the physicality of the film.

The composition of visual elements within the frame may provide a rich source of excess. Striking arrangements abound in *Ivan*; these become particularly prominent because Eisenstein uses so many static or nearly static shots to explore space and further the narrative. The long shots of Ivan's tent on the hill at Kazan would be an example of this. The arrangement of curved lines of soldiers and a group of banners provides a striking composition in which little movement occurs (I, 281-282, Fig. 248). The series of shots of Boyars and ambassadors in the courtyard at the beginning of the illness sequence invites our attention to small shifts of space, to faces and textures of fur and brocade, to the changing visual overtone of the cathedral icon, and to the rhythmic chiming of the various bells. In the opening coronation scene, three bald European ambassadors speak and shake their heads, but of at least equal interest is the pattern formed by their heads in the center of three large white ruffs (I, 9).

The deep-focus shots in the Alexandrov sequence of Part I place Ivan in close-up with the crowd on the snow-covered plain beyond.

[13] Pauline Kael, *Kiss Kiss Bang Bang* (Boston: Little, Brown and Company, 1968), p. 288.

In each shot, Ivan moves his head—up in the first, down in the second (796 and 800, Figs. 194, 195, and 196). These head movements are unmotivated; they seem to exist only to play on shifting graphic relationships between Ivan's profile and the curved shape of the crowd beyond, the amazing juxtapositions of space and volume, the texture of Ivan's hair and skin against the whiteness, and the vertical montage relationships.

The four shots of Ivan's return to Moscow also play on formal values. Since all four shots show the same basic action—the galloping of the procession of Oprichniki and coach—we must conclude that one shot would convey as much narrative information as four (or six or eight). Formal interest rests in the rhythm of the fast music in conjunction with the swift movement and in the small shifts of the church spire in the background at the cuts. Shot 98 (Fig. 249, the first of the segment) has almost the same set-up as shot 99 (Fig. 250). Shot 100 shifts to a longer view of the whole scene, but shot 101 again has almost the same framing. These small changes (a violation of Hollywood's "thirty-degree rule" that every shot should be distinctly different from its neighbors in order to clearly motivate the cut) create variations that add nothing but make our perception of the film more difficult.

The textures, colors, and shapes of the costumes are a frequent site for excess in *Ivan*. For example, the glitter of light on the costumes of Vladimir and Efrosinia in the beaver lullaby scene becomes very prominent (Fig. 230). The contrast of Philip's plain black cloth cassock with Ivan's heavy fur cloak provides the basis for considerable play in the scene of their argument early in Part II. In shot 213, Philip turns suddenly and moves to the throne to lean over and speak directly to Ivan; the shifting train swirls behind him and stretches out into a series of diagonal folds as he moves (Fig. 251). Later, as Philip stalks away, shouting his curse back to Ivan, the long shot frames the entire empty throne room (216, Fig. 213). First Philip moves away, turns briefly to shout back, then continues out; during this, Ivan moves right and then across left to follow Philip. The indirect, hesitating movements of the two men in black against the light flagstones of the floor set up swirling patterns of visual interest and excess. In the Livonian scene, Sigismund leans forward in close-up until his head seems to be suspended in the center of a set of radiating black and white lines composed by his ruff (II, 84, Fig. 252). In the same scene, one

knight wears armor decorated with huge, curling feathers that are elaborately back-lit (68, Fig. 253).

Excess is also present in the *way* things happen. The tassel of Pimen's rosary drags lightly over the carvings on the gold Bible in a close-up during the illness sequence (I, 455). Ivan's sweeping turn as he carries the poisoned cup to Anastasia is unnecessary in relation to the action. Efrosinia's behavior as she sings the lullaby is strange in a way that reaches beyond the narrative connotations. Ivan's kiss on Malyuta's brow before the executions in Part II slips away from the straightforward causal and semic motivation of the scene.

The style of many devices is highly exaggerated in *Ivan* compared to that of the classical narrative film. Elements of the acting such as the abrupt, broad gestures and the staring eyes stand out as strange; we may recognize their function in the filmic system, but this will not obliterate their peculiarity.[14] Whereas the Hollywood norm has accustomed us to clear, seamless space, we are now confronted with frequent, pointless shifts and gaps. Elsewhere I have spoken of the cubistic editing as a perceptual game. If the spectator consciously notices the cubistic cuts in *Ivan*, he or she may indeed be drawn aside from the smoother structures to notice more and more subtle instances of this spatial instability. Indeed, all the stylistic disjunctions I spoke of in Chapter Eight may easily lead spectators into an awareness of excess—unless they strive too hard to recuperate them.

Problematic or unclear elements are likely to become excess. Many of the icons in the cathedral, for example, are never seen in their entirety. They are realistically motivated as portions of a reasonably authentic historical setting, but because they are only partially visible, they invite inspection in a (necessarily fruitless) attempt at identification. Half-glimpsed hallways, slightly out-of-focus backgrounds, and other similar visual presences may all tend to draw the eye, particularly on repeated viewings. What are we to make of the black-clad body that lies in the background of one shot of the execution scene of Part II (285, Fig. 254)? The body is not there in any other shot, nor is there any suggestion that an Oprichnik dies or faints in this scene. Beyond the frequent use of confused spatial cues in the cutting, there is also one point where the geography is flagrantly inconsistent. When Efrosinia leaves the wedding

[14] "Peculiar" and "strange" here have only positive connotations; these qualities are a large part of *Ivan*'s appeal.

banquet to check on the progress of the riot, she goes out by a little door and emerges outside at the head of the stairway. Later, she receives Demyan's report in a little archway at the foot of this same stairway; yet when the pair go through the door in this archway, they (or at least Efrosinia—Demyan has disappeared during the cut to the interior of the hall) are coming in the same little doorway by which Efrosinia had previously exited.

Certain props carry interest beyond their function in the narrative. The repeated close-ups of the emblems of Riga, Reval, and Narva at the beginning of the poisoning sequence are only tangential to the narrative; we would undoubtedly be able to understand Ivan's speech without these visual aids. But their carvings attract attention. Similarly, the coffin and its trappings in the scene of Ivan's mourning are striking and elaborate: Anastasia lies in a hollowed-out log, surrounded by a fan of shining decorations like a peacock's tail.

As with other aspects of the film's style, we may find some of the most extreme examples of excess in the Fiery Furnace play. The use of the spectacle as a substitute for Ivan has a clear function in the narrative; similarly, the choice of the anecdote about Nebuchadnezzar is motivated in terms of the Boyars' vision of their position relative to Ivan. But the manner of the play's execution tends toward excess. Barthes speaks briefly of this scene in discussing excess, pointing to the three boys and "the schoolboy absurdity of their mufflers diligently wrapped around their necks"[15] (see Fig. 255). The mufflers coordinate with the general principles of the play's style, with a heightening of signification accomplished in the various channels by adding a symbolic device to the literal one: the boys stand over fire but also light candles to imply that they are in the fire; they are tied together but also wear mufflers to heighten the concept of bondage; they step into the furnace, but the Chaldeans also turn cartwheels to mark the moment (to suggest a sense of falling or confusion?). But beyond this function, Barthes's description seems to me right; there *is* something about those mufflers that goes beyond their symbolic function in the play. Their individual decorative patterns and strangeness in this context convey a quality that is perhaps, as Barthes says, "absurd," perhaps amusing, touching, or all three. The same is true of other aspects of the scene: the Chaldeans' painted grimaces (Fig. 256), the cymbal crashes, the

[15] Barthes, "The Third Meaning," p. 48.

boys' haloes, and the rest all have qualities beyond their immediate functions.

I have said little about sound, but clearly it can have its excessive features as well. The strange, jangling bell toward which Vladimir glances in the courtyard scene of the illness sequence of Part I would be one example. Birds are heard chirping in only one shot of the scene of the heralds toward the end of Part I. Malyuta's repetition of the word "pes" (pronounced "pyos," meaning "dog") in his conversation with Ivan before the executions of Part II seems to me rather comic, mainly because of the sound of the word itself and the injured tones in which he delivers the lines. In general, music has a great potential to call attention to its own formal qualities apart from its immediate function in relation to the image track. I suspect that the tendency of the actors to speak their lines in separate bits with long pauses between also calls attention to the sounds and rhythms of the dialogue.

A couple of obvious devices in the film seem strongly excessive: the shifts between color and black-and-white stock, which must inevitably cause a perceptual shock dependent entirely upon the physicality of the images; and the use of two identical shots from the coronation sequence (I, 58-59, Figs. 40 and 41) of two young women spectators in the Fiery Furnace sequence of Part II (334-335). In the latter case, we can logically recuperate the repetition by positing that the device simply fits in with all the other parallels between these two scenes; nevertheless, the two shots stand out as disturbing elements because we know they are physically the *same* shots—they violate our expectations about the temporal distinctness of the two scenes.

These examples will suffice to indicate the potentials for excess in *Ivan*. I can do no more than indicate; a systematic analysis is impossible. Why then bother with excess at all? What is its value? Beyond renewing the perceptual freshness of the work, it suggests a different way of watching and listening to a film. It offers one potential way to avoid the traditional, conventionalized views of what film structure and narrative should be—views that fit in perfectly with the methods of filmmaking employed in the classical Hollywood cinema. Spectators need not assume that the entire film consists only of the unified system of structures we call form and style; they need not assume that film is a means of communication between artist and audience. Hence the spectator will not go to a

film expecting to discern what it is "trying to say," or to try and reassemble its parts into some assumed, preordained whole.

Similarly, an awareness of excess may help to change the status of narrative in general for the viewer. One of the great limitations for the viewer in our culture has been the attitude that film equals narrative and that entertainment consists wholly of an "escapism" inherent in the plot. Such a belief limits the spectator's participation to understanding only the chain of causes and effects. The fact that we call this understanding the ability to "follow" the narrative is not accidental. The viewer goes along a preordained path, trying to come to the "correct" conclusions; skillful viewing may consist of being able to anticipate plot events before they occur (as with the detective story, which becomes a game in guessing the identity of the criminal before the final revelation). This total absorption in narrative has some unpleasant consequences for the act of viewing. The viewer may be capable of understanding the narrative but has no context in which to place that understanding because the underlying arbitrariness of the narrative is hidden by structures of motivation and naturalization. After all, narratives are not logical in themselves; they only make use of logic. An understanding of the plot, then, is only a limited understanding of one (arbitrary) portion of the film. But if one looks beyond narrative at both the unified and the excessive elements at work on other levels, the underlying principles of the film (such as the hermeneutic code and patterns of motivation) may become apparent. The viewer is no longer caught in the bind of mistaking the causal structure of the narrative for some sort of inevitable, true, or natural set of events that is beyond questioning or criticism (except for superficial evaluation on the grounds of culturally defined conventions and canons of verisimilitude).

One example of the result of a willingness to view films for excess as well as for unified structures is the genre of experimental films that examines already existing films. These often consist of optical printer alterations of the original film, emphasizing the material aspects of the image. Ken Jacobs' *Tom, Tom, The Piper's Son* (1969) is one such film, which takes a short silent film of the primitive period and blows up and repeats portions of the various shots to create a feature-length film. Narrative begins to break down and tiny gestures, grain, and individual frames become foregrounded. Joseph Cornell made *Rose Hobart* (late 1930s) by taking an obscure American adventure picture (*East of Borneo*, 1932) and turning it

into a play on the concept of narrative by isolating individual shots and cutting them together out of order. He substituted a musical track for the original sound and specified that the film be shown through a purple filter. The result hints obliquely at the original narrative but generally concentrates on the gestures and appearance of Rose Hobart, a minor Hollywood actress, and on the absurdly exotic studio jungle settings. These, as well as some of Stan Lawder's loop films, suggest the structural possibilities that an awareness of excess can create. I don't mean to imply that the spectator and critic will be led to aesthetic creations of their own as a result of watching for excess. But Jacobs' and Cornell's films demonstrate the kinds of perceptual shifts that might take place once one becomes aware of excess.

Once the narrative is seen as arbitrary rather than logical, the viewer is free to ask why individual events within its structure are as they are. The viewer is no longer constrained by conventions of reading to find a meaning or theme within the work as the solution to a sort of puzzle that has a correct answer. Instead, the work becomes a perceptual field of structures that the viewer is free to study at length, going beyond the strictly functional aspects. Each film dictates the way it wants to be viewed by drawing upon certain conventions and ignoring or flaunting others. But if viewers recognize these conventions and refuse to be bound by them, they may strive to avoid having limitations imposed upon their viewing without an awareness of that imposition. Obviously there is no completely free viewing situation; we are always guided by our knowledge and cultural tradition. But a perception of a film that includes its excess implies an awareness of the structures (including conventions) at work in the film, since excess is precisely those elements that escape unifying impulses. Such an approach to viewing films can allow us to look further into a film, renewing its ability to intrigue us by its strangeness. It also can help us to be aware of how the whole film—not just its narrative—works upon our perceptions.

Appendix. Summary of the Action of Part III

Sequence 18

In the Castle at Wolmar, Livonia, Kurbsky dictates a letter for Ivan to a young scribe; he alternates between condemning Ivan's bloody deeds and admitting to himself that Ivan has acted as he must in order to achieve his goal. Kurbsky still envies Ivan and agonizes over his own position "in the dust" before Ivan's power. A Boyar messenger from Moscow arrives; Kurbsky hopes for pardon from Ivan, but the message tells him that the Russian towns Pskov and Novgorod await a signal to join the war against Ivan. Kurbsky dispatches a German knight, Henryk Staden, to infiltrate the Oprichniki and spy for Livonia. He then writes to Sigismund to begin the war against Ivan.

Sequence 19

In his library, Ivan has received Kurbsky's letter and is dictating a reply. Malyuta ushers in Pyotr Volynets, who has defected to Ivan's side; he reveals that Pimen, Kurbsky, and Philip were responsible for the assassination plot. Ivan grieves at this news, but Pyotr goes on to tell of the plot between the Russian towns and Livonia. Ivan's confessor Eustace is present. He at first calls the report a lie; when this makes Ivan suspicious, however, Eustace calls for merciless punishment of Pskov and Novgorod. Fyodor and Pyotr support the idea, while Malyuta remains doubtful. Ivan decides on a secret march to Novgorod, bidding Eustace to stay behind so that he may return for confession after his "sin."

Sequence 20

Ivan's troops march across a snowy plain toward Novgorod. They kill everything in their path, Novgorod patrols, birds, and beasts alike, so that no word of their advance may reach the city. Ivan dispatches Malyuta to the Tver monastery (to kill Philip). The Oprichniki overtake and kill a messenger who carries a warning of Ivan's approach toward Novgorod; the messenger tears away the signature just before he dies. Ivan resolutely moves toward the city.

In Pimen's palace, the Boyars plot for Novgorod and Pskov to secede to Livonia and fight against Ivan. Pimen reveals that he is

awaiting a message from Moscow, but instead of the message, Ivan bursts in upon the meeting, arresting Pimen.

Sequence 21

In the cathedral at Moscow, a monk is reading out a long list of those who have died in Ivan's struggle. Ivan lies prostrate before the fresco of the Last Judgment, overcome by remorse at the slaughter in Novgorod, where about fifteen hundred people perished. Among the names are Efrosinia, Vladimir, Philip, Pimen, and other Boyars. Ivan tries to justify his deeds in a monologue addressed to the "Heavenly Tsar" in the fresco above him.

Meanwhile the Basmanovs, Malyuta, and Staden look on. Basmanov's lieutenant, Demyan, was formerly a servant of the Staritskies; now he approaches Alexei, and they arrange for the deposit of spoils from the sack of the cities. Basmanov has a third of the loot taken to his own coffers, revealing that this deception has been going on for some time. The German, Staden, has also taken spoils that should have gone to the Tsar's treasuries; Fyodor threatens to turn him in but cannot do so without implicating his father as well.

Ivan, in despair, wishes to confess to Eustace; he begins to name those he has had to eliminate in building his unified state. As he names the Kolychevs, Eustace trembles and inadvertently reveals himself to be a member of that Boyar clan. Ivan threatens him, and Eustace reveals that the Boyars on the borders have also betrayed Ivan and that Kurbsky is preparing to march. Ivan snaps out of his despair to forge a message from Eustace to Kurbsky, preparing a trap for the latter.

Sequence 22

Kurbsky receives the message without suspicions, believing that the way to Moscow is now open for Livonia. But Sigismund worries about whether England has joined Moscow. A song about "Ginger Bess" provides a transition to the English court.

Queen Elizabeth is conferring with the German emissary, who wishes to form an alliance between Livonia and England against Ivan. Finally she says to him, "English men-at-arms shall be there, in Russia." The emissary takes this to be a favorable reply to his request; but the queen laughs as he goes out and receives Ivan's ambassador to make her real arrangements.

On the Livonian border, Ivan's army is advancing. Several Boyar governors are arrested by Oprichniki bands headed by Malyuta and the Basmanovs.

Sequence 23

In Alexandrov, Ivan and the Oprichniki are making merry at a feast for the dead, dressed in monks' clothing. Ivan sits and broods as the group sings a mock-pious song. He then reveals that he knows several among them have been enriching themselves at his expense. He indicates Basmanov; the latter fears at first that his own son has betrayed him but quickly realizes it was Demyan who did so. Ivan appoints Fyodor to kill his own father. As they leave the room, Ivan sends Demyan to be killed by dogs.

Outside, Basmanov reveals that he has hoarded much booty to pass on to his line; he desires that his descendants will be able to grow as powerful as Ivan's. Basmanov forces Fyodor to swear to work against Ivan for the Basmanov line. Fyodor then beheads him.

Back inside the hall, Fyodor is unable to hide his betrayal from Ivan, who orders him arrested. Staden steps forward and stabs Fyodor; Ivan sheds a single tear as Fyodor lies dying. But the latter manages to give a warning against Staden as he dies; Malyuta arrests Staden. Suddenly there comes the announcement that the Livonian troops are coming; Kurbsky has fallen into Ivan's trap. Ivan and the Oprichniki prepare for battle and set out on horseback.

Sequence 24

There follows a series of battles as Ivan advances toward the sea. First, Kurbsky in his tent receives the news from the German emissary that Elizabeth has tricked them and sided with Moscow. Kurbsky is hopeful that the border posts are manned by friendly Boyars, but his troops are met by cannonfire. Kurbsky barely manages to escape as his tent is set afire by a shot. Malyuta and Pyotr ride up too late to find Kurbsky. Amid the battle, Ivan rides forward, elated.

Kurbsky is now back at the castle at Wolmar but is once again forced to flee by the advancing battle. Ivan takes the castle easily. A group of peasants bring Staden to Ivan; he has been pillaging their farms. Ivan distributes grain and gives them their soil—now Russian—to till. They beat Staden as he rushes to escape. On the road to Weissenstein, Ivan's troops advance.

At the castle of Weissenstein, the guns of battle are heard in the distance. The Vogt of the castle, Oldenbock, argues with Kurbsky, who wishes to flee before the advancing Russians. Oldenbock declares that the Livonian nobles may not flee; Kurbsky departs ignominiously alone. The Livonians within the castle fling themselves

into drinking and dancing, knowing that the Russian troops are already battering at their gates. As the gates give way, Oldenbock flees to a basement chapel, where he begins exploding kegs of gunpowder in a desperate effort to trap the Russians. Malyuta seizes Ivan's standard and begins climbing the bastions to raise it at the top. Oldenbock lights a pile of kegs; scenes in the vault alternate with scenes of Malyuta climbing. A cutaway scene shows Kurbsky on his horse, fleeing; a shot topples him to the ground, and he disappears into the marsh. Back at the castle, Malyuta has planted the standard just before a large explosion occurs; he is flung down and trapped beneath the wreckage. Pyotr reaches him, and Malyuta sends him to plant the standard once more and take his place as Ivan's sole support. Ivan reaches Malyuta, who says he regrets only that he never will see the sea. Ivan has Malyuta placed on a stretcher, and they set out at a great pace through the thick of the battle. On every side, Ivan's troops are victorious. Finally they reach the dunes near the Baltic; Malyuta catches a glimpse of the sea in the distance, then dies. Ivan walks to the edge of the sea, declaring, "And henceforward even to eternity shall the seas continue obedient to the Russian state." Pyotr and his troops cheer, and the chorus sings of the sea as the narrative ends.

Select Bibliography

By Eisenstein

Eisenstein, Sergei. "Extrait d'un cours sur la musique et la couleur dans *Ivan le Terrible.*" In *Au-delà des étoiles*, translated by Jacques Aumont et al., edited by *Cahiers du cinéma*, pp. 271-311. Paris: Union Générale d'Editions, 1974.

————. *Film Essays and a Lecture.* Translated and edited by Jay Leyda. New York: Praeger, 1970.

————. *Film Form.* Translated and edited by Jay Leyda. New York: Harcourt, Brace, and World, 1949.

————. *The Film Sense.* Translated and edited by Jay Leyda. New York: Harcourt, Brace, and World, 1942.

————. "La musique du paysage." Translated by Luda and Jean Schnitzer. *Cahiers du cinéma*, no. 217 (November 1969), pp. 14-23.

————. "La non-indifférente nature." Translated by Luda and Jean Schnitzer. *Cahiers du cinéma*, no. 218 (March 1970), pp. 6-14.

————. *La non-indifférente nature, I.* Translated by Luda and Jean Schnitzer. Paris: Union Générale d'Editions, 1976.

————. *Notes of a Film Director.* Translated by X. Danko. New York: Dover, 1970.

Levaco, Ronald. "The Eisenstein-Prokofiev Correspondence." *Cinema Journal* 13, no. 1 (Fall 1973): 1-16.

Nizhny, Vladimir. *Lessons With Eisenstein.* Translated and edited by Ivor Montagu and Jay Leyda. New York: Hill and Wang, 1962.

Transcripts of *Ivan the Terrible*

Eisenstein, Sergei. *Ivan the Terrible.* New York: Simon and Schuster, 1970.

————. *Ivan the Terrible: A Screenplay.* Translated by Herbert Marshall and Ivor Montagu. New York: Simon and Schuster, 1962.

Prokofiev, Sergei. *Ivan the Terrible: Oratorio.* Edited by A. Stasevich, translated by Herbert Marshall. Moscow: Soviet Composers, 1962.

On Eisenstein and *Ivan the Terrible*

Amengual, Barthelemy. *S. M. Eisenstein.* Paris: *Premier Plan*, no. 25, n.d.

Bordwell, David. "Eisenstein's Epistemological Shift." *Screen* 15, no. 4 (Winter 1974/1975): 32-46.

Chartier, Jean-Pierre. "*Ivan le Terrible.*" *La Revue du cinéma* 1, no. 1. New Series (1 October 1946): 49-60.

Mitry, Jean. *S. M. Eisenstein.* 2d ed. Paris: Editions universitaires, 1961.

Morse, David. "Style in *Ivan the Terrible*." *Monogram*, no. 1 (April 1971), pp. 28-31.

Oudart, Jean-Pierre. "Sur *Ivan le Terrible*." *Cahiers du cinéma*, no. 218 (March 1970), pp. 15-23.

Peatman, Mary. "Sergei Eisenstein's *Ivan the Terrible* as a Cinematic Realization of the Concept of the *Gesamtkunstwerk*." Ph.D. dissertation, Indiana University, 1975.

Robel, Léon. "Notes fragmentaires pour une étude des rapports entre Eisenstein et Tynianov." *Change*, no. 2 (n.d.), pp. 57-60.

Seton, Marie. *Sergei M. Eisenstein*. London: The Bodley Head, 1952.

Yourenev, Rostislav. *Eisenstein*. Translated by Luda Schnitzer. *Anthologie du cinéma*, no. 44 (Paris, 1964).

BY FORMALISTS AND STRUCTURALISTS

In this section I have listed all the translations of Formalist writings into English and French of which I am aware, whether or not I used them in preparing this book. I have placed an asterisk by those works upon which I drew directly.

Bakhtin, Mikhail. *Problems of Dostoevsky's Poetics*. Translated by R. W. Rotsel. Ann Arbor: Ardis, 1973.

Barthes, Roland. "An Introduction to the Structural Analysis of Narrative." Translated by Lionel Duisit. *New Literary History* 6, no. 2 (Winter 1975): 237-272.

———. *S/Z*. Translated by Richard Miller. New York: Hill and Wang, 1974.

———. "The Third Meaning." Translated by Richard Howard. *Artform* 11, no. 5 (January 1973): 46-50.

Bernshtein, S. "Aesthetic Presuppositions for a Theory of Declamation." Translated by Ann Shukman. *Russian Poetics in Translation* 4 (1977): 71-89.

Brik, Osip. "Selected Writings." Presented by Maria Enzensberger, translated by Diana Matias. *Screen* 15, no. 3 (Autumn 1974): 35-118.

———. "The So-Called Formal Method." Translated by Ann Shukman. *Russian Poetics in Translation* 4 (1977): 90-91. Also in "Documents from *Lef*," translated and edited by Richard Sherwood. *Screen* 12, no. 4 (Winter 1971/1972): 42-44.

Culler, Jonathan. *Structuralist Poetics*. Ithaca: Cornell University Press, 1975.

Eikhenbaum, Boris. "The Illusion of *Skaz*." Translated by Martin P. Rice. *Russian Literature Triquarterly*, no. 12 (Spring 1975), pp. 233-236.

———. "Leskov and Contemporary Prose." Translated by Martin P. Rice. *Russian Literature Triquarterly*, no. 11 (Winter 1975), pp. 211-224.

*———. "Literary Environment." Translated by I. R. Titunik. In *Readings*

in Russian Poetics, edited by Ladislav Matejka and Krystyna Pomorska, pp. 56-65. Cambridge, Mass.: The MIT Press, 1971.

———. "Literature and Cinema." Translated by Thomas L. Aman. *20th Century Studies* 7/8 (December 1972): 122-130.

———. "O. Henry and the Theory of the Short Story." Translated by I. R. Titunik. In *Readings in Russian Poetics*, edited by Ladislav Matejka and Krystyna Pomorska, pp. 227-270. Cambridge, Mass.: The MIT Press, 1971.

———. "On Tolstoy's Crises." Translated by Carol A. Palmer. In *20th Century Russian Literary Criticism*, edited by Victor Erlich, pp. 97-101. New Haven: Yale University Press, 1975.

———. "Problems of Film Stylistics." Translated by Thomas Aman. *Screen* 15, no. 3 (Autumn 1974): 7-32.

———. "Pushkin's Path to Prose." Translated by Irene Etkin Goldman. In *20th Century Russian Literary Criticism*, edited by Victor Erlich, pp. 86-96. New Haven: Yale University Press, 1975.

———. "Some Principles of Literary History: The Study of Lermontov." Translated by Ann Shukman. *Russian Poetics in Translation* 5 (1978): 1-8.

———. "The Structure of Gogol's 'The Overcoat'." Translated by Beth Paul and Muriel Nesbitt. *The Russian Review* 22, no. 4 (October 1963): 377-399.

———. "Sur la théorie de la prose." In *Théorie de la littérature*, translated and edited by Tzvetan Todorov, pp. 197-211. Paris: Seuil, 1965. [Part I is the same as "Leskov and Contemporary Prose" above; Part II is the same as section 2 of "O. Henry and the Theory of the Short Story."]

*———. "The Theory of the 'Formal Method'." Translated by I. R. Titunik. In *Readings in Russian Poetics*, edited by Ladislav Matejka and Krystyna Pomorska, pp. 3-37. Cambridge, Mass.: The MIT Press, 1971.

———. *The Young Tolstoi*. Translated by David Boucher et al., edited by Gary Kern. Ann Arbor: Ardis, 1972. [Includes a glossary of Formalist terms.]

Heath, Stephen. "Film and System: Terms of Analysis, I." *Screen* 16, no. 1 (Spring 1975): 7-77.

Jacobson, Roman. "The Dominant." Translated by Herbert Eagle. In *Readings in Russian Poetics*, edited by Ladislav Matejka and Krystyna Pomorska, pp. 82-87. Cambridge, Mass.: The MIT Press, 1971.

———. "Linguistics and Poetics." In *Style in Language*, edited by Thomas A. Sebeok, pp. 350-377. Cambridge, Mass.: The MIT Press, 1960.

———. "On Realism in Art." Translated by Karol Magassy. In *Readings in Russian Poetics*, edited by Ladislav Matejka and Krystyna Pomorska, pp. 38-46. Cambridge, Mass.: The MIT Press, 1971.

Lef. "Translations from *Lef* with an Introduction." Translated and edited by Richard Sherwood. *Screen* 12, no. 4 (Winter 1971/1972): 25-58.

Novy Lef. "From *Novy Lef* with an Introduction." Edited and introduced by Ben Brewster. *Screen* 12, no. 4 (Winter 1971/1972): 59-100. [This item and the preceding one include passages by Russian Formalists.]

Propp, Vladimir. "Fairy Tale Transformations." Translated by C. H. Severens. In *Readings in Russian Poetics*, edited by Ladislav Matejka and Krystyna Pomorska, pp. 94-114. Cambridge, Mass.: The MIT Press, 1971.

*————. *Morphology of the Folktale*. Translated by Laurence Scott, edited by Louis A. Wagner. 2d ed. Austin: University of Texas Press, 1968.

Reformatsky, A. A. "An Essay on the Analysis of the Composition of the Novella." Translated by Christine Scholl. *20th Century Studies* 7/8 (December 1972): 85-101.

*Shklovski, Viktor. "Art as Technique." In *Russian Formalist Criticism: Four Essays*, translated and edited by Lee T. Lemon and Marion J. Reis, pp. 3-24. Lincoln: University of Nebraska Press, 1965.

————. "La construction de la nouvelle et du roman." In *Théorie de la littérature*, translated and edited by Tzvetan Todorov, pp. 170-196. Paris: Seuil, 1965.

————. "Excerpts from *Eisenstein*." Translated by Chris Pike and Joe Andrew. *Essays in Poetics* 2, no. 1 (1977): 66-82.

*————. "Form and Material in Art." Translated by Charles A. Moser and Patricia Blake. In *Dissonant Voices in Soviet Literature*, edited by Patricia Blake and Max Hayward, pp. 20-28. New York: Harper & Row, 1962.

————. "In Defense of the Sociological Method." Translated by Ann Shukman. *Russian Poetics in Translation* 4 (1977): 92-99.

————. "Isaac Babel: A Critical Romance." Translated by John Pearson. In *Major Soviet Writers*, edited by Edward J. Brown, pp. 295-300. New York: Oxford University Press, 1973.

————. "The Mystery Novel: Dickens' *Little Dorrit*." Translated by Guy Carter. In *Readings in Russian Poetics*, edited by Ladislav Matejka and Krystyna Pomorska, pp. 220-226. Cambridge, Mass.: The MIT Press, 1971.

————. *O teorii prozy*. Moscow, 1929.

*————. "On the Connection Between Devices of *Syuzhet* Construction and General Stylistic Devices." Translated by Jane Knox. *20th Century Studies* 7/8 (December 1972): 48-72.

————. "Parallels in Tolstoy." In *20th Century Russian Literary Criticism*, edited by Victor Erlich, pp. 81-85. New Haven: Yale University Press, 1975.

————. "Poetry and Prose in Cinematography." Translated by Thomas L. Aman. *20th Century Studies* 7/8 (December 1972): 128-130.

*————. "Pushkin and Sterne: *Eugene Onegin*." Translated by James M. Holquist. In *20th Century Russian Literary Criticism*, edited by Victor Erlich, pp. 63-80. New Haven: Yale University Press, 1975.

*————. "The Resurrection of the Word." Translated by Jane Knox. *20th Century Studies* 7/8 (December 1972): 41-47.

*————. "Sterne's *Tristram Shandy:* Stylistic Commentary." In *Russian Formalist Criticism: Four Essays*, translated and edited by Lee T. Lemon and Marion J. Reis, pp. 25-57. Lincoln: University of Nebraska Press, 1965.

————. "*Strike* and *Battleship Potemkin*." Translated and edited by Joe Andrew and Chris Pike. *Essays in Poetics* 2, no. 1 (1977): 60-65.

————. *Sur la théorie de la prose*. Lausanne: Editions l'Age d'Homme, 1973.

Tomashevski, Boris. "Literary Genres." Translated by L. M. O'Toole. *Russian Poetics in Translation* 5 (1978): 52-93.

————. "Literature and Biography." Translated by Herbert Eagle. In *Readings in Russian Poetics*, edited by Ladislav Matejka and Krystyna Pomorska, pp. 47-55. Cambridge, Mass.: The MIT Press, 1971.

*————. "La nouvelle école d'histoire littéraire en Russie." *Revue des études slaves* 8 (Paris, 1928): 226-240.

————. "Sur le vers." In *Théorie de la littérature*, translated and edited by Tzvetan Todorov, pp. 154-169. Paris: Seuil, 1965.

*————. "Thematics." In *Russian Formalist Criticism: Four Essays*, translated and edited by Lee T. Lemon and Marion J. Reis, pp. 61-95. Lincoln: University of Nebraska Press, 1965.

Tynjanov, Juri. "Destruction, Parodie" and "Fragments d'*Archaistes et Novateurs*." Translated by Lily Denis. *Change*, no. 2 (n.d.), pp. 67-76.

————. "Dostoevsky and Gogol." In *20th Century Russian Literary Criticism*, edited by Victor Erlich, pp. 102-116. New Haven: Yale University Press, 1975.

*————. "Des fondements du cinéma." Translated by Sylviane Mossé and Andrée Robel. *Cahiers du cinéma*, no. 220/221 (May-June 1970), pp. 58-69.

————. "The Meaning of the Word in Verse." Translated by M. E. Suino. In *Readings in Russian Poetics*, edited by Ladislav Matejka and Krystyna Pomorska, pp. 136-145. Cambridge, Mass.: The MIT Press, 1971.

————. "Motifs." *New Left Review*, no. 43 (May-June 1967), pp. 75-78. [Portion of "Rhythm as the Constructive Factor of Verse," following.]

————. "On Khlebnikov." Translated by Charlotte Rosenthal. In *Major Soviet Writers*, edited by Edward J. Brown, pp. 89-99. New York: Oxford University Press, 1973.

*————. "On Literary Evolution." Translated by C. A. Luplow. In *Readings in Russian Poetics*, edited by Ladislav Matejka and Krystyna Pomorska, pp. 66-78. Cambridge, Mass.: The MIT Press, 1971.

*————. "Plot and Story-line in the Cinema." Translated by Ann Shukman. *Russian Poetics in Translation* 5 (1978): 20-21.

*————. "Rhythm as the Constructive Factor of Verse." Translated by

M. E. Suino. In *Readings in Russian Poetics*, edited by Ladislav Matejka and Krystyna Pomorska, pp. 126-135. Cambridge, Mass.: The MIT Press, 1971.

————. "Les traits flottants de la signification dans le vers." Translated by Tzvetan Todorov. *Poétique*, no. 28 (1976), pp. 390-397.

————. "Tyutchev and Heine." Translated by C. R. Pike. *Russian Poetics in Translation* 5 (1978): 9-19.

————. *Le vers lui-meme*. Translated by Jean Durin et al. Paris: Union Générale d'Editions, 1977. Also in English as *The Problem of Verse Language*. Translated by Michael Sosa and Brent Harey (Ann Arbor: Ardis, 1981).

Tynjanov, Juri, and Jacobson, Roman. "Problems in the Study of Literature and Language." Translated by Herbert Eagle. In *Readings in Russian Poetics*, edited by Ladislav Matejka and Krystyna Pomorska, pp. 79-81. Cambridge, Mass.: The MIT Press, 1971.

Vinogradov, V. V. "The Problem of *Skaz* in Stylistics." Translated by Martin P. Rice. *Russian Literature Triquarterly*, no. 12 (Spring 1975), pp. 237-250.

————. "The Tasks Facing Stylistics." Translated by Ann Shukman. *Russian Poetics in Translation* 5 (1978): 24-29.

Volosinov, V. N. "Reported Speech." Translated by Ladislav Matejka and I. R. Titunik. In *Readings in Russian Poetics*, edited by Ladislav Matejka and Krystyna Pomorska, pp. 149-175. Cambridge, Mass.: The MIT Press, 1971.

Yarkho, B. "A Methodology for a Precise Science of Literature (Outline)." Translated by L. M. O'Toole. *Russian Poetics in Translation* 4 (1977): 52-70.

ON THE FORMALISTS AND STRUCTURALISTS

Aman, Thomas L. "The Formalists and Cinema: An Introductory Note." *20th Century Studies* 7/8 (December 1972): 120-121.

Bowlt, John E. "Introduction." *20th Century Studies* 7/8 (December 1972): 1-5.

————. "Russian Formalism and the Visual Arts." *20th Century Studies* 7/8 (December 1972): 131-146.

Conio, Gérard, ed. and trans. *Le Formalisme et le futurisme russes devant le Marxisme*. Lausanne: Editions l'Age d'Homme, 1975. [Contains sections by Eikhenbaum and Tynjanov.]

Erlich, Victor. *Russian Formalism: History—Doctrine*. 3d ed. The Hague: Mouton, 1969.

Jameson, Frederic. *The Prison-House of Language*. Princeton, N. J.: Princeton University Press, 1972.

Kristeva, Julia. "The Ruin of a Poetics." Translated by Vivienne Mylne. *20th Century Studies* 7/8 (December 1972): 102-119.

Lemon, Lee T., and Reis, Marion J., trans. and eds. "Introduction." In *Russian Formalist Criticism: Four Essays*, pp. ix-xvii. Lincoln: University of Nebraska Press, 1965.

Matejka, Ladislav. "The Formal Method and Linguistics." In *Readings in Russian Poetics*, edited by Ladislav Matejka and Krystyna Pomorksa, pp. 281-295. Cambridge, Mass.: The MIT Press, 1971.

Narboni, Jean. "Introduction à *Poetika Kino*." *Cahiers du cinéma*, no. 220/221 (May-June 1970), pp. 52-57.

Nowell-Smith, Geoffrey. "Introduction: Tzvetan Todorov." *Film Reader* 2 (1977): 15-18.

Pomorska, Krystyna. *Russian Formalism and Its Poetic Ambiance*. The Hague: Mouton, 1968.

———. "Russian Formalism in Retrospect." In *Readings in Russian Poetics*, edited by Ladislav Matejka and Krystyna Pomorska, pp. 273-280. Cambridge, Mass.: The MIT Press, 1971.

Revuz, Christine. "La théorie du cinéma chez les formalistes russes." *Ça*, no. 3 (January 1974), pp. 48-71.

Schmidt, Paul. "First Speculations: Russian Formalist Film Theory." *Texas Studies in Literature and Language* 17 (Special Russian Issue, 1975): 327-336.

Sherwood, Richard. "Viktor Shklovsky and the Development of Early Formalist Theory on Prose Literature." *20th Century Studies* 7/8 (December 1972): 26-40.

Shukman, Ann. "Russian Formalism: A Bibliography of Translations and Commentaries (Works in English, French, German, and Italian)." *Russian Poetics in Translation* 4 (1977): 100-108.

Thompson, Ewa M. *Russian Formalism and Anglo-American New Criticism*. The Hague: Mouton, 1971.

Todorov, Tzvetan. "The Methodological Heritage of Formalism." In *The Poetics of Prose*, translated by Richard Howard, pp. 247-276. Ithaca: Cornell University Press, 1977.

———. trans. and ed. "Présentation." In *Théorie de la littérature*, pp. 15-27. Paris: Seuil, 1965.

———. "Some Approaches to Russian Formalism." Translated by Bruce Merry. *20th Century Studies* 7/8 (December 1972): 6-19.

Zima, Pierre. "De la structure textuelle à la structure sociale: les contributions formalistes et structuralists à la sociologie de la littérature." *Revue d'Esthétique*, no. 2/3 (1976), pp. 186-223.

Addenda Bibliography Notations

Since the time I completed this study, a number of additional works on the Formalists and on *Ivan the Terrible* have come out. For those interested in further reading, I include brief annotations.

Aumont, Jacques. *Montage Eisenstein*. Paris: Editions Albatros, 1979.
 The chapter "Meurtre dans la chambre nuptiale" on pages 119 to 149

deals with *Ivan*. Aumont compares the poisoning scene in Part I with the scene of Ivan's discovery that Anastasia was murdered. For the most part, Aumont follows an early structuralist approach derived from Raymond Bellour's concept of "rhymes" and from Christian Metz's Grande Syntagmatique method of segmenting. (Given the fact that the Grande Syntagmatique was originally formulated by Metz to apply to Hollywood films, Aumont has some predictable difficulties in attempting to segment *Ivan* with it.) Aumont discovers the usual kinds of structuralist oppositions: black versus white costumes, deep space versus close-ups, movement versus stasis, and so on. The final three pages introduce psychoanalysis to show how Fyodor is a sexual substitute for Anastasia.

Bennett, Tony. *Formalism and Marxism*. London: Methuen and Co., Ltd., 1979.

A sympathetic but uneven discussion of the Formalists that attempts to show how their work might be usefully developed into a Marxist system. Bennett sees the Formalists as "inescapably and radically historical" (p. 50) but views that historicity as abstract, unable to deal with concrete external forces (pp. 68-69). While he is more interested than Medvedev and Bakhtin (see subsequent bibliographic entry) in preserving the useful aspects of Russian Formalism while introducing into their system a Marxist view of history, Bennett runs into contradictions and problems in discussing the Formalist system. For example, he states quite rightly at one point that the Formalists, unlike the structuralists, did not see literature as analogous to language (p. 46). Later he links the Formalists' problems with history to those of Saussure with his synchronic-diachronic split (pp. 69-75); yet this formulation only works if we assume that the literary system is equal to *la langue*, which it is not for the Formalists. At other times, Bennett depends heavily on the works of Jacobson for his discussion of Formalism, even while admitting at one point that Jacobson is not typical of the movement (p. 45). At the same time, Bennett downplays Tynjanov, the best historical theoretician among the Formalists.

On the whole, Bennett provides an interesting summary of the Formalists' relations to more recent Marxist work, but the reader would do well to come to his book with a good grounding in the basic Formalist system.

Britton, Andrew. "Sexuality and Power, Pt. 2." *Framework* 7/8 (Spring 1978): 5-11.

Britton uses a late structuralist psychoanalytic approach to do a reading of *Ivan*'s "supreme importance for gay cinema." He traces the relation of male/female roles in the film to the possession of power, finding that the bulk of Part I upholds a traditional phallocentric view, while Part II challenges and undermines this view. Part II, he argues, "analyses the mechanisms of repression." The article demonstrates how late structur-

alism easily becomes simply a new hermeneutic, a method for creating readings of meaning without taking into account the medium of film. The meanings are no doubt new, but the process of simply skimming meanings out of the film fails to deal with form and style in any original way.

Medvedev, P. N., and Bakhtin, M. M., *The Formal Method in Literary Scholarship*. Translated by Albert J. Wehrle. Baltimore: The Johns Hopkins University Press, 1978.

Originally written in 1928, this book is probably the most extensive, systematic attack on the Formalist movement to date. The authors claim to be critiquing Formalism entirely on its own terms in order to pick out its accomplishments and use them as the basis for a Marxist study of literature. The first half of the book makes some useful points about problems in the Formalist system; for example, the authors point out that, although the Formalist view of historical change depends upon continuous novelty for the sake of defamiliarization, it does not provide a way of accounting for the form this novelty takes. Yet this does not mean that such a way could not be found, using and extending Formalist assumptions. But Medvedev and Bakhtin are interested more in brushing away problematic aspects of Formalism rather than in extending the Formalist system to encompass Marxist purposes. (For a more positive approach to this problem, see Tony Bennett's *Formalism and Marxism*, and Ben Brewster and Geoffrey Nowell-Smith's articles.)

The second half of *The Formal Method* begins increasingly to assign different definitions to Formalist terms, then to critique the movement on the basis of these new meanings. In particular, the authors fail to understand what Shklovski meant by "material," relegating it back into its traditional role as "content." They dismiss motivation altogether, and overemphasize the Formalists' interest in transrational language. (Although the Formalists definitely had a strong tie to the Futurist writers, the bulk of their examples are drawn from other types of literature.)

Ultimately, Medvedev and Bakhtin deny that the Formalists acknowledged any connection between the work and the real world, claiming that they "feared" meaning (p. 105). They relegate Formalism to a hedonistic, art-for-art's-sake position that, I believe, does not do justice to the Formalist system. Nevertheless, the book provides valuable evidence of the attitudes that brought about the official end of Formalism; it also makes some quite legitimate points about weak places in Formalism that need additional work.

Sheldon, Richard. *Viktor Shklovsky: An International Bibliography of Works By and About Him*. Ann Arbor: Ardis, 1977.

A thorough bibliography by the major translator of Shklovski's works into English.

Index

aesthetic films, 25-30, 48. *See also*
 practical films; informational films
Alexander Nevsky, 157, 195, 224,
 226, 233, 256-258
Andrew, Dudley, 116
L'Année dernière à Marienbad, 66
art for art's sake, 10, 33, 293
Astaire, Fred, 243
Auden, W. H., 11
auteur criticism, 19, 20
automatization, 52, 57, 175
axis of action, 54, 117, 122

background, 12, 14-18, 20, 47-49, 53,
 57-58, 158, 205, 218, 259, 264, 296
background construct, 49-51, 69, 87
Band Wagon, The, 243
baring of the device, 35-37, 46, 164,
 176, 178, 184, 195, 212, 217
Barthes, Roland, 9, 17, 39-41, 43, 51,
 70, 112, 199-200, 286, 288-293,
 299
Bazin, André, 28, 54
Bed and Sofa, 8
Bellour, Raymond, 20-21
Berkeley, Busby, 113, 243-244
Birds, The, 21
Blazing Saddles, 43-44
blooping, 55, 203
Bordwell, David, 5, 37, 54
Bresson, Robert, 66
Brik, Osip, 8
Brooks, Mel, 43
Browne, Nick, 21
Burch, Noël, 4, 20, 34, 41, 54, 63,
 267

Cabinet of Dr. Caligari, The, 174, 178
camerawork, 26, 127, 174, 177, 258
character, 38-39, 46, 55, 71-74, 78,
 95, 99, 106, 110, 172, 174-175,
 199-200, 222, 281-282, 286. *See
 also* seme

cheat cut, 268-271
Cherkasov, Nicolai, 74
Chinoise, La, 277
*Chronicle of Anna Magdalena Bach,
 The*, 66
Chushingura, 6
cinematicness, 24, 26, 31, 38
Citizen Kane, 38, 213
Clair, René, 56
classical narrative cinema, 53-59, 66-
 67, 72, 114, 122, 158-159, 172,
 174, 199, 203, 205, 207, 211, 213,
 215, 218, 223, 225-226, 229, 242,
 256-258, 260, 265, 267, 277-278,
 281, 283-286, 288, 296, 298, 300.
 See also Hollywood
Cloak, The, 8
closure, 40-41, 43-44, 66, 107, 110,
 281
communications model of art, 10-12,
 22, 44-45, 300
Constructivism, 48
content, 10-11, 18, 24, 31, 33, 49,
 291. *See also* form/content split
continuity: editing, 55, 114-115, 167,
 266-267, 271-272, 277; system, 54,
 117, 204, 265-266, 268, 275, 288
Copland, Aaron, 207
Cornell, Joseph, 301-302
cubistic editing, 63, 267-268, 270-271,
 275, 286, 298
Culler, Jonathan, 10, 12, 259, 261-262

Day of Wrath, 66
defamiliarization, 32-33, 35, 41, 45,
 47, 52-53, 57, 59-60, 167, 175,
 187, 260-261, 263, 293
deformation, 17, 111, 174, 179
devices, 33, 35, 46, 264, 267, 292,
 294-295. *See also* baring of the de-
 vice
diachronic, 17-18
dialectical materialism, 5

dialogue hook, 56, 61, 63, 79, 280, 283-284
Diary of a Tenement Gentleman, 66
discontinuities, 53, 58, 67, 112, 261-287
disjunctions, 65, 67, 111, 246-247, 261-286
displacement, 65, 72-73, 75, 96, 98, 102-103, 110-111
Doane, Mary Ann, 55
documentary films, 29-30
dominant, 25, 34, 46, 57, 59, 63-67, 112-113, 116, 123, 127, 133, 180, 193, 202, 226, 229, 234, 238, 244, 246, 256, 258, 273, 275
Dreyer, Carl, 264

East of Borneo, 301
ecstasy, 6-7
editing, 26, 63, 112, 122-123, 142, 144, 147, 163, 198, 244, 247, 258, 265, 269, 272, 274, 277, 287. *See also* continuity; cubistic editing
1812 Overture, 218
Eikhenbaum, Boris, 8, 23, 31, 38, 70
Eisenstein, Sergei, 3-8, 20, 28, 51, 56, 61, 67, 70, 77, 95, 100, 116, 118, 122, 130, 158, 160, 184, 189, 194, 198, 202, 207, 213-215, 218, 224-227, 229-234, 239, 244-245, 247-248, 256-258, 264, 267-268, 272, 277, 281, 283, 285, 296
Eisler, Hanns, 203-204, 207, 224, 248-249, 257, 260
Equinox Flower, 36
Erlich, Victor, 27, 47n
excess, 65, 111, 168, 177n, 287-302
expressionism, 64, 172-202
eyelines, 54, 114-115, 118-120, 132, 134, 139, 142, 144, 163, 199, 200, 267, 272-274, 277

figure of distress, 43-44, 75, 102, 141, 286
Ford, John, 48, 57, 159, 264
form, 10, 11, 14, 23, 27, 291. *See also* form/content split
form/content split, 10, 11, 14, 19, 31, 33

framing, 26, 28, 54, 112, 114, 140, 161
Freud, Sigmund, 289-290n
function: of art, 31-33, 113; of devices, 25, 34, 39, 78, 80, 82, 87, 91, 94-95, 99, 101, 107-108, 111, 143, 172, 185, 187, 202, 267, 273, 286-287, 289, 292, 294-295, 299-300

genre, 18, 20, 37, 57-58, 70
Godard, Jean-Luc, 56, 66, 277
Gris, Juan, 73, 267

Hanet, Kari, 21
Hanoun, Marcel, 34
Hawks, Howard, 57, 114-115
Heath, Stephen, 42-44, 102, 263, 286, 288-290
hermeneutic code, 40-41, 43-46, 50, 63, 65, 67-68, 71-73, 88, 95-96, 111, 113, 182, 301
His Girl Friday, 37, 39
history, 12, 16-18, 20, 47, 51, 52, 58, 70-71, 86-87, 157, 199, 204, 282-283, 298
Hitchcock, Alfred, 19, 21, 36, 266
Hobart, Rose, 302
Hollywood, 48, 53, 55-56, 58, 59, 63, 113-116, 153, 158, 174, 203-204, 206-208, 215, 218, 223, 229, 234, 242-244, 248-249, 257-260, 265-268, 275-277, 281, 283, 296-298. *See also* classical narrative cinema
Holy Mountain, The, 43-44
House on Trubnoi Square, The, 8
Huillet, Daniélle, 38, 264
Husserl, Edmund, 27

ideology, 50, 283
illustration, 207, 211, 215, 226-227, 246, 260
informational films, 28-29, 48
inner speech, 6
interpretation, 11-12, 15-20, 67, 197, 262, 294. *See also* meaning
Ivan IV, 51, 69-70, 100

Jacobs, Ken, 301-302

Jakobson, Roman, 8-9, 12, 20-21
Jodorowsky, Alexandro, 43-44

Kabuki theater, 5-6, 171, 184-185,
 198, 215
Kael, Pauline, 296
Krieger, Murray, 10-11

La Chinoise, 277
language: poetic (New Criticism), 10;
 poetic (Russian Formalism), 11, 24-
 25, 31, 45, 48; practical (Russian
 Formalism), 11-12, 15, 24, 48, 52;
 scientific (New Criticism), 10
langue, 13-16
Laura, 37
Lawder, Stan, 302
Lef, 8
legibility, 41, 189, 295
leitmotif, 204, 207, 217, 258
Le Million, 56
Les Vacances de Monsieur Hulot, 34,
 56
Lévi-Strauss, Claude, 13
Lieutenant Kizhe, 8
linguistics, 13
literariness, 23-25, 32
Logische Untersuchungen, 27

Magnificent Ambersons, The, 56
Maltese Falcon, The, 200
Man Who Shot Liberty Valance, The,
 39
Marxism, 7-8, 16, 50
Mary of Scotland, 57-58, 72, 84, 159,
 172, 203-206, 213, 215, 242, 250,
 265-266, 282-284
material, 24, 33, 69, 173, 200, 289-
 292
meaning, 12, 14, 16, 19, 20-22, 33,
 49, 67, 103, 111, 188, 231, 262,
 288-290, 293, 302. See also inter-
 pretation
Meet Me In St. Louis, 243
Metz, Christian, 21
Millar, Gavin, 266-267
Million, Le, 56
mise-en-scene, 26, 55, 63-64, 83, 93,
 112, 120, 122, 146, 158, 167, 172-
 202, 258, 264, 268
monistic ensemble, 5-6
montage, 4-7, 28, 113, 231, 285. See
 also vertical montage
montage sequence, 56, 63, 153, 206,
 242, 264, 284
Moscow Linguistics Circle, 27
motivation, 34, 36, 44, 46, 65, 70, 73,
 77, 81-87, 90, 94, 101-103, 111,
 123, 158, 167, 172, 183, 185-186,
 215, 264-265, 278, 281-282, 288-
 290, 293-295, 298-299, 301; artis-
 tic, 35-36, 54, 207, 213, 223, 259,
 287, 293-294; compositional, 35-36,
 69-71, 91, 101, 173-175, 207-208,
 223, 259, 286, 293; realistic, 35-36,
 51, 55, 69-71, 173-174, 207-208,
 223, 259, 293, 298
move, 45-46, 64, 67, 71, 73, 75-78,
 95, 98-99, 107, 110, 112
Mukařovský, Jan, 54
music, 203-213, 217-223, 224-260,
 280, 283, 300

narrative, 20-21, 38, 40-46, 53-54, 57,
 61-111, 113, 121, 130, 141, 143,
 154, 158, 163, 167, 172, 175, 178,
 182, 186, 194, 197, 200, 202, 204,
 207, 213, 222-223, 227, 231, 234,
 260-263, 265-267, 273, 280-281,
 283, 285-292, 294-295, 297-302
naturalization, 259-260, 262-263, 265,
 301
neoformalism, 7-8, 20, 22, 53, 59, 67,
 113
New Criticism, 8-17, 19
Nicht Versöhnt, 38, 66, 264
Novyi Lef, 8

October, 5, 7
Old and New, 7
Olympia, 29
optical effects, 26
Oudart, Jean-Pierre, 90
overdetermination, 65, 68, 75, 110-
 112, 275
overtone, 123, 133, 170, 180, 193,
 226, 234, 244-245, 258, 273

Ozu, Yasujiro, 35-36, 66, 265-266

parole, 14-16
Pavlovian physiology, 5
Peatman, Mary, 217-218
perception, 27, 33, 47; aesthetic, 11,
 15-17, 22-23, 26-28, 30, 32-35, 38,
 41, 46, 52-53, 58, 111, 175, 204,
 213, 231, 259, 261-262, 267-268,
 275, 277, 288, 290, 292-295, 297,
 300, 302; practical, 23
Peter the First, 59, 73-74n
Petrov, V., 59, 73-74n
Play Time, 41
plot, 37-38, 46, 142n, 146, 268, 294.
 See also story/plot distinction
Potemkin, 5, 7
practical films, 25-30, 48. See also aes-
 thetic films; informational films
Prague Linguistic Circle, 9
Preminger, Otto, 37
proairetic code, 40-41, 43-46, 65, 67,
 72, 74, 79, 84, 88, 95, 98, 102,
 110, 112-113, 124, 126, 142n, 175,
 192, 221, 289
Prokofiev, Sergei, 217-218, 226, 250,
 257-258
Propp, Vladimir, 9, 45
protagonist, 39, 67-68, 72-73, 84,
 157, 282
Puccini, Giacomo, 204

Quatre Cents Coups, 66

Ray, Man, 31
reader, the, 14-18, 22
redundancy, 65-67, 101, 111-113,
 158, 175, 179, 202, 260, 275, 295
Reisz, Karel, 266-267
repetition, 34, 90, 111, 135, 167, 175,
 187, 202, 217, 264, 295
Resnais, Alain, 26, 30
retardation, 34, 69, 71, 81, 94, 104,
 111, 167
Richter, Hans, 31
Riefenstahl, Leni, 29
Robbe-Grillet, Alain, 262
Rogers, Ginger, 243
Rope, 266-267
Rose Hobart, 301

roughened form, 34, 40-41, 194, 213,
 231, 259, 275, 287, 292
Russian Formalism, 4, 8-18, 20, 23-24,
 27-28, 30-37, 39-42, 44-49, 51-53,
 111, 207, 226, 230n, 231, 261-263,
 287, 291, 293

Salt, Barry, 242
Sarris, Andrew, 4
screen direction, 54, 115, 272-273
seme, 39, 46, 55, 64, 68, 71-72, 75,
 78, 80, 83, 85-88, 91, 96, 99, 100,
 112-114, 120, 124, 129, 136-137,
 151-152, 162, 167, 175, 195, 197,
 199-201, 221, 281, 289, 295, 298
Sergeant York, 57-58, 72, 96, 114-
 119, 122, 159, 172, 200, 203-206,
 213, 215, 225, 242, 249, 265, 282-
 284
Shadow of a Doubt, 27
Shklovski, Viktor, 8, 23, 27, 32-33,
 35, 38-39, 44-45, 52, 113, 134n,
 167, 230n, 261, 263, 291
Simple histoire, Une, 34
Singin' in the Rain, 242
Socialist Realism, 8, 58-59, 67
sound, 26, 41, 55-56, 64, 67, 112,
 202, 203-260, 268, 275, 281, 300
Spy Who Came in From the Cold,
 The, 27
Stage Fright, 36
staircase construction, 34, 40-41, 46,
 58, 75, 79, 134n, 247, 290
Stalin, Josef, 58
Steiner, Max, 206, 226, 258
Storm Over Asia, 8
story, 37-38, 41, 46, 51, 142n, 283,
 294. See also story/plot distinction
story/plot distinction, 37-38, 51, 62,
 101. See also story; plot
Straub, Jean-Marie, 38, 264
structuralism, 8-10, 12-17, 20-22, 261-
 262
SVD, 8
Swept Away, 50
synchronic, 17-18
Système de la mode, 17

Tati, Jacques, 41, 56
Tchaikovsky, Peter, 218

Tom, Tom, The Piper's Son, 301
Tomashevski, Boris, 8, 38, 42, 46, 57
Top Hat, 243
Touch of Evil, 35, 42, 289
Tout va bien, 56
Toute la memoire du monde, 26, 29-30
transparent motivation, 70
Tristram Shandy, 35, 52
Trotsky, Leon, 16
Tynjanov, Juri, 8, 31, 34, 37, 48-49, 51, 59, 259

Une Simple histoire, 34

Vacances de Monsieur Hulot, Les, 34, 56
vertical montage, 7, 207, 224-260, 275, 297
violence, 42-45, 68, 71, 75, 88, 95, 102, 121, 141, 263

Wagner, Richard, 204
Welles, Orson, 56
Wertmuller, Lina, 50
Wilde, Oscar, 30
Wings of a Serf, 8
Wood, Robin, 19

Illustrations

COLOR PLATE 1, SHOT 625

COLOR PLATE 2, SHOT 626

COLOR PLATE 3, SHOT 490

COLOR PLATE 4, SHOT 490

COLOR PLATE 5, SHOT 497

COLOR PLATE 6, SHOT 607

COLOR PLATE 7, SHOT 618

COLOR PLATE 8, SHOT 726

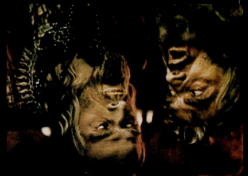

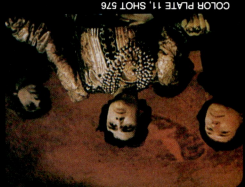

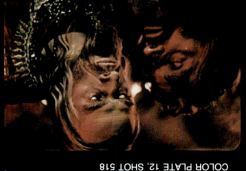

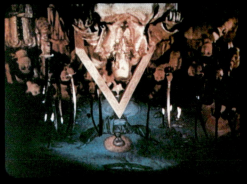

FIG. 1, *SERGEANT YORK*

FIG. 2, *SERGEANT YORK*

FIG. 3, *SERGEANT YORK*

FIG. 4, *SERGEANT YORK*

FIG. 5, *SERGEANT YORK*

FIG. 6, *SERGEANT YORK*

FIG. 7, *SERGEANT YORK*

FIG. 8, *SERGEANT YORK*

FIG. 16, SHOT I, 17

FIG. 15, SHOT I, 16

FIG. 14, SHOT I, 7

FIG. 13, SERGEANT YORK

FIG. 12, SERGEANT YORK

FIG. 11, SERGEANT YORK

FIG. 10, SERGEANT YORK

FIG. 9, SERGEANT YORK

FIG. 24, SHOT I, 45

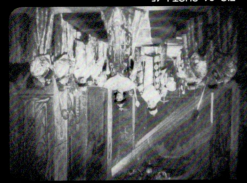

FIG. 23, SHOT I, 32

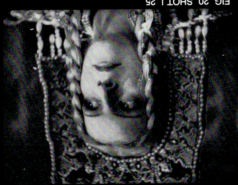

FIG. 22, SHOT I, 26

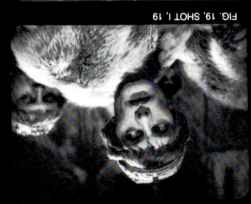

FIG. 21, SHOT I, 26

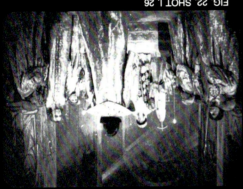

FIG. 20, SHOT I, 25

FIG. 19, SHOT I, 19

FIG. 18, SHOT I, 18

FIG. 17, SHOT I, 17

FIG. 25, SHOT I, 48

FIG. 26, SHOT I, 55

FIG. 27, SHOT I, 56

FIG. 28, SHOT I, 57

FIG. 29, SHOT I, 68

FIG. 30, SHOT I, 80

FIG. 31, SHOT I, 86

FIG. 32, SHOT I, 87

FIG. 33, SHOT II, 315

FIG. 34, SHOT II, 316

FIG. 35, SHOT II, 317

FIG. 36, SHOT II, 318

FIG. 37, SHOT II, 320

FIG. 38, SHOT II, 320A

FIG. 39, SHOT I, 34

FIG. 40, SHOT I, 58

FIG. 41, SHOT I, 59

FIG. 42, SHOT II, 344

FIG. 43, SHOT II, 122

FIG. 44, SHOT II, 349

FIG. 45, SHOT II, 358

FIG. 46, SHOT II, 362

FIG. 47, SHOT II, 366

FIG. 48, SHOT II, 375

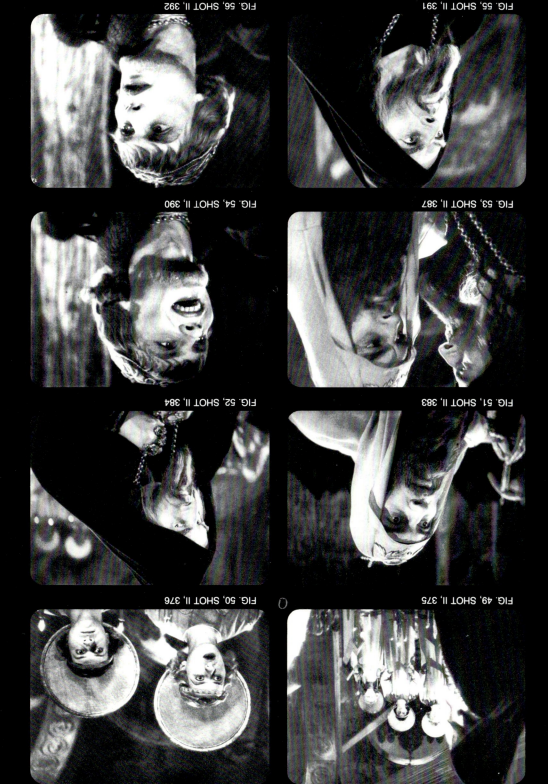

FIG. 56, SHOT II, 392

FIG. 55, SHOT II, 391

FIG. 54, SHOT II, 390

FIG. 53, SHOT II, 387

FIG. 52, SHOT II, 384

FIG. 51, SHOT II, 383

FIG. 50, SHOT II, 376

FIG. 49, SHOT II, 375

FIG. 64, SHOT II, 103

FIG. 63, SHOT II, 398

FIG. 62, SHOT II, 398

FIG. 61, SHOT II, 397

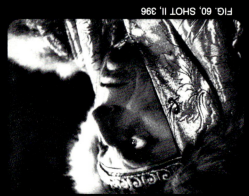

FIG. 60, SHOT II, 396

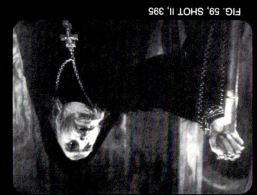

FIG. 59, SHOT II, 395

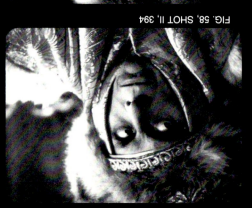

FIG. 58, SHOT II, 394

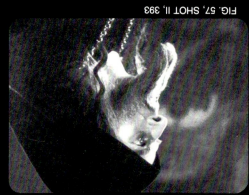

FIG. 57, SHOT II, 393

FIG. 72, SHOT II, 205

FIG. 71, SHOT II, 186

FIG. 70, SHOT II, 179

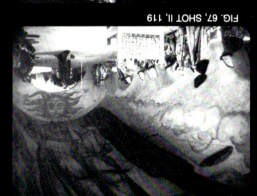

FIG. 69, SHOT II, 175

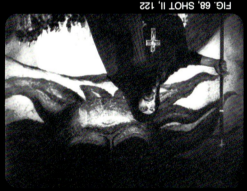

FIG. 68, SHOT II, 122

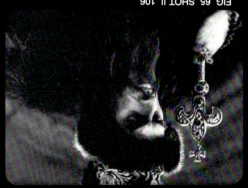

FIG. 67, SHOT II, 119

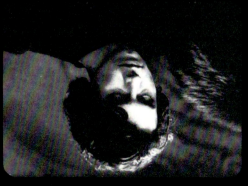

FIG. 66, SHOT II, 107

FIG. 65, SHOT II, 106

FIG. 73, SHOT II, 205

FIG. 74, SHOT I, 108

FIG. 75, SHOT I, 109

FIG. 76, SHOT I, 109

FIG. 77, SHOT I, 131

FIG. 78, SHOT I, 135

FIG. 79, SHOT I, 136

FIG. 80, SHOT I, 137

FIG. 81, SHOT I, 138

FIG. 82, SHOT I, 139

FIG. 83, SHOT I, 140

FIG. 84, SHOT I, 141

FIG. 85, SHOT I, 141

FIG. 86, SHOT I, 142

FIG. 87, SHOT I, 164

FIG. 88, SHOT I, 165

FIG. 89, SHOT I, 173

FIG. 90, SHOT I, 203

FIG. 91, SHOT I, 204

FIG. 92, SHOT I, 256

FIG. 93, SHOT I, 245

FIG. 94, SHOT I, 265

FIG. 95, SHOT I, 654

FIG. 96, SHOT I, 655

FIG. 104, SHOT I, 700

FIG. 103, SHOT I, 696

FIG. 102, SHOT I, 661

FIG. 101, SHOT I, 660

FIG. 100, SHOT I, 659

FIG. 99, SHOT I, 658

FIG. 98, SHOT I, 657

FIG. 97, SHOT I, 656

FIG. 112, SHOT I, 519

FIG. 111, SHOT I, 729

FIG. 110, SHOT I, 715

FIG. 109, SHOT I, 703

FIG. 108, SHOT I, 703

FIG. 107, SHOT I, 702

FIG. 106, SHOT I, 702

FIG. 105, SHOT I, 701

FIG. 112, SHOT I, 519

FIG. 111, SHOT I, 729

FIG. 110, SHOT I, 715

FIG. 109, SHOT I, 703

FIG. 108, SHOT I, 703

FIG. 107, SHOT I, 702

FIG. 106, SHOT I, 702

FIG. 105, SHOT I, 701

FIG. 113, SHOT I, 632

FIG. 114, SHOT I, 633

FIG. 115, SHOT I, 642

FIG. 116, SHOT I, 649

FIG. 117, SHOT II, 128

FIG. 118, SHOT II, 230

FIG. 119, SHOT II, 236

FIG. 120, SHOT I, 410

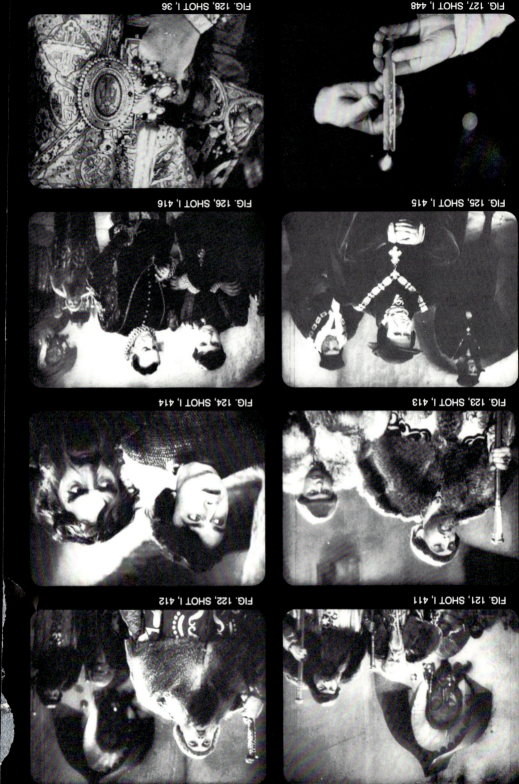

FIG. 127, SHOT I, 448

FIG. 128, SHOT I, 36

FIG. 125, SHOT I, 415

FIG. 126, SHOT I, 416

FIG. 123, SHOT I, 413

FIG. 124, SHOT I, 414

FIG. 121, SHOT I, 411

FIG. 122, SHOT I, 412

FIG. 129, SHOT I, 445

FIG. 130, SHOT I, 445

FIG. 131, SHOT I, 458

FIG. 132, SHOT I, 460

FIG. 133, SHOT I, 476

FIG. 134, SHOT I, 501

FIG. 135, SHOT I, 509

FIG. 136, SHOT I, 526

FIG. 137, SHOT I, 544

FIG. 138, SHOT I, 553

FIG. 139, SHOT I, 590

FIG. 140, SHOT II, 54

FIG. 141, SHOT II, 61

FIG. 142, SHOT II, 89

FIG. 143, SHOT II, 95

FIG. 144, SHOT II, 166

FIG. 145, SHOT II, 160

FIG. 146, SHOT II, 174

FIG. 147, SHOT II, 269

FIG. 148, SHOT II, 270

FIG. 149, SHOT II, 283

That's not enough!

FIG. 150, SHOT II, 287

FIG. 151, SHOT II, 663

FIG. 152, SHOT II, 667

FIG. 160, SHOT II, 676

FIG. 159, SHOT I, 759

FIG. 158, SHOT I, 408

FIG. 157, SHOT I, 405

FIG. 156, SHOT I, 384

FIG. 155, SHOT I, 373

FIG. 154, SHOT I, 267

FIG. 153, SHOT II, 667

FIG. 168, SHOT II, 417

FIG. 167, SHOT II, 400

FIG. 166, SHOT II, 310

FIG. 165, SHOT II, 305

FIG. 164, SHOT II, 290

FIG. 163, SHOT I, 425

FIG. 162, SHOT I, 99

FIG. 161, SHOT II, 690

FIG. 176, SHOT II, 137

FIG. 175, SHOT II, 665

FIG. 174, SHOT II, 94

FIG. 173, SHOT I, 263

FIG. 172, SHOT I, 263

FIG. 171, SHOT I, 246

FIG. 170, SHOT I, 219

FIG. 169, SHOT II, 489

FIG. 177, SHOT II, 673

FIG. 178, SHOT I, 165

FIG. 179, SHOT I, 472

FIG. 180, SHOT I, 473

FIG. 181, SHOT I, 561

FIG. 182, SHOT I, 562

FIG. 183, SHOT I, 579

FIG. 184, SHOT I, 628

FIG. 191, SHOT II, 682

FIG. 192, SHOT I, 757

FIG. 191, SHOT II, 682

FIG. 189, SHOT I, 761

FIG. 190, SHOT II, 340

FIG. 187, SHOT I, 124

FIG. 188, SHOT I, 182

FIG. 185, SHOT II, 720

FIG. 186, SHOT I, 95

FIG. 200, SHOT II, 226

FIG. 199, SHOT II, 243

FIG. 198, SHOT II, 116

FIG. 197, SHOT I, 803

FIG. 196, SHOT I, 800

FIG. 195, SHOT I, 796

FIG. 194, SHOT I, 796

FIG. 193, SHOT I, 793

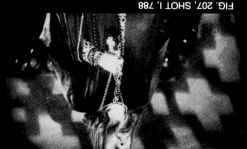

FIG. 207, SHOT I, 788

FIG. 208, SHOT I, 662

FIG. 205, THE CABINET OF DR. CALIGARI

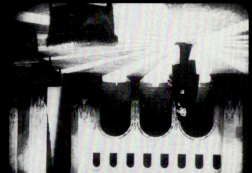

FIG. 206, SHOT I, 431

FIG. 204, SHOT I, 104

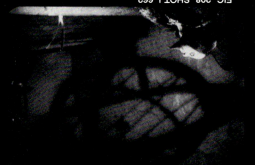

FIG. 203, SHOT II, 286

FIG. 202, SHOT II, 286

FIG. 201, SHOT II, 247

FIG. 209, SHOT II, 147

FIG. 210, SHOT II, 147

FIG. 211, SHOT I, 724

FIG. 212, SHOT II, 710

FIG. 213, SHOT II, 216

FIG. 214, SHOT II, 291

FIG. 215, SHOT II, 297

FIG. 216, SHOT II, 311

FIG. 224, SHOT I, 583

FIG. 223, SHOT II, 110

FIG. 222, SHOT II, 110

FIG. 221, SHOT II, 110

FIG. 220, SHOT II, 434

FIG. 219, SHOT II, 345

FIG. 218, SHOT II, 408

FIG. 217, SHOT I, 286

FIG. 225, SHOT II, 708

FIG. 226, SHOT I, 240

FIG. 227, SHOT I, 110

FIG. 228, SHOT I, 332

FIG. 229, SHOT I, 333

FIG. 230, SHOT II, 440

FIG. 231, SHOT II, 441

FIG. 232, SHOT I, 275

FIG. 239, SHOT II, 256

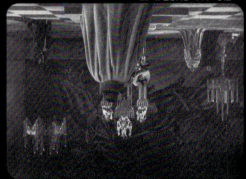

FIG. 240, SHOT II, 257

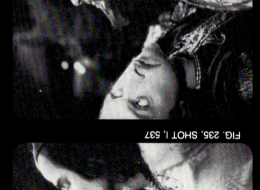

FIG. 237, SHOT I, 539

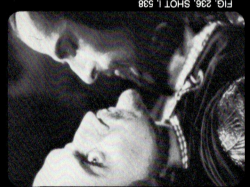

FIG. 238, SHOT II, 57

FIG. 235, SHOT I, 537

FIG. 236, SHOT I, 538

FIG. 233, SHOT I, 276

FIG. 234, SHOT I, 277

FIG. 248, SHOT I, 282

FIG. 247, SHOT II, 284

FIG. 246, SHOT II, 282

FIG. 245, SHOT II, 102

FIG. 244, SHOT II, 101

FIG. 243, SHOT I, 356

FIG. 242, SHOT I, 347

FIG. 241, SHOT II, 306

FIG. 256, SHOT II, 332

FIG. 255, SHOT II, 327

FIG. 254, SHOT II, 285

FIG. 253, SHOT II, 68

FIG. 252, SHOT II, 84

FIG. 251, SHOT II, 213

FIG. 250, SHOT II, 99

FIG. 249, SHOT II, 98